TURNER ON THE THAMES

TURNER ON THE THAMES

River Journeys in the year 1805

DAVID HILL

BCA

LONDON NEW YORK SYDNEY TORONTO

In memory of my parents
John Whitaker Hill, 1914–1966
Ella Hill, 1921–1978

endpapers from *Tombleson's Thames*

half-title page Turner's house at Isleworth (detail from Pl. 54).

frontispiece Bathers at Eton, Windsor Castle in the background (Detail from Pl. 193).

This edition published 1993
by BCA by arrangement with
Yale University Press
CN 9174

Set in Linotron Sabon by Best-set Typesetter Ltd, Hong Kong
Printed in Singapore by C.S. Graphics Ltd
Designed by John Trevitt

Contents

IV THE ISLEWORTH SKETCHBOOKS:

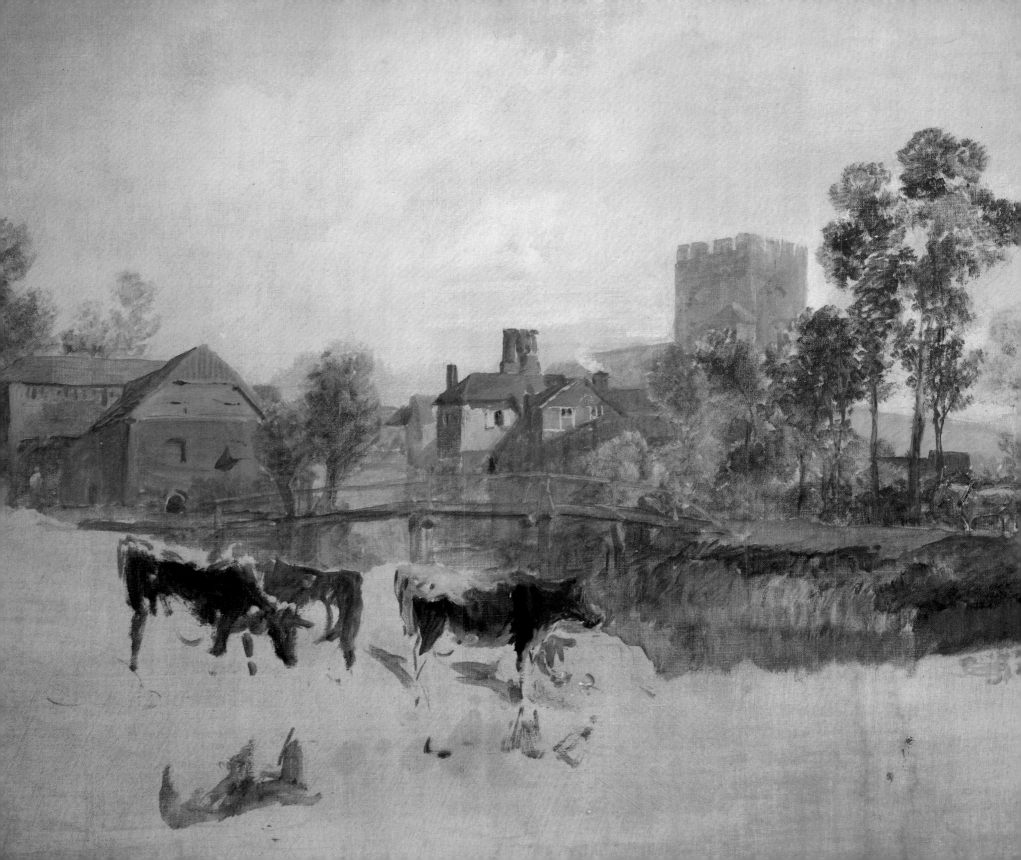

Preface and Acknowledgements

It is the highest gratification, to admirers of intellect, to watch *and* trace *the general* workings of minds, patiently enured to classical study, and the close observation of nature *– and such were the men to whom it is the purpose of these discussions to direct your attention to – the naturalistic,* original.

John Constable, 1836[1]

This book attempts to watch and trace the workings of Turner's mind during one of the most productive periods of his career. In 1805 he moved into Syon Ferry House, overlooking the Thames at Isleworth. He was equipped with five sketchbooks, a library of books, painting materials, canvases, boards, and a boat, and he spent the succeeding months pottering up and down the river, 'enured' in 'classical study, and the close observation of nature'.

The account is divided into four parts. The first outlines Turner's early association with the Thames, the second deals with his Isleworth sketches, the third examines the studio work based on those sketches, and the fourth sets out the reference material on which this account is based.

The main part of the book is concerned with reconstructing Turner's expeditions from Isleworth, and with tracing his thoughts as they develop page-by-page through the sketchbooks and from one painting to another. This has been a time-consuming task. I began my work on Turner's Thames sketchbooks while I was a student at the University of Leeds in 1975, and, after fifteen years of river exploration, photographs of sketches in hand, ferreting out comparative views in libraries and record rooms, and gingerly assembling one piece of evidence onto another, only to see my construction collapse several times like a house of cards, I believe that I can now propose an account and arrangement of one of the most remarkable periods in Turner's creative development.

This has not been a straightforward task. It has been known for some time that Turner lived at Syon Ferry House, Isleworth, but the matter of when exactly, or indeed even of precisely where Ferry House was, still less what he might have done there, has not been established. In 1961 the leading Turner scholar A. J. Finberg dated Turner's residence there to 1811–12,[2] and this was followed by John Gage in 1969[3] and Gerald Wilkinson in 1974,[4] but was corrected to about 1805 in the catalogue of the Turner bicentenary

exhibition held at the Royal Academy in 1974–5.[5] This was when I began work on an undergraduate dissertation for the University of Leeds, 'J. M. W. Turner at Isleworth 1804–6'. I have incorporated any results of that research which are still valid into the present work. In 1982 Patrick Youngblood published[6] the results of research into the Poor Rate books for the parish of Isleworth in Chiswick Public Library, containing documentary references to Turner's residency at Ferry House, and I have managed to take this further by using the Parish Rate books, not mentioned by Youngblood, to find further references. It is now possible to date Turner's occupancy of Ferry House to the summer of 1805.

Identifying the work done then has likewise been difficult, but, starting with the *Studies for Pictures Isleworth* sketchbook (TB XC), in which Turner wrote his address as 'Sion Ferry House Isleworth', I have assembled a group of five sketchbooks. Past scholars have hazarded various dates for these, ranging between *c*.1804 and 1812,[7] but there is some internal evidence evidence to date them to 1805 and a considerable amount of evidence to relate them one to another. The main part of this book attempts to pick a pathway through this material, following imaginative and topographical itineraries suggested by the sketches themselves. The dating and relationship of the sketchbooks is discussed in Part IV, where the contents of each are listed in full.

The sketchbooks are related to two groups of oil sketches which are virtually unique in Turner's career. The first is a group of small oil sketches on mahogany panels, and the second is a group of larger oil sketches on canvas. These likewise have been variously dated between *c*.1805 and 1812[8] For fifty years they languished in the lumber of the Turner Beqest until, about 1910, they were cleaned, restored, and put on display. As Finberg noted:

They are certainly the most important group of oil-paintings which Turner made direct from nature, and, with a few exceptions, they are the only oil-paintings of this kind that he ever made. When they were first exhibited, a little more that a hundred years after they had been painted, the public and critics of the day were surprised to find that Turner's realistic rendering of light and atmosphere were not only more truthful and convincing, they were also more instantaneous, more vivid and dexterous, than those of modern artists who had devoted their lives to direct painting in the open air.[9]

Turner rarely coloured from nature even in watercolour, preferring instead to make pencil sketches, and he hardly ever painted in oils direct from nature. These oil sketches represent some of his freshest and most naturalistic work and when, as is now possible, they are seen the context of the sketchbooks, which include some similarly stunning sketches in watercolour, besides lovingly detailed topographical records, or literary, historical, and poetic conpositions of the highest sublimity, we see one of the most wide-ranging, challenging and productive programmes of study in Turner's entire career.

There are many people who have given me more help and time than I had any right to expect. Let not their number diminish my gratitude to them all: Elizabeth Aldworth, Martin Butlin, Emma Chambers, Ann Chumbley, Ben Cohen, Shirley Corke, Emma Derapriam, Diana Douglas, Viscount Dunluce, Celina Fox, John Gage, Robin Griffith-Jones, Craig Hartley, Kenneth Hood, Diana Howard, Peter D. Kingsley, Fr Keith Kinnaird, Michael Kitson, M. J. H. Liversidge, Frank Milner, Kate Mitchell, Ann Livermore, D. J. Lyon, David Posnett, Dr D. B. Robinson and staff, David Setford, Eric Shanes, Andy Sharpe, M. J. Swarbrick, Martin Tillyer, Mary Tussey, Robert Upstone, Penny Ward, Ian Warrell, Al Weil, Henry Weymss, L. White, Dr J. Selby Whittingham, Reg Williams, Andrew Wilton, I. F. Wright, and Dorothy M. Yarde. Special thanks are due to Andrea Cameron, local studies librarian for the London borough of Hounslow, whose attention to my queries must at times have seemed well beyond the call of duty, and to Evelyn Joll, Cecilia Powell, and David Blayney Brown who read the manuscript with outstanding thoroughness and care and made many valuable suggestions for improvement. Any remaning gaffes are entirely my fault. All pictures are reproduced by kind permission of their owners. Thanks also to Rob Bentinck, Bill and Sue Burke, and Mary and Andy Prince, who at various times provided accommodation, sustenance, and diversion, and proved enthusiastic guides to Thames pubs that Turner 'might' have frequented. Without them this book would have been finished years ago. Thanks finally to the crew of the *Silver Cygnet*: Joe Pickard (chief engineer), who drove us there and back and claimed to have caught a huge pike; David Morris (galley) who didn't catch anything but served delicious stewing steak on carpet; and John Hill (cabin boy) who didn't fall overboard once.

David Hill
Bretton Hall College (University of Leeds)
July 1992

I LANDSCAPE OF YOUTH

Early Work and Exploration

London Boyhood. Schooldays at Brentford and Sunningwell. Visits
to Oxford. Apprenticeship and early career. Growing interest in Thames
subjects. Success at the Royal Academy.

In 1805 Turner moved into Syon Ferry House, overlooking
the Thames at Isleworth. He was thirty years of age, widely
travelled in Britain and Europe, and established as one of the
leading painters in the country. He had a reputation for
paintings of castles and abbeys, mountains and precipices,
historical and biblical epics, tempestuous seas and dramatic
skies, and every aspect of nature at her most stunning or
beautiful. At Isleworth he exchanged sublimities for the
seclusion of a Thames backwater and spent the succeeding
months pottering, strolling, and fishing, sailing a small boat
up and down, reading poetry, daydreaming, and making
sketches, watercolours, and oil sketches from nature. Most
of his work was made purely for his own study and pleasure.
He stepped back from his success, retreated from his public,
and reconstructed himself and his art by immersing himself
completely in quiet nature.

He was rebaptizing himself in his source, for the river had
made him what he was. Much of his formative experience
had occurred on the banks of the Thames. He was born in
London's Covent Garden, little more than a stone's throw
from the river, went to school in the market-garden village
of Brentford, and made his first sketches when staying at
his uncle's house up-river at Sunningwell. Thames scenes
provided the subjects of his earliest known works and his
first successful submission to the Royal Academy. After 1805
he maintained a home on or within easy reach of its banks
for most of the rest of his life. It was in the last of these,
overlooking Battersea and Chelsea Reaches from Cheyne
Walk, that he died. Throughout his career he returned to the
Thames to sketch and paint, to record its landmarks and its
history, to watch the sun rise and set, to fish, study reflec-
tions, or simply watch the water flowing. It is as if he

believed that proximity to the Thames was essential to
becoming and remaining himself, and in the work produced
at Isleworth he laid the foundations of much of his later
development. This book follows one of the most important
creative periods of his career and traces the experience
that fuelled his imagination, the process whereby this was
transmuted into art, and the effects of this period on his
subsequent work.

He was born at 21 Maiden Lane, in rooms above a cider
cellar, in a house squeezed into a narrow street between the
west end of Covent Garden Market and the Strand.[1] He was
the first child of William Turner, a barber and wig-maker,
and Mary Marshall, the daughter of a salesman. Their
circumstances were modest, but their son was delivered into
the very heart of English life. The market had supplied the
capital since the thirteenth Century; the Inns of Court were
just up the Strand; beyond was the City, the Pool of London,
and the Tower; up-stream, Whitehall and the Houses of
Parliament. The area was thronged with gentlemen's and
artists' houses, taverns, coffee-houses, theatres, brothels,
barrow-boys, clubs, and all society about its business and
pleasure. It was also the artistic and cultural heart of England.
Across the fashionably Italianate piazza were Covent Garden
and Drury Lane theatres. Over the Strand was Somerset
House, the home of the Royal Academy, and nearby in John
Street the headquarters of Society of Arts. The house in
Maiden Lane had in the years immediately preceding Turner's
birth seen service as an auction room, the exhibition rooms
of the Free Society of Artists, and the home of the Academy
of the Incorporated Society of Artists. Life classes and lectures
on anatomy and colour had been held there, and among the
members of the Incorporated Society were George Romney,

1 J. W. Archer, *26 Maiden Lane*, 1852. The house in which Turner grew up. His father ran a hairdresser's shop on the ground floor and hung watercolours around the door to sell to his customers. The site, between Covent Garden Market and the Strand, currently awaits redevelopment.

Watercolour, 35.5 × 22.0 cm, British Museum, London.

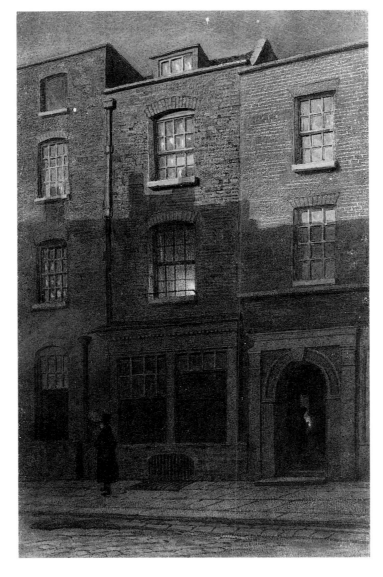

Francis Wheatley, Joseph Farington, and Ozias Humphrey. Their paraphernalia was removed only six months before Turner's parents moved in as newly-weds in 1773.[2]

Before their child was a year old the Turners moved to nearby St Martin's,[3] but by 1790 they were back in Maiden Lane, at number 26 across the street from their first home (Pl. 1). 'The old barber's shop was on the ground floor, entered by a little dark door on the left side of Hand Court. The window was a long, low one; the stairs were narrow, steep and winding; the rooms low, dark, and small, but square and cosy, however dirty and confined they may have

been. Turner's bedroom, where he generally painted, looked into the lane.'[4] Hand Court was 'a sort of gloomy horizontal tunnel with a low archway and prison-like gate of its own, and you had to stand a good minute in the dim light of the archway before you could see the coffin-lid door to the left'.[5] When Ruskin visited the house in 1860 he found its windows filled 'with a row of bottles, connected, in some defunct manner, with a brewer's business', but he saw enough to construct a colourful account of the artist's youthful habitat, compounded of

> dusty sunbeams up or down the street on summer mornings; deep-furrowed cabbage-leaves at the greengrocer's; magnificence of oranges in wheelbarrows round the corner, and Thames shore within three minutes' race . . . old clothes, market- womanly types of humanity, anything fishy and muddy, like Billingsgate or Hungerford Market . . . black barges, patched sails and every possible condition of fog . . . Forests of masts, Ships with the sun on their sails, red-faced sailors with pipes appearing over the gunwales.[6]

Ruskin further observed that Turner attached himself to everything that bore the image of the place he was born in: 'Maiden Lane or Thames Shore. He particularly enjoyed and looked for *litter*, like Covent Garden wreck after the market. His pictures are often full of it from side to side . . . His foregrounds had always a succulent cluster or two of greengrocery at the corners. Enchanted oranges gleam in Covent Gardens of the Hesperides; and great ships go to pieces in order to scatter chests of them on the waves.'[7] Our most vivid memories are often snippets and details, a litter of colours, smells, textures, and sounds left over from the past. Turner stored up such things throughout his life and used them as the material from which he constructed his art.

Nowhere could have been further from nature than Covent Garden, yet nowhere was it possible to learn more of the world. Examples of almost anything were being traded within a mile of his birthplace, and views of every part and feature of the known world were to be found in the stock of print-sellers, picture dealers, and galleries within the same compass. From this paradox sprang his constant desire to travel and explore. At the end of the eighteenth century, however, one did not have to travel very far to escape the confines of the city. Beyond Westminster the river-banks became increasingly rural and the villages small and picturesque. It might now require some effort of the imagination to picture Brentford as a small market town surrounded by fields and leafy lanes, but it was here that

Turner made his first acquaintance with what the rest of the world had to offer.

The boy was ten years old when 'in consequence of a fit of illness' he was sent to stay with his uncle in Brentford.[8] The illness in question seems to have been that of his seven-year-old sister Mary, who was buried at St Paul's Church, Covent Garden, on 20 March 1786. The children were old enough to have been close and for the boy to have felt the loss. His mother was forty-seven and must have suffered even more. Turner does not seem to have returned to his parents' home for any great length of time until he was fifteen.

Turner's mother bestowed upon her son the complete array of names carried by her forebears. Her grandfather and great-grandfather were both named Joseph Mallord and were butchers, her father was William Marshall, a salesman from Islington, and her brother was Joseph Mallord William Marshall, another butcher. By naming her son Joseph Mallord William, and by sending him to stay with his namesake, it might have been hoped that young Turner would follow in his uncle's footsteps. Joseph Marshall's shop and house were at the north side of Brentford market-place next door to an old inn, the White Horse (Pl. 2). The boy was sent as a day student to Mr White's school, consisting of fifty boys and ten girls, in the High Street opposite the Three Pigeons.[9] Presumably Turner's parents paid the school fees and also board and lodging to Marshall. Turner remembered that on his way to and from school he would amuse himself by drawing on the walls in chalk.[10] His talent proved marketable and for twopence a plate he coloured engravings for a friend of his uncle, a local distillery foreman named Lees. This work, in an edition of Henry Boswell's *Picturesque Views of the Antiquities of England and Wales*, newly published in 1786, survives today in Chiswick Public Library.[11]

Young Turner had seen enough artists and their work in Covent Garden to have nurtured ambitions in that direction for himself, and Eric Shanes has already drawn attention to the importance of Boswell's work in Turner's subsequent career:

This book contained a letterpress and a large number of engravings, by various artists, of 'picturesque scenes', seventy of which were hand-tinted by Turner, often with imaginative handling, especially in the skies. Fifty-eight are of *exactly* the same subjects as Turner's own later 'Picturesque Views in England and Wales' and the similarity in the two titles is obvious. The book evidently made a profound impression on the young Turner, not only in opening up imaginative horizons in its literary letterpress, but also awakening his latent sense of history and romantic imagery through its pictorial stimulus.[12]

Boswell introduced him to many of the sites he was to visit for himself over the next few years, and a few that he could walk to in the immediate vicinity. Thus 'he came to know the reaches of the upper Thames in the neighbourhood, walked about Putney and Twickenham, and stared across serene and spacious meadowland, paddock or park, with tree clumps and stately mansion entries, the chestnut avenue of Bushey Park, the iron gates and carved pillars, the terraces of Hampton Court; reedy shores with swans and green nooks, the river in its many moods, reflecting cattle and summer elms.'[13] As soon as he could afford it he returned to the same neighbourhood to live.

Mr White's school was the first formal education that the boy received. We know that his father could read and write a little, for it is said that he taught his son to read,[14] and it is probable that his mother could too, given her background. Books were extremely expensive, however, and it is hard to imagine that young Turner was very much more than basically literate when he was enrolled at Mr White's. He would have been taught reading, writing, arithmetic, religion, discipline, and manners. The purpose was to prepare him for a trade[15] such as that of his uncle and to teach him his place in society. Turner could not have acquired more than rudimentary literary or linguistic skills, nor wit, nor much of a classical vocabulary or cultured enunciation, such as might be required of a future Royal Academician.

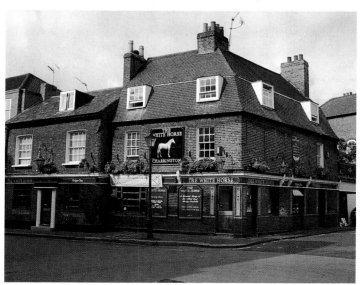

2 Brentford – Marshall's House and White Horse. As a boy, Turner went to school in Brentford and stayed with his uncle, who owned the cottage to the left of the pub. The cottage is now 'Turner's Bar'.

Photograph, the author.

3

Instead he developed his visual sensibility. It would have been difficult to imagine that there was much chance of his becoming half the success that he was; his circumstances were far too lowly for that. So when his father was cutting the hair of a Royal Academician, Thomas Stothard, one day, he was careful in his choice of words: 'My son,' he said, 'is going to be a *painter*.'[16]

So it was, while still at school in Brentford, that Turner began to think himself into his proposed identity. His work colouring engravings for Mr Lees might have been menial, but his willingness to undertake such work and, what is more, learn something from it, is one of the features that made him a success. John Gage has remarked upon the 'strong effects of lighting and weather, and broad, simple, saturated washes of colour'[17] that he applied. His principal means of learning was by copying and imitation, a practice which he continued for much of his life. Turner emulated many things he admired because for him that was the best way of coming to understand it. The fact that he continued to copy for so long, that he was willing for most of his life to learn new things, is another of the ingredients of his success. Both his choice of career and the means whereby his ambition would be realised were decided in his earliest known works. They are proudly signed and dated "W Turner 1787", and both are copies of engravings.

Folly Bridge and Bacon's Tower, Oxford (Pl. 3) was copied from the *Oxford Almanack* for 1780 (Pl. 4). The *Almanack* image was of an impressive size, one of the largest engravings commonly available, of excellent quality and by one of the leading watercolour artists of the time, Michael Angelo Rooker. Since it had been made to hang on a wall for twelve months it must have been designed to sustain and reward repeated scrutiny. Modern concern with novelty means that copying has come to be discounted as an almost worthless activity, but it is neither so easy nor so straightforward as it often seems to be thought. In order to replicate anything one has to discover how it is made, and in the case of something made by hand one has to acquire the same skills, techniques, processes, and materials that the original maker possessed. To discover what these are and then master them requires knowledge, perception, inventiveness, and ingenuity, and lessons thus learned prove lasting and valuable. What Turner discovered was the basis of his future career.

Although Turner's copy seems weak at first, he had been deeply engrossed in the detail and arrangement of Rooker's picture. In the foreground two Oxford fellows in academic dress superintend a third as he steps carefully from the bank into a punt, which the boatman carefully holds to the bank with his pole. Across the water a small sailing-boat lies moored in the shade of a mill. Beyond lies a deep shade under a wharf. Immediately next to this is the lightest and most active part of the picture, where the mill-race empties into the pool. Rooker exercised considerable thought and knowledge in managing the effect of light reflecting from the disturbed water, extending into the area one might otherwise expect to be dark, and reflecting upwards into the gloom beneath the wharf. Above this we see a timber-yard with stacks of sawn planks surmounted by an interesting complex of roofs, gables, and chimneys around the thirteenth-century observatory, which demanded considerable thought in controlling the play of light and shade. To the right by the bridge a number of boats are moored at the limit of the navigation. The buildings to the right are weak in the original but again show consideration of the light, in this case being directly reflected from them as they face the light source to the left. In front a labourer sorts out a consignment of tree boles, which seem to have been off-loaded from the boat in dock and which were presumably destined for the timber-yard opposite. Rooker thought out story-lines appropriate to the place, which are unfolded gradually as we make our journey through the picture, a similar journey to the one the figures in the foreground are about to embark upon. His grasp of light and reflections, and his construction of elaborate and graceful interactions of pictorial space, together with his consistency of narrative, are features which came to characterize Turner's own mature work. As A. J. Finberg noted, even though he was discussing a boy of only twelve: 'It is clearly the work of one who has done that sort of thing before, and who has made up his mind to go on doing similar jobs as soon as this one is finished.'[18]

He repeated the exercise in other Thames views of *Eton College* and *Nuneham Courtenay*.[19] He also adapted plates from William Gilpin's *Observations relative to Picturesque Beauty*, published in the 1780s,[20] which, like Boswell's *Picturesque Antiquities*, represented the latest in popular landscape literature. He seems to have been especially attracted to the work of Paul Sandby, one of the most important watercolourists of the day, who had been a founding member of the Royal Academy and was one of the leading teachers of the art. It is said that Turner attended Sandby's drawing school in St Martin's Lane,[21] which must have been very near his parents' home when they lived in that area, but no further evidence to corroborate or date this attachment has yet come to light. The results of these endeavours were exhibited at his father's shop. One early biographer had seen

3 *Folly Bridge and Bacon's Tower, Oxford*, 1787. One of Turner's earliest known works. A copy of the 'Oxford Almanack' engraving for 1780 (Pl. 4).

Watercolour, 30.8 × 43.2 cm, Tate Gallery, London, TB I-A.

4 James Basire after M. A. Rooker, *North-West View of Friar Bacon's Study [&c]*, From the Oxford Almanack for 1780.

Copper engraving, 27.7 × 45.4 cm, Ashmolean Museum, Oxford.

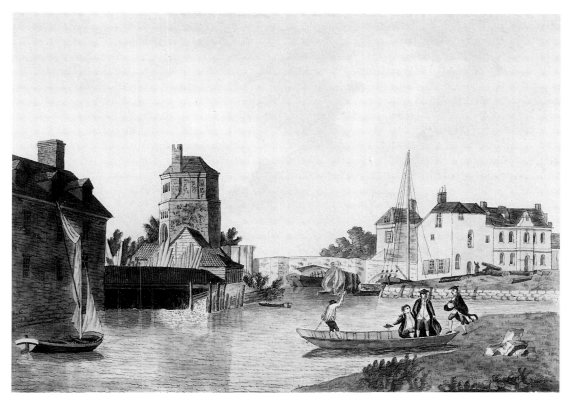

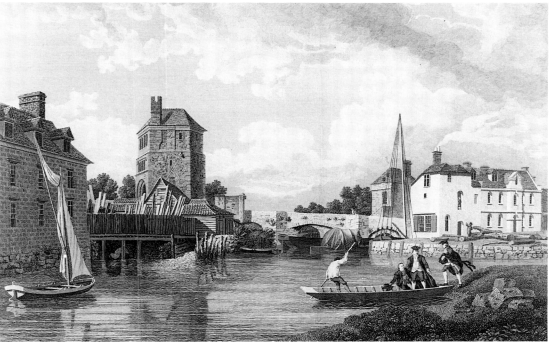

'a very early drawing, either a copy or an imitation of Paul Sandby, signed W. Turner, which had been . . . purchased . . . from the hairdresser's window . . . and that drawings of a similar character were hung around its entrance, ticketed at prices varying from one shilling to three.'[22] This rather homespun form of exposure paid off when, probably in the spring of 1789, a Revd Nixon from Kent was impressed enough by the drawings to bring Turner to the attention of a Royal Academician, J. F. Rigaud. He sent the boy to the Royal Academy schools as a probationer and on 11 December 1789, after a term's trial, he was formally accepted as a student.[23]

In order to attend the Royal Academy, Turner must have finished his schooling and moved back to live with his parents, now returned to Maiden Lane. We are told that he spent a year at Mr Coleman's school at Margate and lived with a relative of his mother's, and a number of drawings made in Margate and Kent, not unlike *Folly Bridge* in style, suggest that this must have been about 1788.[24] Back in London, we are also told that he worked for the architect Thomas Hardwick, who was the son of a builder from Brentford, and it is possible that Joseph Marshall had something to do with securing a position for his nephew through his local contacts.[25] Fourteen would have been the usual age at which to start some kind of trade apprenticeship. Perhaps the most likely combination of these elements is that Turner was in Margate until the summer of 1789 and moved back to London to work for Hardwick at the beginning of the autumn, thus being able to support himself while attending classes at the Royal Academy.

He spent some part of the summer making his first sketching tour. His uncle had retired from Brentford to a cottage near the church at Sunningwell[26] (Pl. 5), not far from the Thames between Oxford and Abingdon. The village cannot have changed much since Turner's day. It is approached down narrow lanes between hedgerows filled with cow parsley and briars, boasts a village pond and a pub called the Flowing Well, and has largely managed to escape new development and traffic. He went prepared with his first sketchbook, a moderately sized, landscape-format book with 26 sheets of relatively coarse paper bound cheaply in card covered with marbled paper. It contains sketches of Nuneham Courtenay, the seat of Earl Harcourt, overlooking the Thames three miles south-east of Sunningwell.[27] This was a popular subject with early Thames topographers, as was Radley Hall, still nearer, just over a mile towards the river from Sunningwell, to which Turner devoted another three sketches.[28] His eye for potentially marketable subjects

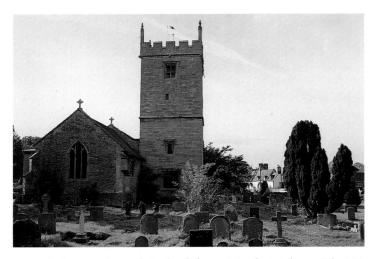

extended to a view of Oxford from North Hinksey (Pl. 11) and presumably for his own practice and interest he made a few sketches of Sunningwell church[29] from near his uncle's cottage (Pl. 6), and a pencil sketch and watercolour of an old manor house, presumably in the neighbourhood.[30] Turner seems to have anticipated making watercolours from some of these sketches and a number of pages are squared up to facilitate transfer and enlargement.[31] Back in London in the autumn Turner made at least two further drawings in the sketchbook, the first of Isleworth church (Pl. 7), probably already familiar to him after having lived nearby at Brentford, and another of Lambeth Palace (Pl. 8) to which he could have walked from Maiden Lane. In making the sketch of Isleworth, he cannot have imagined that fifteen years later he would be so successful in his art as to be able to live there.

At about this time Turner began to attend seriously to his perspective drawing. He enrolled at a recently founded evening class run by Thomas Malton, who specialized in architectural subjects and worked as a scene painter at the Covent Garden theatre.[32] Malton had been exhibiting at the Royal Academy since 1768 and had built up a reputation for watercolours of 'modern buildings of the period, the smoothness of dressed stone, the symmetry of Italian facades . . . well-peopled and enlivened with the incidents of the daily life of his time'.[33] At the time he opened his evening class he must have been working on his well-known views for *A Picturesque Tour through the Cities of London and Westminster*, which was published from 1792 onwards. Turner does not seem to have been a very apt pupil if anything in the fanciful account by Walter Thornbury is to be believed:

of Malton], has a much more competent and professional look.'[36] The selection jury at the Royal Academy evidently thought so too, and included it in their exhibition for 1790. Turner was not yet fifteen.

The Archbishop's Palace, Lambeth (Pl. 9) does not show quite what it purports in its title. The main subject is the Swan inn, Church Street. Over the roof of the pub we can just see the top of the tower of St Mary's church, while peeping round the corner is the gateway of the Archbishop's palace. In the distance to the left we glimpse an arch of Westminster Bridge. The sun, low in the north-west, streams through a gap between the gateway and some sheds to the left. The cobbled street and the wall of the pub are bathed in light. In the foreground a sprightly dandy walks arm in arm with a behatted young lady. Beyond them a woman carrying a bundle of laundry on her head walks hand in hand with her son, and a dog scampers alongside. Still further on two boys are playing, and to the right a customer sits in the sunshine on a bench outside the inn, chatting to the landlord through an open window. The peace is only emphasized by a horse and cart clattering into the picture from the right. No one ever seems to have noticed Turner's audacity in choosing a viewpoint. A more usual treatment of the Palace was from near the Houses of Parliament on the opposite bank of the river to the left,[37] showing the Palace buildings ranged along the waterside. Later pictures from a similar viewpoint to Turner's show greater deference to the subject and concentrate more on the gateway and the church.[38] Instead Turner gives prominence to the pub and to ordinary characters indulging in low-life pleasures. He has even gone so far as to distort the topography to achieve this end. Samuel Ireland's view published in 1792 (Pl. 10), suggests that there was much more space between the pub and the Palace gates than Turner allows, quite enough for him to have taken a view there happily. Turner instead condenses this space so as to obstruct our view with a public house, as if it, the 'WINES' that it sells, and the characters that it attracts, are more worthy of our attention than the Palace. And what could be wrong with that, the picture argues? Dogs and children play, boats sail on the river, *l'amour* and dalliance are pursued on the very doorstep of the Archbishop of Canterbury, supplies arrive by cart, the evening sun shines warmly and the world goes on very nicely.

The upper limit of his Thames explorations in the summer of 1789 had been Oxford and the city came to hold a particularly important place in his development. Its importance to him is recognised in the title, 'Oxford', which he gave to his first sketchbook, even though there is only one

5 OPPOSITE, TOP LEFT Sunningwell, near Oxford. Turner made some of his first sketching tours from his uncle's cottage, nearly opposite the church.

Photograph, the author.

6 OPPOSITE, TOP RIGHT Sunningwell Church, 1789.

Pencil, 11.2 × 24.8 cm, Tate Gallery, London, TB II 12.

7 OPPOSITE, BELOW Isleworth Church, 1789. Young Turner cannot have imagined that Isleworth would become so important to him in later years.

Pencil, 11.2 × 24.8 cm, Tate Gallery, London, TB II 22.

8 ABOVE Lambeth Palace, 1789.

Pencil, 11.2 × 24.8 cm, Tate Gallery, London, TB II 21.

Old architects now alive still remember the sad day when Malton, worn out and hopeless, shut up the books, and rolling up the blotted diagrams, took the crest-fallen boy back to Maiden Lane. 'Mr Turner,' he said, 'it is no use; the boy will never do anything; he is impenetrably dull, sir; it is throwing your money away; better make him a tinker, sir, or a cobbler, than a perspective artist!'[34]

The facts of the matter are best seen in the work, which suggests a quite different story. The sketches of Nuneham Courtenay and Radley Hall made in the summer are weak, but that of Isleworth Church (Pl. 7) is much more assured. That of Lambeth (Pl. 8), furthermore, actually puts method into practice, constructing pictorial space methodically with vanishing points and perspective lines, all carefully ruled and worked out. It took him a while longer to assimilate the lessons into his finished work, but in the comparison between the watercolour of Lambeth made for Hardwick[35] and a second attempt at the subject, Finberg detected an enormous improvement. The first he thought 'a dull drawing which might have been made by a self-taught student of topographical engravings; the second version with its gaily coloured and artfully placed figures [also a characteristic

9 *The Archbishop's Palace, Lambeth*, exhibited RA 1790. Turner's first exhibit at the Royal Academy. When it was accepted, he was not yet fifteen. Despite the title, Turner seems to have been more interested in the pub than the palace.

Watercolour, 26.3 × 37.8 cm, Indianapolis Museum of Art, USA.

sketch in it of the city, and that but a distant view (Pl. 11). The subject proved a difficult one with the city three miles distant, too far away to make out the buildings clearly, the interval a maze of complex nuances of distance, space, and perspective, and no previous experience with which to tackle it. The result, naturally enough, is vague in its details, tentative in its drawing, and timid in its colour. It nevertheless represents his first known attempt at the sort of subject with which he was to excel as no other.

His difficulties were compounded by the fact that he would have been conscious that he was dealing with a subject his role models had made their speciality. Nevertheless he translated the sketch into a finished watercolour (Pl. 12), very much in the style of his main model at this time, Paul Sandby. Were it not for its position at the very start of his career, we might accept unreservedly the description of it as 'suppressed and imitative', and the criticism that: 'The spires and domes of the city are feebly rendered and the architecture, as a whole, is poorly related to the countryside.'[39] It is perhaps also worth considering for its merits. If we overlook the foreground trees, the space as a whole is managed reasonably well. We can easily imagine a route across the fields to the city, and learn from it something of the distances beyond. It is only when we look closely at the city that we realize that Turner as yet had little knowledge of what he was depicting. In its vagueness about the buildings and their relationship to each other the picture taught him a vital lesson about his own need to learn.

His study of Oxford was to occupy him more than that of any other city over the next ten years, and when he returned about 1791 to make a second attempt at a prospect of the city he was rather better prepared. A watercolour in the Turner Bequest (Pl. 13) shows a view taken from Boar's Hill, about half a mile south of the viewpoint of the one made in 1789. He now handles the buildings with a confidence born of increased knowledge. The landscape is well laid out, painted with more knowledge of the plan of the city and its geography, and of the Oxfordshire plains rolling northwards towards Woodstock and Bicester. Turner no longer has any need for the foreground trees designed to make the picture look more substantial and old masterish, and presents his new skills without the need for such a diversion. He seems to have been proud of his achievement and mounted it on card, drew a neat wash-line border and carefully inscribed "A view of the CITY of OXFORD" in his best script along the bottom.

About the same time he used another sketchbook, now at the Art Museum of Princeton University, to make sketches of

10 TOP Samuel Ireland, *Lambeth*. A more typical treatment of the subject than Turner's.

Etching and aquatint, from 'Picturesque Views on the River Thames', 1792.

11 MIDDLE Oxford from North Hinksey, 1789.

Pencil, 11.2 × 24.8 cm, Tate Gallery, London, TB II 7.

12 BELOW Oxford, 1789. Turner's first tentative attempt at the sort of panoramic landscape in which he was to excel as no other.

Watercolour, 24.7 × 43.1 cm, Tate Gallery, London, TB III A.

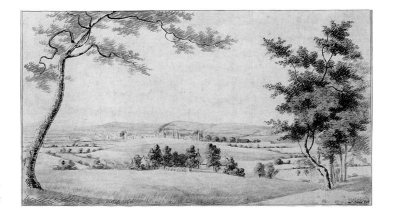

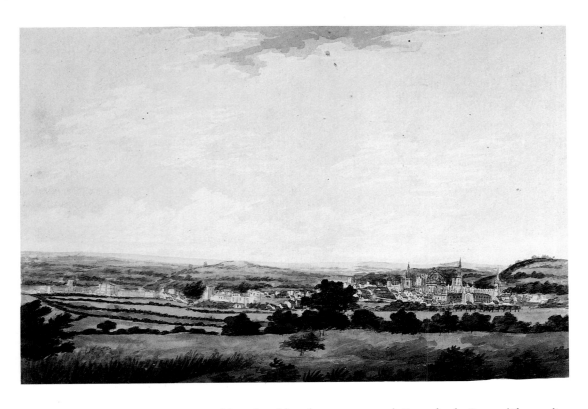

old abbey church (Pl. 15). An examination of the shadows suggests that the sun is high and to our right, that is, in the south or south-west, fixing the time as afternoon in midsummer. The shadows are accurately observed, even to that of the chimney cast on the adjacent roof. The picture throughout gives a sense of careful and time-consuming scrutiny. Tiny details are recorded which other artists might have ignored, the corner missing from the right-hand corner of the stonework above the two angle buttresses to the left, the way in which the three lancets of the chimney are slightly offset to the right. The longer one pursues the comparison between watercolour and fact, the more one becomes impressed by the quality of Turner's detail, to the extent that one begins to wonder whether every stone and crack was recorded individually. Turner clearly spent a great deal of time over this picture, and as it contains such a wealth of circumstantial detail, it seems that it could only have been painted on the spot.

Although the subject perfectly suited Turner's technical development at this time, it is worth considering why he chose this group of buildings in particular when he could have found similar ones more or less anywhere. Abingdon Abbey was one of the most ancient Benedictine foundations, dating from 670, and at its peak it had grown to be one of the greatest.[41] At the dissolution of the monasteries the abbey church was dismantled completely, its stone shipped off by barge to London, and all that survived was a range of outbuildings, including the checker and an adjacent granary and long gallery. Abingdon was the county town of Berkshire and its court found large numbers of people to imprison. Thus in 1637 the Corporation bought the granary to the right of the picture and used it as a Bridewell until the beginning of the nineteenth century. Hence it seems to have acquired the title of Starve Castle,[42] and Turner placed considerable emphasis on this with his inscription to the left "The remains to Abingdon Abbey now called STARVE CASTLE ABINGDON". He had an especially keen eye for the fate of great buildings, castles turned into cow-byres or abbeys into cart-sheds, and he also had a keen interest in the condition of the people who lived and worked in the places he depicted. The means by which they made their living was one of his principal concerns. England was undergoing serious economic upheavals and many were unable to make a living of any kind. These were perhaps the principal inhabitants of this place, and Turner no doubt intended us to notice the irony in a supply waggon serving Starve Castle. After the storming of the Bastille in 1789, social injustice was very much at the forefront of public consciousness.

13 ABOVE *A View of the City of Oxford*, c.1791. Comparison with the earlier effort indicates the rapidity with which Turner developed as a young man.

Watercolour 30.4 × 46.3 cm, Tate Gallery, London, TB III B.

14 OPPOSITE, LEFT *The Remains of Abingdon Abbey now called Starve Castle Abingdon*, c.1793. The old abbey buildings were then in use as a gaol. Turner's use of the name 'Starve Castle' perhaps indicates a concern for the plight of the inmates.

Watercolour, 27.0 × 20.7 cm, Ashmolean Museum, Oxford.

15 OPPOSITE, RIGHT Abingdon Abbey, the Checker and thirteenth century chimney. Turner's view is perfectly preserved to this day.

Photograph, the author.

his schoolday haunts around Brentford. Some life studies suggest that Turner was progressing with his academic work, but the most careful sketching was reserved for a three-page panorama of Syon House, the home of the Duke of Northumberland between Brentford and Isleworth. In this sketch Turner adopted a practice of continuing from spread to spread which he was to use on many occasions in later life. He made the most of the visit, and there are also sketches of Isleworth church and Kingston.[40]

He also returned upstream to Abingdon, a couple of miles south of Sunningwell and within easy walking distance of his uncle's cottage. By the time he painted *The Remains of Abingdon Abbey* (Pl. 14) in about 1792 he was bold enough in his handling of perspective to tackle an impressively complex jumble of buildings, gables, chimneys, and roofs, and to sort it out admirably. Furthermore he invests his buildings with a sense of volume, which is not just an effect of his drawing but is still more dependent on his control of the play of sunlight and shadow over the structure. The subject is the still-standing thirteenth-century chimney of the checker of Abingdon Abbey (the name recalls the building's original use as a counting-house), looking south-east from an area known as the Base Court to the west of the site of the

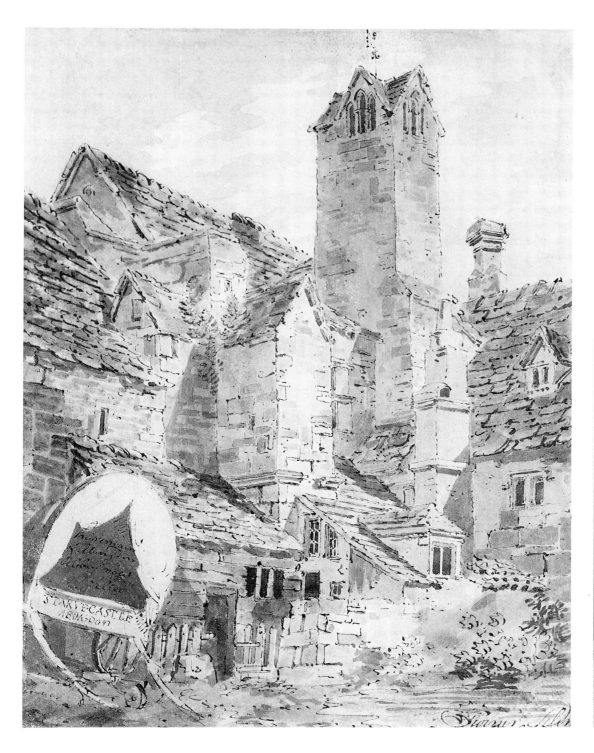

There would have been many capable of imagining an equation between the French Revolution and this picture. War with France was declared on 1 February 1793, and it was to cast an ominous shadow over Turner's work at Isleworth eight years later.

Despite the watercolour's truth to the site of Abingdon Abbey in many respects, it seems unlikely that a patch of white cloud would have manoeuvred itself so conveniently behind the chimney. It tells us that Turner had begun building up his repertoire of pictorial tricks and devices. It was recorded that 'The way he acquired his professional powers, was by borrowing, where he could, a drawing or picture to

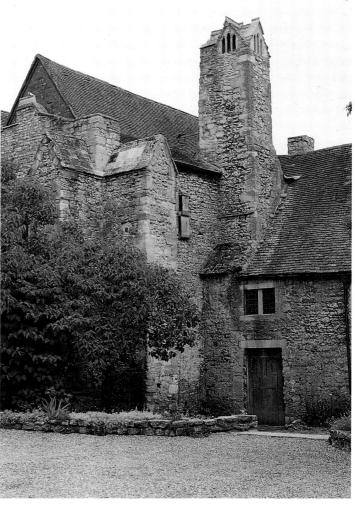

copy from; or by making a sketch of any one in the Exhibition early in the morning, and finishing it at home.'[43] At the time he needed it most, he not only found a ready supply of works to study, but also someone prepared to pay him to copy them.

Dr Thomas Monro had a collection of drawings by modern artists 'larger than any I have seen before', one visitor recorded,[44] and he freely allowed young artists to study and copy his pictures. This encouragement went beyond mere access to his paintings or portfolios or

assisting them with his own judicious advice. He had a pleasant way of bringing them together, in a system which combined the benefit of this kind of study with material instruction and with a small pecuniary profit to them at the same time. In winter evenings he encouraged young men to make a studio of his house. There they put their sketches into pictorial shape under the doctor's eye, and he gave them their supper and half a crown apiece for their work. Desks were provided with a candle which served for two sketchers, one sitting opposite to the other.[45]

This Academy met on Friday evenings between six and ten and the supper consisted of oysters. Turner remembered that he was paid three shillings and sixpence for his work.[46]

It is said that Dr Monro first bought Turner's work from the barber's shop and that he got to know the artist while he was colouring prints for John Raphael Smith's publishing and print-dealing business in King Street, two streets north of Maiden Lane.[47] Turner was still a student at the Royal Academy schools, but there was no landscape class, and Dr Monro's supplied the deficiency. The alternative Academy was regularized after Dr Monro moved from Bedford Square to 8 Adelphi Terrace, overlooking the Thames a very short walk from Maiden Lane, about the end of 1793 or early in 1794. Turner testified that he had attended for three years and in that time he had the opportunity to study a representative collection of the range of subjects, compositional devices, techniques, and methods current in British landscape painting.[48] One recent authority found it hard 'to be sure quite how his talent was benefitted by the repetitive exercises that he [Monro] prescribed',[49] but this is to fail to recognize how useful copying can be and that slow-built foundations are the most solid. The fact that Turner continued his studies for such a length of time is testimony enough to the fact that he found it neither 'menial', as the same writer describes it, nor 'submissive'. Repetitive it may have been, to judge from the large numbers of wash draw-

ings which survive,[50] but drawing is the best way of looking that there is. Drawing requires understanding, and engraves that understanding deeply on the mind. Thus Turner came to understand and to retain all the lessons there were to be learned from the landscape and architectural watercolourists he studied.

One of the pictures he made about this time is a view of *Old Blackfriars Bridge* (Pl. 16), taken from mid-river looking south towards the Surrey shore. It is an odd view, since the real interest at Blackfriars would have been a more expansive view showing something of the City and St Paul's, or at least more of the river and its banks. Instead we are close under the upstream side of the bridge, just about to drift underneath, looking across a steep rake of arches to a small piece of shore, where some steps lead down to the water in front of a small building. It is a subject certainly calculated to challenge his ability as a perspective draughtsman, and his weakness in this department was remarked upon by Edward Dayes: 'Though his pictures possess great breadth of light and shade, accompanied with a fine tone of colour, his handling is sometimes unfirm, and the objects are too indefinite: he appears, indeed, to have but a superficial notion of form.'[51] It might seem that this particular scene was taken more to correct this deficiency than for its scenic interest. It rewards close consideration nevertheless. The effect of a summer afternoon sun, high to the right and casting sharp shadows across the bridge, is exceptionally well seen. So are the complex reflections of the bridge piers in water, which we know was streaming from right to left. Furthermore, we learn that the river is tidal from the discoloration of the piers, and that it is ebbing, since that discoloration is dark and therefore still wet. It is the ebbing that has caused the accelerated flow through the bridge and the smooth stream of the water. Clearly the picture was made for more reasons than the problems it posed as a difficult architectural exercise. The painting is a model of his knowledge of the subject and his understanding of the processes of nature.

While he was working for Monro, Turner won his first commission from the printmaking trade. He had served a good apprenticeship and from hand tinting and copying he had a particularly good idea of what was required. The commission came from Harrison & Co. of Paternoster Row, publishers of various periodicals and part-works, including the *Copper-Plate Magazine* and the *Lady's Pocket Magazine*. The first issue of the former was published on 1 February 1792 and subsequent parts appeared at monthly intervals thereafter. Each number contained two engravings with

16 *Old Blackfriars Bridge*, c.1795. Even though made primarily as an exercise in perspective, Turner has taken an interest in the detail which is a characteristic of his work at this time.

Watercolour 26.2 × 17.1 cm, Whitworth Art Gallery, Manchester.

some descriptive text and cost one shilling. The series built up into a collection of views of picturesque, architectural, and antiquarian subjects by many of the younger artists of the time, including Edward Dayes, Francis Nicholson, and Turner's friend and contemporary Thomas Girtin, who had a view of Windsor published in the fourth number on 1 May 1792. Turner had to wait some while for his inclusion but on 1 May 1794 his view of Rochester was issued in number 28. This was followed a few months later by a view of Chepstow published on 1 November. Both the publishers and their engravers seem to have been satisfied with the young man's work and when one of the main engravers, John Walker, took over publication of the *Copper-Plate Magazine* himself, he also acquired, perhaps with the title, fourteen Turner watercolours which he continued to engrave and publish up to 1798. At the same time Harrisons bought a further sixteen drawings from Turner for publication in their own *Lady's Pocket Magazine*, an inferior publication to the *Copper-Plate Magazine*, with smaller and cheaper engravings. Doubtless neither paid Turner very much for his work, for the few that survive are quite small and bear no comparison in quality with his exhibited work from the same period, but nevertheless a total of thirty-two drawings represents a considerable order, his first major commission and his breakthrough to professional status as an artist.[52]

The engravings of *The Tower of London*, *Westminster Bridge* (Pl. 17), *Chelsea Hospital*, *Staines*, *Windsor*, *Wallingford*, and *Oxford*, together with studies of Richmond (Pl. 18) and Windsor (Pl. 19), show that Turner made an extensive survey of the Thames while he was still in his teens. The print collections available in his youth usually contained Thames subjects, especially London, Windsor, Eton, and Oxford. As a young artist attempting to read his market, it would have been quite obvious to him that there was a demand for Thames views, and it is quite natural that he would have wanted to build up his own stock of reference material. By 1792 the market was buoyant enough for Samuel Ireland to publish the first work devoted solely to *Picturesque Views on the River Thames*, with maps, a full description of the journey downstream from source to estuary, and over fifty views of places to be seen *en route*. It was based on a sketching tour made for the purpose in 1790 and although it cannot be claimed that the sepia aquatint plates are of any great artistic value in themselves, the two-volume set with its high-quality typography, paper, and printing, was an attractive package. The approach was successful enough for the publishers John and Josiah Boydell to pirate the idea. Their *History of the River Thames*

appeared in two volumes with a text by William Combe in 1794 and 1796 and was designed with a very up-market appeal. At £10 it was expensive, but its large format, and bright hand-coloured plates based on drawings by the Royal Academician Joseph Farington, made it luxurious and most purchasers had their copies expensively bound in morocco for their libraries. The Boydells pirated more than the idea from Ireland, however, for in addition to following the same general arrangement, tracing the river from source to sea, their book also hijacked his text, plagiarizing large chunks of it without acknowledgement or credit and allowing their luxury production to overshadow Ireland's precedence in the field.[53] Ireland is more important for he took his journey for pleasure. His representation of the Thames as a recreational river was at this time new, and we should not underestimate the role of this motive in Turner's own travelling.

Although Ireland's attitude to the river was novel, his pictures on the whole were much less so: bridge after bridge, sometimes with a church or a house in the middle distance, the horizon a third of the way up the page, taken from the waterside with the river in the foreground, trees either side, and a boat or two for variety. Most sketchers or photographers of the river will have arrived at similar results. Such, it would seem, is the stuff of which river pictures are almost bound to be made, and it is perhaps inevitable that in most hands they will tend to look alike. Farington's plates, on the whole, are merely bigger versions of Ireland's, enlivened by being coloured and by one or two elevated or distant prospects. An alternative which Turner mastered early in his career was that of cropping. Ireland's Thames views generally suffer from having attempted to include too much, with the result that the subject is invariably pushed back into the middle distance. Edward Dayes advised on this point in his *Instructions for Drawing and Coloring Landscapes*, which echoes teaching current when Turner was learning his trade: 'Great care should also be taken, not to take in too great an extent of horizon; the rules of perspective admit of only 45°; this if possible, should never be exceeded, as it will increase the difficulty in the management; and one common fault is the including too much.'[54]

A sketch by Turner of *St Paul's Cathedral from the Thames* (Pl. 20), made about 1795, shows how effective limiting one's attention can be. From his viewpoint near the southern end of Blackfriars Bridge he would have had a grand sweep of the river, boats, barges, and workmen in front of him, with the bridge to his left, St Paul's and the City before him, and the river curving around to his right towards London Bridge, the Monument, and St Magnus.

17 *Westminster Bridge*, engraved by J Walker after W Turner, from the *Copper Plate Magazine*, 1 August 1797. Turner's work for the *Copper Plate Magazine*, marks his introduction to professional life as an artist.

Victoria and Albert Museum.

18 Richmond, c.1795. Turner's first-known study of the view from Richmond Hill. The oil splashes testify to its having seen action next to Turner's easel.

Pencil and watercolour, 14.0 × 22.2 cm, Tate Gallery, London, TB XXVII K.

19 Windsor, c.1795. Turner's earliest sketch of Windsor. Taken from a viewpoint upriver to the west, to which he was to return many times in later years.

Pencil, 21.6 × 27.3 cm, Tate Gallery, London, TB VIII D.

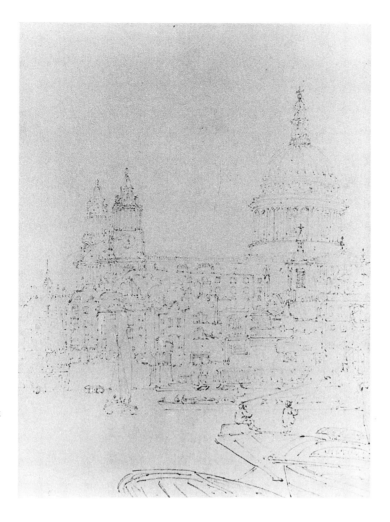

20 St Paul's from the Thames, c.1795. Taken from the Southwark bank near Blackfriars Bridge, but using an imaginatively cropped composition to give the subject dramatic immediacy.

Pencil, 22.9 × 16.5 cm, Private Collection.

Thames study of about the same time, *York House Water Gate* (Pl. 21). The scene shows the baroque riverside gateway of York House prominently in the right foreground of the composition, but it cannot truly be said to be the main subject. That honour goes to the wooden tower and chimneys of the York Buildings Waterworks Company. Behind it stand the riverside mansions to which it pumped water from the river, and below is the company wharf with barges tied up and a crane for off-loading coal. Turner draws a number of ironic contrasts: the aristocracy of the baroque gateway against the plebeian waterworks; the dirty barges against a spruce yacht; the way in which the waterworks obscure and disfigure the very riverside that the mansions came to gaze upon. The smoke blowing from its chimneys towards their windows only serves to add insult to injury. As at Lambeth, Turner goes to some lengths to exclude features which would normally have been thought of as deserving prominence. The haze to the left obscures Westminster Bridge and Abbey, the Houses of Parliament and Whitehall. Adelphi Terrace is excluded from the composition at the right, which seems to point significantly to Turner's intention, since it must have meant something to him after his recent attendance there at Dr Monro's and it was one of the principal subjects on this stretch of the river. Only Turner, however, dared make the waterworks his main subject.

Having gone most of the way towards completing the picture, he stopped. Perhaps he feared the market might not be ready for such things, but this has left us with a remarkable document of his watercolour technique at this time. The gradation of the sky, the sensitivity of his overlaying of washes to build up tone, the precise and complex stopping out of rigging and trees, argue almost perfect control of his medium. The basic method was common enough, and Edward Dayes has left us a detailed account of it in his *Instructions for Drawing and Coloring Landscapes*:

Supposing the outline complete, and ready to work on ... make all the shadows, and middle tints, with Prussian blue, and a brown Indian ink ... the clouds being previously sketched in, and as light as possible, the student begins with the elementary part of the sky, laying it in with Prussian blue, rather tender, so as to leave himself the power of going over it once or twice afterwards, or as often as may be necessary; then with the blue, and a little Indian ink, lay in the lightest shades of the clouds; then the distance, if remote, with the same colour, rather stronger. Next proceed to the middle ground, leaving out

Instead of opting for the landscape format, however, Turner goes for an upright, limiting himself to a narrow angle of view, forsaking a great deal of interest for an arresting immediacy of engagement. The foreground boats draw the eye into the composition across the river, boat by boat, to the far shore with the big cathedral above the lesser buildings. The effect is of almost telescopic emphasis on the size of St Paul's, exaggerated still further by the fact that we cannot see where it ends at the right. It dominates the surrounding buildings, and visually forces the eye down into the composition to sort out the complex jumble of roofs, windows, narrow streets, and towers, piled one on another almost as if in some sort of competitive scramble up the slope of Blackfriars.

The same concentration of focus is found in another

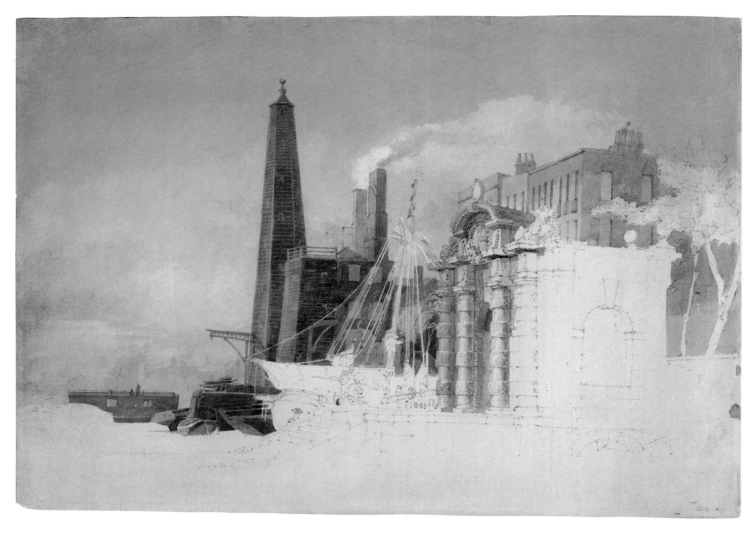

21 LEFT York House Water Gate, c.1795. One of the most interesting documents of his process at this time.

Pencil and watercolour, 30.0 × 42.1 cm, Tate Gallery, London, TB XXVII W.

22 OPPOSITE, LEFT Old London Bridge, c.1795. A view from midriver, looking north along the old London bridge (demolished in 1831) to St Magnus, the Monument and the waterwheel of the London waterworks company.

Pencil, 27.6 × 20.0 cm, Tate Gallery, London, TB XXVIII J.

23 OPPOSITE, RIGHT Joseph Farington, *Old London Bridge and the Monument*, c.1794. Comparison of views of the same subject reveals Turner's much greater abilities in achieving visual drama.

Ashmolean Musuem, Oxford.

the blue in coming forward; and lastly, work up the fore-ground with brown Indian ink only. This operation the student many repeat till the whole is sufficiently strong to his mind, marking the dark parts of the fore-ground as dark as the ink will make it; that is to say, the touches of shadow in shade. Great care must be taken to leave out the blue gradually as the objects come forward, otherwise it will have a bad effect. Attention must also be given to the middle tints, that they are not marked too strong, which would make it, when colored, look hard. The same grey colour, or aerial tint, may be first washed over every terrestrial part of the drawing required to be kept down; that is, before coloring; as color laid over the grey will, of course, not be so light as where the paper is without it.[55]

Turner's drawing shows signs of the colourist he was to become in the touches of brilliant blue around the watergate, but it is remarkable how closely he followed the conventional method practised by most watercolourists of his age at this time. What distinguishes his work is its quality, a quality dependent on utter dedication to his craft, the ambition and drive to handle the medium perfectly, and at the end of the day the ability to realize in paint a careful sensibility, an almost transcendent craftsmanship, and tenderness, something emphasized by Dayes.

Turner's art is a balance of convention and rebellion. Elsewhere in the *Instructions* Dayes explains that an artist should never approach too closely to his subject, for the perspective would make it seem distorted:

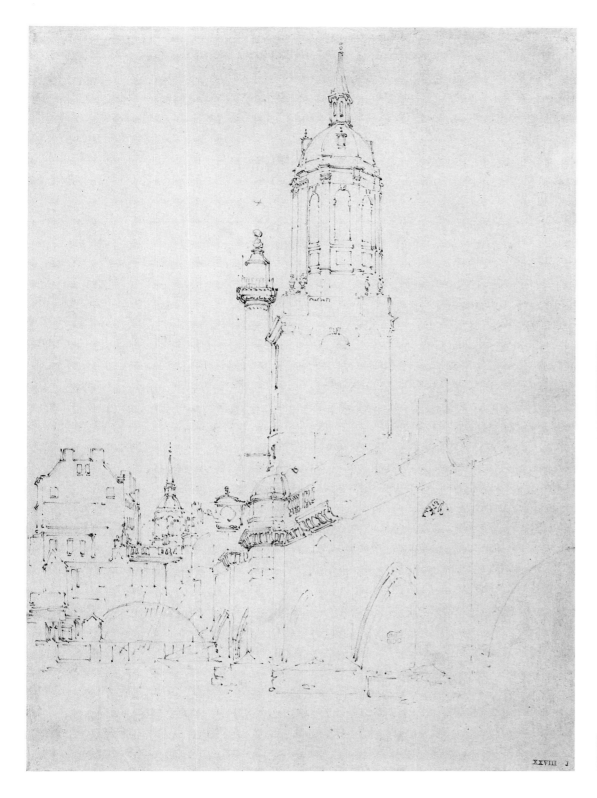

XXVIII J

In sketching from Nature, care must be taken not to get too near an object, as, by having too short a point of distance, it will be made to appear under so great an angle as to look quite distorted. This disagreeable effect will be avoided by observing (unless prevented by circumstances,) never to be nearer the building, &c. than twice its elevation, or length, which will bring the object within an angle of 45°.[56]

The sketch of *Old London Bridge with St Magnus the Martyr and the Monument* (Pl. 22) might have been made out of sheer defiance for such a principle. Rules in art produce stagnation and the comparison between Turner and an artist working within the convention, Joseph Farington and his dull drawing for Boydell's *Thames*, speaks for itself (Pl. 23). Turner's sketch also illustrates how well he had come to understand architecture, to the point at which he no longer had to draw every detail of his buildings. One

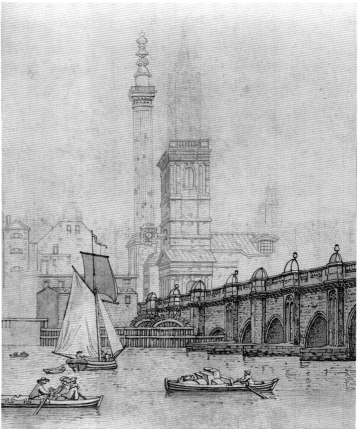

17

window and a count of the rest, a detail of a cornice, one stretch of fluting, and he could construct the rest, knowing the principles which underpinned it.

He proceeded to make a finished watercolour from this sketch (Pl. 24), and although the drama of the original composition was diluted a little in the process, the result is hardly the 'straightforward translation of architectural information into a watercolour', as it was recently described.[57] We look north, with the Monument and St Magnus dominating the centre of the composition. Turner has decided what time of day and year it is and has set the sun at about 45° in the south-east, hence mid to late morning in spring or autumn. To draw attention to his consideration of these matters, he set the clock of St Magnus at the pivotal point of the composition, with the eye led directly to it by the dramatic arrow created by the bridge. It reads twenty-five minutes to eleven. On the upstream side of the bridge is a waterwheel, and the dramatic perspective points to this even more than to the clock. The wheel belonged to the London Waterworks Company, which dated back to 1580, taking advantage of the constriction of the river by the bridge to harness the head of water to pump it up to the City,[58] operating on both the ebb and flow tides. Turner made a particular point of this by showing the current flowing upstream, emphasizing it still further by showing two boats struggling to negotiate the resulting hazard. Although no one seems to have noticed it, this is the whole point of the picture and the explanation for the presence of the waterwheel. The bridge had stood since Norman times and its narrow arches were a considerable inconvenience to shipping – only smaller boats could pass at all – and to the flow of the river. The result was that when the tide was flowing as shown here, the river was so obstructed as to create a fall of water which could be a foot high, or more if spring tides and winds combined. The result was a guaranteed head of water, and hence of power, at every tide throughout the year at the very heart of the capital. Turner made a unique characteristic of the site his subject, a feature which Farington, though sketching the same subject from exactly the same angle, completely failed to comprehend. It is this intelligence and knowledge which underpins Turner's pictures, distinguishing him from virtually every other painter of his generation.

In 1797 he exhibited his first Thames subject in oils, *Moonlight, a Study at Millbank* (Pl. 25). While enthusing over his other exhibits that year, the reviewers ignored the study altogether and it is worth considering why Turner should have thought so slight a production worth showing at all. In using the word 'study' Turner seems to have intended

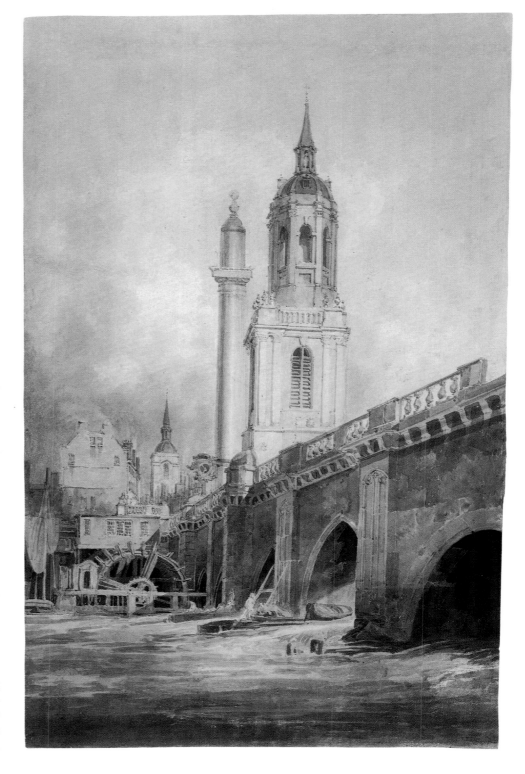

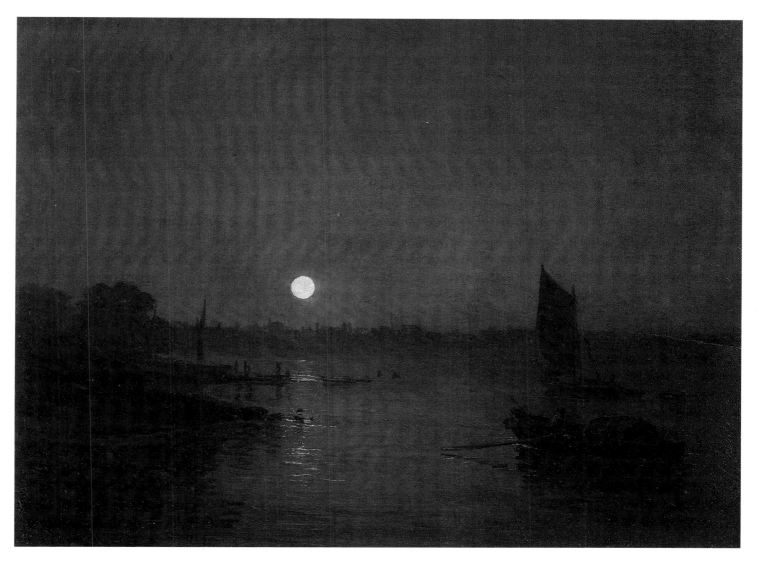

24 LEFT *Old London Bridge*, c.1795. Londoners would have been expected to notice that the river is apparently flowing the wrong way. The old London Bridge had such narrow arches that it obstructed the flow of water. Whenever the tide was ebbing or flowing (as here), there would be a considerable fall of water through the bridge. This was a serious problem for river traffic as we can see, but also provided a continual head of water to power the waterwheel.

Watercolour, 34.6 × 21.9 cm, Tate Gallery, London, TB XXVIII K.

25 RIGHT *Moonlight, a Study at Millbank*, exhibited RA 1797. The exhibition of such a study, apparently painted from nature, was pioneering at this time, but such naturalism was to become a major feature of Turner's later Thames work.

Oil on mahogany, 31.5 × 40.5 cm, Tate Gallery, London.

to signal that it was not to be considered in the same way as a 'finished' work. It also suggests that the painting is the product of an actual act of observation by one who made a practice of studying such things as moonlight or 'sunset previous to a gale' as given in the title of a larger painting in the same show, and that his work contains knowledge of such matters as a result. He furthermore implies that the picture was painted from nature, and such an activity was one that his audience would have admired.

The theme of moonlight was one that he had explored the previous year in his oil painting, *Fishermen at Sea*, 'with a full moon appearing behind wind-torn clouds and casting a silvery glimmer on the heaving surface of the dark-green water'.[59] Moonlight views were popular through the work of the much-collected French painter Joseph Vernet, who had died in 1789, and they were a speciality of painters in England such as Joseph Wright of Derby or Philippe Jacques de Loutherbourg. Turner's moon is rising in the east and the first evening star shines above it. Light lingers in the sky and, to judge from the purplish cast, it has been a warm day.

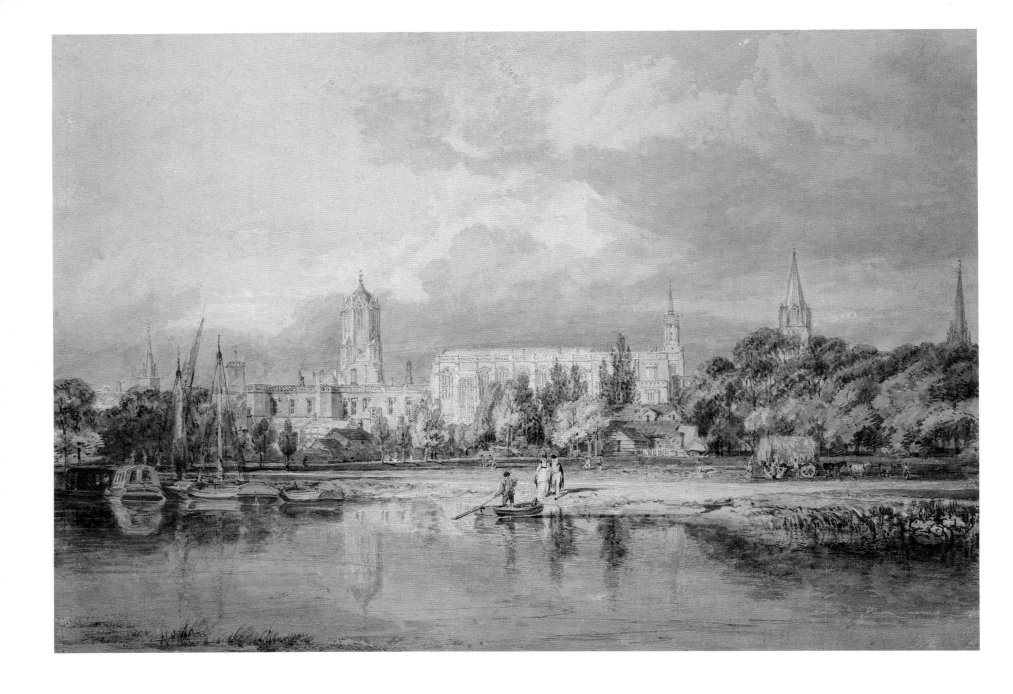

26 *South View of Christ Church, &c, from the Meadows*, 1798–9. The view from the river near Folly bridge is now obscured by trees, but it is still possible to see hay being cut in the meadows towards the end of June.

Watercolour, 31.5 × 45.1 cm, Oxford, Ashmolean Musuem.

Work continues still, and a group of figures is silhouetted against the river while two boats pass by to the right. There is little wind, to judge by the stillness of the water and the idleness of the sail. The moon is not reflected as a lesser painter might have shown it, for it is not yet high enough for its reflection to be seen. Just the top of its disk makes an appearance, and a few ripples catch and carry the light as they travel slowly across the river towards us. The distance between them tells us how still the surface of the water must be, how little wind, and how deep and slow the flow of the river. We can almost hear the gentle plashing of the ripples and the dipping of the oars, or feel the warmth and closeness of the night. Here is a painter who has not only studied the river, but has listened closely enough to nature, as Ruskin put it, 'to understand its language'.[60] Not surprisingly, the messages he received seem profound.

Shortly afterwards the Delegates of the Clarendon Press moved to secure his services for the *Oxford Almanack*.[61] He had succeeded the artists who had been his role models, Rooker and Dayes, and we can be sure that the work he submitted to the Delegates was the very best that he could manage. He judged his strongest card to be a *South View of Christ Church, &c. from the Meadows* (Pl. 26) published in 1799, showing the Thames in the foreground, looking over Christ Church meadows to the college and an array of spires and towers including, from left to right, St Aldate's, Carfax Tower, Tom Tower, Christ Church hall with the spire of All Saints' to the right, the Cathedral and finally the spire of St Mary's.

Christ Church had been his principal subject at Oxford for a number of years and one of the most impressive of his earlier watercolours was a view from the meadows.[62] In the *Almanack* watercolour, however, he pulled back to show as much as he could of the city nestling among mature trees and meadows. The shadows cast by the central figures stepping into the boat tell us that the sun is approaching the west, but still at an elevation of about 30° so that the time of day would be late afternoon and the season near midsummer. The meadows have just been cut and a loaded haywain is being led away at the right. The process is lent urgency by the fitfulness of the weather. The near college buildings are in bright sunlight set against a the dark shower-cloud. Those behind are plunged into shadow, and since we know from the smoke blowing in front of Tom Tower that the wind is in the west, we know that the present sunshine will imminently become shade, and that a shower is on the way like the one seen in the distance. It is perhaps not the time to be embarking on the river.

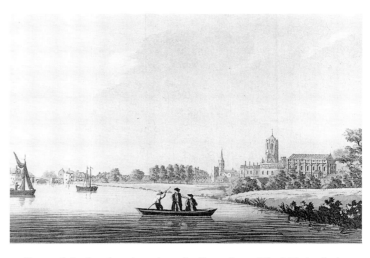

27 RIGHT Samuel Ireland, *View of Christ Church, Oxford*, etching and aquatint, from 'Picturesque Views on the River Thames', 1792.

Samuel Ireland painted a similar view (Pl. 27) including Folly Bridge to the left, which shows how close Turner had returned to the site of Rooker's engraving and his own beginnings, and the figures perhaps recall those copied then. Ireland also shows how daring Turner was in cropping so close as to give a telescopic effect of immediacy. In reality Christ Church is further away than Turner's picture suggests, almost half a mile from Tom Tower to his viewpoint opposite the end of the long walk across Christ Church Meadow. The view of the college is now totally obscured by trees but a visit to the site shows how much Turner has edited out of his view. To the left is Folly Bridge, and Rooker's view was taken from a point on the riverbank directly opposite, and to the right the dome of the Radcliffe Camera and the towers of Merton and Magdalen Colleges are prominent. In fact today they are the main features of the site. A visit in late June, however, will demonstrate that as much as Turner has contracted the meadow he has been true to its purpose, and one can still see hay being cut on or about the longest day.

Ireland's sky suggests that Turner was perhaps still willing to learn by copying, for it seems possible that the two are alike by something other than coincidence. Each, however, is entirely appropriate to the place and the time of year. It is midsummer and the sun is strong. The sky gives a sense of the scale of the Oxfordshire plains, studded about with thermals brewing piles of cumulus. There is a sense of things greater even than the towers and spires of the ancient churches and colleges: the surrounding land; the cycle of days, seasons, sun, evaporation, and rain; fertility and whatever makes things grow in this place; the reason for the city and the University being here at all.

In his early twenties Turner's success at the Academy exhibitions brought him to the attention of leading patrons of the day, such as Sir Richard Colt Hoare of Stourhead, William Beckford of Fonthill, Lord Harewood of Harewood, and led to his election as an Associate of the Royal Academy in November 1799. His ambition grew with his success and he began to cultivate ambitions in the higher branches of art, the sublime, epic, and historical. In 1798 literary quotations began to appear in catalogue entries at the exhibition,[63] and in 1799 Turner exhibited his first historical subject, *The Battle of the Nile*.[64] In 1800 and 1801 he produced two biblical subjects, *The Fifth Plague of Egypt* and *The Army of the Medes*[65] and about the same time he began to experiment with themes from classical literature, although he did not have the confidence to exhibit the results.[66] His role models changed: Dayes, Malton, and Rooker were succeeded by Reynolds, Cozens, and Wilson, and these in turn by Rembrandt, Poussin, and Claude. Increased access to the houses of the aristocracy allowed him to study the pictures they contained, the colour, the technique, the tonality, the weightiness of the great masters at first hand.

If he was to become a full Royal Academician, then he had to learn the forms associated with greatness, and his watercolour view of *London: Autumnal Morning* (Pl. 28) exhibited in 1801 shows that he learned his lessons well. The picture as it survives to us has lost much of its colour but its tonal weight and composition are nevertheless as impressive, weighty, and 'old-masterish' as great pictures were conceived to be. It seems unlikely that one would have found Tuscan farmhouses, stone pines, or cypresses on Clapham Common, from where the view is taken, but Turner arranges his material so that we might see what we prefer, and the rising mist obscures the realities of the Thames valley enough for us to be able to imagine tobacco and olive groves at Vauxhall and Lavender Hill, vineyards and orchards at Battersea and Nine Elms, ready to bask in the autumn sunshine until harvest. Beyond the silver river floats a spired and domed city, Arno and Tiber, Florence and Rome, rolled into one. The aristocracy of the seventeenth and eighteenth centuries had invested considerable time, expense, and trouble in attempting to make England look more like their vision of Italy. They built Palladian villas, landscaped parks with temples, lakes, views composed like paintings by Claude, towers, campaniles, and domes, a world fit for themselves to live in and rule over. Turner's picture assured them that their efforts had been a success, and he was rewarded for his own endeavours by being elected a full Royal Academician in February 1802.

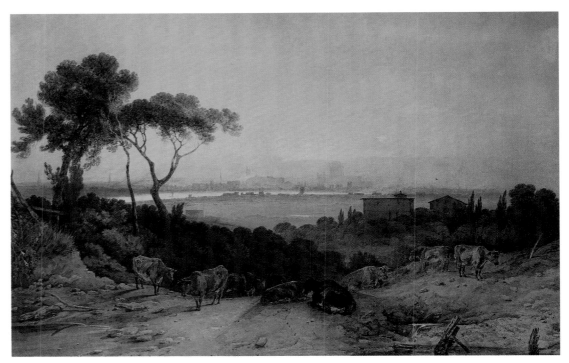

28 *London: Autumnal Morning* exhibited RA 1801. One of the grandest of Turner's early watercolours, showing the view from Clapham Common over Vauxhall to Westminster and St Paul's.

Watercolour, 60.3 × 99.1 cm, Private Collection.

Turner's establishment as an Academician was attended by a number of changes in his domestic arrangements. In 1799, when he was elected an Associate, he moved out of his parents' home in Maiden Lane after considering the move for a year. On 24 October 1798 he had discussed matters with Farington:

He talked to me about his present situation. He said that by continuing to reside at his Father's he benefited him and his Mother: but He thought He might derive advantages from placing himself in a more respectable situation. He said, He had more commissions than He could execute and got more money than he expended. The advice I gave him was to continue in his present situation till He had laid aside a few hundred pounds, and He then might with confidence, and without uneasy apprehensions place himself in a situation more suitable to the rank He bears in the Art. I afterwards called upon him at his Father's a Hair Dresser, in Hand-Court, Maiden Lane. – The apartments to be sure, small and ill calculated for a painter.[67]

On 12 October 1799 he asked Farington's opinion on lodgings in George Street, Hanover Square, and on the 30th Farington reported that: 'He has looked at lodgings in Harley Street which he may have at about £50 or £55 a year,

and asked my opinion of the situation. I said If the lodgings were desirable, the situation is very respectable and central enough.'[68] By 16 November Turner had moved in, but not entirely happily:

J Serres [marine painter to the King] is to have the use of a parlour and a room on the 2nd floor in the House in which Turner lodges in Harley Street, which he much objects to as it may subject him to interruption. Serres to use these rooms from Ten in the forenoon till 3 or 4 in the afternoon, when the Rev Mr Hardcastle is to have the use of them, he being the Landlord. Serres' wife, etc. are in other lodgings where his family concerns are carried on.[69]

Mrs Serres was violent and unbalanced and would have reminded Turner of similar distress in his own family.[70] His mother is reported as having developed an 'ungovernable temper',[71] and before he moved out of Maiden Lane we learn that he sought refuge 'from many domestic trials too sacred to touch upon' three or four nights a week at the home of his friends the Wells family in Mount Street, Grosvenor Square.[72] We cannot know what these 'domestic trials' were, but on 27 December 1800 Turner's mother was committed to Bethlehem Hospital, where she died on 15 April 1804.[73]

In the meantime Turner struck up a relationship with Sarah Danby, a widow of 46 Upper John Street, near Holborn.[74] She had earlier lived with her husband at Henrietta Street, not far from Maiden Lane, where, it may be, they first met. John Danby, a composer and songwriter, died on 16 May 1798. In the following years she bore him two girls, Evelina and Georgiana.[75] Much gossip has accrued to the relationship. Otherwise serious authors have discovered in Turner a morbid distrust of women and marriage, precipitated, so it is contended, by his mother's illness, reinforced by exposure to Mrs Serres.[76] One conjectured recently: 'Whether he even "fell in love" with Sarah in any profound sense may be doubted: he kept her and all the children at arm's length, in a separate house at 46 Upper John Street.'[77] There is no evidence that Turner 'kept' Sarah

at all. The house was in fact hers, her husband had died there, and presumably left her an annuity. She also had four children of her own. It would be convenient for Turner to visit and the family could remain together, settled in their own home. There is no reason to doubt that they had anything but an unexceptional relationship, or to believe that Turner behaved in any way dishonourably. Things cannot have gone so well at Harley Street, however, for by April 1801 he had moved to 75 Norton Street, Portland Row, a little nearer Sarah, across Great Portland Street in what is now Bolsover Street. This was a joint tenancy with a friend of Sarah's named Roch Jaubert, who was her late husband's publisher.[78]

Sometime around March 1802 William Turner senior, at the age of fifty-seven years, left Maiden Lane.[79] His son was a success, just elected a Royal Academician, and could afford to support his father's early retirement. Turner continued to live at Norton Street until after April 1803, though at about the time his father moved out of Hand Court Turner paid £350 for the lease of the Harley Street house in which he had lodged and began to build a gallery 70 by 30 feet.[80] It is possible that his father took up residence straight away and entered upon the role of part-time housekeeper, canvas stretcher, gardener, and day-to-day general manager, which he was to play until the end of his life. Certainly it would have been advantageous to have someone to oversee the work on the new gallery, which was completed by 1803,[81] especially since he was away on the Continent for three months in 1802, when building work would have started. He took up residence in time to give Harley Street as his address in the 1804 Academy catalogue and to open the gallery to visitors for the first time in May. He must have had twenty to thirty pictures on show, including quite a number of earlier works,[82] but apart from one criticism that he should not have shown so many together, the event does not seem to have occasioned any public comment. He seems to have sold numerous pictures and the very possession of such a venue for his own work itself suggests that he had secured a position of some considerable rank 'in the art'.

II IMAGINATION FLOWING
Thames Studies of 1805

I Isleworth and Kew

Troubled times. Escape to Ferry House. Sketchbooks and library. Revisits
Brentford and Kew. Backwaters and reeds. Unsettled weather. Sketches
in watercolour.

Turner's success as a Royal Academician brought mixed
blessings. After his election he served two years on the
Council during a stormy period of political infighting. A
faction had developed within the Academy, which sought to
exploit differences between the King and the President,
Benjamin West. There were numerous schemes and dissensions which culminated in a succession of heated and sometimes ill-tempered meetings, which 'almost destroyed the
esprit de corps of the Academicians. Turner was evidently
disgusted with the condition of affairs' and during a Council
meeting on 11 May 1804 there was an angry scene after
three members left the room to carry on some private discussion. Farington was one of the three:

> On our return to the Council we found Turner who was
> not there when we retired. He had taken my Chair and
> began instantly with a very angry countenance to call us
> to account for having left the Council, on which moved
> by his presumption I replied to him sharply and told him
> of the impropriety of his addressing us in such a manner,
> to which he answered in such a way, that I added his
> conduct as to behaviour had been the cause of complaint
> to the whole Academy.[1]

Thereafter Turner absented himself from Academy business
altogether, to the extent that he submitted nothing for the
exhibition in 1805 and showed at his own gallery instead.

Turner also encountered criticism of his work. In 1803
Hoppner 'reprobated the presumptive manner in which he
paints and his carelessness' and Sir George Beaumont thought
'his foregrounds ... comparatively blots'. The *Sun* described

his work as 'proof of genius losing itself in affectation
and absurdity'[2] and in 1804 accused him of painting with
'birch broom and whitening'.[3] In 1805 Hoppner said that
his gallery 'appeared like a *Green Stall*, so rank, crude, and
disordered were his pictures' and Benjamin West thought
his work tending to imbecility'.[4]

Over these professional troubles hung a darker and more
ominous cloud. The war with France had gone badly, and on
31 July 1804 the King addressed Parliament regarding 'the
preparations which the enemy has been forming, for the
declared purpose of invading this Kingdom'.[5] *The Times* of
6 August reported that 'the *time is not far distant*, when,
every probability induces us to think, the attempt will be
tried' and on 25 August it warned 'A very few days, it is
generally imagined, must decide the question, whether we
are to be invaded or not.' On the 30th it told its readers that
there were 'upwards of one hundred and eighty thousand
men' at Boulogne, poised to invade. On 6 August it explained that 'The fair sex ... it will be the pride of Britons
to guard from insult or violation.' This grim prospect
remained throughout the winter, and late in 1804 or early in
1805 Turner rented a house out of town, overlooking the
Thames at Isleworth.[6] He cannot have made much use of it
while preparing for his exhibition of 1805, but it must have
seemed something of a relief to have been able to escape
there when he closed his gallery on 1 July.

Syon Ferry House stood at the end of Isleworth wharf.
Although it was demolished sometime in the mid-nineteenth
century, there remains much at Isleworth today that Turner
would recognize. All Saints' church, rebuilt in 1969–70

29 Isleworth church and riverside.
Syon Ferry House stood on the
riverside between the church and
the Pavilion summerhouse to the
right. The church is much altered
since Turner's time, but he would
still recognise the Pavilion, and the
London Apprentice pub to the left
of the church.

Photograph, the author.

30 S. Warren after Schnebbelie,
Isleworth, 1806. A view of
Isleworth at about the time Turner
lived there. Ferry House stands to
the right of the slipway.

Copper engraving published in Dr Hughson's
'Description of London', Chiswick Public Library.

after a fire, still overlooks the river and the wharf, with the London Apprentice pub at one end and the ferry slipway at the other (Pl. 29). Downstream stretches Syon Park, and on the far bank the open spaces of Richmond Park and Kew. Ferry House can be made out to the right of the ferry slipway in an engraving in *Dr Hughson's Description of London* (Pl. 30) published in 1806 when perhaps Turner was still living there. It can also be seen in Samuel Leigh's later *Panorama of the Thames* (Pl. 31), and in a few sketches by Turner.[7] One of these (Pl. 32) shows Isleworth church to the left, and to the right the summerhouse called the Pavilion belonging to the Duke of Northumberland.[8] Ferry House is the building immediately to the right of the church. From these and other sources[9] we can gather that Ferry House was a modest, double-fronted building under a pitched roof, with its own small summerhouse overlooking the river at the end of the garden. It was as deep as it was broad[10] and probably had three or four bedrooms on the first floor and two or three reception rooms on the ground floor.

In 1805 Isleworth was a small village with market gardens and flour mills,[11] and the wharf in front of the church would have been busy with coal and timber being unloaded, vegetables being despatched to markets in the city, flour and calico from the mills, and consignments of gunpowder from factories on Hounslow Heath being loaded for the arsenals at Woolwich. The latter trade would have been particularly brisk at this time, but most of the parish consisted of orchards and market gardens providing Covent Garden and London with fresh fruit and vegetables. At the end of the wharf stood the London Apprentice, which had watered the local population from at least 1731. From his south-facing windows Turner could have looked out over the river to the Deer Park at Richmond and to his left he could have watched the morning sun rise over the park and the new buildings of the Royal Palace at Kew. He was about a mile downstream of Richmond Bridge and Hill and the same distance from his old school and his uncle's house in the market square at Brentford. He was renewing contact with the landscape of his youth.

He used five new sketchbooks: a large, calf-bound volume with brass clasps and grey-washed paper, which he labelled *Studies for Pictures Isleworth* (TB XC); a pair of half-bound books in marbled boards with brass clasps, again with grey-washed paper, which came to be known as *Hesperides (1)* (TB XCIII) and *Hesperides (2)* (TB XCIV); a smaller but thicker half-bound book with white paper, labelled *Wey, Guilford* (TB XCVIII); and finally a marbled paper-bound book of large sheets of white paper which could be rolled up

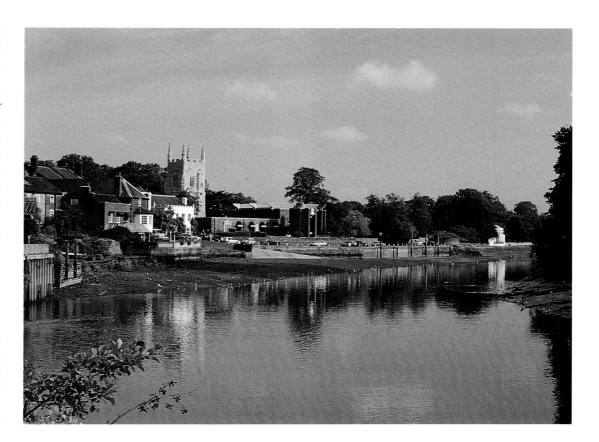

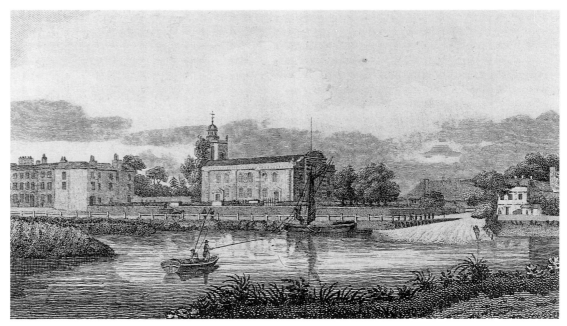

31 Samuel Leigh, *Panorama of the Thames*, c.1830, detail of Isleworth wharf including London Apprentice, church, Ferry House and Pavilion summer house. Chiswick Public Library.

books with records of the Thames and ideas for pictures which were to lay the foundations of his work for at least the next decade. Dozens of subjects and compositions for paintings were laid down, some worked up immediately, others over succeeding years, some not for a decade or more. We see him shaping his Thames observations into grand classical day-dreams. On the other hand these observations were also extended into a series of oil sketches painted direct from nature onto boards and canvases, which are some of the most naturalistic pictures he ever produced. As will become evident, the time spent at Isleworth was one of the most productive periods in his entire career.

After writing his new address inside the cover of his *Studies for Pictures Isleworth* sketchbook he set off to explore his new surroundings.[14] The oldest landmarks in the neighbourhood were the fourteenth-century tower of All Saints' church on the riverside near the house, and Syon House downstream, built about 1550. Many of the buildings round about, however, were more recent. The church, apart from its tower, had been completely rebuilt in the baroque style modified from designs by Sir Christopher Wren in 1705–6. The interior of Syon had been remodelled by Robert Adam in 1761. Most of the riverside houses and cottages near the church had been built during the eighteenth century, and many of the more substantial houses along the riverside towards Richmond housed prominent men of arts and letters. Lacy House was built for William Lacy, co-owner and builder of the Drury Lane Theatre, and it was subsequently occupied by Sir Edward Walpole and Richard Brinsley Sheridan. Just down the river was the late eighteenth-century Pavilion summerhouse in Syon Park. It has been claimed that 'This spot was almost the perfect embodiment of his [Turner's] aesthetic requirements: a group of buildings clustered by the river, with its curving reaches, noble parkland bordering the water and the Duke of Northumberland's shooting lodge in the form of a round and pillared classical temple . . . providing a Claudian motif ready to hand among the English trees.'[15]

The *Studies for Pictures Isleworth* sketchbook was designed for use in just this kind of Arcadia. It has a full calf binding, four brass clasps, two flyleaves of white paper at either end, and 80 leaves of good-quality, grey-washed paper in between. It seems worthy of housing the work of an old master and designed to last until its user became one. The grey wash was intended to reduce glare from the page when working outdoors in bright sunshine, and toned paper was commonly used by artists of the seventeenth century working in the heat and light of the Roman Campagna. Turner's

for carrying, which he inscribed *Thames from Reading to Walton* (TB XCV). Their use overlaps but a general chronology of exploration is discernible, starting around Isleworth, Kew, and Richmond, journeying upstream to Hampton Court, Walton Bridges, and Windsor, along the Wey to Godalming, Guildford, and Newark Priory, and further up-river to Reading and the villages to Oxford, finishing with a trip to the Port of London and the Estuary. A full listing of the contents of these books, together with a discussion of the grouping and dating, is given in Part IV below.

He also went prepared with a library of books. It is apparent from the sketchbooks that he read Virgil. Homer, Plutarch, Ovid, and Pope and it seems very likely that he acquired R. Anderson's *The Works of the British Poets* (1795), which we know him to have owned,[12] for the purpose. This was to be the most sustained period of literary study so far in Turner's career and Anderson's thirteen large volumes, each nearly two inches thick, testify to the seriousness with which he regarded his self-education. He could have read Pope's versions of Homer's *Iliad* and *Odyssey* in volume 12, together with Dryden's versions of Virgil's *Pastorals* [i.e. *Eclogues*], *Georgics*, and *Aeneid*, and we know that he read Pope, Milton, and Thomson, available in other volumes. It is unlikely that he intended to plough through the entire 10,350 pages from Chaucer to James Grainger MD, but his acquisition of the whole set suggests that he intended to approach his mission with considerable zeal.[13] During his time at Isleworth he filled up his sketch-

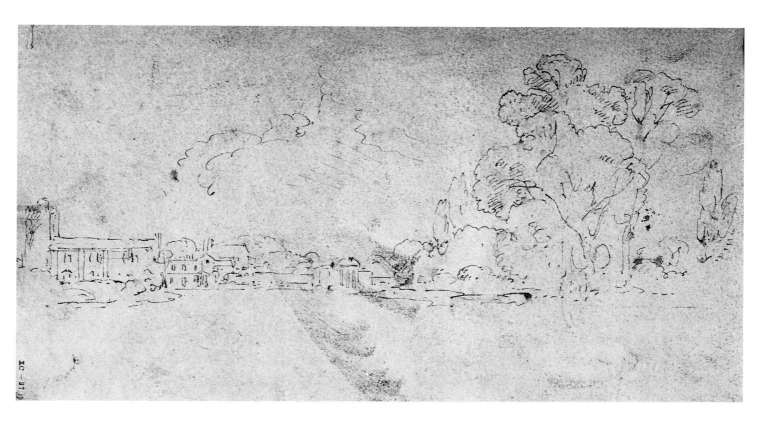

32 Isleworth Church and the Pavilion from the river, 1805.

Pen and ink, 14.6 × 25.4 cm, 'Studies for Pictures Isleworth' sketchbook, Tate Gallery, London, TB XC 27.

first sketches at Isleworth show that he went in search of a motif such as Poussin or Claude might have studied, and the first three pages of the *Studies for Pictures Isleworth* sketchbook, together with a page of the larger *Thames from Reading to Walton* sketchbook,[16] were devoted to the study of a classical rotunda nestled among trees by the river (Pl. 33). I have not been able to identify the original, but there must have been several such structures in villa gardens around Isleworth. It is interesting, nevertheless, that Turner's first thought was to search for the classically ideal river, and it is indicative of the importance that he attached to this search that the composition formed the basis of a finished oil painting (Pl. 183). These sketches mark the beginning of a dialogue between the ideal river and the real which was to maintain Turner's interest throughout the Isleworth sketchbooks.

His next sketches show him exploring his schoolday haunts around Brentford. One major new development in the area was Kew Palace, which had been started in 1801 and had by now assumed its general shape, having had about £100,000 spent on it.[17] Up to this time George III had been relatively modest in his palaces and one of his favourite

residences was Kew. When his mother died in 1772 he moved into the White House, a relatively simple Palladian house designed by William Kent, and installed his sons, George and Frederick in the Dutch House next door, a merchant's house built in 1631 by a Dutch refugee, Samuel Forterie. His reserve was appropriate to a reign which was spent mostly at war, but at the beginning of the nineteenth century he seems to have determined on entering the new century with a flourish. He commissioned James Wyatt, Surveyor General and Comptroller of the Office of Works, to redesign the State Apartments at Windsor and to build a grand palace at Kew in the mediaeval Italian style. These were immensely lavish projects: £300,000 was spent at Windsor and £500,000 at Kew. In 1801, however, the King suffered a bout of insanity and was incarcerated in the Dutch House by his physicians. He recovered, but there was further reason for concern when the illness returned in 1804.[18] These events would still be fresh in Turner's memory.

One sketch among those at Kew in the *Studies for Pictures Isleworth* sketchbook (Pl. 34) shows a barge offloading onto a heavy waggon with six horses and it is possible that these supplies were arriving for further work on the building. The

27

33 TOP LEFT A temple by the river, 1805. A study for *Isis* (Pl. 183).

Pencil, wash, and wiping-out, 14.6 × 25.4 cm, 'Studies for Pictures Isleworth' sketchbook, Tate Gallery, London, TB XC 6.

34 BELOW LEFT Barge unloading near Kew. The barge is possibly bringing supplies for the new Kew Palace, then being built.

Pen and ink, 14.6 × 25.4 cm, 'Studies for Pictures Isleworth' sketchbook, Tate Gallery, London, TB XC 8.

35 TOP RIGHT Kew Palace from downstream. The new palace can be seen towering over the gables of the old Dutch House. Syon House in the centre distance.

Pen and ink, over pencil, 14.6 × 25.4 cm, 'Studies for Pictures Isleworth' sketchbook, Tate Gallery, London, TB XC 8a.

36 BELOW RIGHT Kew Palace and Brentford, from the mouth of the Brent, 1805. Probably the basis of the finished watercolour, Pl. 40.

Pen and ink over pencil, 14.6 × 25.4 cm, 'Studies for Pictures Isleworth' sketchbook, Tate Gallery, London, TB XC 11.

next sketch in the series (Pl. 35) shows the Palace from a viewpoint on the river and must have been taken from a boat. To the left the new building can be seen raising itself above the old. In front can be seen the Dutch House with its stepped gables, dwarfed by the towers behind. In the event the new building was never completed. When the King's illness returned yet again in 1811 work was halted for good, with the palace still little more than a shell. Wyatt died in 1813, the King in 1820, and the building was demolished in 1827.

Another sketch was taken from the mouth of the River Brent, upstream of the Palace and on the opposite side of the river (Pl. 36). One is forced to wonder why Turner chose a viewpoint which interposed so many trees before the subject as to obscure it almost completely. Wyatt's buildings can be seen peeping out at the right; at the centre of the composition can be seen Kew Bridge, and to the left can be seen a structure compounded of two buildings, one behind the other. The one in front was an old windmill, which, according to Leigh's *Panorama* of 1828 was then in use as a basket

factory. On Wednesday 27 August 1805 *The Times* reported that:

> His Majesty's *chateau* at Kew, is proceeding as fast as possible. By the erection of a castellated range of buildings opposite the North front, with a Gothic gateway in the centre, the disagreeable appearance of Brentford is nearly hidden from the entrance of the house. Great alterations are making in the gardens, and several new plantations and walks have been formed, with a view to the future disposition of the grounds, in consequence of the situation of the new residence. Most of the temples have been recently repaired and painted, and a fosse is now digging in a semi-circular direction, which will enclose the house from that part of the gardens in which the public may be permitted to walk. From various points of the grounds the new building forms a very picturesque object.

George Cooke's engraving, published in 1806 (Pl. 37) shows the view from the towpath, but it is clear that Turner's

interest was as much with the 'disagreeable' sight of Brentford as with the palace. In fact he made a point of staying so far away from the palace as to be able barely to see it. His viewpoint is that of one who positively seeks to remain at a distance, concerned as much with commonality as with the grand expression of statehood being constructed in the park. While he was still at the mouth of the Brent he turned round to record the view of Syon looking in the opposite direction (Pl. 38). The house appears between willows which serve as a screen to divide us from the park. Turner locates his viewpoint in the common world, in the world of the two figures fishing from their punts in the foreground.

His last sketch in the series is the least and most interesting at the same time (Pl. 39), for it is of nothing in particular, some parkland by the river, cows grazing in the meadow and standing in the water, trees reflected in the river. Turner's sketches more usually show a well-known landmark such as a gentleman's house, a castle, bridge or lock, mountain or waterfall, and it is not often that such nondescript scenes appear in his art. As anyone who has travelled on the river will remember, however, the journey is mostly composed of passages of ordinary river-bank separating the noteworthy features. Such a stretch of river-bank as the one recorded in this sketch must have accounted for the largest part of Turner's experience of the Thames, and it is interesting that he took the trouble to record a scene that would normally have passed into oblivion. Such things came to occupy him increasingly during his Thames studies.

Later pages in the *Studies for Pictures Isleworth* sketchbook show that he returned to Kew to make further studies. He made a sketch of the Palace and the Dutch House from the same viewpoint as the first,[19] a little more carefully, as if to suggest that he was considering making a finished picture; another sketch of Kew Bridge from downstream,[20] and another of the Brentford riverside from the mouth of the River Brent.[21] He also re-sketched Kew Palace, Kew Bridge, and Brentford in a watercolour in the *Hesperides I* sketchbook (Pl. 47). He liked the view enough to elaborate it into two finished watercolours. The first (Pl. 40) shows a similar view to that sketched in the *Studies for Pictures Isleworth* sketchbook (Pl. 36), and, like the sketch of Syon from the

37 TOP LEFT George Cooke, *The Palace of His Majesty George the Third at Kew, Surrey.*

Copper engraving published in 'Beauties of England and Wales', 1806, Surrey record Office, County Hall, Kingston upon Thames.

38 TOP RIGHT Syon House from the mouth of the Brent, 1805. From the same viewpoint as Pl. 36, but looking in the opposite direction.

Pen and ink, 14.6 × 25.4 cm, 'Studies for Pictures Isleworth' sketchbook, Tate Gallery, London, TB XC 12.

39 LEFT Trees by the river, 1805. Unusual in that it has no landmark, and indicating that Turner was beginning to take an interest in the stuff of which river experience is generally composed.

Pen and ink, 14.6 × 25.4 cm, 'Studies for Pictures Isleworth' sketchbook, Tate Gallery, London, TB XC 14.

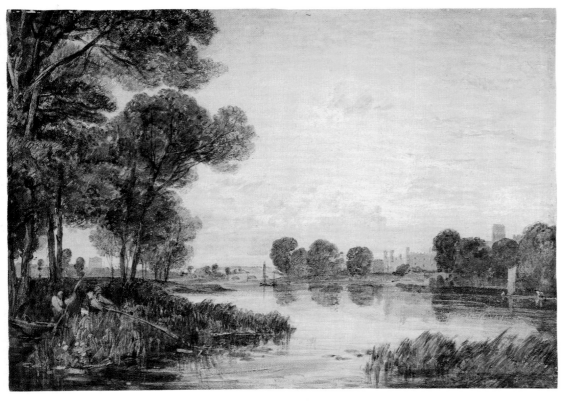

same viewpoint (Pl. 38), includes men fishing from a punt. The composition is tidied up, but the relationship with the sketch suggests that this is a studio work, albeit one in which the informality of its technique served as a reminder of studying direct from nature. The other does not exactly compare with any of the sketches, and although the technique is elaborate enough to suggest that it could be a studio work, it is possible that it was made direct from nature. The lovely effect of evening sunlight splashing across the upper boughs of the trees has the immediacy of an effect actually captured as it was observed.

A third, much larger watercolour (Pl. 41) records the view downstream from the Surrey bank opposite Ferry House, taking in Syon to the left and Kew to the right. Although its size would suggest that it was a studio work, it is extraordinarily freely painted, and might be an ambitious sketch from nature which was intended to be worked up to a finished condition. Once again the buildings are not the principal subject and he chose a viewpoint from which they were obscured behind trees, bushes, reeds, boats, almost anything that would serve the purpose. The real subject is not even the river, although we have to look across it to the buildings. It is, rather, his seclusion in the backwater. The unifying factor in this whole group of sketches and watercolours is a sense of retirement, out of the mainstream, away from the current, withdrawal from the world and its preoccupations. One writer has described it as 'The contemplation of reedy backwaters, the tranquillity of nature, with civilization rarely nearer than the horizon. It is as if Turner was taking a deep breath.'[22] It might have been a breath of relief at escaping from the cares of his career, his gallery, and the Academy, at being able to relax away from society, and at finding a secluded haven in a world over which the threat of imminent invasion hung like a dark cloud. Fishermen try their luck from punts and we can have no doubt that he made time enough to pursue his favourite sport of fishing. He revelled in the consideration of reeds, lilies, sand, stones, grasses, flowers, cattle drinking, ducks, swans, and dark reflections in still water. His subject was his retreat into nature and his contact with the physical stuff of which it was made. When the *Studies for Pictures Isleworth* sketchbook was catalogued at the beginning of this century, a leaf was

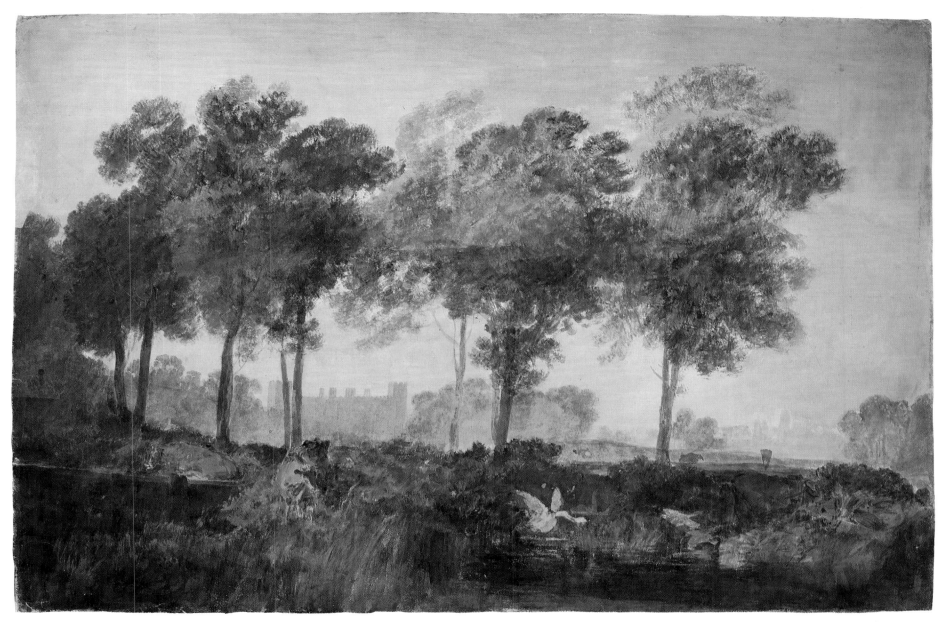

found pressed between the pages at a sketch of Syon House (Pl. 42).

Nature celebrated Turner's arrival at Isleworth with some vivid weather. Reports in *The Times*[23] indicate that conditions were unsettled through most of the summer. There were prevailing cold winds at the end of May, showers in mid-June, and a severe thunderstorm on the 28th. July saw consistently high pressure but recorded $3\frac{1}{2}$ inches of rain, which is 50 per cent more than usual. August came in with another severe thunderstorm on the 6th and towards the end of the month there were various reports of it being gloomy throughout the day (21st), of 'unfavourable weather that had lately prevailed' (26th) and of 'louring clouds [which had] prevailed for some days ... strong south-westerlies ...

42 Syon House (above), with
(below) a pressed leaf found
between the pages of the
sketchbook at this point.

Pen and ink and pencil, 14.6 × 25.4 cm, 'Studies
for Pictures Isleworth' sketchbook, Tate Gallery,
London, TB XC 34a-35.

threatening deluges of rain' (29th). On the 28th the whole summer was described as having been 'chequered with alternate showers and sunshine'.

He took another new sketchbook, *Hesperides (1)* (TB XCIII) and began it by recording some of these effects of weather in colour. Like *Studies for Pictures Isleworth* it is a well-made book, with sturdy marbled boards, brown leather spine and corners, and two brass clasps. The paper is of good quality and prepared with a wash of grey. He could hardly have had a more dazzling subject to begin with (Pl. 43), a barge framed by a rainbow bright against a leaden sky. Although the sun must be behind us, our viewpoint is in shade. A sense of heaviness is emphasized by the viewpoint being set beneath a tree whose branches hang into the top of the picture, and by the stillness of the river. At the base of the tree we can see a figure leaning against the trunk and another seated on the ground, apparently sketching. Presumably they have been sheltering from the rain but remain to wonder at the rainbow and delight in the lifting of the gloom. The two in the rowing boat to the right and the crew of the barge, meanwhile, must have taken a thorough soaking, but such is the price of discovering nature at her best.

The second sketch is no less vivid (Pl. 44). Clouds loom over the river. A boat makes its way to the left, scratched and wiped out of the paint to reveal the white paper beneath, and a number of figures stand on the river-bank to the right, suggesting that the boat is a ferry. To the far left is the Pavilion summerhouse and at the centre, through a screen of trees, is Syon House, lit up in the sun. The ferry in the watercolour must then be Syon Ferry, but the dominating theme is not of topographical information but of physical experience; contrast and changeability, bright sky against dark clouds, instantaneous shafts of sunlight picking out buildings, sunlit boats against still water, light with dark, wind with calm, warm with cold, dry with wet, a succession of the most vivid sensations possible.

The reality of paint was also important to him, and these sketches are fluid, dynamic, and tactile, working wet into wet with saturated colour, exploiting the texture of the paper, dragging, scratching, wiping and dabbling: painting spontaneously, without premeditation, allowing nature to work through him. The next in the series shows another rainbow (Pl. 45), even more spectacular than the first, doubled and reflected in the river. Turner communicated his excitement through the paint-marks: animated dashing in, hurried scratching and wiping, saturated colour, loaded

RIGHT Detail from Pl. 41.

43 River Scene with Rainbow, 1805. The first of a series of five studies from the 'Hesperides (1)' sketchbook (to Pl. 47), which represents some of the freshest and most naturalist work that Turner ever produced.

Watercolour, 17.1 × 26.4 cm, 'Hesperides (1)' sketchbook, Tate Gallery, London, TB XCIII 42a.

LEFT Detail from Pl. 43.

brush, wet paint threatening to overwhelm the sheet, detail made out with touches steadied just enough to be legible.

The fourth sketch (Pl. 46) is perhaps the quietest subject of the series: a few moored boats, trees on the bank, billowing clouds and curtains of rain hanging in front of a bright sky. It is also the most tangibly painted. The river is awash with colour and Turner has not only immersed himself in

nature but also in his medium. We can see where he dabbled both fingers and cuffs in the paint.

The fifth sketch shows Kew from the mouth of the Brent (Pl. 47), already sketched in the *Studies for Pictures Isleworth* sketchbook (Pl. 36). The weather conditions are again fresh and blustery, with shower clouds blowing across the sky and bright sunshine picking out the Bridge and Palace to the

right. He worked quickly and broadly, with saturated colour on the toned paper, dragging his brush across the page, unrevised where it failed to cover at the first attempt, leaving paint standing in pools on the page, drying marks, blots, and the unconcealed presence of the materials with which he worked. The paint was so damp as to have blotted on the opposite page when he closed up the book. There is no work by Turner which more tangibly conveys the reality of his setting down experience and sensation actually as it happened. To be aware of one's senses is to be aware of one's existence in the physical world, to feel fully alive. His senses were telling him that they were functioning brilliantly, he saw, felt, and we might guess touched, smelled, and tasted clearly, vividly, healthily. Here is a man who had found himself.

44 Thames at Isleworth, 1805. Syon Ferry crossing the river towards Ferry House, with the Pavilion in the background.

Watercolour, 17.1 × 26.4 cm, 'Hesperides (1)' sketchbook, Tate Gallery, London, TB XCIII 11.

RIGHT Detail from Pl. 44.

45 River Scene near Isleworth, 1805. Compare the larger watercolours from the 'Thames from Reading to Walton' sketchbook (Pls. 51, 53).

Watercolour, 17.1 × 26.4 cm, 'Hesperides (1)' sketchbook, Tate Gallery, London, TB XCIII 40a.

He developed his watercolours on an even larger scale in the *Thames from Reading to Walton* sketchbook (TB XCV). This was a large roll sketchbook, bound in marbled paper covers which could be rolled up for carrying. At 10 × 15 inches it was over twice the size of *Studies for Pictures Isleworth* or *Hesperides (1)* sketchbooks, and it was clearly intended for work of some substance or elaboration. The

book was broken up by Turner and 48 loose leaves of white paper survive, many of which were creased, dirtied, and battered while still in his studio. Most are pencil sketches of Thames subjects above Richmond, but nine pages were used for watercolour and although the larger scale required him to work with more planning and slightly less animation than in the *Hesperides I* sketchbook, the results are some of the

freshest, most naturalistic, and interesting work in water-colour so far. As one commentator put it: 'They would seem to be Turner's first group of fully developed watercolour studies produced for his personal interest and use, rather than as preliminary designs for other works.'[24] It seems that he is not so much looking in order to paint, but painting in order to look. He relaxes the sense of urgency of the

Hesperides I sketches and expands across the page as if he could happily have spent all day at it.

One place at which he spent time was Kew Bridge.[25] The result was one of his most spacious, quiet, and loving water-colours (Pl. 48). He seems to have positively revelled in the sensations of looking. The colour is fresh, clear, and vivid. The distant buildings are particularly sharp and the bridge

46 River Scene with Barges, 1805.

Watercolour, 17.1 × 26.4 cm, 'Hesperides (1)' sketchbook, Tate Gallery, London, TB XCIII 39a.

RIGHT Detail from Pl. 46.

47 Kew Bridge and Palace, 1805.
A similar view to that sketched in
the 'Studies for Pictures Isleworth'
sketchbook (Pl. 36).

Watercolour, 17.1 × 26.4 cm, 'Hesperides (1)'
sketchbook, Tate Gallery, London, TB XCIII 38a.

is reflected brilliantly against the blue of the water. The
weather is cool and showery. As we can see from the pennant
on the mast to the left, the wind blows fitfully from the
north. Beyond the bridge, a plume of smoke has been rising
gently upwards, but has been caught by a gust which now
drives it almost horizontally. Meanwhile at water level it is
calm, for the bridge and trees at the right are reflected

clearly. The sun is shining brightly on the bridge from the
north-west and the time of day must be near sunset in
summer.

The fitfulness of the weather is further emphasized by the
left two arches of the bridge being plunged into shade. In
an age where the camera now captures this kind of event
without our thinking, we should not allow ourselves to take

such things for granted. In this one device he reinforces both the idea of evening that he wants to convey and also the blustery weather, combining to give the impression that the effect is an instantaneous one and will quickly pass, and of vitality, in the fleeting heightened brightness of the moment. Such things were beyond the ability or even knowledge of virtually every other painter of his day, and they are matters to which photography, since it captures such things without even so much as a flicker of thought, has made us virtually blind today.

We might also give some thought to the matter of how long it would have taken Turner to complete this picture,

48 Kew Bridge, 1805. Note the shadow passing over the right-hand arches of the bridge, suggesting a moment of actual time.

Watercolour, 25.7 × 36.5 cm, 'Thames from Reading to Walton' sketchbook, Tate Gallery, London, TB XCV 42.

and to the circumstances under which it might have been made. It has been suggested that the more elaborate of the *Thames from Reading to Walton* watercolours were painted in the studio over pencil sketches made from nature.[26] *Kew Bridge* is certainly elaborate, and the precision with which the paint has been applied contasts very markedly with the bravura of the *Hesperides I* sketches. Even for an artist such as Turner, who could finish one of his most elaborate watercolours in half a day, it is inconceivable that he could have worked so quickly as to have set down this fleeting effect in real time. The edges of colour against colour are so crisp that one part must have been finished and dry before the adjacent area was worked up, and one would guess that there must be at least two hours' work here. If this is a studio work, however, it is hard to explain why certain areas, particularly the foreground, are so broad, merely dragged over with the brush, or the figures little more than patches of white paper. There is a strong sense that the picture is unfinished, that it was left off because there was insufficient time to complete it. These are clear suggestions of its having been painted from nature.

Turner nevertheless underpinned his observations with a complex pictorial structure. There is a series of parabolic curves traced through the bend of the river and continued in the clouds, overlain by a subtle network of crossing diagonals. The picture thus becomes not only about the vitality of looking and being, but also about the achievement of composure and order. It is not only a view of Kew, but a record of a state of being attained there, involved as the eel trappers are in their work of setting pots, engrossed as the fisherman is in his business of attending to his tackle, enjoying his contact with nature as the solitary figure is, walking in the meadows on the opposite bank, poised and composed as the picture is, and calm as the river is lying quietly at the low point of the tide.

In another watercolour in the *Thames from Reading to Walton* sketchbook Turner attains a condition almost of transcendence (Pl. 49). The subject is unidentified, but perhaps shows a view of Syon reach looking towards Isleworth. We can just make out a church tower between the trees at the right, but the picture is otherwise empty, no boats, no strollers, no fishermen. The real subject is once again his retirement from society. The sun is low in the sky to the right and while it catches the trees to the left, the river is in shade, glimmering with colour. One commentator, however, observed that 'The composition ... with its odd intervals and uneasy horizon perhaps takes it out of the first rank.'[27]

The washes of colour have failed to cover the grain of the paper, the overwash has failed to cover the sky and the river to the right. The foreground wash has missed the bottom edge, the elbow of the river is awkwardly unresolved, the waterline is poorly defined. It is hard to read the distances and the composition seems lopsided and naive. It seems as if Turner kept his normally effortless stylistic sensibility deliberately in check, so as not to allow it to impose itself on the observation. Here, away from the reach of society, the river becomes fully itself. In escaping from the crowd Turner was able to glimpse Nature as it were, unrobed.

The remaining watercolours in the *Thames from Reading to Walton* sketchbook show scenes around Isleworth. A clue to this is offered by a sketch in the *Hesperides (1)* sketchbook (Pl. 50). A couple of barges are being unloaded. A team of horses and a waggon stand alongside in the water. Numerous small boats and figures busy themselves round about. We can tell from the fact that the barges are beached that we are in the tidal reaches of the river, and near enough to the sea for there to be a considerable rise and fall. This would suggest a location below Richmond. Isleworth is the first wharf downstream from Richmond, the next being Brentford, and since the next page of the sketchbook (f. 26a) shows a view of Isleworth wharf and church, it would seem more than likely that this shows the same site. We would be looking upstream with the towpath on the opposite bank, the London Apprentice and the church to the right, and Syon Ferry House directly behind us.

Three of the *Thames from Reading to Walton* watercolours show similar scenes. In the most elaborate (Pl. 51) two barges can be seen at the right, their cargoes sheeted over awaiting onward transit or unloading. Between them two figures are attending to a canvas cover on a smaller boat. The river is still and the reflections dark. A small rowing boat leaves a solitary ripple in its wake and two small boats approach in the distance. At the left a ferryman sets off across the river to collect two figures on the opposite bank. A sheet of cloud spreads overhead from behind to the right, a solitary patch of blue sky remains in front, and at the right rain is already falling, driven ahead by the wind. The sky and the onset of the shower has been captured with some speed, but the rest of the picture is more leisurely. Like the watercolour of Kew Bridge (Pl. 48) it must have taken a couple of hours at least, and if the threatened rain actually fell Turner must have had some shelter under which to complete his work.

He sketched a similar scene in one of the *Hesperides*

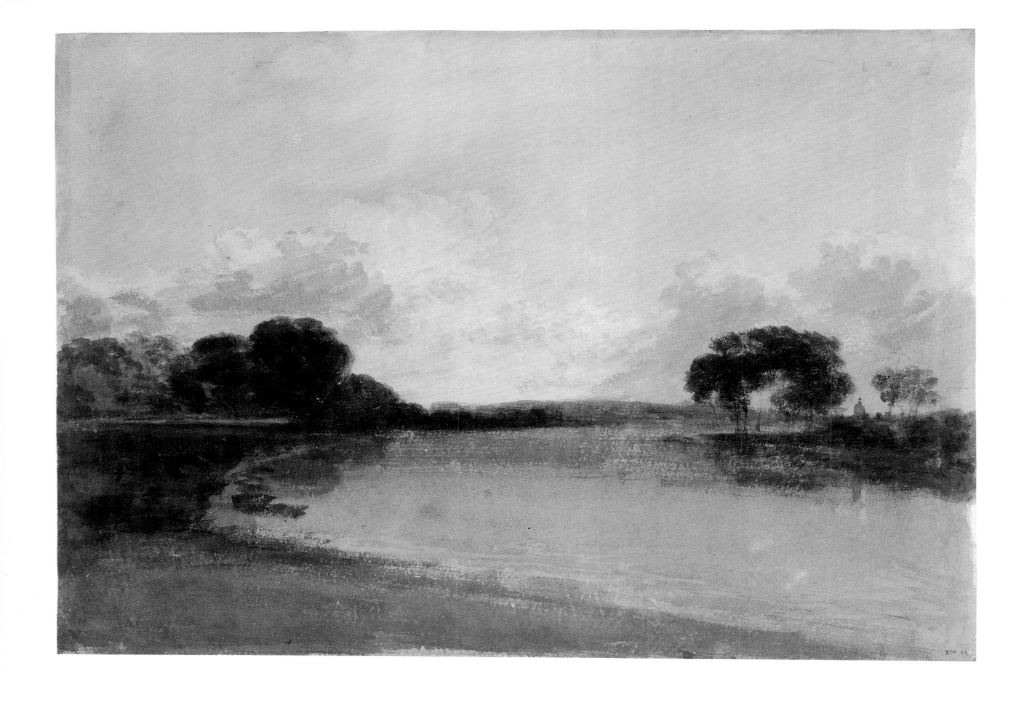

49 Syon Reach, 1805. An awkward composition, almost refusing to conform to the ideals of
composition.

Watercolour, 25.7 × 36.5 cm, 'Thames from Reading to Walton' sketchbook, Tate Gallery, London, TB XCV 33.

(1) watercolours (Pl. 45). A tree, a wall, and boats are included here in the foreground, but the trees on the far bank are remarkably alike. The river narrows in the same way, although the distant buildings cannot be seen in the *Hesperides (1)* sketch. To the left of the tree lies a barge with a smaller single-masted boat beyond it. The sun in each case is to the right and, while a shower is threatening in the larger watercolour, one is clearing off in the smaller and a magnificent rainbow has appeared. A second watercolour in the *Thames from Reading to Walton* sketchbook shows a similar subject (Pl. 52). We see rather more to the right where a number of buildings are visible.[28] The similarity of weather effect to the previous watercolour (Pl. 51) is quite striking. Cloud spreads diagonally across the top right of the composition, the wind blows from the same direction, quite

50 River Scene near Isleworth, 1805. Possibly the view from Ferry House.

Pen and ink, 17.1 × 26.4 cm, 'Hesperides (1)' sketchbook, Tate Gallery, London, TB XCIII 27a.

51 Thames near Isleworth, 1805. Compare Pls. 50, 45.

Watercolour, 25.7 × 36.5 cm, 'Thames from Reading to Walton' sketchbook, Tate Gallery, London, TB XCV 49.

FOLLOWING PAGE

52 ABOVE Thames near Isleworth, 1805. There was a small summerhouse overlooking the river from the garden of Ferry House (see Pls. 30, 31 and 54), which could have provided the vantage-point for this watercolour.

Watercolour, 25.7 × 36.5 cm, 'Thames from Reading to Walton' sketchbook, Tate Gallery, London, TB XCV 12.

53 BELOW Thames near Isleworth, 1805. Figures waiting for the ferry.

Watercolour, 25.7 × 36.5 cm, 'Thames from Reading to Walton' sketchbook, Tate Gallery, London, TB XCV 45.

strongly to judge from the way in which the rain is being carried away as it falls, the sun is also to the right, barges occupy the same part of the composition, and a ferry-boat sets off at the bottom left. Turner is exploring the same theme in each, and in many respects the idea of being able to identify the subject is an irrelevance. If Turner had intended the location to be part of the subject he would have included something to facilitate its identification. It matters only that this is life on the river as he was coming to know it.

A third watercolour (Pl. 53) belongs to the group. The building to the right might possibly be the same as the one shown in Pl. 52, and the far bank with its poplars also begs comparison. The conditions, however, are rather calmer here. The wind is blowing from the left and, although a shower is falling at the centre of the composition, it is being carried away by the breeze before it reaches the ground. The river is low and a barge is making its way slowly through the narrows. Three figures stand in the sun watching it go by, waiting, one presumes, for the ferry-boat beached on the opposite bank to come across and collect them. Near the ferry are a number of other figures also waiting, since the ferryman must let the larger boats pass the shallows of the crossing, and he will have to wait a little longer, since a second barge is following. At the bottom left there are three cows by the water. The theme seems to be unhurried, accepting as long as it takes and making the best of it, not just resigned but enjoying it. Turner has settled into the slow pace of life next to the river. The cows ruminate, the world waits on the barges, the river is low and lazy, the barge heavy, the sun shines on our faces, the breeze blows cool and showery, and there is all the time in the world to set this down on the page and every reason to take it.

A fourth page (Pl. 54) shows a small house on the river-bank with a summerhouse in the river wall. There is a tree in the foreground, the end of a wall and railings to the left, a house in the distance, and a figure waving to the artist from a slipway. Comparison of the house with Ferry House as shown in the 1806 print (Pl. 30), Leigh's *Panorama* (Pl. 31), and Turner's sketch of Isleworth (Pl. 32), suggests very strongly that this is the same house. The wall to the left would therefore be the end wall of the churchyard and the railings those along the wharf. A photograph taken in about 1880 (Pl. 55) shows that Ferry House had by then dis-appeared, but the wall and railing can still be seen. Another taken about ten years later (Pl. 56) shows the Pavilion to the right with Park House to its left, and, in the very centre, a tree so similar to that recorded in the watercolour, allowing for its greater age, as to suggest that it might be the very

RIGHT Detail from Pl. 52.

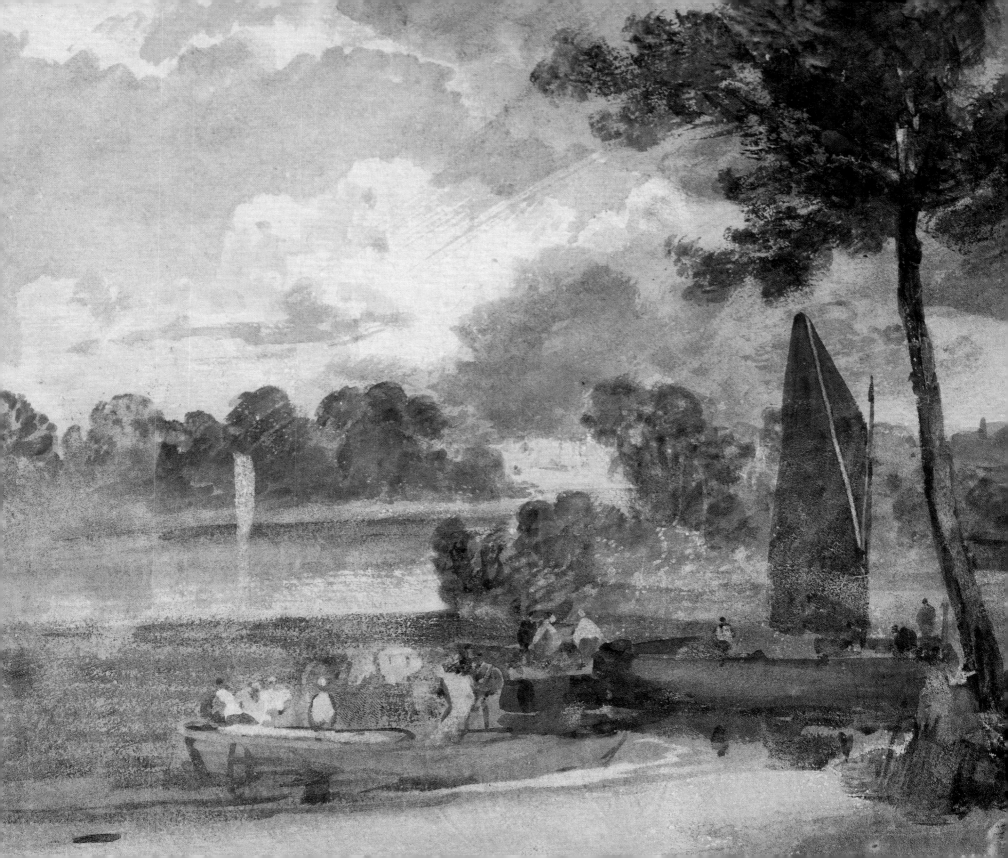

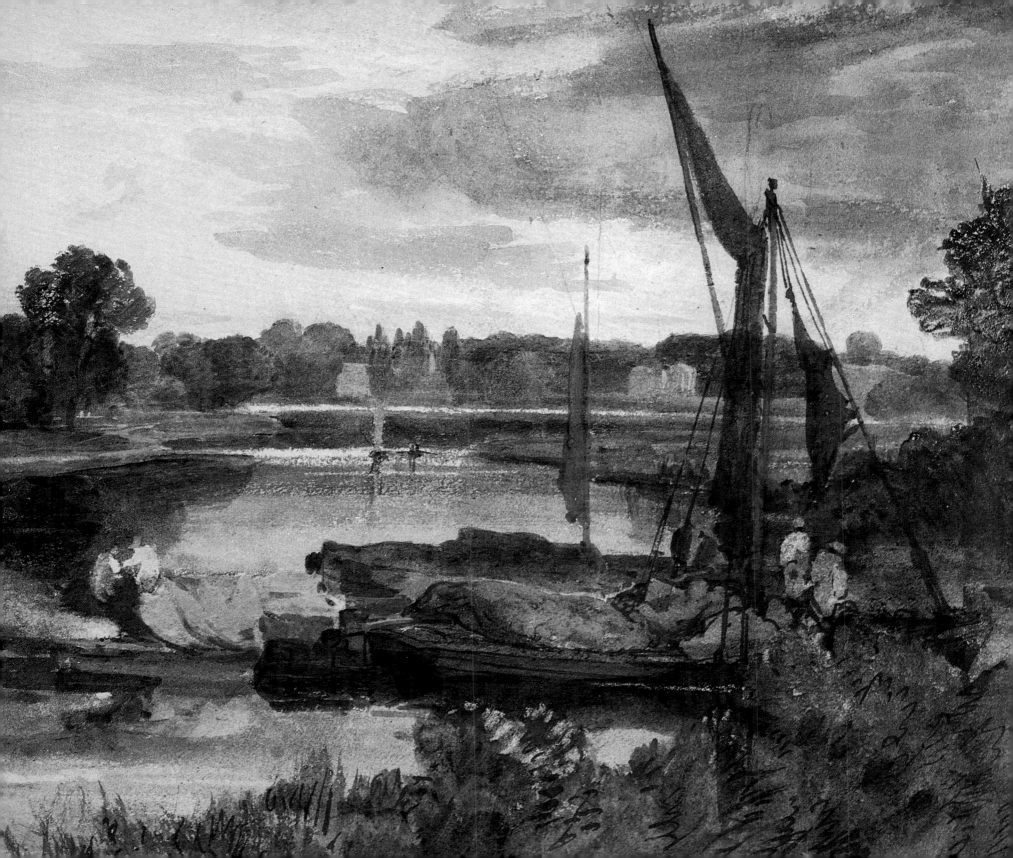

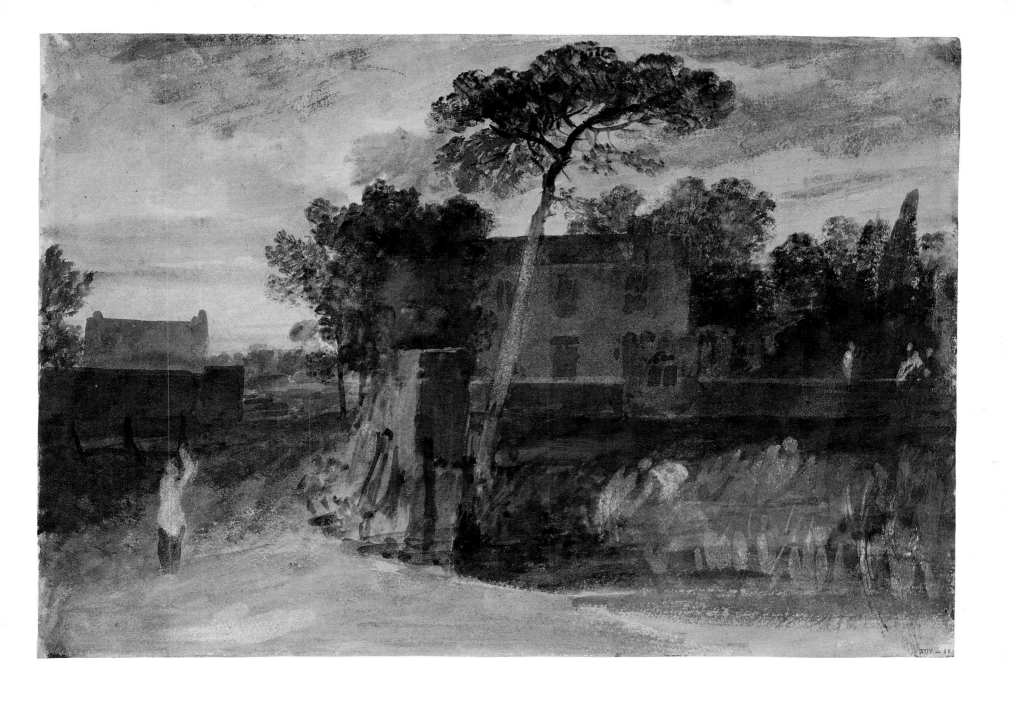

54 Syon Ferry House, Isleworth, 1805. Compare Ferry House as recorded in Pls. 30, 31. Turner
is recording his return from the river at the end of the day.

Watercolour, 25.7 × 36.5 cm, 'Thames from Reading to Walton' sketchbook, Tate Gallery, London, TB XCV 48.

LEFT Detail from Pl. 51.

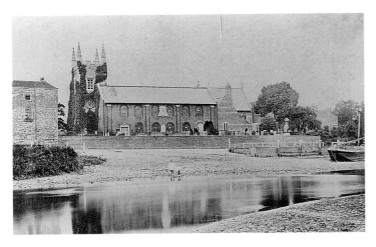

same. If this is Ferry House, the summerhouse might well have been the viewpoint for some of the watercolours discussed above. In the present sheet, however, Turner would be looking north and the sun is setting in the north-west. His viewpoint is from the water, and the figure is someone who knew him and was apparently glad to see him. It is almost as if we were sitting with him in the boat, being called in to dinner at the end of a day on the river.

55 Isleworth, c.1880. Ferry House seems by this time to have disappeared.

Photograph, Chiswick Public Library.

56 Isleworth, c.1890. Although Ferry House has gone, the tree and wall at the centre of the photograph might be the originals of those sketched by Turner in many of his Isleworth studies.

Photograph, Chiswick Public Library.

Richmond Bridge and Hill. The Muses of Poetry and Art. Readings in the classics.

After getting his bearings around Ferry House, Turner next made an expedition up to Richmond.[29] The town had been the site of a royal palace since the thirteenth century, and was one of the premier resorts on the whole river Thames. When Daniel Defoe described Richmond in 1724 he noted that the court attracted a large following and that the town proved 'a most agreeable retreat for the first and second rate gentry, with a great deal of the best company in England'. He noted that, as a result, 'The town and the country adjacent, encrease daily with buildings, many noble houses for the accommodation of such, being lately rais'd and more in prospect.'[30] He was particularly impressed with the results of this development:

> It is not easy to describe the beauty with which the banks of the Thames shine on either side of the river, from hence to London, much more than our ancestors, even of but one age ago, knew any thing of. If for pleasant villages, great houses, palaces, gardens, &c. it was true in Queen Elizabeth's time, according to the poet that
>
> The Thames with royal Tyber may compare
>
> I say, if this were true at that time, what may be said of it now? when for one fine house that was to be seen then, there are a hundred; nay, for ought I know, five hundred to be seen now, even as you sit still in a boat, and pass up and down the river.[31]

Defoe saw the Thames valley as a triumph of civilization, unrivalled in the modern world, a glorious harmony of nature and man's art 'both in the extreamest beauty'.

> In a word, nothing can be more beautiful; here is a plain and pleasant country, a rich fertile soil, cultivated and enclosed to the utmost perfection of husbandry, then bespangled with villages; those villages fill'd with these houses, and the houses surrounded with gardens, walks, vistas, avenues, representing all the beauties of building, and all the pleasures of planting: It is impossible to view these countries from any rising ground and not be ravish'd with the delightful prospect.[32]

By Turner's time the view from Richmond Hill (Pl. 57) was more overlaid with literary and artistic eulogy than almost any other place in the world. James Thomson had lived in Kew Foot Lane and was buried in St Mary's churchyard. His description of the prospect on a summer's day in 1727 was one of the most widely read passages of poetry of its age (Pl. 58). It shaped perception of the view for a century or more, and we can be sure that visitors were delighted with the 'smiling meads', 'radiant Summer opening all its pride', 'spotless Peace', 'Enchanting vale', and 'Happy Britannia' spread before them and that their eyes were indeed 'exulting', 'Raptured', and 'Feasted'. In case anyone was unsure what to see or feel, the lines had been transcribed onto a board and nailed to a tree at the end of the Terrace.[33] A foreign visitor in 1782 declared it to be 'one of the finest prospects in the world. Whatever is charming in nature or pleasing in art, is to be seen here. Nothing I have ever seen or ever can see elsewhere, is to be compared to it.'[34] It was a place so thickly 'haunted by Muses' as to be positively congested. Alexander Pope and Horace Walpole had lived at nearby Twickenham. The view from the hill had been painted by Auguste Heckel, Antonio Joli, Francesco Zucarelli, and Joseph Farington and their work was known to thousands through engravings.[35] According to Thomson it was 'beyond whate'er the Muse has of Achaia or Hesperia sung'. Achaia was a region of ancient Greece and Hesperia the name given by the ancient Greeks to Italy. The names served generally to evoke the landscapes described by the great poets of classical antiquity. A prospect surpassing even this would deserve the greatest rhetoric that art could muster.

Turner had painted the view twice before. The first time was about 1793, when he made a blue and grey study in the manner learned at Dr Monro's (Pl. 18). It is a fairly straightforward record of the prospect, but nevertheless it has a grandeur and breadth which belies its battered and grubby few square inches. Richmond Hill faces south-west and is a particularly fine spot for observing skies, since on a good day it commands a horizon of up to a hundred miles, with the sun striking grand shafts of light from behind clouds. Turner recorded all this in his early sketch, and the oil-stains and

FOLLOWING PAGE

57 ABOVE The view from Richmond Hill. In Turner's day, as now, one of the most celebrated views in Britain.

Photograph, the author.

58 BELOW James Thomson, *Summer*, from an edition of 'The Seasons', 1778. The description of the view from Richmond Hill beginning at line 1400 was a major reason for Richmond's fame. In Turner's time the lines were written on a board and fastened to a tree for visitors to read.

splashes of colour testify to how useful the study later proved in his studio.

His second version of the view came at the subject somewhat obliquely. It was called *The Festival upon the Opening of the Vintage of Macon* (Pl. 59) and was exhibited at the Academy in 1803. Turner had visited the famous wine city of Mâcon on the river Saône in central France in 1802, but the painting owed little to the sketches made then.[36] His principal intention seems to have been to produce a painting in the manner of Claude. His method, painting 'in size colour on an unprimed canvas', was modelled on Claude,[37] as was the general tonal structure and composition, and the idea of figures enacting some ceremony in a landscape with classical buildings. However, the principal feature of this landscape, a wooded plain seen from a hill, with a bend in the river below, owes less to the Saône valley or Claude than to the Thames seen from Richmond Hill, and it seems possible that the early sketch (Pl. 18) was consulted in its development. Some new building has been called for, but without this we would be left with Petersham Meadows and the Thames snaking away in the centre towards Twickenham.

54

By that kind *School* where no proud mafter reigns,
The full free converfe of the friendly heart, 1395
Improving and improv'd. Now from the world,
Sacred to fweet retirement, lovers fteal,
And pour their fouls in tranfport, which the SIRE
Of love approving hears, and *calls it good.* 1399
Which way, AMANDA, fhall we bend our courfe?
The choice perplexes. Wherefore fhould we chufe?
All is the fame with thee. Say, fhall we wind
Along the ftreams? or walk the fmiling mead?
Or court the foreft-glades? or wander wild
Among the waving harvefts? or afcend, 1405
While radiant Summer opens all its pride,
Thy hill, delightful * Shene? Here let us fweep
The boundlefs landfkip: now the raptur'd eye,
Exulting fwift, to huge AUGUSTA fend,
Now to the * Sifter-Hills that fkirt her plain, 1410
To lofty *Harrow* now, and now to where
Majeftic *Windfor* lifts his princely brow.
In lovely contraft to this glorious view
Calmly magnificent, then will we turn

*The old name of *Richmond*, fignifying in Saxon *Shining*, or *Splendor.*
* *Highgate* and *Hamftead.*

To

To where the filver THAMES firft rural grows. 1415
There let the feafted eye unwearied ftray:
Luxurious, there, rove thro' the pendant woods
That nodding hang o'er HARRINGTON's retreat;
And, ftooping thence to *Ham's* embowering walks,
Beneath whofe fhades, in fpotlefs peace retir'd, 1420
With HER the pleafing partner of his heart,
The worthy QUEENSB'RY yet laments his GAY,
And polifh'd CORNBURY wooes the willing Mufe,
Slow let us trace the matchlefs VALE OF THAMES;
Fair-winding up to where the Mufes haunt 1425
In *Twit'nam's* bowers, and for their POPE implore
The healing God * ; to royal *Hampton's* pile,
To *Clermont's* terrafs'd height, and *Efher's* groves,
Where in the fweeteft folitude, embrac'd
By the foft windings of the filent *Mole*, 1430
From courts and fenates PELHAM finds repofe.
Inchanting vale! beyond whate'er the Mufe
Has of *Achaia* or *Hefperia* fung!
O vale of blifs! O foftly-fwelling hills!
On which the *Power of Cultivation* lies, 1435
And joys to fee the wonders of his toil.

* In his laft ficknefs.

HEAVENS!

Richmond was ripe for this sort of treatment. By Turner's day it had been described so many times in verse and pictures, formed and reformed in poetic and classical terms, and was so haunted by *genius loci* that it had become more a product of historical, poetic, and pictorial associations than of fact. It had become an ideal of the sort one might expect to find realized in a distant, romantic place, especially one such as Mâcon in the country of Claude's birth. When Turner spoke of Claude, he described a type to which all landscape might wish to conform: 'Pure as Italian air, calm, beautiful and serene ... The golden orient or the amber-coloured ether, the midday ethereal vault and fleecy skies, resplendent valleys, campagnas rich with all the cheerful blush of fertilisation, trees possessing every hue and tone of summer's evident heat, rich, harmonious, true and clear.'[38] No site in all Britain came closer to this in the imagination than Richmond.

Turner began his survey by making a two-page panorama

of Richmond Bridge and Hill from a viewpoint upstream on the Middlesex bank (Pl. 60). He would have been particularly interested in the group of buildings at the centre of the right-hand sketch. The one on the left is The Wick, built by Lady St Aubyn in the year of Turner's birth, and to its right is Wick House, four years older, which was built for Sir Joshua Reynolds, first President of the Royal Academy. It is recorded that

> Reynolds entertained his many friends at the house – Dr Johnson and Boswell, Mrs Thrale, Edmund Burke, Edward Gibbon, Garrick, Goldsmith and Sheridan would all have been in these rooms. Dr Burney and his famous daughter Fanny Burney, the novelist and diarist, came to dinner in June 1782, when Fanny met Edmund Burke for the first time. 'Sir Joshua's house,' she wrote, 'is delightfully situated, almost at the top of Richmond Hill. We walked near dinner time upon the terrace, and there met Mr Richard Burke the brother of the orator.' Reynolds was proud of his view. He made Fanny and Edmund Burke both give their separate opinions of it – then compared them. It is said his "View from Richmond Hill" was his only landscape.[39]

Such was Turner's regard for Reynolds that it was recorded by an early obituarist that he chose to live in the vicinity 'that he might live in sight of Sir Joshua's house upon the hill'.[40]

After taking the view from the river, he ascended the hill to examine the Great Prospect. On this occasion he seems to have shrunk from its challenge, peering at the view through branches and bushes almost as if afraid of it. Foreground trees, however, were a characteristic device of Claude, and Turner was probably measuring the extent to which the reality of Richmond conformed to the ideal. His sketches suggest that he found it not nearly so artfully arranged as the Muses would have had it. The hill seems little more than a slope, and hardly high enough to see the river over the trees at its foot. The trees themselves are mostly young and shrubby, showing little regard for picturesque situation and contriving to obscure the main asset of their site, the view. In spite of them Turner managed to take views upstream over Petersham and Twickenham (Pl. 61) and downstream over the bridge towards Isleworth (Pl. 62). A close examination of the latter will reveal Isleworth church tower, carefully made out on the distant riverside, just to the right of the central arch of the bridge. Despite the sketches, Turner does not seem to have felt confident enough to take on the subject yet, for although he later painted several pictures of the view from the hill, these particular observations were developed no further.

He descended from the hill to sketch the bridge (Pl. 63) and these studies resulted in two finished paintings (Pl. 185–6). Richmond Bridge was designed by James Paine and was about the same age as the artist. It was started in 1774, opened in 1777, and by 1779 it had begun to attract attention. The *London Magazine* of September, for example, published a *View of the New-Bridge, at Richmond in Surry* with an enthusiastic description:

> The bridge erected across the River Thames at Richmond in Surry, is a simple, yet elegant structure, and, from its happy situation, is one of the most beautiful ornaments of

60 Richmond Bridge and Hill, 1805. Two pages forming a coninuous panorama. The buildings in the centre of the right-hand page are The Wick and Wick House, home of Sir Joshua Reynolds. The Star and Garter to the right.

Pen and ink, 14.6 × 25.4 cm, 'Studies for Pictures Isleworth' sketchbook, Tate Gallery, London, TB XC 19, 18.

61 TOP LEFT Thames from
Richmond Hill, 1805. Looking
upstream towards Marble Hill and
Twickenham.

Pen and ink, 14.6 × 25.4 cm, 'Studies for Pictures
Isleworth' sketchbook, Tate Gallery, London,
TB XC 22.

62 BELOW LEFT Thames from
Richmond Hill, 1805. Looking
downstream over Richmond Bridge
towards Isleworth.

Pen and ink, 14.6 × 25.4 cm, 'Studies for Pictures
Isleworth' sketchbook, Tate Gallery, London,
TB XC 25.

63 RIGHT Richmond Bridge from
downstream.

Photograph, the author.

the river and the country adjacent . . . from whatever point
of view this bridge is beheld, it presents the spectator with
one of the richest landscapes nature and art ever produced
by their joint efforts, and connoisseurs in painting will
instantly be reminded of some of the best performances of
Claude Lorraine.[41]

Nature when properly managed, and equipped with such
ornaments as Richmond Bridge, could come to resemble the
best performances of Claude and thus, to eighteenth-century
eyes, the best of all possible worlds.

Turner's most detailed sketches of the bridge show the
view from the Surrey bank and that in the *Thames from
Reading to Walton* sketchbook (Pl. 64) was often by his
easel, to judge from the oil-stains spattered across it.[42] He
worked with a sharp pencil-point, carefully recording the
form of the main spans, the arches to the right, the houses
on Richmond Hill, and the Star and Garter on its crest. The
finished paintings, however, were based on three pen-and-
ink studies in the *Hesperides (1)* sketchbook. The first (Pl.
65) was taken from a similar viewpoint to the pencil studies.

The Star and Garter can be seen to the left of the boat's mast
and in the foreground a number of figures can be seen on the
river-bank. The second (Pl. 66) was taken from a more
distant viewpoint on the Twickenham bank, with a group of
women and children watching as their menfolk work in the
river. Three figures on shore haul in a net, assisted by others
in a boat and a punt. In the final sketch (Pl. 67) Turner
returned to the Surrey bank, to a slightly more distant view-
point than the first, to discover still more activity taking
place. Some cows have come down to the river to drink, a
sail has been hoisted to the right, and a number of figures are
busying themselves around the boats. The foreground figures
include women bathing their children and another plunging
into the water for a swim. Although the use of pen and ink
and the stylishness of the drawing suggests a consciously
artistic approach, the detail and varying viewpoints leave
little doubt that Turner was sketching from life.

He seems to have spent as much time reading as sketch-
ing or painting, and throughout his studies we find him
synthesizing his Thames experience with the poetic world of
the ancients. Immediately before sketching at Richmond we

find him imagining the scene with a trireme and the shores developed with temples and palaces (Pl. 68) and while he was there a real state barge appeared and was recorded (Pl. 69). Throughout these sketchbooks he made equations between the scenery through which he moved in fact and in his imagination. At the same time as he was sailing up and down the Thames, he was reading in the Bible, Ovid's *Metamorphoses*, Virgil's *Aeneid*, Homer's *Iliad* and *Odyssey*, and Plutarch's *Lives*. He looked particularly for riverside scenes he could relate to his own situation. Looking through these sketchbooks we see a constant dialogue between dream and reality. It is as if the river carries him back in time. Dido and Aeneas meet near Richmond, Pompey and Cornelia at Lesbos on Thames, Portia waves goodbye to Brutus at Isleworth. Historic palaces, Kew, Hampton, Windsor Castle, and Syon House drift into view on the banks. Miraculous

64 ABOVE Detail from Richmond Bridge, 1805. Turner's most detailed study of the bridge, spattered with oil stains from its use next to his easel. Compare Pl. 186.

Pencil, 25.7 × 36.5 cm, 'Thames from Reading to Walton' sketchbook, Tate Gallery, London, TB XCV 24.

65 LEFT Richmond Bridge and study of figures, 1805. Used as the basis of the painting, Pl. 186.

Pen and ink, 17.1 × 26.4 cm, 'Hesperides (1)' sketchbook, Tate Gallery, London, TB XCIII 38-37a.

66 RIGHT, ABOVE Richmond Bridge, 1805. Used as the basis of the painting, Pl. 185. The fishermen would have been netting salmon, then so common in the Thames as to be thought commonplace.

Pen and ink, 17.1 × 26.4 cm, 'Hesperides (1)' sketchbook, Tate Gallery, London, TB XCIII 36a.

67 RIGHT, BELOW Richmond Bridge, 1805. Another study for the painting, Pl. 186.

Pen and ink, 17.1 × 26.4 cm, 'Hesperides (1)' sketchbook, Tate Gallery, London, TB XCIII 35a.

68 Classical river scene with trireme, 1805. Turner used the scenery of Richmond as the basis of daydreams and classical imaginings.

Pen and ink, 14.6 × 25.4 cm, 'Studies for Pictures Isleworth' sketchbook, Tate Gallery, London, TB XC 16.

69 BELOW LEFT Lord Mayor's Barge and Shallop, 1805. Turner's Isleworth sketchbooks routinely mix poetic musings with contemporary observation. This ceremonial procession up to Richmond presumably provided the springboard for the composition Pl. 68.

Pen and ink, 14.6 × 25.4 cm, 'Studies for Pictures Isleworth' sketchbook, Tate Gallery, London, TB XC 20.

70 FAR RIGHT Embarkation scene, 1805. Turner seems to have focused particularly on subject which featured fateful partings from widows. Perhaps something of his own situation with Sarah Danby is reflected in his choice of subjects.

Pen and ink, 14.6 × 25.4 cm, 'Studies for Pictures Isleworth' sketchbook, Tate Gallery, London, TB XC 1.

transformations create reeds, swans, pools, poplars, peacocks, and heifers drinking at the riverside.

On some pages he lists four or five potential subjects for a composition. Scenes from Plutarch's *Lives* featuring Portia, Cleopatra and Cornelia, for instance, are grouped together on the first page of the *Studies for Pictures* sketchbook (Pl. 70). All three were widows and each of their last loves,

Brutus, Antony, and Pompey, sailed away to fulfil a fateful destiny. Turner also read the greatest of these stories, that of Dido and Aeneas from Virgil's *Aeneid*. Virgil tells of Aeneas landing at Carthage, Dido's love for him kindled by Juno, his departure to found Rome, and Dido's forlorn demise. This story, which was to become a lifelong theme for Turner, makes its first appearance here among Richmond landscapes

cast in an epic Claudian mould (Pl. 71). In this reading programme Turner seems to have latched onto stories which featured heart-rending and fateful embarkations, and it is tempting to see something of his own situation reflected in the selection. Perhaps there was a parting from a woman in his own life to sail off on the Thames in search of his fated destiny in art. However this may be, the subjects selected by Turner were mostly epic tragedies of the heart and, to judge from a passage of poetry copied out in a sketchbook of about 1799, Turner had been reflecting on themes of tempestuous romance for some while:

> Love is like the raging Ocean
> Winds that sway its troubled motion
> Women's temper will supply
> Man the easy bark which sailing
> On the unblest treachrous sea
> Where Cares like waves in fell succession
> Frown destruction oer his days
> Oerwhelming crews in traitrous way
>
> Thus thro life we circling tread

> Recreant poor or vainly wise
> Unheeding grasp the bubble Pleasure
> Which bursts his grasp or flies[43]

The consequences of passion form the principal subject of Ovid's *Metamorphoses*. In truth it is little more than one long procession of gods pursuing and raping nymphs and then facing the various retributions of their wives. Turner combed through this for riverside subjects, and his sketchbooks contain numerous visualizations of incidents which caught his fancy. The story of Io seems to have been one of his favourites. Ovid tells us that Jupiter had a passion for her and was afraid of his wife, Juno, finding out. In order to conceal his lover, he turned her into a heifer, and in this guise she was put in the charge of the hundred-eyed Argus. Ovid describes a number of melancholic riverside scenes, including Io's meeting with her father, the river god Inachus. Eventually Mercury goes to free her by slaying Argus, whom he lulls to sleep by recounting a story. Turner imagined this as a riverside scene (Pl. 72) with a heifer to the left, and the other figures in the foreground.

60

The story told by Mercury to Argus, that of Pan and Syrinx, also attracted Turner's attention. Syrinx is an attractive nymph pursued with lustful intent by Pan. He finally catches up with her by the 'still water of sandy Ladon', a river of Arcadia. The sisters of the stream transform her into marsh reeds which make beautiful music in the wind, and Pan binds them together to make pipes. Ovid's *Metamorphoses* is a rich diet of sensual and even erotic imagery, which Turner obviously enjoyed, and it is perhaps not surprising that the story of Salamicis should also have caught his eye. She lived by a woodland pool which was visited one day by the youth Hermaphroditus, who much inflamed her desire. She became uncontrollable when he stripped to bathe and their underwater union was made permanent in a fusion of their physical characteristics. Ovid's next story also fired Turner's imagination. It tells of Phaethon, who attempted to drive the chariot of his father, the sun. He was consumed by the heat, and his charred body fell into the river Eridanus, where a memorial was raised to him. His sisters wept over the tomb until they were transformed into poplar trees whose tears turned to amber in the sun.

The subject to which he seems to have been most attracted was that of Latona and the herdsmen. Latona was celebrated for her beauty and often consorted with Jupiter. Juno jealously persecuted her and condemned her to wander endlessly over the earth. Eventually, consumed by thirst, she came to a lake, but the local peasants would not allow her to drink. For their unkindness she turned them into frogs. The main point of the story, however, was her speech on a universal right to water:

> Beside the lake, peasants were gathering bush osiers and reeds and sedge, that grew abundantly in the marshy soil. The Titan's daughter drew near, and knelt down to drink the cool water, but the country folk tried to prevent her, Then the goddess appealed to them: 'Why do you keep me away from the water?' she said. 'Water is there for the use of all. Nature has made rippling streams, as she made air and sunlight, not for individuals, but for the benefit of all alike. I come in search of something to which all men have a right.'[44]

This must have struck a chord with Turner, for he placed the subject at the top of a list of prospective compositions (Pl. 73) and began a painting based on the composition (Pl. 74).

On the next page of the sketchbook we find him reading the story of Jacob in Genesis and listing potential subjects, including "Jacob and Esau", "Jacob and Rachel", and "Laban searching for his Images".[45] This was a particularly

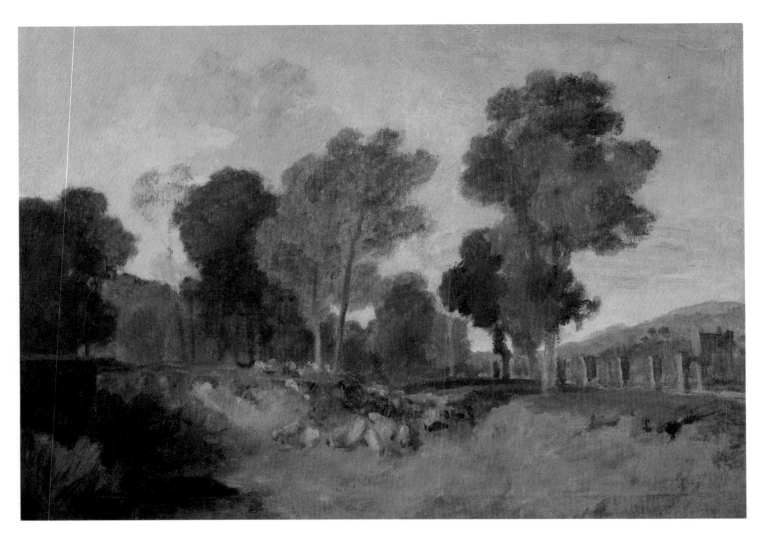

74 *Trees Beside the River, with Bridge in the Middle Distance,* 1805. The beginning of a painting developed from studies in the 'Studies for Pictures Isleworth' sketchbook.

Oil on canvas, 88.0 × 120.5 cm, Tate Gallery, London (2692).

fruitful source for seventeenth-century painters, particularly Claude, and it may be from popular engravings of Claude's work that Turner developed his own interest in the story. It is possible, once again, that the story held some personal significance for him. The story is a farrago of deceit and dishonesty. Jacob and Esau, Turner's first thought for a subject, were the twin sons of Isaac. Esau was the first-born, a simple, country type who spent his days outdoors. Jacob was a scheming 'dweller among tents', who tricked his brother of his birthright and his father's blessing. Esau was enraged and Jacob fled to the neighbouring country of Harran, where he met and fell in love with Rachel, Turner's next subject. Her father, Laban, was every bit as devious as

Jacob, and after a number of plots and counter-plots, Jacob fled back to Esau, taking both of Laban's daughters, most of his sheep, and his portable altar with statues (his images). Laban gave chase and searched for his images, Turner's third subject, but failed to find them because his daughter lied to him. In all this Esau is the only character who is consistently honest and decent. It is clear that Turner's sympathies were with him, for in the same note of subjects he quotes some lines from Pope's *Summer* pastoral: "A Shepherd's Boy, he seeks no better name / Leading his Flock beside the Silver Thames." The simple riverside life must have seemed a much more attractive proposition than the recent scheming 'among the tents' of the Royal Academy.

III Windsor

Turner's boat. River trip to Windsor. Oil sketches on panel. Painting from nature. 'The vicious practice of Turner and his followers'.

Turner was not beside the Thames for long before he ventured on it. We know from his close friend the Revd H. S. Trimmer, who was vicar at nearby Heston from 1804, that he had a boat at Richmond[46] which he must have acquired about the time he moved into Ferry House because some of the first drawings in the *Studies for Pictures Isleworth* sketchbook show Kew from the water (Pl. 35–6). We can derive some idea of what this boat looked like from four pages of studies in the *Wey Guilford* sketchbook (Pl. 75–6). The studies include a lateen, with its long diagonal spar and

triangular sail, together with a sprit-sailed boat to the right, with its spar springing from the mainmast, and a lug-sailed rig, with its spar squarely crossing the mainmast, and another lateen above. He is evidently comparing their relative merits. The lateen would have been more typical of the Mediterranean or Lake Geneva than of the Thames, but the sketches examine how the sail would perform when close-hauled or luffing, that is, sailing nearly into the wind or facing directly into it. A large sail capable of sailing as near as possible into a light wind would be the first requirement

75 RIGHT Studies of a small boat, 1805. The first of two spreads of studies in which Turner is considering alternative rigs for a small boat.

Pen and ink, 11.6 × 18.3 cm, 'Wey Guilford' sketchbook, Tate Gallery, London, TB XCVIII 7a-8.

76 FAR RIGHT Studies of a small boat, 1805.

Pen and ink, 11.6 × 18.3 cm, 'Wey Guilford' sketchbook, Tate Gallery, London, TB XCVIII 8a-9.

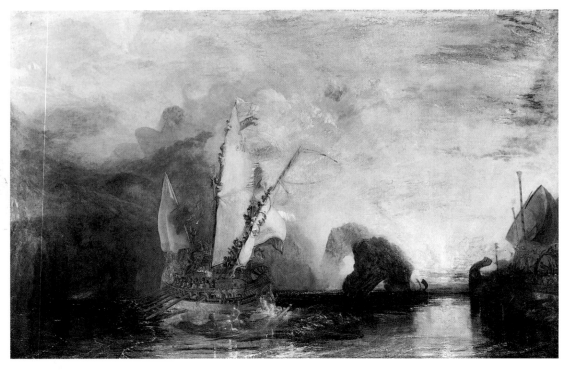

of river sailing in valleys sheltered by trees and buildings and with little room for tacking. The lateen, although not the most practical sail for the circumstances (most Thames sailing-boats were sprit-sailed), seems to have appealed to him and he went on to make further studies on the next pages and to work out how to measure up the area of canvas required.

The *Wey Guilford* sketchbook is another well-made book, bound in India-red, comb-striped boards with a brown leather spine and corners, and speckled edges to the pages. Measuring roughly $7\frac{1}{2} \times 4\frac{1}{2}$ inches, it is smaller than either the *Studies for Pictures Isleworth* or *Hesperides (1)* sketchbooks and, with 138 leaves of good-quality paper, is also considerably thicker. It seems more portable and workmanlike, a notebook which could easily be carried in the pocket, just the sort of sketchbook to be convenient while touring.

Turner began the book with a series of old-masterish studies in pen-and-ink wash. He began by visualizing subjects from Virgil and Homer, great events by ancient shores and rivers featuring Dido and Aeneas, Chryses, and Ulysses and Polyphemus (Pl. 77). The last became the basis of one of his most famous paintings, *Ulysses deriding Polyphemus* (Pl. 78), exhibited in 1829, which Ruskin described as 'the central picture in Turner's career'.[47] Next come the boat studies, and following these he made another series of sepia studies, imagining what would be required to make Isleworth (Pl. 79–80) and Richmond[48] into the sort of place Ulysses or Aeneas would have recognized, in a series of riverside views transformed into Claudian dreams. These are discussed in more detail in Part III. A Mediterranean boat like a lateen would have seemed the appropriate vessel to sail through such dreams, and sometime after the completion of these studies he set off to the most historic site on the whole river, and started a new series from the opposite end of the book.

Windsor (Pl. 81) was the highlight of most tourists' Thames journeys, with its great castle on a cliff above the river, the picturesque town clustered at its side, Eton opposite with its college and soaring chapel, and the historic Thames plains spread around, where William the Conqueror hunted and King John signed the Magna Carta. The castle had been founded by William for policing his new-won estates, but it quickly became established as a royal lodge for hunting in the nearby forest. It was developed into a palace by successive monarchs over the centuries and was the oldest and greatest of the royal palaces still in use. To many eyes it embodied the entire history of civilized England. The

77 OPPOSITE, ABOVE Composition of 'Ulysses [and] Poly[phemus]', 1805. Extending his reading to Homer, and laying down a composition which was to bear fruit more than twenty years later in one of his most famous compositions, Pl. 78.

Pen and ink and wash, 11.6 × 18.3 cm, 'Wey Guilford' sketchbook, Tate Gallery, London, TB XCVIII 5.

78 OPPOSITE, BELOW *Ulysses deriding Polyphemus – Homer's Odyssey*, Exh RA 1829.

Oil on canvas, 132.5 × 203.0 cm, London, National Gallery (508).

79 RIGHT, ABOVE Composition of Isleworth, 1805. Looking across the river to Ferry House, with the church to the left.

Pen and ink, 11.6 × 18.3 cm, 'Wey Guilford' sketchbook, Tate Gallery, London, TB XCVIII 11.

80 RIGHT, BELOW Composition of Isleworth, 1805. Looking downstream to the Pavilion and Syon House.

Pen and ink, 11.6 × 18.3 cm, 'Wey Guilford' sketchbook, Tate Gallery, London, TB XCVIII 13.

81 BOTTOM Windsor from the north west.

Photograph, the author.

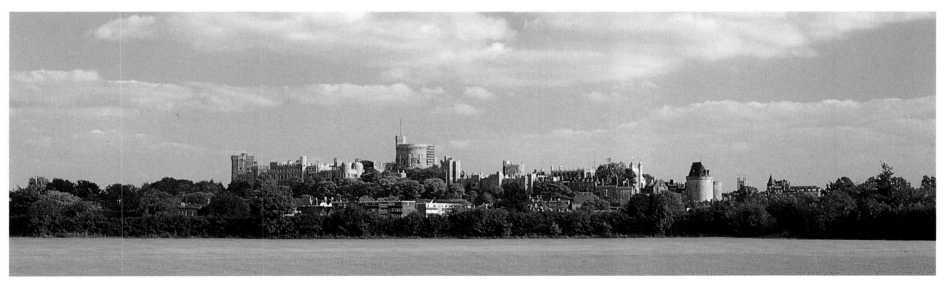

topographers naturally made a great feature of it. Samuel Ireland had four illustrations of Windsor and Eton in his *Picturesque Views* and the Boydells five in their *History*. In 1724 Daniel Defoe devoted no fewer than twelve pages of his *Tour through the Whole Island* to Windsor,[49] when he could happily dispose of a whole city in a paragraph or less. He called it 'The most beautiful, and most pleasantly situated castle and royal palace, in the whole isle of Britain'.[50]

Turner's visit from Isleworth was his first major survey of the site and the only earlier sketch to have survived is a pencil drawing made in the early 1790s (Pl. 19).[51] He began his studies in the *Wey Guilford* sketchbook with a sketch of Eton College chapel (Pls. 82, 83). His viewpoint was near the top end of the lock island looking north-north-west towards the college chapel. The weir is visible to the left, a rather ramshackle affair to judge from Turner's indications, with water pouring through the sluices into the pool below. The drawing itself is no more than a couple of minutes' work and the buildings are made out with surprising brevity for an architectural draughtsman of such renown. The second sketch (Pl. 84) shows Windsor Castle from the same viewpoint near the weir, but looking upstream in the opposite direction. It was no more time-consuming than the first. His main objective seems to have been to establish a quick geography of the site, and so he continued in the same hurried style through sketches of the college chapel and the Fellows' Garden from near the lock (Pl. 85), Winchester Tower and St George's Chapel looking up the river (Pl. 86), and a general view of the castle (Pl. 87), showing the north-east range with the State Apartments to the left, crowned by an octagonal watch-tower, and the Norman gateway and north terrace to the right. The Round Tower is just visible behind the trees and the view is closed at the right by the Winchester Tower. He continued the view to the right on the next page (Pl. 88), including St George's Chapel and the Curfew Tower, and a rustic bridge in the foreground.[52] Throughout these sketches he was clearly working in haste, and was unable to give his customary attention to detail. Nevertheless he recorded enough to be able to use these sketches as the basis of a series of major paintings (Pls. 190, 192, 193).

He made another sketch of the castle from a similar viewpoint downstream of the lock (Pl. 89), and another of Eton from nearby (Pl. 90). The last explains the brevity of the previous work. He is looking west and the chapel is silhouetted against the sun setting towards the right. Evening was drawing in and he must have been pressed for time

82 OPPOSITE, ABOVE Eton College Chapel from the River. From Romney Lock island.

Photograph, the author.

83 OPPOSITE, BELOW Eton College Chapel from the head of Romney Lock island, 1805. The first of a series of pencil sketches at Windsor and Eton which formed the basis of a number of studio pictures. This the basis of the painting, Pl. 192.

Pencil, 11.6 × 18.3 cm, 'Wey Guilford' sketchbook, Tate Gallery, London, TB XCVIII 136a.

84 ABOVE, LEFT Windsor Castle from near the head of Romney Lock island, 1805.

Pencil, 11.6 × 18.3 cm, 'Wey Guilford' sketchbook, Tate Gallery, London, TB XCVIII 135a.

85 ABOVE, RIGHT Eton College Chapel from near Romney Lock, 1805.

Pencil, 11.6 × 18.3 cm, 'Wey Guilford' sketchbook, Tate Gallery, London, TB XCVIII 134a.

86 RIGHT Windsor Castle from the north, 1805. Looking up the river from near Romney Lock, with the Winchester Tower in the centre, St George chapel to the right, and the state apartments to the left. The basis of the painting, Pl. 193.

Pencil, 11.6 × 18.3 cm, 'Wey Guilford' sketchbook, Tate Gallery, London, TB XCVIII 134-133a.

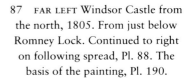

87 FAR LEFT Windsor Castle from the north, 1805. From just below Romney Lock. Continued to right on following spread, Pl. 88. The basis of the painting, Pl. 190.

Pencil, 11.6 × 18.3 cm, 'Wey Guilford' sketchbook, Tate Gallery, London, TB XCVIII 133-132a.

88 LEFT Windsor Castle from the north, 1805. The continuation of Pl. 87 to the right.

Pencil, 11.6 × 18.3 cm, 'Wey Guilford' sketchbook, Tate Gallery, London, TB XCVIII 131a.

89 BELOW Windsor Castle from the north-east, 1805. From a more distant viewpoint to Pls. 87, 88.

Pencil, 11.6 × 18.3 cm, 'Wey Guilford' sketchbook, Tate Gallery, London, TB XCVIII 131-130a.

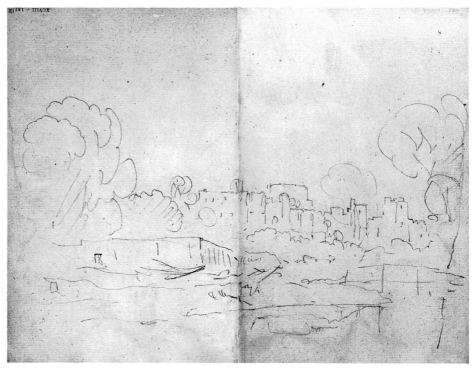

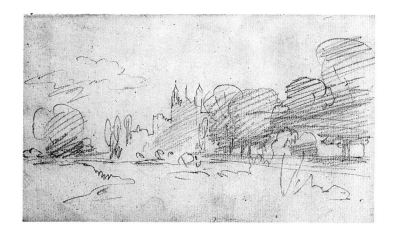

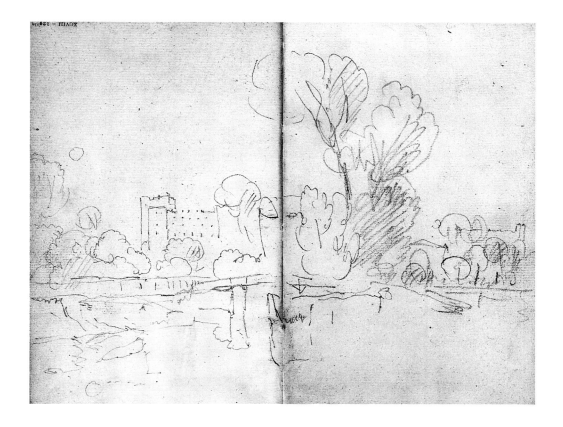

before the light failed. The next page shows a view of the castle from the same place (Pl. 91). At first sight we might assume that it is morning, for what appears to be the sun is rising to the left and is reflected in the river below. However, the view looks almost due south and for the sun to be so low in this part of the sky the time of year would have to be close to the winter solstice. As we can see from the foliage, this is not the case. In the previous sketch of Eton, however, the sun was setting in the north-west and in this he has simply turned around to record the full moon rising as it would, opposite the setting sun. This would explain the lack of detail and would also suggest, given the concentration on subjects around and just downstream of the lock, that Turner moored up here for the night. We can see how still it was from the clarity of the reflections, and we can imagine him sitting on his boat as night gathered in, his dinner cooking in a pot over a small fire, his rod propped on the side waiting for a bite, fish rising in the shadows, and his sketchbook on his knee, setting down a quick note while he still had light to see the moon rising over the castle and its reflection slipping quietly into the darkening river.

The next day he sketched the view from the north terrace of the castle (Pl. 92). When Samuel Pepys visited Windsor in 1666 he exclaimed: 'But Lord! the prospect that is in the balcone in the Queen's lodgings, and the terrace and walk, are strange things to consider, being the best in the world, sure.'[53] Defoe described how Elizabeth I 'usually walked [on the terrace] for an hour every day before her dinner, if not hindered by windy weather, which she had a particular aversion to; for as to rainy weather, it would not always hinder her; but she rather loved to walk in a mild, calm rain, with an umbrella over her head.' He went on to claim that neither Versailles nor 'any of the royal palaces of France, or

a Rome, or Naples' had anything to rival it.[54] A view with such a reputation and pedigree deserved Turner's prolonged contemplation and over six pages of the sketchbook he constructed a grand continuous panorama (Pl. 93) starting at Eton College and Romney Lock and swinging to the right across the meadows to the terrace and State Apartments. On the next page he panned left over the Brocas to Clewer church, where William the Conqueror is reputed to have worshipped, and closed the view with the north-west range of the castle at the far left. He finished by scrambling down the bank to take a view of the terrace as a whole, with the Norman gateway and Winchester Tower (Pl. 94).

The main purpose of this visit to Windsor, however, was not to make pencil sketches. The Turner Bequest contains eighteen oil sketches on mahogany-veneered panels.[55] Most show subjects on the Thames or its tributary, the River Wey. They are all small, the largest measuring less than three feet wide, and they would have offered readily portable solid surfaces on which to paint, ideal for working out of doors.

90 ABOVE, LEFT Eton College Chapel from the river, sunset, 1805. Compare the photograph, Pl. 82.

Pencil, 11.6 × 18.3 cm, 'Wey Guilford' sketchbook, Tate Gallery, London, TB XCVIII 129a.

91 ABOVE, RIGHT Windsor from the north, 1805. The same view as the oil sketch, Pl. 95. The full moon rising to the left of the castle, and reflected in the still river below.

Pencil, 11.6 × 18.3 cm, 'Wey Guilford' sketchbook, Tate Gallery, London. TB XVIII 129-128a.

92 Eton College chapel from Windsor Castle Terrace.

Photograph, the author.

93 Panorama of the view from Windsor Castle Terrace, 1805.

Pencil, 11.6 × 18.3 cm, 'Wey Guilford' sketchbook, Tate Gallery, London, TB XCVIII 126-125a, 128-127a, 126a.

94 Windsor Castle, the north terrace from below, 1805.

Pencil, 11.6 × 18.3 cm, 'Wey Guilford' sketchbook, Tate Gallery, London, TB XCVIII 125-124a.

Their irregular size suggests that they were offcuts which simply happened to come to hand, and that he was making do and improvising, not for the sake of making a durable finished statement, which could only be crafted in the studio, but for examining and recording the actual process of working in the landscape. He used some of the panels as they were, painting directly onto the wood. Most, however, were prepared with a ground, in some cases a thin coat of white primer, in others a thick chalky ground brushed so thick and dry across the grain that it set immediately, preserving every bristle-mark. All the surfaces were so absorbent that the oil was quickly sucked out of the paint, leaving little or no time for adjustment and reworking. Thus every first thought was preserved and the result is a fascinating document of Turner battling with a combination of medium and support which simply did not allow the kind of preplanning and artfulness that he was accustomed to enjoying in the studio.

Scholars have often been drawn to them.[56] It has not, however, been realized quite how closely they can be related to the Wey Guilford sketchbook.[57] In that book the Windsor sketches are followed by a series exploring the River Wey from Godalming through St Catherine's and Guildford to Newark Priory.[58] Exactly the same range of Windsor and River Wey subjects is found in the oil panels, and since there is no evidence in the sketchbooks of any other tour on the River Wey, it seems reasonable to conclude that the panels were made in conjunction with the sketchbook. It has been argued that the panels represent 'a single campaign playing a crucial part in the rapid development of Turner's approach to nature',[59] and this campaign is here presented in the context of a wider programme in which he extended himself from the most elevated, poetic, historical, and academic styles of his career to the most naturalistic. These small panels are the direct transcript and witness of his confrontation with nature: his creativity at work before our very eyes at one of the most important and complex points of his development.

There are four oil panels of Windsor, one from a viewpoint to the north and three from viewpoints to the west. The first (Pl. 95) is known as Windsor Castle from Salt Hill, but comparison with a sketch in the Wey Guilford sketchbook (Pl. 91) shows that the viewpoint is actually on the river below the lock. The similarity is striking. Allowing for the more naturalistic perspective of the oil, which draws the castle forward less than the drawing, and is less compressed, it is clear that both show exactly the same view. The trees are the same, the largest with a distinctive lean to the left, and two smaller ones growing in the same place just to the left of the round tower. The panel was prepared with a thick ground brushed out roughly across the grain, and Turner's fingers must have been quite a mess after smearing colour across the sky, working it almost dry, rubbing it across the grain to create a tactile and energetic surface.

He used the same panoramic format for the other three oil panels at Windsor. In order of times of day the first is the one known as Windsor from Lower Hope (Pl. 96), which shows a view from near the racecourse with Clewer church spire picked out in sunlight at the right. The sun is in the south-west and the time of day mid-afternoon. Eton College chapel can be seen towards the left with a shower drifting across the sky beyond, while Windsor in the centre has been plunged into sudden shade. Turner's object seems to have been to set down as quickly as possible the most ephemeral of effects. His paint on this occasion was fluid and quick and he dashed in the shower with a few vigorous strokes, a great swirl of grey cloud with one sweep of a large brush, and the rent of blue sky with paint smeared from his finger.

His next shows Windsor Castle from the Meadows (Pl. 97), taken from a slightly nearer viewpoint with the sun falling from a more westerly direction. Again the object was to capture an almost instantaneous effect of light and weather. Clouds still stream up from the left, but the castle is now brilliantly picked out in sunlight. We can sense Turner waiting for his moment almost like a photographer, watching the clouds drift across the sun, ready to snap his subject at the instant the light comes good. The third subject, Windsor Castle from the River (Pl. 98), was taken from a

71

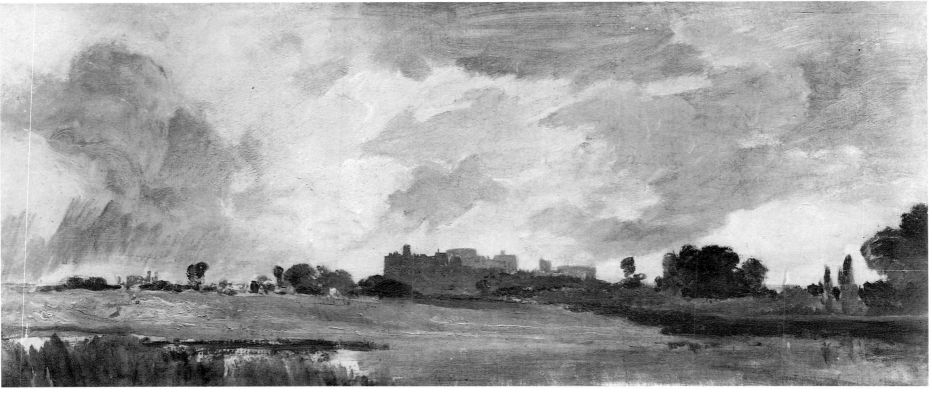

72

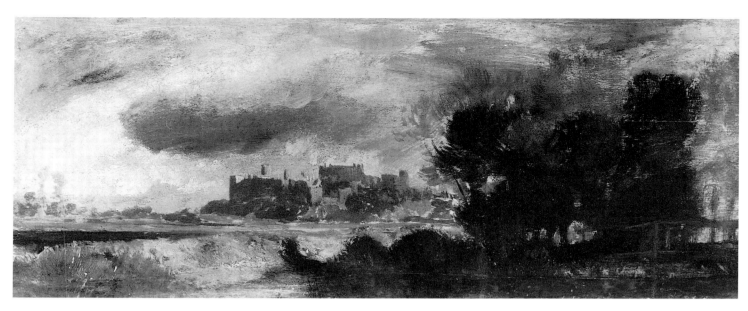

95 OPPOSITE, ABOVE *Windsor Castle from the River* (known as 'Windsor Castle from Salt Hill', 1805. The first of four oil sketches of Windsor (to Pl. 98), from a series made in conjunction with sketches in the 'Wey Guilford' sketchbook. Taken from a viewpoint near the foot of Romney Lock island, the painting records exactly the same view as the pencil sketch, Pl. 91, and was probably taken the following day.

Oil on Mahogany panel, 27.0 × 73.5 cm, Tate Gallery, London (2312).

96 OPPOSITE, BELOW *Windsor from Lower Hope*, 1805. With Eton College chapel to the left beneath a passing shower.

Oil on Mahogany panel, 32.0 × 73.5 cm, Tate Gallery, London (2678).

97 RIGHT, ABOVE *Windsor Castle from the Meadows*, 1805. Evening. The views from the west are now largely obscured by trees.

Oil on Mahogany panel, 22.0 × 55.5 cm, Tate Gallery, London (2308).

98 RIGHT, BELOW *Windsor Castle from the River*, 1805. Returning to the viewpoint of one of his earliest sketches of Windsor, Pl. 19, and compare his last treatment of the subject, Pl. 205.

Oil on Mahogany panel, 20.0 × 36.5 cm, Tate Gallery (2306).

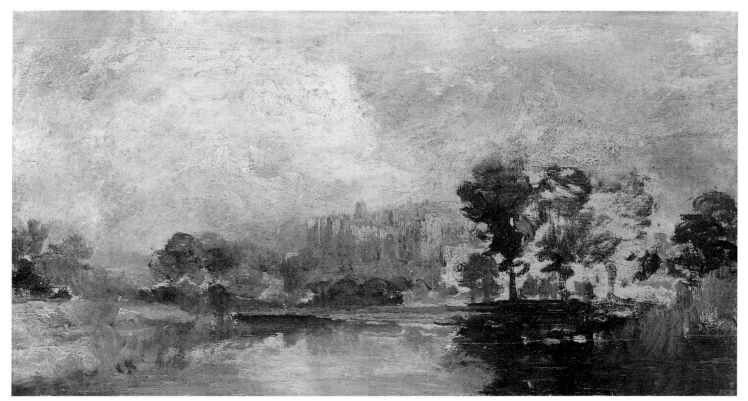

still nearer viewpoint, this time obviously in mid-river, with the sun still further towards the west, now far enough round to rake across the north front of the castle, as in the sketch from the lock. The sun must be near the horizon, for it has gained considerably in warmth of colour and bathes the castle in pink and purple. Again the fleeting moment was all he required. The trees to the right remained mere ciphers against the bare ground of the panel.

Since his process is so visible, it is worth considering how Turner could have painted at all in oils out of doors. He would obviously have needed some basic equipment and materials: spirit and linseed oil in jars or bottles, and something to hold small working quantities of each: brushes and palette, pencils, paint, containers, boards, rags, sketchbooks, an easel perhaps, already quite a list. Clearly he kept his colours to a minimum, two greens, yellow, ochre, two blues, white, black, dark brown, red, vermillion, and a purple, a dozen colours at the most. Collapsible metal tubes of the type we now take for granted were not available until near the end of Turner's life. The first patent was taken out in America in 1841.[60] By 1805, however, a number of firms of artists' colourmen were established. Reeves, for example, was founded in 1766, and other firms of this period included Ackermann's and Newman's. Artists were using them increasingly for the purchase of ready-made materials and equipment. The colourmen took on the specialized development of the chemistry and preparation of materials, their properties and interaction, and offered advice and guarantees on their products. By the date of these sketches a wide range of ready-made oil colours was available, sold in bladders tied

at the top to form small bags.[61] One of Turner's travelling paintboxes, containing some of these colours, survives to this day (Pl. 99) and it might be the very one used on this trip. Such developments gave artists the freedom to rove away from their workshops, and in these panels Turner is celebrating the opening up of a world of new possibilities for a painter's relationship with nature.

His Thames oil sketches of 1805 are one of the most important groups of *plein-air* studies of their era. They belong to a more generally developing interest in painting from nature, out of which the practice of one of its greatest exponents, John Constable, was derived. A number of artists had experimented with the idea in the seventeenth and eighteenth centuries but in the early years of the nineteenth, especially in Britain, the practice was widespread enough to suggest that a movement was taking shape.[62] Turner made his first experiments in painting from nature while staying with his friend W. F. Wells[63] at Knockholt in Kent, probably in October 1799, and he produced a number of oil sketches on paper of beech trees, park scenery, and cottage interiors.[64] At the same time Constable, not long established in London, was beginning to formulate his ideas, and in May 1802 he decided to spend his summer working from nature at his Suffolk home of East Bergholt. A letter he wrote at this time is one of the most famous manifestos of naturalism in the history of art:

> For these two past years I have been running after pictures and seeking the truth at secondhand . . . I shall shortly return to East Bergholt where I shall make some laborious studies from nature – and I shall endeavour to get a pure and unaffected representation of the scenes that may employ me with respect to Colour particularly and anything else – drawing I am pretty well master of. – There is little or nothing in the [RA] exhibition worth looking up to – there is room enough for a natural painture.[65]

A number of others were also producing small studies from nature and it is striking that many were working in the Thames valley. William Delamotte, for example, whom Turner seems to have known well and visited in Oxford in 1800, moved to Great Marlow in 1803 to take up the post of drawing-master at the Royal Military College and made a number of sketches of Thames valley subjects. Another Thames valley painter, William Havell, whom Turner also knew, was also painting from nature in oils, particularly around Reading, and he could have met Turner boating up the Thames on similar business on these tours.[66] About

99 Turner's Paintbox, c.1805. A travelling paintbox containing ready-ground pigment tied in small bladders. Metal tubes for paint were not yet invented.

Tate Gallery, London, TGA 7315.6 (Presented by Mis M H Turner).

the same time, and in subsequent years, a group of young students, including John Linnell, William Mulready, and William Henry Hunt, was also experimenting with oil sketching on the Thames.[67] Although only Constable went on to make it anything like a major part of his work, these stirrings were part of a growing widespread interest in the point of creative contact between an artist and his motif. In 1805, just before Turner went to Isleworth, the Society of Painters in Water Colours held its first exhibition at Brook Street in London. Turner must have taken a keen interest since his friend W. F. Wells was its instigator and one of the founder exhibitors. Of the 275 exhibits,[68] no fewer than thirty-four were described as 'Sketches' or 'Studies from Nature'. The artists clearly believed that not only was there some merit in making such things, but that there was also a market for them.

Although only thirty years of age Turner was by far and away the best established of the artists experimenting with the new naturalism, and he was looked on by some as a figurehead. One of these was William Havell, who thought Turner superior to Claude, Poussin, 'or any other artist'.[69] The strength of his influence is most graphically demonstrated by his detractors. In June 1806 a party comprising Sir George Beaumont, Henry Edridge, Thomas Daniell, and William Alexander enjoyed roast beef and pigeon pie at Joseph Farington's house and 'Passed a very sociable evening. We had a strong conversation on the merits of Wilson as a Landscape Painter and the vicious practice of Turner and his followers was warmly exposed.'[70] In 1807 Turner showed some Thames pictures at his own gallery, which brought forth some particularly strong condemnation. On 5 May Benjamin West went along to see them 'and was disgusted with what he found there; views on the Thames, crude blotches, nothing could be more vicious'.[71] Although we cannot be certain what these pictures were, they were obviously the result of the exploration of the Thames begun in 1805. It is possible that some were actually the sketches painted from nature. Either way Turner's views on the Thames were clearly not to everyone's taste.

IV The River Wey

Exploration of the Wey Navigation. Godalming. St Catherine's Lock and Hill. Guildford. Newark Priory.

His next excursion with the *Wey Guilford* sketchbook was along the River Wey navigation, which joins Godalming and Guildford to the Thames at Weybridge. His expenses *en route* were recorded in a note inside the back cover:

Hampton	3				
Ripley	12	6			
Lock	2	6			
W –	1	6			
Guilford	10				
	2				
Boat	5				
Godlaming [i.e. Godalming]	10	6			
Man	2				
St Cath	3	6	2	12	6

We can see from this that he sailed up the Thames and stopped at Hampton, Ripley, Guildford, Godalming, and St Catherine's. The larger disbursements at Ripley, Guildford, and Godalming suggest that he stopped at these sites overnight. His first sketches (Pls 100, 101) were taken at Godalming from the meadows near Boarden Bridge, where a complex of weirs marks the upper limit of navigation for even the smallest craft. Boats have used the river since mediaeval times but the navigation, which had improved the river with new locks and canal cuts allowing heavily laden barges to pass, was relatively new. The stretch to Guildford was opened in 1654 and extended to Godalming in 1764, carrying corn and coal from London and timber, iron, chalk, gunpowder, and agricultural produce in the opposite direction. Turner would have been unusual in sailing through it

for pleasure, but his new approach to travel for its own sake was part of the movement from which our modern outlook was created. Nowadays the only traffic is pleasure craft and the navigation is owned and maintained by the National Trust.

Besides sketching in the *Wey Guilford* sketchbook, Turner also painted a number of oil sketches on panels. The hill behind the church provided the viewpoint for the first[72] of these, *Godalming from the South* (Pl. 102), in which the church appears to the left, with the meadows beyond, the town clustered below, and the Wey meandering three and a half miles north-east towards St Catherine's Hill, with Guildford hidden beyond. The time of day was evening. He selected a panel with a relatively smooth ground, and worked calmly and at ease. The details of the distance are clear enough for us to be able to see that the round hills were mostly bare of trees, and the small hilltop chapel of St Catherine stands out starkly. Turner's sketches often show that there were far fewer trees in the landscape than now, and in a country that had been at war for most of the past fifty years, where grazing and agricultural land and timber were at a premium, this is not surprising. The woods nearer to hand are shrubby, and were probably coppiced to maximize their use. Similar care is evident in tracing the course of the river, picking it out in the distance with a fine brush loaded with white, and in the middle distance by the line of willows at its side. Elsewhere he worked more freely, pushing and smoothing the paint with his fingers in the sky and distances, dashing in the foreground trees and banks, and scratching through the still-soft paint with the stock of his brush. The result bears the signs of his physical involvement with his materials, and of his recording the scene in real time which did not allow the foreground to be resolved, all the ground to be covered, each of the buildings to be made out in detail, or to get round at all to the tree at the top right. We can see where he has rubbed out the paint across the grain of the wood, and where the oil has been absorbed too quickly for him to smooth out the sky as much as he would have liked. This is Turner at work, actually looking at his subject and devising means to set it down as he goes along, not concealing his means and his marks but making them the very stuff of which the result is composed. And not only can we see signs written on it by the circumstances under which it was painted, we can also see signs written by carrying it home. While the paint was still wet, another board or card stuck to its surface and left its impression in a vertical line just left of centre and a horizontal line across the sky just above St Catherine's Hill.

On 29 November 1822 William Cobbett declared that 'Every body, that has been from Godalming to Guildford, knows, that there is hardly another such a pretty four miles in all England. The road is good; the soil is good; the houses are neat; the people are neat; the hills, the woods, the meadows, are all beautiful.'[73] The next pencil sketch shows St Catherine's Hill from near the lock as Turner approached from Godalming (Pl. 103). He seems to have been as pleased as Cobbett was later and decided to stop a while and enjoy it. He took out one of his larger mahogany boards (Pl. 104) prepared with a thin ground, which in places barely covered the wood. From the size of the board chosen he seems to have been happy to spend some time painting it and he had all day before him, for the sun was in the east. Once again he had to struggle against the absorbency of the surface. Colours sank into the sky before the next was applied, making it difficult to work wet into wet, and the blue patch is isolated from the rest of the sky by areas of almost bare

wood. We can almost feel the cloying of the paint as Turner attempted to smooth it out. Below, he exploits the ground for his light by leaving patches bare, smearing in the hill with unmixed green and white, and sketching in the trees with two greens only, stabbing them in with a broad brush so that the bristle-marks are splayed out across the surface. The dark water and timber posts to the right are dashed in with thin, runny black, and the details of cattle, houses, bridge, and chapel were added with thick, creamy touches of unmixed and undiluted pigment. These sketches have a tactility which is vivid beyond almost all his other work. We cannot fail to feel Turner's own physical involvement with his materials; liquid brush-marks, dry brush-marks, scratches, scrapings, smearings, working the materials with his fingers.

The next pencil sketch (Pl. 105) suggests that creature comforts were the first of his concerns at Guildford. It was taken from the second floor of a building in the High Street

103 RIGHT St Catherine's Hill, near Guildford, 1805. From near St Catherine's Lock, looking north. A similar view to the oil sketch, Pl. 104.

Pencil, 11.6 × 18.3 cm, 'Wey Guilford' sketchbook, Tate Gallery, London, TB XCVIII 118a.

104 ABOVE St Catherine's Hill, Guildford, 1805.

Oil on Mahogany panel, 36.5 × 73.5 cm, Tate Gallery, London (2676).

directly opposite the entrance to Quarry Street. A water-colour by Job Bulman in the Guildford Museum (Pl. 106) shows the same view from ground level in about 1780. The building was the White Lion Hotel, one of the five large coaching inns Guildford possessed at this time, which was no doubt well capable of furnishing Turner with dinner and a room. It looked over the High Street to a pub, identified by the sign of the Star in Bulman's watercolour, and to St Mary's church, with its Saxon tower built about 1050. Turner was high enough to be able to see the castle over the buildings to the left, with its keep built about 1125 and the remains of the palace which served as a royal hunting residence, being visited by King John no fewer than nineteen times and by Henry III even more often. We can imagine Turner in his room, having his lunch and thinking about what to do next, where to go, and deciding that before he does anything he is going to spend a quiet half-hour in the window, sketching the view outside.

The hotel was convenient for the river, only a few yards down the High Street, and Turner returned to the waterside to sketch. His next drawing (Pl. 107) records the view from the foot of the hill, looking to St Catherine's across Guildford Mills. This was the industrial heart of the town, and since early mediaeval times flour mills had operated here. As the wool trade developed fulling mills were opened, and in 1701 a water-powered pump was built to provide the

105 OPPOSITE ABOVE RIGHT Guildford, Quarry Street, 1805. Taken from a second-floor window of the White Lion Hotel (the site now redeveloped), looking across the High Street to the Star and St Mary's, with the castle above left.

Pencil, 11.6 × 18.3 cm, 'Wey Guilford' sketchbook, Tate Gallery, London, TB XCVIII 117a.

106 OPPOSITE BELOW RIGHT Job Bulman, *Quarry Street, Guildford*, 1780.

Watercolour, Guildford Museum.

107 ABOVE St Catherine's Hill, near Guildford, 1805. From near the foot of the High Street with Guildford Mills in the foreground.

Pencil, 11.6 × 18.3 cm, 'Wey Guilford' sketchbook, Tate Gallery, London, TB XCVIII 116a.

108 CENTRE St Catherine's Hill, near Guildford, 1805. From the river, approaching from Guildford.

Pencil, 11.6 × 18.3 cm, 'Wey Guilford' sketchbook, Tate Gallery, London, TB XCVIII 115a.

109 BELOW St Catherine's Hill and Ferry, 1805.

Pencil, 11.6 × 18.3 cm, 'Wey Guilford' sketchbook, Tate Gallery, London, TB XCVIII 114a.

town with piped water. In 1794 an iron foundry had been set up. His next sketch (Pl. 108) was taken from the relative peace of the riverside opposite the meadows looking up to St Catherine's – a line denoting the reflection of the willow to the left tells us how calm the water was. He took a third sketch at St Catherine's ferry (Pl. 109), with the chapel above and a number of boats moored on the riverside, which seems to suggest that this is where he left his boat for the night. His next sketch (Pl. 110) was taken from the same viewpoint, looking back down the river to Guildford, with the castle in the centre and the tower of Holy Trinity church to the right. The same view was pointed by W. F. Varley in 1819 in a watercolour in Guildford Museum (Pl. 112). The watercolour shows on the right the chalk quarries which gave Quarry Street its name, and the castle in evening light with the sun coming from the left.

Varley's watercolour makes an interesting comparison with the oil sketch Turner made of the site (Pl. 113). He chose to treat this view as an upright and worked on his small board quite thickly, and apparently at some length. He quickly learned that working from the motif requires some preplanning, since an area that you want to overpaint might well be still wet, as happened at the top left and right. He chose his colour for the castle keep carefully, recording that the sun was on the horizon, casting a red light on the keep while it had already set in the valley below. Mixing and blending white, green, ochre, India red, and brown, he whipped up his painting of the town into a creamy richness. As with the *Godalming* sketch, he seems to have had an accident, and just left of centre is a vertical line running up to about half-way, where something, perhaps a brush, stuck to the surface and brought the paint away with it. Such, however, are the marks of the circumstances under which it was made. They are an integral part of the piece. So is the material on which it is painted: it gives the paint its particular quality, and in its ragged-edged, misshapen, rough-hewn form was also visibly the product of circumstances, the best available. Given their *ad hoc* roughness, it seems grotesque that these oil sketches are currently displayed in overpowering gilded frames, settings for the valuable commodities of art, great statements, great artifices. Nothing could be further from the rough and ready feel of these sketches.

Turner's last stop on the River Wey was at Newark Priory, a twelfth-century Augustinian house not far from Ripley. The ruins (Pl. 114) consisted of the presbytery walls and the south transept rising to a distinctive gable, standing in a field with the river and navigation to the south and circled by the

110 TOP LEFT Guildford from St Catherine's, 1805. Guildford Castle and Trinity church tower to the right. The same view recorded in the oil sketch, Pl. 113.

Pencil, 11.6 × 18.3 cm, 'Wey Guilford' sketchbook, Tate Gallery, London, TB XCVIII 113a.

111 LEFT Guildford Castle from the Wey near St Catherine's, morning.

Photograph, the author.

112 TOP RIGHT W. F. Varley, *Guildford from near St Catherine's Ferry*, 1819.

Watercolour, Guildford Museum.

abbey stream. His last sketch at Guildford[74] shows the time of day then to have been morning; it would have been afternoon by the time he navigated the eight miles and six locks down to Newark. From the bridge it was just over a mile to walk up the lane to Ripley to find a hotel for some dinner. He spent the later part of the afternoon and evening surveying the ruins and managed to complete four pencil sketches and three oil sketches in the time. The pencil sketches (Pl. 115) explored various views from near the abbey stream to the north and seem to have been made with the intention of arriving at an understanding of the layout of the walls.[75] The first oil sketch (Pl. 116) was taken from the south, apparently from the navigation just above the lock, looking across the course of the river, indicated by the fence to the right, to the south transept with one bay of the choir visible to the left and three bays of the presbytery to the right. The sun shines brightly from behind and about 30° to the left and is still quite high in the sky, which would set the time of day at about 4.00 p.m. Turner's choice of viewpoint might have been influenced by the arrangement of the trees, the largest in the foreground setting off the ruins beyond to the right, and a glimpse of the distance to the left closed by more trees. Once he had stationed the main tree on the golden section of his composition he had an ideally Claudian arrangement. It is a striking lesson in the power of aesthetic experience that, even when Turner was working in his most naturalistic manner, his knowledge of art exerted its influence over deciding what was noteworthy at the site. In this case, in its own subversive way, art succeeded in making nature imitate it, even though Turner was attempting to achieve the reverse.

The sketch is one of the most highly wrought of the series and is unique in that it is outside the Turner Bequest. Its original owner was the Revd Dr Thomas Lancaster, perpetual curate of Merton, Surrey, between 1801 and 1827, near enough to Isleworth for him to have been almost a neighbour and near enough to Newark for it to have held a local interest. We do not know how or when he acquired it, but it would appear that Turner worked it up in the studio for him, for the sky has been overpainted up to the trees and the foreground weeds and lilies are much more elaborate than anything he attempted in the other oil sketches. Furthermore, the abbey as we see it in the painting cannot have been painted from the motif, for a number of post-holes in the gable wall, for example, appear now as blind openings, and the presbytery wall to the right appears to consist of three unbroken bays, whereas in fact it had only two, the third belonging to the wall behind on the opposite side of the church. Nevertheless, many parts of the original

113 *Guildford from the Banks of the Wey*, 1805. Evening.

Oil on Mahogany panel, 25.0 × 20.0 cm, Tate Gallery, London (2310).

114 BELOW Newark Priory from the River Wey.

Photograph, the author.

115 RIGHT Newark Priory, 1805. From the north.

Pencil, 11.6 × 18.3 cm, 'Wey Guilford' sketchbook, Tate Gallery, London, TB XCVIII 105a.

sketch did remain visible. The grain of the ground can be seen through the lilies and river-bank in the foreground, while the paint has failed to cover parts of the sky. Despite the overworking Turner did not conceal its nature as a sketch. It is remarkable enough that he should have parted with something so rough, but still more so that someone should have wanted it at this time, when most thought that visible paintwork was a crude deficiency in workmanship, no more than 'mortary' and trowelling.[76]

His second oil (Pl. 117) was taken from a viewpoint further to the left and later in the day, for the sun had moved far enough to the north to leave the south-facing gable in shade. Although he does not seem to have spent very long about it, and nor could he, given the hour, he has recorded

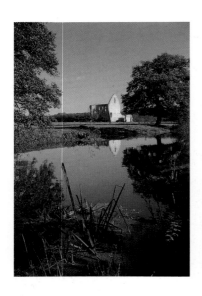

116 RIGHT *Newark Abbey*, 1805. From the south. A more finished panel than the others, and possibly exhibited in Turner's own gallery.

Oil on panel, 27.9 × 45.7 cm. The Loyd Collection.

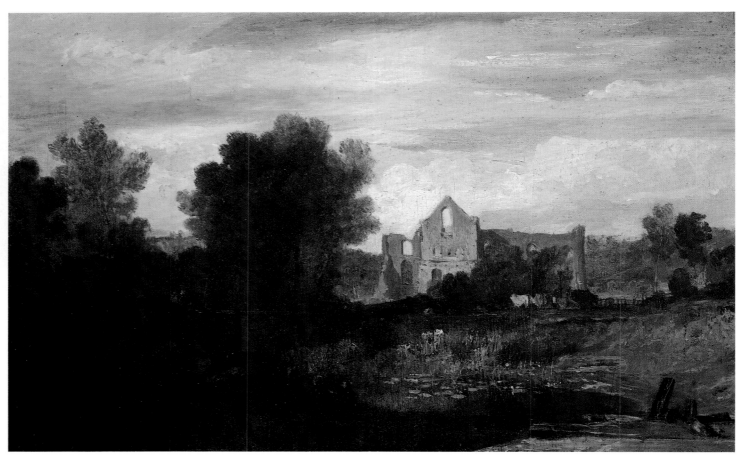

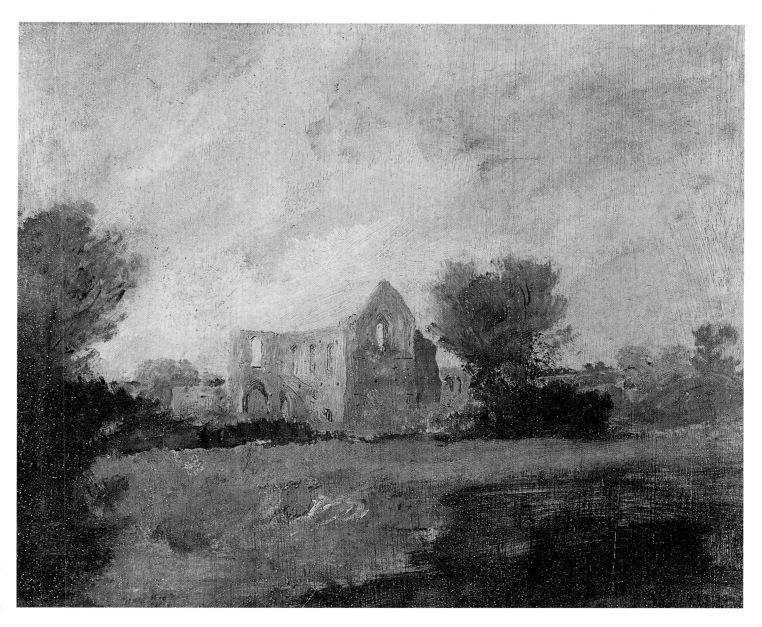

117　*Newark Abbey*, 1805. From
the south-west, see Pl. 114.

Oil on mahogany, 29.5 × 35.0 cm. Tate Gallery,
London (2302).

some fascinating observations of the complex play of light across the walls. The gable is in shadow but borrows enough light from the sky for the post-holes to be sharply indicated. The wall of the presbytery to the right, however, although facing the same direction, is darker, being shaded by the tree. On the other hand the wall of the choir to the left is well lit by sunlight reflected from the adjacent transept wall. Similarly the far wall of the presbytery also borrows light from the wall opposite, which must be in full sun. Such is the complexity of reality, more subtle and surprising than invention could ever be.

The final oil sketch made at Newark (Pl. 118) shows the ruins from the west with the sun falling on the gable from the south-east, so the time of day must have been morning. This was the largest of the sketches made at the site and, like the sketch made at St Catherine's Lock (Pl. 104) the size of

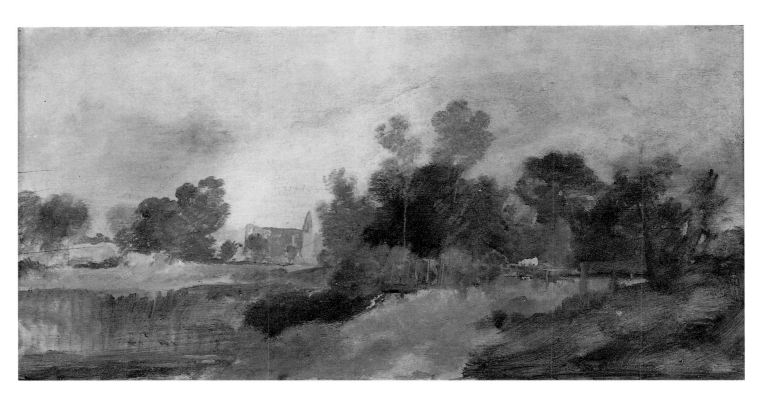

118 *Newark Abbey on the Wey*, 1805. From the west.

Oil on mahogany, 37.0 × 73.5 cm, Tate Gallery, London (2677).

board selected suggests that he must have had plenty of time to spend over it. It is remarkable, therefore, how broadly painted it remained. It is perhaps a little less rough than the smaller sketch of Newark from the south-west (Pl. 117), but the paint was left just as it dried out in the sky, the trees dashed in as tonal blocks, and the water little more than an unreadable puddle. In *Windsor Castle from Lower Hope* (Pl. 96) a similar gesture in the sky at the left was readable as a passing shower; here it remains an unintelligible fence of marks in the water to the left. It is the sign only of the painter having looked, but at what we cannot tell. Turner has almost departed from representation for an abstract language of marks standing for the act of looking. It was to be three-quarters of a century before the Post-Impressionists reached such a point again.

V Walton Bridge

Overnight stops. Walton oil sketches. 'Pictures of nothing'.

Turner would have passed through Walton Bridge on each of his journeys upstream from Isleworth to Windsor or Guildford. There has been a ford at Walton since at least Roman times, but the first bridge was built in 1750. It consisted of a brick causeway, which still survives to carry the road over the marshy south bank, and a wooden lattice-work bridge over the river itself. The wooden lattice was replaced in 1786 by a bridge of four brick arches, and this was the structure Turner recorded. This in turn made way in 1864 for a four-span lattice of iron girders, and as a result of damage inflicted during World War II the present 'temporary' bridge alongside was opened in 1953. The second bridge was perhaps not so elegant as the first,[77] but was nevertheless much to be preferred to the later ones, and Turner enjoyed the site enough to stop on a number of occasions, making numerous sketches in pencil or pen and ink, together with two oil sketches on panel.

On one of these visits he made seven pen-and-ink sketches in the *Hesperides (2)* sketchbook, a companion to the *Hesperides (1)* sketchbook, having exactly the same binding and presumably bought at the same time. It seems to have been new and unused when he took it out at Walton. His first sketch (Pl. 119) was taken from a viewpoint upstream of the bridge, near the old ford where the river swings north towards Shepperton. It was evening, for a few lines of shade tell us that the sun was to the left in the north-west, and

he worked as quickly and economically as possible, setting down the bridges in no more than eight strokes and the background in only a few more. To the left there are cattle, each one described in four or five touches: in the centre a barge rests in mid-river with its sail down, mast and shrouds reflected in still water, and a few horses browse on the bank to the right. Despite the brevity, it is remarkable how much he managed to get down.

It is interesting that he devoted the time available to contingencies rather than to permanent features. Thus he gave hardly any attention to the bridge, still less to the church, which is barely discernible just above the blot to the right of the boat. Instead he concentrated on the cows, their individual characters and attitudes, the boat, its reflection, the little figure sitting in the stern, the cloud, the direction of the light, the weather conditions, the horses on the bank which had been towing the barge on the windless river. These are the things which were special in the moment of his being there. There was all the time in the world for things which would still be there in the morning.

He pursued the passing features through the remainder of the series. The next sketch recorded a riverside derrick, sparing time for only vague indications of cattle and the boat. A punt with a figure in the stern had manoeuvred beneath the crane where a number of figures were working. In the foreground the horses picked their way down the steep bank to drink after their day's work. In a third sketch (Pl. 120, below) Turner returned to the general composition, with a different arrangement of cows and horses, and in further sketches he concentrated on the horses and some figures who had appeared to superintend them. All these elements found their way into a finished painting which he worked up from the sketches (Pl. 188).

The last sketch of the visit (Pl. 120, above) shows the opposite side of the bridge and must have been made the next day, for the sun is high in the sky and the time of day is near noon. Since it was set on a page facing a sketch made the previous evening it seems possible that he had conceived the idea of a pair of finished pictures with contrasting times of day and weather conditions. The sky is filled with shafts of light illuminating a busy scene. In the centre is a figure

119 Walton Bridges, 1805. Taken in the evening from a viewpoint upstream on the north bank. Turner seems to have been primarily concerned with the circumstantial details rather than the permanent features. The basis of the finished picture, Pl. 188.

Pen and ink, 14.6 × 22.9 cm, 'Hesperides (2)' sketchbook, Tate Gallery, London, TB XCIV 4.

way (Pl. 122). The sun was low to the south-west, shining brightly on the left bank as a carter made his way home for the night and a couple of boatmen tied up by a riverside house. The river was a flat calm reflecting the waggon and horses and boats, still enough for him to have been able to drift long enough in mid-river to make the painting. The sky glows to the right where the sun must have been near the horizon, for the trees cast long shadows and the light catches the lower clouds in streaks of ochre and white. Someone seems to have lit a fire away to the left, for two patches of dark smoke drift across the water. The effect cannot have lasted for more than a few minutes and there are many signs of the speed with which he worked. The causeway begins in yellow ochre at the left but turns green as he worked over the still wet paint of he trees. The waggon and horses were made out in seconds. His blue would not quite cover the sky. The wood contributes to the effect of the picture in other ways. It is much easier to work the paint along the grain than across it, and so the emphasis of the picture is persistently horizontal. The long streak of cloud, the long line of arches, the low line of distant trees, the low viewpoint on the wide river, the banks converging gently into the

with upraised arms surrounded by sheep and other figures shearing and washing. Once again it is the contingent events at the site which occupied him, and these again formed the basis of a finished picture (Pl. 190). The permanent features were recorded in a double-page spread of the *Thames from Reading to Walton* sketchbook (Pl. 121). It was not, perhaps, Turner's most languid or composed drawing, but he managed to set down the house and tollbooth to the left, the forms of the main groups of trees on the banks, and the Saxon tower of Walton church between the trees on the right-hand page. It was a drawing which saw considerable action in the studio and was spattered with oil and paint and covered with dirty thumb- and fingerprints in the process. The finished pictures derived from it are discussed in Part III.

He seems to have used Walton as a regular overnight mooring, and on another visit he stopped in the approaches and painted an oil sketch on an unprimed wood panel, recording the view looking upstream to the bridge cause-

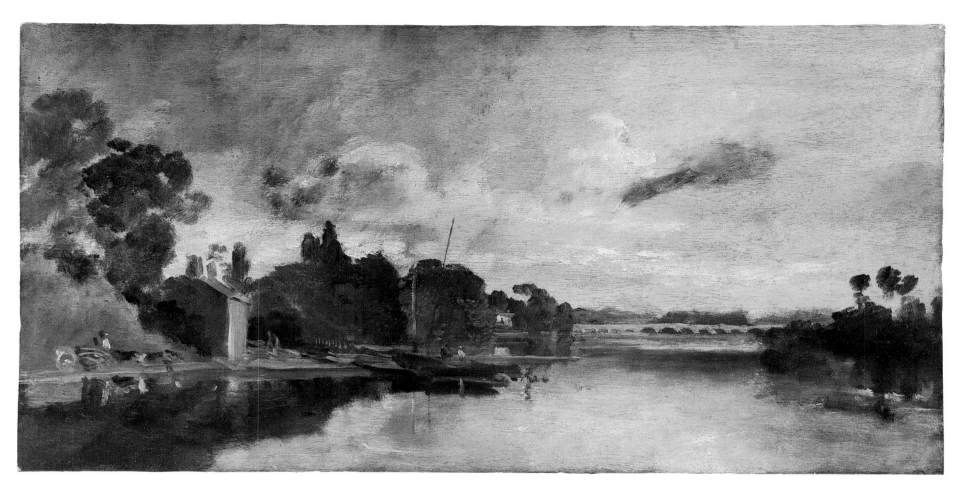

122 *The Thames near Walton Bridges*, 1805. From downstream near the eighteenth-century pub, The Swan, evening. Notice where the ochre of the bridge has blended with the still-wet green of the trees behind.

Oil on mahogany, 37.0 × 73.5 cm. Tate Gallery, London (2680).

picture, all conspire to settle the composition along the grain, to go and be one with the flow. A few verticals punctuate the repose, but serve only to emphasize the tranquillity. A solitary mast stands dark against the sky to tell us that the boat it belongs to is at rest, and that the painter is as calm as his subject in the control of the stroke with which it is made out. He could have relaxed still further that night in the Swan Inn, which overlooks the river from the left and was first licensed in 1770.

A companion panel in the Turner Bequest (Pl. 123) was also painted on unprimed wood and uses a similar device of an isolated vertical to emphasize the peace of the scene. It has been given the title of *Walton Reach* and, while there is no denying the similarity of composition and subject-matter to the panel of *Walton Bridges*, there is nothing in it to confirm the identification and a better title would be *A Scene on the Thames, perhaps near Walton Bridges*. This might

seem like mere pedantry but the distinction is important, for the picture is unusual in having no obvious landmark. The remaining oil sketches on panel are similarly unidentifiable. A panoramic sketch of *Tree Tops and Sky* (Pl. 124) has been identified as Guildford Castle,[78] but this diverts attention from the fact that the principal subject is the sky and Turner paid so little attention to the castle as to make it virtually unrecognizable. Another small panel shows *A Narrow Valley* (Pl. 125) and comparison with *Godalming from the South* (Pl. 102) suggests a similar location, but nevertheless the subject remains no more than a few rooftops, a green field, some trees in the blue distance, and the sky. Of the others, one shows *A Ford* (Pl. 126) which might be a view on the Wey, perhaps of St Catherine's; another shows a view assumed to be *The Thames near Windsor* (Pl. 127), but there is in fact no sign of Windsor. The subjects are simple, consisting of sky, water, trees on the bank, a cart splashing over

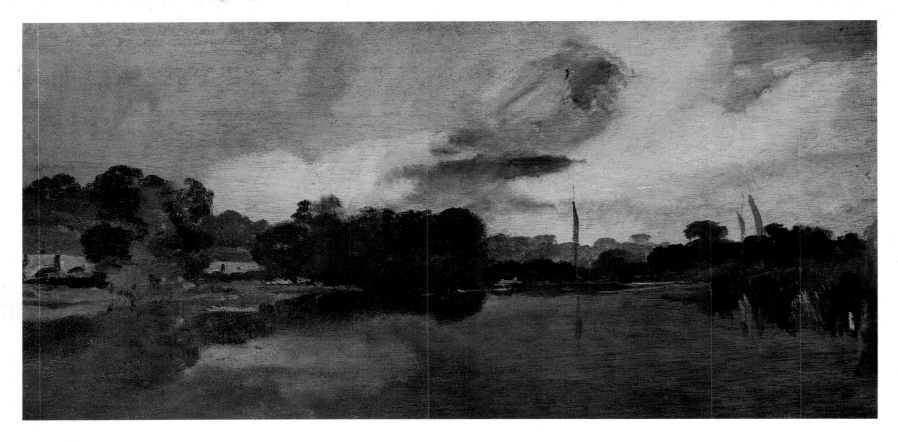

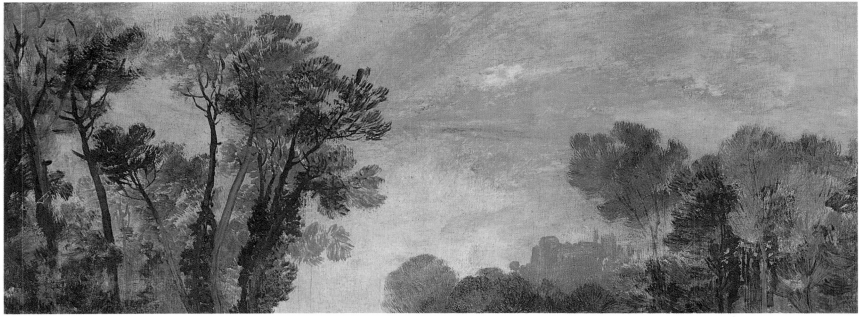

88

PREVIOUS PAGES

123 TOP LEFT *Walton Reach [?]*, 1805. A large number of the oil studies on mahogany are of unidentifiable subjects.

Oil on mahogany, 37.0 × 73.5 cm. Tate Gallery, London (2681).

124 BOTTOM LEFT *Tree Tops and Sky, Guildford Castle (?) Evening*, 1805.

Oil on mahogany, 27.5 × 73.5 cm, Tate Gallery, London (2309).

125 ABOVE *A Narrow Valley*, 1805.

Oil on mahogany, 20.5 × 16.5 cm, Tate Gallery, London (2303).

126 TOP RIGHT *A Ford*, 1805.

Oil on mahogany, 37.0 × 73.5 cm, Tate Gallery, London (2679).

127 BELOW RIGHT *The Thames near Windsor [?]*, 1805.

Oil on mahogany, 18.5 × 26.0 cm, Tate Gallery, London (2305).

LEFT Detail from Pl. 122.

a ford, a solitary figure in white walking on the river-bank, as if Turner was attempting to get away from well-known tourist spots. He even endeavoured in one panel (Pl. 128) to ignore one of the most important sites on the whole river. There is enough visible at the left to identify the chimneys as those of *Hampton Court Palace from the River* (cf. Pl. 135), not Eton as has previously been thought. One is tempted to wonder why he included them at all, unless it was to highlight his decision to devote his attention to the common things of which his river experience was composed. The interest of *Sunset on the River* (Pl. 129) is self-evident, concentrating his whole attention on the light left in the sky, the purpling dusk gathering in the distance, the cool river around us, red-tinged clouds above. He worked at great speed to set down the effect before it faded and as a result left his every gesture and touch visible, the paint coming to serve as a record of his elation at the sight. The final oil sketch on panel is a view *On the Thames(?)* (Pl. 130), which shows some buildings on the far side of the river, possibly those of Isleworth, but which, in any case, were certainly not painted to be recognizable. The painting is not a representation of a scene so much as a map of the act of looking, an image of the point at which the artist came into contact with the world in which he moved.

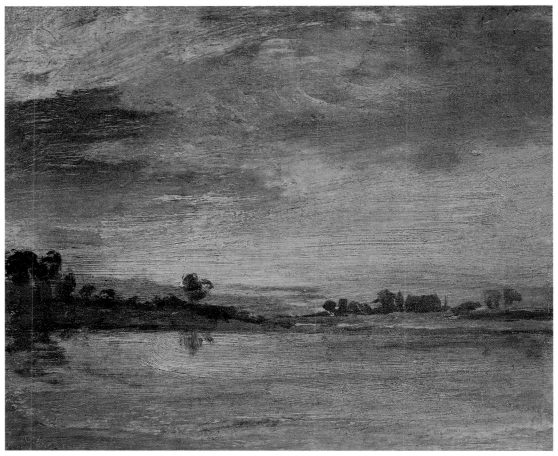

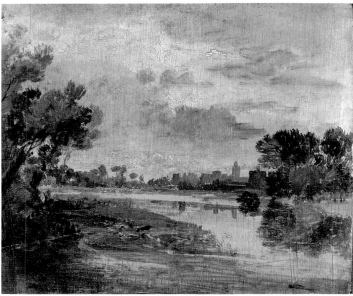

128 TOP LEFT *Hampton Court from the River*, 1805. Known as 'Eton from the river', but the subject was never intended to be recognisible.

Oil on mahogany, 37.0 × 66.5 cm, Tate Gallery, London (2313).

129 TOP RIGHT *Sunset on the River*, 1805.

Oil on mahogany, 15.5 × 18.5 cm. Tate Gallery, London (2311).

130 LEFT *On the Thames?*, 1805.

Oil on mahogany, 29.5 × 35.0 cm, Tate Gallery, London (2307).

VI The Thames from Richmond to Oxford

Richmond, Kingston, and Hampton: Oil sketches on canvas. Fine weather.
Nature's paintbrush. Harvesters at Kingston. Reflections at Hampton.

From the small panels Turner's oil sketching grew in both size and ambition. The Revd H. S. Trimmer, who knew Turner well at this time, recorded: 'From his boat he painted on a large canvas direct from Nature. Till you have seen these sketches you know nothing of Turner's powers. There are about two score of these large subjects, rolled up and now national property.'[79] In fact only fifteen canvases can now be identified as belonging to this group,[80] but although Trimmer might have exaggerated the number he did not exaggerate their importance and the insight they offer into Turner's process or 'powers'. All but one[81] measure about 3×4 feet and are painted on a dry chalky ground. Although they have now been laid down and framed, they were originally painted as unstretched sheets. He seems to have cut primed 6×4 feet canvases into two,[82] rolled or folded the handier-sized pieces for carrying, and then pinned them to a board as required. The series represents his first sustained effort at painting direct from nature in oils on canvas, and the choice of scale and material suggests that he had ambitions beyond merely sketching, perhaps of developing the canvases into finished pictures.

Of the fifteen, two show Thames estuary scenes and a third shows Margate.[83] Eight can be positively identified as scenes on the Thames upstream of Richmond, and four are unidentified, but seem likely to have been painted in the same area. The identifiable subjects in order of sailing up-river are Richmond, Kingston, Hampton Court, Windsor, Cliveden, Reading, Goring, and Dorchester, showing that Turner made a tour from Richmond to the vicinity of Oxford. Exactly the same topographical range is found in the *Thames from Reading to Walton* sketchbook, and the closeness of the relationship between individual sketches and paintings, for example, between views of *Goring Mill and Church* (Pl. 155, 157) and *Willows beside a Stream* (Pl. 171), suggests that they were made on the same visit to the sites. The oil sketches on canvas, being painted quite thinly in bright, often transparent colour on a white ground, bear close comparison with the watercolours in the *Thames from Reading to Walton* sketchbook, and it seems an irresistible

conclusion that the sketchbook and canvases were in use on the same tour.

The *Thames from Reading to Walton* sketchbook measures approximately 10×15 inches and was originally bound in marbled paper covers so that it could be rolled up for carrying. We can tell from its size that Turner intended to invest time and care in filling it, and that he attached some importance to the work it was to contain. He had already travelled up the Thames to Windsor, and knew the upper reaches around Abingdon from his youth, but this is the first time that he followed the actual course of the river. The title was not one of Turner's best. In fact its sketches divide into two groups, those made around Isleworth and those made up-river, which begin at Cliveden and continue upstream to Dorchester. The only identifiable subject between Richmond and Cliveden is Walton bridges. The oil sketches are more evenly spaced along the river, but his selection of subjects is nevertheless erratic. There are no detailed drawings of Kingston Bridge, which was picturesquely dilapidated at this time, none of Garrick's house and temple at Hampton, none of Chertsey Bridge, Staines, Maidenhead, Cookham, Wargrave, Sonning, Mapledurham, or Whitchurch. There is one grand house, Park Place at Henley, and the remains of another, Cliveden, but there is no sign of any of the dozens of other houses which lined the route. We have to conclude that Turner pleased himself where he stopped, what he sketched, or how long he took, and had no sort of brief or itinerary to follow. His pace is slow and relaxed, his subjects quiet and simple, his attitude of easygoing, sunny-afternoon contentment.

Many of the canvases and *Thames from Reading to Walton* sketches are the result of a good few hours' work, and Turner seems to have enjoyed a settled spell of weather in which to make them. The smaller oil panels and earlier sketches in watercolour show that the weather was then predominantly breezy and showery, as was reported in the press for July and August. It is hard to imagine that Turner would have been very keen on the idea of wrestling with large sheets of canvas in a small boat in such conditions. In

September and October, however, the weather improved dramatically, and from the beginning of the harvest to the end of the autumn it seems to have been almost uninterruptedly fine. On 29 August *The Times* reported on the 'louring clouds that have for some days prevailed in our atmosphere', but on 2 September it could report that the weather had recently been fine and that the harvest had been gathered 'heavy and good'. On 1 October it recorded that the season throughout September had 'continued unusually fine and favourable' and on 1 November reported the unusual fineness of October as a whole. Conditions had very much favoured the harvest, and many of Turner's sketches show harvesting taking place or the corn in the fields. This was the ideal time in which to make a lengthy and lazy painting expedition on his boat.[84]

He seems to have begun his oil sketching on shore before tackling the problems of working on the boat, since one of the canvases shows a view which can be identified as *Richmond Bridge from Downstream on the Middlesex Bank* (Pl. 131). The viewpoint is at a distance from the river, looking through a screen of trees to the bridge, with Richmond Hill in the background. It is much more a picture of trees than of anything else and a detailed drawing in the *Hesperides (2)* sketchbook (Pl. 132) shows that he was prepared to invest further time and effort in their study. It resembles those to the right of the painting closely enough to make one wonder if they are perhaps the same.

A watercolour in the *Thames from Reading to Walton* sketchbook (Pl. 133) shows a very similar subject to the oil. Although both have been painted direct from nature, a comparison of the results suggests that they were painted with rather different intent. The watercolour has been painted with such method and control as to imply that the results were meant to be seen. The colour is fresh and the paintwork is bound together by a network of painterly effects. The stabbing and dabbing of the bristles, the limited palette, the working of wet into wet, the use of thick paint and a well-loaded brush are features from which we can read the circumstances under which the picture was made. This, furthermore, is what the picture is about. The paint has not been used to describe the subject so much as the circumstances under which it is being observed. For all the variety of brushwork, we cannot tell what type of trees these are, what particular form they take, or even what time of year it is. His paint-marks were instead dictated by the circumstances, the limitations of time and resources, working direct from nature, and he allowed those circumstances to write

themselves directly onto the page. He became, in effect, nature's paintbrush.

We might describe the watercolour as a finished sketch, but the oil is rather different. None of its paintwork was ever intended to be seen. The trees to the right have not been sketched at all. Turner's scribble of paint describes little more than the space they occupied. Similarly the two main trees in the right foreground have been dashed in without much concern for the quality of the marks with which they are made out. So what was Turner attempting? It is a record of a specific place to some extent – the arrangement of actual forms – the quality of the light and colour, and he seems to have taken greater care over the bridge and the way that it stood brightly against the deep blue background. In none of this, however, is there any suggestion that these passages were developed for any pictorial interest in their own right. If these marks were not meant to be seen, then they were made to be covered up. Turner was laying in the groundwork for a picture to be finished later, but one in which nature herself had laid in the underpainting.

131 *The Thames glimpsed between Trees, possibly at Kew Bridge*, 1805. The bridge seems to be Richmond as seen from downstream on the Middlesex bank. The first of a series of large oil sketches on canvas, probably intended as beginnings from nature that could be worked up in the studio into an exhibitable condition.

Oil on canvas, 91.0 × 121.5 cm, Tate Gallery, London (5519).

133 RIGHT Richmond Bridge,
1805.

Pencil, 25.7 × 36.5 cm, 'Thames from Reading to
Walton' sketchbook, Tate Gallery, London,
TB XCV 46.

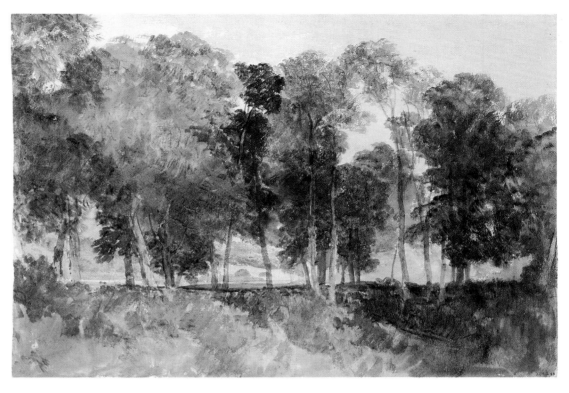

132 BELOW Study of trees, 1805.
Possibly the same trees as seen in
Pl. 131.

Pencil, 14.6 × 22.9 cm, 'Hesperides (2)'
sketchbook, Tate Gallery, London, TB XCIV 1a-2.

Sailing up-river from Isleworth, the first site at which Turner stopped to work was Kingston, where he made an oil sketch of figures on the river-bank (Pl. 134). He later developed the composition into a finished picture (Pl. 200) and identified the subject as *Harvest Dinner, Kingston Bank*. The sketch was dashed out on a half-sized canvas in no more than a few minutes' work. It is in many respects the nearest an artist at the beginning of the nineteenth century could come to a snapshot. Turner usually made quick pencil sketches under these circumstances, and it is interesting that he even attempted this subject in paint. From the low viewpoint we can tell that it was made from the boat, and perhaps he had moored for his dinner when these farmhands came down to the riverside. The woman to the left has her back to us, the man crouched on the ground is intent on his drinking, but one figure is standing, as it were on guard for his companions. Turner was so close that he could not have painted for long without being noticed and the slightness of the sketch would suggest that perhaps he made it surreptitiously.

The next subject upstream is *Hampton Court from the Thames* (Pls. 135, 136), and this time he took a more leisurely

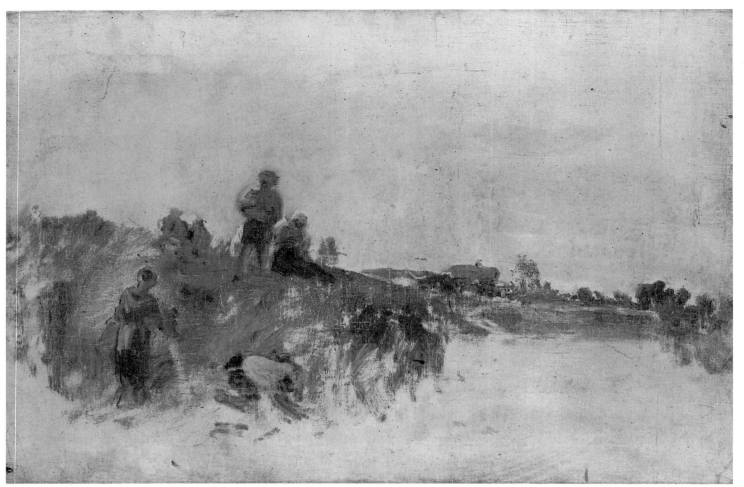

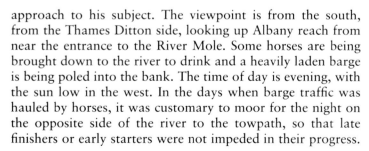

134 LEFT *Sketch for 'Harvest Dinner, Kingston Bank'*, 1805. Has the appearance of being sketched in great haste. Turner showed considerable concern for the lives of those working on the river and on its bank. Used as the basis of a painting, Pl. 200.

Oil on canvas, 61.0 × 91.5 cm, Tate Gallery, London (2696).

135 ABOVE Hampton Court, evening. From the Thames Ditton bank.

Photograph, the author.

approach to his subject. The viewpoint is from the south, from the Thames Ditton side, looking up Albany reach from near the entrance to the River Mole. Some horses are being brought down to the river to drink and a heavily laden barge is being poled into the bank. The time of day is evening, with the sun low in the west. In the days when barge traffic was hauled by horses, it was customary to moor for the night on the opposite side of the river to the towpath, so that late finishers or early starters were not impeded in their progress.

Turner's spot adjacent to Ditton fields would have been an ideal overnight mooring, with the towpath on the opposite bank and the Albany pub just a short walk downstream along the riverbank.[85] He spent the evening dedicating considerable attention to the forms and colour of the reflections. He was already one of the leading experts in the depiction of water but, as always, he was willing to look at nature afresh and study attentively, being modest enough in his practice to assume that his knowledge could always be improved.

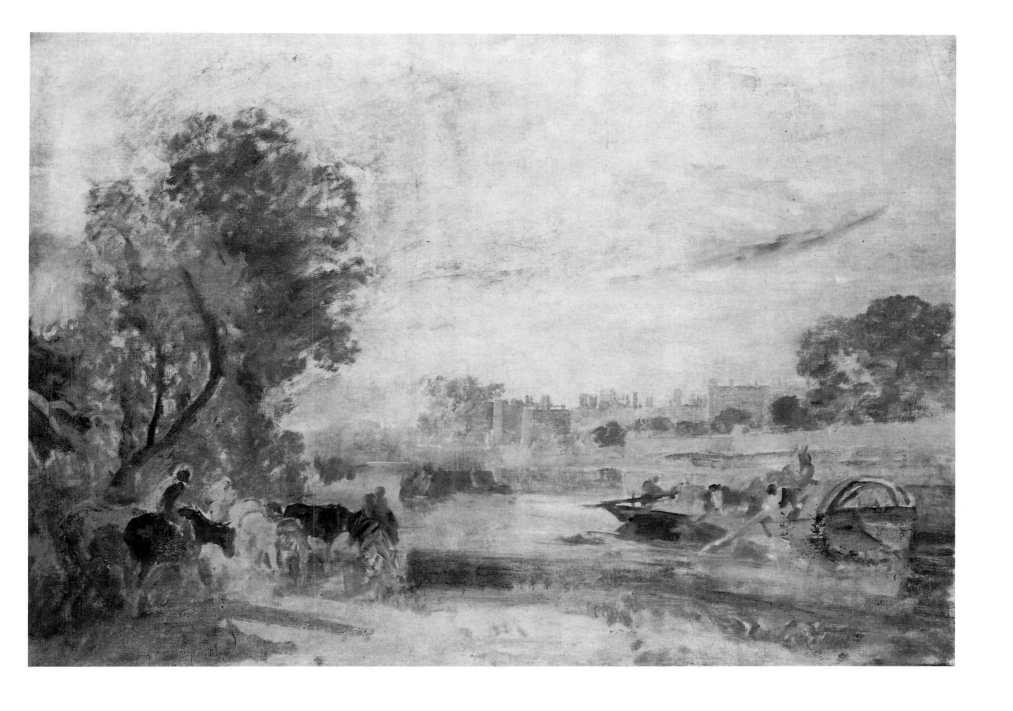

136 *Hampton Court from the Thames*, 1805.

Oil on canvas, 86.0 × 120.0 cm, Tate Gallery, London (2693).

Windsor to Reading: Times of day. More fishing than painting. Camping at Cliveden. Marlow. Henley. Park Place. Shiplake. Caversham Bridge and Reading.

After Hampton his next identifiable stop was at Windsor. He moored upstream of the town, near Clewer, and settled down to record the view across the meadows to the castle in a leisurely oil sketch on canvas (Pl. 137). It was evening, as we can see from the shadows cast by the horses to the left, and the river dusky and calm. Although the attraction of sketching under conditions such as these are obvious enough, so many of his sketches show evening scenes[86] as to lead one to suspect that painting was not the principal reason for his being on the river, since most of his days seem to have been occupied otherwise. His subjects are mostly places he stopped at for some other reason: to moor overnight, to wait for passage through a lock, to visit an inn, or to fish. One suspects that the main reason for the trip was not so much to paint, more to have a holiday, and he suited himself as to what he achieved and how complete or stylish were the results. Thus his painting on this occasion was more of backwater than of castle, not so much of Windsor as of his distance from it. The real point of the view was to record that Turner was off-duty.

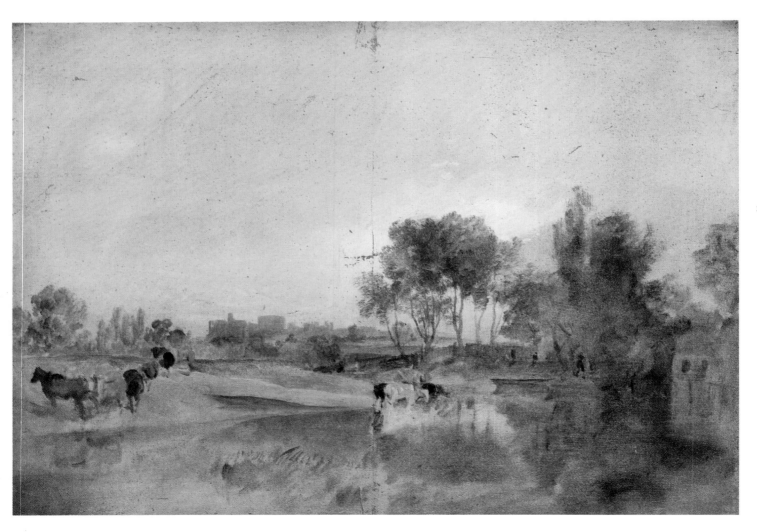

137 LEFT *A Thames Backwater with Windsor Castle in the Distance*, 1805. Taken from near Clewer. A sense of sequestration runs through many of Turner's Thames subjects of this time.

Oil on canvas, 86.5 × 121.0 cm, Tate Gallery, London (2691).

138 RIGHT *Barge on the River, Sunset*, 1805. Bargemen settling down for the night in Cliveden reach, with the remains of Cliveden House in the distance, Cliveden woods to the right, and the setting sunlight rising from the river. Compare Pl. 199 for a finished painting on the same theme.

Oil on canvas, 85.0 × 116 cm, Tate Gallery, London (2707).

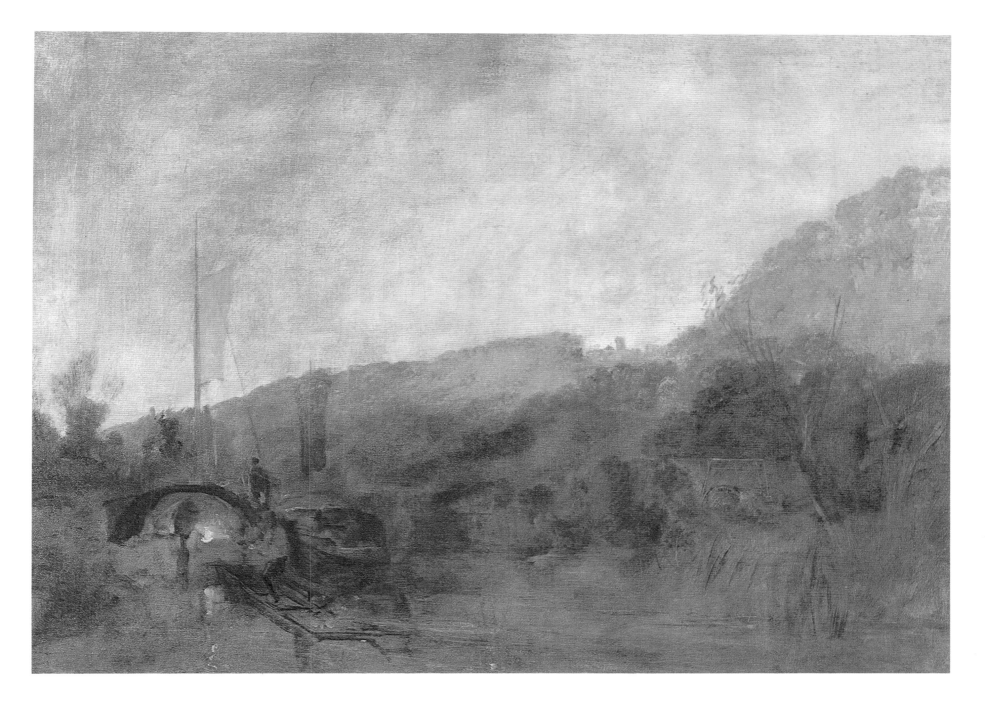

His next subject was a *Barge on the River, Sunset* (Pls 138, 139), taken from a viewpoint about a mile above Boulter's Lock, looking upstream to Cliveden as the sun lifted from the river. Two boats are moored on an island away from the main channel to the left, and two barge-men are cooking some dinner on a fire. They might have been surprised to find themselves the subject of such scrutiny, and Turner depicts one looking in his direction, as if he has just

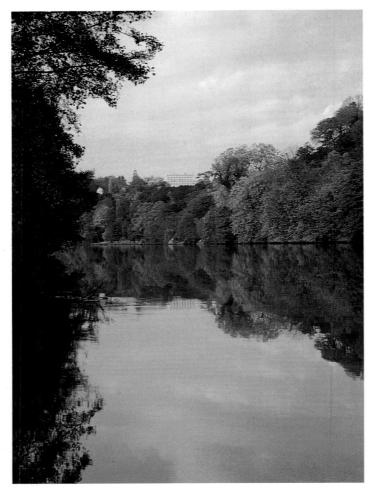

noticed that he was being observed. The fact that Turner moored beside them (or vice versa) suggests that they might have passed the evening in company. Camping out must have been quite a novelty for someone with a house in Harley Street, and the purpose of the sketch seems to have been to record the experience. It is entertaining to imagine what conversation might have passed between them. Turner had visited mountains in Wales and Scotland, walked on rivers of ice in the Alps, knew men such as William Beckford of Fonthill who were as rich as Croesus, moved in elegant society and the Royal Academy, and had dined in the presence of the King. The experience of the boatmen would have been almost equally rich. They might have crewed on ships sailing to the furthest reaches of the globe or served time in the Navy. They would know men who were serving in the war and had perhaps returned wounded or maimed. They would know of the state of trade and of the effects of the economy. They could describe their living and the conditions in their village or town. And at the end of the talk, they could settle down for sleep listening to the night lapping at the boat.

While at Cliveden he found time to leave the boat and walk up to the site of Cliveden House, the former home of the Duke of Buckingham. The house was famous for its association with James Thomson, whose 'Masque of Alfred' containing the ode 'Rule Britannia' was first performed there. Of the house, unfortunately, there was little for Turner to record, it having been destroyed in a fire in 1795. It remained, as Turner's sketch records, a melancholy wreck (Pl. 140), with its crumbling paths and balustrades, and empty windows looking out onto the river as it flowed away downstream beneath the hanging woods to Maidenhead.

Turner's next stop was at Marlow (Pl. 141), another six miles or so upstream, where his friend William Delamotte taught drawing at the Royal Military College and used some of his time there to make oil sketches of Thames valley subjects. Samuel Ireland also thought highly of the place:

[The] New Bridge, which is of wood...has been recently [i.e. in 1790] finished at an expense of about eighteen hundred pounds. It has a remarkable ascent, and forms the best object as a wooden bridge that I remember to have seen. The ballustrades are painted white, in imitation of stone-work; and the whole scenery contiguous is pleasingly variegated by the rich verdure of the adjacent woods. Below the bridge, the objects combine most happily for the pencil, where the river branches out into

139 LEFT, ABOVE Cliveden Reach, with Cliveden House in the distance, evening. The present Cliveden House was built in 1851.

Photograph, the author.

140 LEFT, BELOW View from the ruins of Cliveden House, looking downstream towards Maidenhead, 1805. The eighteenth-century Cliveden House was destroyed in a fire in 1795, and remained at this time a ruin.

Pencil, 25.7 × 36.5 cm, 'Thames from Reading to Walton' sketchbook, Tate Gallery, London, TB XCV 32.

141 OPPOSITE, ABOVE Marlow bridge and church. Most of the main features, including the church, bridge, and 'Complete Angler' were altered in the 1830's. Turner seems to have been attracted to sites offering evidence of unchanged ways and structures, however delapidated. Many of these sites were nearing the end of their days.

Photograph, the author.

142 OPPOSITE, BELOW Marlow, 1805.

Pencil, 25.7 × 36.5 cm, 'Thames from Reading to Walton' sketchbook, Tate Gallery, London, TB XCV 2.

two channels, one of which (the water being penned up by the Marlow Lock) causes a perpetual fall into the other stream, just below the bridge, which makes a pleasing though shallow cascade.[87]

Turner made three pencil sketches in the *Thames from Reading to Walton* sketchbook. His first (Pl. 142) is a similar view to Ireland's (Pl. 143), from the top of the lock looking across the weir, and although it was taken in haste he noted the details carefully, recording in the centre of the drawing that the bridge had '12' main piers. In 1835 it was replaced by the present suspension bridge a little further upstream and at the same time the little church of All Saints' was replaced. The new structures were grander affairs altogether, the bridge a particularly impressive product of the new technology. The simple structures sketched by Turner were rooted in the old world. A wooden bridge had crossed the river here since 1300 and parts of the old church had stood since St Walstan, Bishop of Worcester, celebrated Mass in the town in the year 1070. In 1805 it was a world approaching the end of its days. There is one element of the composition which is recognizable today, however, the pub at the left, then called the Angler's Rest and now the Compleat Angler hotel. He left the boat to cross the bridge and walk downstream a mile or so to make a quick sketch of the well-known view from Winter Hill,[88] looking upstream back to Marlow, with the church and bridge to the right and Bisham church tower further in the distance to the left. The final sketch (Pl. 144) took a closer look at Bisham from the river, showing the Norman tower of All Saints' with the calm river lapping at its foundations, and the Tudor mansion of Bisham Abbey beyond, founded by the Knights Templars. Much of this remains unchanged to this day.

His next stop was at Henley (Pl. 145), eight miles further or, where he sketched the approaches from Temple Island looking along the river to the bridge and church with Remenham to the left (Pl. 146). The temple was a James Wyatt design, built in 1771 as an eye-catcher for Fawley Court, but Turner does not seem to have been interested in recording its details very carefully. This stretch of river is now famous as the course of Henley Regatta, a straight mile from the starting-line at the temple to the bridge, but in 1805 such things had not yet been imagined. His sketch from Remenham Hill (Pl. 147) shows the deeply worn road from Maidenhead making its way down the hill to the bridge, with the sixteenth-century tower of St Mary's church beyond, and the thirteenth-century Angel on the Bridge to the left. The whole town consists of Hart Street beyond

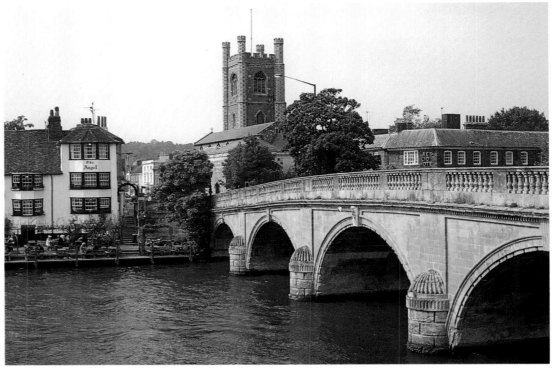

143 TOP LEFT Samuel Ireland, *Marlow*, 1792.

Etching and aquatint, from 'Picturesque Views on the River Thames'.

144 BELOW, LEFT Bisham Church and Abbey, 1805. The Norman tower of All Saints and the Tudor mansion beyond. The site is perfectly recognisable today.

Pencil, 25.7 × 36.5 cm, 'Thames from Reading to Walton' sketchbook, Tate Gallery, London, TB XCV 5.

145 ABOVE Henley. The bridge of 1786, with St Mary's church beyond and the 13th century Angel pub to the left.

Photograph, the author.

the church and the buildings flanking the market square, and a further row of buildings along the riverside from the Angel. The whole is so small as to make us wonder what sustained it.

The sketch records the geographical reasons for Henley's development, the town's situation at an ancient river cross-ing serving as a trading and market centre, with road access to Reading, Maidenhead and Marlow, coach routes and river trade to London and Oxford. It was situated on prime agricultural land, served as a commercial centre for the large number of estates and farms in the vicinity, and had been able to attract and thrive upon the wealth that circulated

147 RIGHT Henley from the east, 1805. From Remenham Hill, looking down to the bridge and town.

Pencil, 25.7 × 36.5 cm, 'Thames from Reading to Walton' sketchbook, Tate Gallery, London, TB XCV 7.

148 FAR RIGHT Park Place, Henley, 1805. Looking over Marsh Lock and Mill, about a mile upstream of Henley.

Pencil, 25.7 × 36.5 cm, 'Thames from Reading to Walton' sketchbook, Tate Gallery, London, TB XCV 26.

149 BELOW Shiplake, 1805. Taken from just below the lock, with Cotterell's Mill by the side of the lock, the entrance to the river Loddon to the left, and the sun setting over the church of St Peter and St Paul in the distance.

Pencil, 25.7 × 36.5 cm, 'Thames from Reading to Walton' sketchbook, Tate Gallery, London, TB XCV 10.

146 LEFT Temple Island and Henley Bridge, 1805. Looking down, the present Henley regatta course, from Temple island in the foreground, Henley Bridge in the distance, and Remenham church to the left.

Pencil, 25.7 × 36.5 cm, 'Thames from Reading to Walton' sketchbook, Tate Gallery, London, TB XCV 8.

through it, hence the large church and the impressive stone bridge which had been built in 1786. The last was particularly noteworthy, since Horace Walpole had made the extravagant claim that it was 'the most beautiful in the world, next to the Ponte di Trinita [in Florence]'.[89] Travellers on the river knew to look out for its masks of the Thames facing downstream and Isis facing upstream, which had been carved by Walpole's cousin, the Hon. Mrs Damer.

Her father, General Conway, owned Park Place, a little upstream on the opposite bank, which formed the subject of another sketch (Pl. 148) as seen from the meadows beyond the town with Marsh Mill on the right. The house had been occupied by Frederick, Prince of Wales, during the middle years of the eighteenth century, but in Turner's day was better known for General Conway's later development of the grounds into an artistic and literary landscape, in conjunction with James 'Athenian' Stuart. This had involved building a number of elaborate garden ornaments, including one made from the steeple of St Bride's, Fleet Street, together with various ruins, including the Druids' Temple, made from a neolithic burial chamber discovered on Jersey in 1785, when the General was Governor, and Happy Valley, with its Ragged Arches composed of stones brought from Reading Abbey. Turner's sketch records the relationship between the grand house on its eminence, with open lawns in front and a valley leading down to the river, and the *ad hoc* jumble of mill buildings at Marsh Lock, hidden from sight of the house by a shoulder of land in between.

He finished his day by stopping three miles above Henley at Shiplake, just below the lock. Ireland thought 'Cotterell's

Mill and Lock, which objects, though humble in themselves, yet constitute a very picturesque scene, highly deserving observation'[90] and Turner's sketch (Pl. 149), shows the entrance to the River Loddon to the left and the Thames weir. In front a barge and tender are waiting to go up, while another to the right is passing through the lock next to the paper mill. On the hillside in the distance can be seen the church of St Peter and St Paul, in which Tennyson was married in 1850, and above it the sun settling into the west, scattering rays of light across the sky and shadows on the trees below it.

He devoted more time to his next stop at Reading than to any other locality on the tour. Since the hour of the day in

his sketch at Shiplake suggests that he stopped there over-night, he probably sailed the seven miles up to Caversham Bridge the next morning and after dinner spent the rest of the day in sketching and painting. His attention to the site would perhaps surprise most latter-day visitors, at least until recently, since the Berkshire side was badly despoiled by factory development and railway sidings. In 1805, however, the land between river and town was all open water-meadow and fertile flood plain. Caversham Bridge was a wonderfully delapidated arrangement of Norman and Gothic arches, brick, stone, and wooden sections, with houses clinging to it and odd bits of causeway, which had struggled and improvised their way across the river and marshes since the thirteenth century. The view over it from Caversham church towards Reading was well-known and admired in the eighteenth and early nineteeth centuries. One tourist even composed a poem to celebrate it:

THE VIEW FROM CAVERSHAM. WARREN HILL. 1781.
Whence the eye views with rapture and delight,
All that can please or charm the gladden'd sense;
A town, a rural bridge, a country rich
By yellow Ceres in abundance dress'd;
Full many a cot, and many a rural seat
Of fond tranquillity, and mutual love.
　　Beneath, thro' meadows verdant, smiling, gay,
Old silver Thames 'without o'erflowing full',
Glides gently on; and to proud London wafts
The wealthy product of each fertile shore.
　　Happy the man, who with a mind at ease,
And body firm, with upright well-pois'd limbs,
These walks and lanes can traverse; by his side
Such an instructor, and companion,
As heretofore my youth has met withall . . .
Dealing out learning and bright reasons lore;
And by his converse, flowing like the Thames,
Improve the soul, and lift it to his God.[91]

This would have been an appropriate description of Turner as he made his most detailed pencil sketch of the whole tour (Pl. 150). It shows him at his most composed and tranquil, prepared to take as long as was necessary to set down every detail of the prospect before him. His placement of the details is confident, precise, sharp, and meticulous, his sight clear and his co-ordination of head and eye effortless and accurate. He was very much a man 'with mind at ease, / And body firm' and hardly a detail, bush, tree, field, or build-ing was too trivial for his attention. At the top left is the Norman tower of St Peter's, Caversham. The river flows into

the picture at the bottom right and makes its way through the bridge, past the island beyond and away into the distance through the lock towards Sonning, Shiplake, and Henley, where he had already sailed. In the centre distance is the site of Reading Abbey, where the young Jane Austen went to school only twenty years before, and to the right the tower of St Lawrence's church, with the town, the spire of St John's, and the tower of St Mary's made out clearly. Even down to the minutiae, Turner's pencil remained sharp and crisp, and he must have sat for hours to have traced the details so carefully.

He took two further sketches, one from a viewpoint to the left of the first,[92] from near the top of the hill on the road to Wallingford, with St Peter's now to the right. Not satisfied even with this he went on to make another[93] from a viewpoint slightly more distant than the first and lower down. The clarity with which he sorted out the spacing and relationship of details in these sketches, especially in the first, is stunning, and the routes of exploration provided for the eye are endless. A camera could record such a scene in an instant, with the photographer hardly having to look at the subject at all. Sketching requires the identification and

150　ABOVE Caversham Bridge, 1805. From near St Peter's, Caversham (to the left), looking over old Caversham bridge towards Reading.

Pencil, 25.7 × 36.5 cm, 'Thames from Reading to Walton' sketchbook, Tate Gallery, London, TB XCV 1.

151　OPPOSITE, ABOVE Caversham Bridge, 1805. A detailed sketch of the ramshackle mediaeval structure.

Pencil, 25.7 × 36.5 cm, 'Thames from Reading to Walton' sketchbook, Tate Gallery, London, TB XCV 41.

152　OPPOSITE, BELOW *Caversham Bridge with Cattle in the Water*, 1805. The stare of the cattle make us aware of ourselves as intruders.

Oil on canvas, 85.5 × 116.0 cm, Tate Gallery, London (2697).

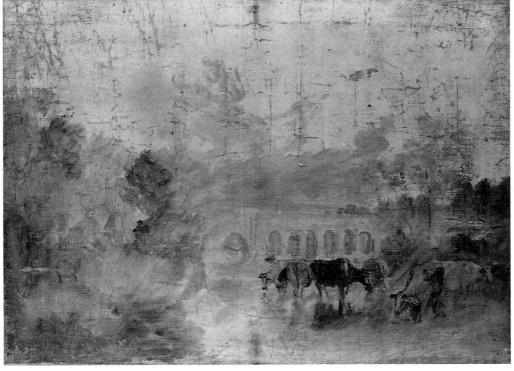

description of the features to be set down, understanding of the relationship of one part to another, and of each part to the whole. It takes time, consideration, and reflection. Each mark is a sign of having looked, understood, and examined. These sketches are not just views of the place, they are documents of contemplation and comprehension. Turner's interest was strong enough for him to spend hours pursuing it, and this is an experience which most of us would miss completely with a camera. These drawings are records of a different century's pace, and a way of relating to things which we have come to forget.

Down by the river, just upstream of the bridge, where he presumably moored his boat, he extended his interest to a close study of the details of the bridge (Pl. 151). Parts had collapsed and been rebuilt over the years and as a result just about every arch was different. He seems to have been fascinated and described each one separately, noting that the second from the left was ribbed beneath, that each was a different height and width, that the narrow spans were obviously built before technology or means had allowed more elegant or spacious arches, that the whole was in some state of delapidation, with weeds growing from the mortar, and that the piers had to be protected with guard-posts to prevent river traffic colliding with them. The arches were far too narrow to pass through, so a gap had been provided, spanned by a wooden structure, which allowed the barges to proceed. A waggon was recorded, trundling its load over the shaky structure towards Reading.

He finished his work with an oil sketch from a slightly more distant viewpoint (Pl. 152). The canvas is in a battered condition since Turner folded it in half, causing losses of paint from the top and bottom edges, and then rolled it up and squashed it, causing further losses along creases right across the surface. Nevertheless there is enough left to interest us. The time of day is evening and the westerly sun lights the face of the bridge brightly. In the distance can be seen the tower of St Lawrence's and behind the bridge an ominous cloud looms up over the horizon. In the foreground some cattle have come down to the river to drink and are standing up to their knees in the water. Cattle are regular company to anyone who spends time on the river-bank, and, as anyone who has attempted to fish or moor at a cattle drink will testify, they tend to behave as if it is their rightful domain. Turner recorded these cattle subjecting him to such scrutiny that we are made to feel that he was intruding. This was a device which he used commonly in his Thames pictures. It remainds us that he was in many ways an explorer in a foreign land.

Reading to Oxford: Pangbourne. Goring. Cleeve. Shillingford. Dorchester.
Wilows beside a stream. Abingdon. Culham. Sutton Courtenay. Return to Isleworth.

From Caversham Bridge it is six miles up to Pangbourne where Turner stopped next. He moored below the lock to sketch the view up to the mill (Pl. 153). This was one of the best fishing sites on the whole river, particularly for trout bred in the River Pang, which flows into the pool from the left. In fact the whole stretch up from Reading attracted anglers, especially to Mapledurham, just above Purley, and the Roebuck Inn, just below, where parties would dine.[94] His interest in Pangbourne was less than usually scenic. The sketch was taken from under the toll bridge of 1792, which most tourists remarked upon, and he ignored picturesque Whitchurch, which is a favourite subject with photographers today, and which was immediately to his right from this viewpoint. Nor does his mind seem to have been particularly focused even on the limited matter to hand, for although he recorded the lock gates reflected against the evening light, he found little time to include anything more. The fishing seems to have proved far more engrossing than the sketching.

He had by now sailed into a world in which nothing had ever changed very quickly. In 1805 the majority of the population still lived in rural communities and had been born in or within a few miles of the villages in which they lived.[95] Turner was a representative of a new type. Socially and geographically mobile, he was hardly ever in a place to which he properly belonged, and his art in many ways reflects the situation in which he found himself. He was constantly interested by the way people made their livings and were bound to their circumstances, and on this tour he sought sites in the Thames valley which were the product of a slow and stable rate of change. He would not find as much of this in the Thames valley now. He was exploring at the beginning of a social revolution which was to result in movement and change becoming the norm. For the time being, however, strangers would have stood out in a Thames-side village, and they would generally have arrived at a speed of no more than four miles an hour.

At Goring he made two pencil sketches and an oil sketch, which must have detained him for a full day. One of the pencil sketches (Pl. 154) shows the view looking downstream to the church framed in Goring Gap, where the Thames cut through the Chiltern chalk. At the left he traced the trees interlocking and repeating patterns of twinning and forking, and managed to suggest a succession of waves of colonization, of trees and bushes that had germinated at various times and were now at various stages of development. Grass grows at the water's edge, suggesting equability and fertility. On the opposite bank we see the results of erosion, where the thick meadow soil is slowly being carried away in chunks. Colonization and deposition on one side, erosion on the other, and the course of the river swinging lazily from one side to another: few painters understood so well the processes which shape the landscape.

The second pencil sketch (Pl. 155) recorded the view from near the lock (Pl. 156). The church was built in

153 FAR LEFT Pangbourne, 1805. From the pool below the lock, evening. Pangbourne was famous for its trout fishing. From the brevity of this sketch we can suspect where Turner's priorities lay.

Pencil, 25.7 × 36.5 cm, 'Thames from Reading to Walton' sketchbook, Tate Gallery, London, TB XCV 16.

154 LEFT Goring, 1805. A distant view looking downstream to the town commanding the passage of the river through the Goring Gap.

Pencil, 25.7 × 36.5 cm, 'Thames from Reading to Walton' sketchbook, Tate Gallery, London, TB XCV 19.

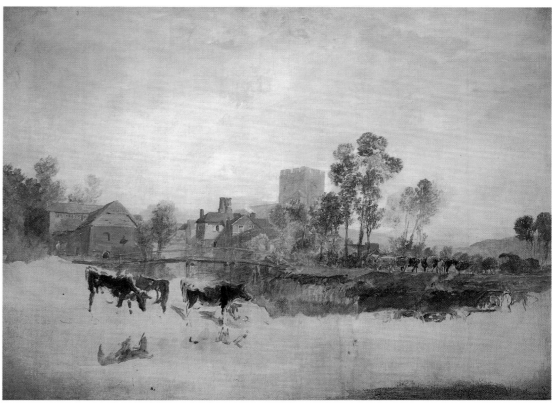

early Norman times and was dedicated to St Thomas of Canterbury when it became the priory church for a convent of Augustinian nuns. The tower is unusual in having an original, exterior stair turret at its north-west angle. He enjoyed the subject enough to make an oil sketch (Pl. 157) from a viewpoint a little further downstream. He enjoyed the full sun shining on his back and right shoulder and must have spent all afternoon about it, for the result is the most unhurried, careful, and complete of the whole series of canvases. The light warms the brick wall of the mill to the left, and a shutter is propped open to ventilate the interior. He paid close attention to its shadow, and the endlessly subtle shifts of architectural detail and form, the odd turret on the tower, the form of the old towpath bridge, the unusual chimneys, the brick infills around the timber frame,

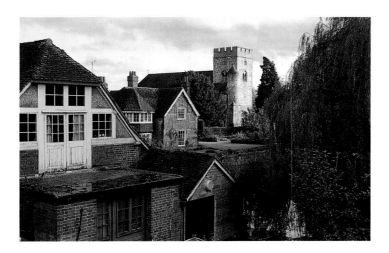

the curious little windows in the gable, the positions of the cattle or horses, the pattern of colour on their backs, and their reflections in the water. The picture is a catalogue of details more complex than could have been invented, which must have resulted from the artist having observed them in nature. Reality, Turner had been delighted to discover, is more interesting than can be imagined.

He made slow progress thereafter. He managed only half a mile before another site caught his attention. Below Cleeve Lock he stopped to record the sixteenth-century mill (Pl. 158), its quiet backwater seeming to have insulated it from time (Pl. 159). Five miles further and he sketched Wallingford Bridge (Pl. 160–61), which 'from its appearance, seems to vie with the oldest structures of the kind on the Thames...truly Gothic, and of immense strength. The pointed angular sterlings on the upper side are so well constructed, as to be capable of resisting the most violent torrent of water from the winter floods.'[96] Turner made these his subject, and the signs of its age. He seems to have delighted in the weeds growing in the mortar. Both sites survive almost unchanged. Another mile and a half brought

155 ABOVE LEFT Goring, 1805. The mill and church from below the lock.

Pencil, 25.7 × 36.5 cm, 'Thames from Reading to Walton' sketchbook, Tate Gallery, London, TB XCV 17.

156 LEFT Goring mill and church from the bridge.

Photograph, the author.

157 ABOVE Goring Mill and Church, 1805. A similar view to the sketch, Pl. 155. Turner has been engrossed in the details of the mill and church bathed in warm afternoon sunlight, and has carried this oil sketch to a greater level of detail and finish than many of the others.

Oil on canvas, 85.5 × 116 cm. Tate Gallery, London (2704).

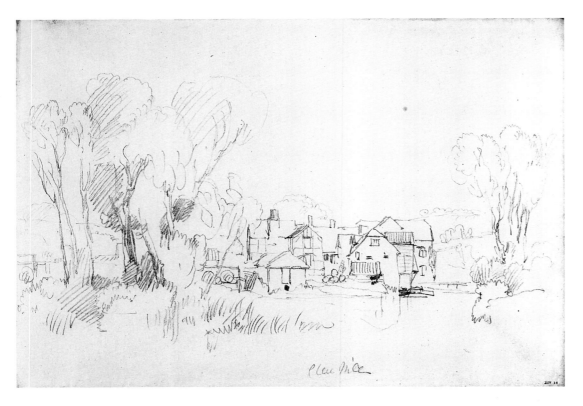

cleve mice

158 Cleeve Mill, 1805. Turner made slow progress in this part of the river, stopping frequently to make sketches, many of them careful and detailed.

Pencil, 25.7 × 36.5 cm, 'Thames from Reading to Walton' sketchbook, Tate Gallery, London, TB XCV 18.

159 Cleeve Mill from the river.

Photograph, the author.

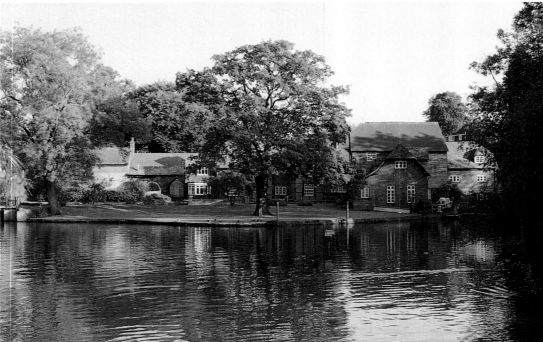

160 Wallingford Bridge and church from upstream.

Photograph, the author.

161 Wallingford, 1805. The balustrade was added in 1809.

Pencil, 25.7 × 36.5 cm, 'Thames from Reading to Walton' sketchbook, Tate Gallery, London, TB XCV 39.

162 LEFT, ABOVE Benson, 1805.
From the pool below the lock,
looking over the weirs to St Helen's
church.

Pencil, 25.7 × 36.5 cm, 'Thames from Reading to
Walton' sketchbook, Tate Gallery, London,
TB XCV 14.

163 LEFT, BELOW Samuel Ireland,
Shillingford, 1792.

Etching and aquatint, from 'Picturesque Views on
the River Thames'.

164 RIGHT, ABOVE Shillingford,
1805. Looking west towards
Dorchester, with the evening sun
over Wittenham clumps, the Bridge
Hotel in the foreground.

Pencil, 25.7 × 36.5 cm, 'Thames from Reading to
Walton' sketchbook, Tate Gallery, London,
TB XCV 40.

165 RIGHT, BELOW Shillingford,
1805. Looking east towards
Benson. The wooden bridge has
now been superseded by a stone
structure.

Pencil, 25.7 × 36.5 cm, 'Thames from Reading to
Walton' sketchbook, Tate Gallery, London,
TB XCV 30.

him to Benson and a view of St Helen's church across the weir (Pl. 162) where, as Samuel Ireland noticed, 'the gentle fall of its waters, forming a continual cascade, connects a pleasing selection of objects, highly worthy the exertions of an artist.'[97] He wound up his day at Shillingford (Pl. 163) where:

> The beauty of the scenery from the vicinity of Dorchester, greatly improves in verdure and richness. The easy sloping hills on the Berkshire side of the river are crowned with a variegated combination of Sylvan objects, while here and there a chalky break in the cliff renders the view strikingly diversified, and highly interesting . . . The light and elegant bridge of Shillingford, with the variety of carriages that are continually passing and repassing, aided by the gliding objects on the water beneath, greatly add to the natural beauty of the landscape. In this delighful retreat the skilful angler finds high gratification.[98]

It does not seem like Turner to have passed up angling in favour of sketching, but the first of his drawings at Shillingford (Pl. 164) was as time-consuming as any made on this tour. The bridge was built in 1786 and later replaced by a stone structure, but the Bridge Hotel still stands. In the distance to the right can be seen the tower of Dorchester Abbey and to the left the Iron Age hill settlements of Sinodun Hills and Wittenham Clumps, with the sun setting over them. The second sketch (Pl. 165) recorded the view in the opposite direction and, even though the day was drawing in, there was enough light for him to be able to see the tower of Benson church in the distance. Ireland described its appearance 'above a luxuriant range of yellow waving corn fields, while in the distance the background is formed from the hills of Nettlebed and the adjoining woods'[99] and Turner's sketch made a point of noting that the fields were full of corn beyond the toll house to the left.

The last of the identifiable subjects in the *Thames from Reading to Walton* sketchbook shows Dorchester Abbey (Pl. 166) taken from the shallow River Thame, near the site of the present bridge built in 1811–13, which marks the limit of navigation for small boats from the main river. It is not entirely successful as a view of the church, which under different circumstances would certainly have warranted investigation of its interior and viewpoints around the town. Dorchester is one of the most ancient Christian sites in England, founded by St Birinus in 634, and it was an important Roman and Neolithic settlement before that. The Saxon cathedral had been replaced in the early twelfth century and enlarged in about 1340, thus assuming the

general form that Turner recorded, and it had been an important Augustinian abbey. It has many outstanding features, including a magnificent Jesse window, but in Turner's sketch it remained mostly obscured by trees, and seems awkwardly shunted to the left. Nevertheless the sketch entirely captures the first impression of the church as one approaches along the river. Better views might no doubt have been obtained from elsewhere, and Turner had twenty years' experience of locating and recording them, but in this case that would have been to abandon the river.

The remaining leaves from the *Thames from Reading to Walton* sketchbook and four oil sketches remain unidentified. Some ought to be recognizable. The one of a ferry (Pl. 167), with what appears to be a Saxon church tower among the trees to the left and a bird on the wing across the water, seems to capture perfectly the spirit in which Turner was working. The same is true of the oil sketch of a *Weir and Cattle* (Pl. 168), one of the most serene of the oil sketches and fascinating in the inventiveness with which the cattle are made out. Another of a *House beside a River* (Pl. 169) gives the impression that it was perhaps of some personal interest to Turner, although the rather grander house in the background should prove identifiable.[100] The rest come into the category of unidentifiable sketches, consisting of riverside willows and stumps, except for *Washing Sheep* (Pl. 170) which is perhaps a view on the River Thame, looking towards Sinodun Hill and Wittenham Clumps, although the real subject is of the old pollard willow cantilevering itself to an unlikely degree across the river.[101] Other sketches are pervaded by a sense of decay and isolation, with gnarled and ancient stumps twisting and resprouting along backwaters. Pollard willows crack and split if not trimmed regularly and their condition in his sketches (Pl. 171)[102] suggests that they had been long neglected. It seems almost as if the way of life which had maintained them had come to an end and the river was returning to a primordial condition.

In addition to the *Thames from Reading to Walton* sketchbook and related canvases, the *Hesperides (2)* sketchbook also records a visit to the upper reaches of the river. From the back cover, which begins at 'Whittingham' (i.e. Wittenham, just above Dorchester), a series of eleven sketches records subjects at Abingdon (Pl. 172), Culham, Sutton Courtenay, and Clifton,[103] as well as cattle standing in the water and willows overhanging backwaters.[104] Although they continue the itinerary and subjects of the larger sketchbook and canvases the style is wholly different, pen and ink or pencil on toned paper, and in some cases brief to the point of unintelligibility.[105] Their disengagement suggests

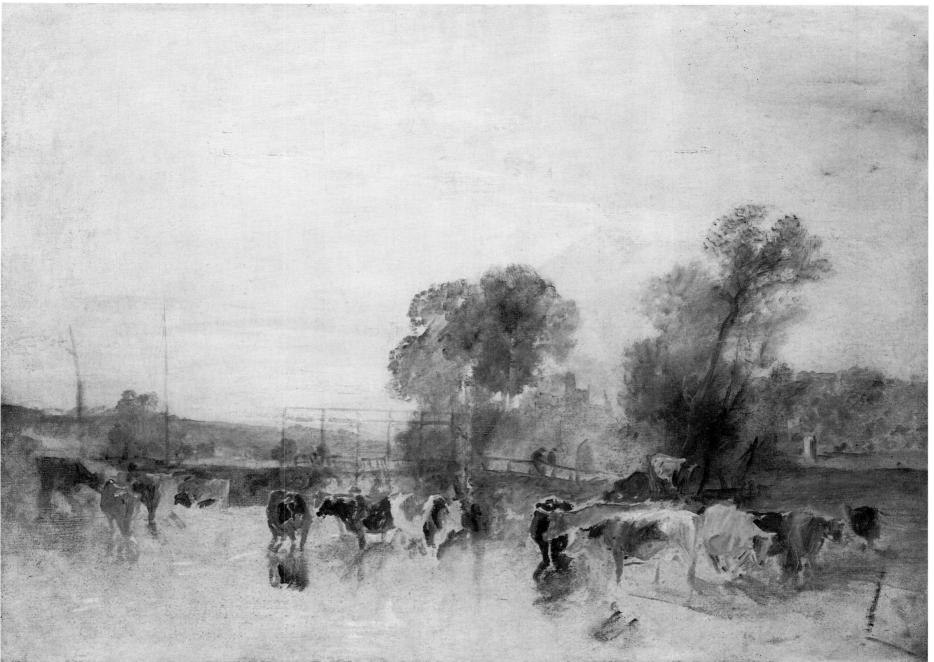

166 OPPOSITE, ABOVE Dorchester, 1805. The Abbey church from the river Thames.

Pencil, 25.7 × 36.5 cm, 'Thames from Reading to Walton' sketchbook, Tate Gallery, London, TB XCV 29.

167 OPPOSITE, BELOW Punt crossing river, 1805. The Saxon church tower to the left might prove identifiable.

Pencil, 25.7 × 36.5 cm, 'Thames from Reading to Walton' sketchbook, Tate Gallery, London, TB XCV 15.

168 ABOVE *Weir and Cattle*, 1805.

Oil on canvas, 88.0 × 120.0 cm, Tate Gallery, London (2705).

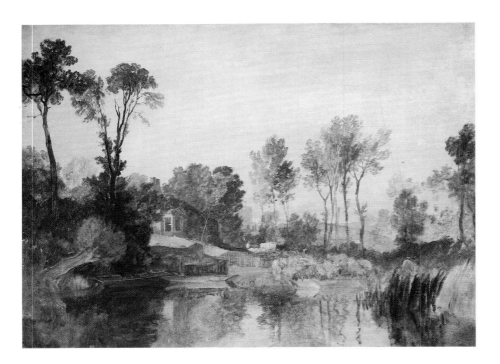

169 LEFT *House beside the River, with Trees and Sheep*, 1805.

Oil on canvas, 90.5 × 116.5 cm, Tate Gallery, London (2694).

170 BELOW LEFT *Washing Sheep*, 1805. Perhaps a view on the River Thames, near Dorchester, looking towards Wittenham clumps in the distance.

Oil on canvas, 84.5 × 116.5 cm, Tate Gallery, London (2699).

171 BELOW RIGHT *Willows beside a Stream*, 1805.

Oil on canvas, 86.0 × 116.5 cm, Tate Gallery, London (2706).

172 OPPOSITE, ABOVE LEFT Abingdon Bridge and church, 1805. A view from the mill island, looking at the back of the Nag's Head pub on the bridge, with the spire of St Helen's church beyond. Used as the basis of a finished picture, Pl. 194.

Pen and ink, 14.6 × 22.9 cm, 'Hesperides (2)' sketchbook, Tate Gallery, London, TB XCIV 41-40a.

173 OPPOSITE, ABOVE RIGHT Oxford: Christ Church from the River, 1805. An evening study of the view recorded for the 'Oxford Almanack', Pl. 26.

Watercolour, 26.1 × 41.1 cm, Tate Gallery, London, TB CXXI G.

174 OPPOSITE, BELOW Christ Church, Oxford. South range from the Memorial Garden.

Photograph, the author.

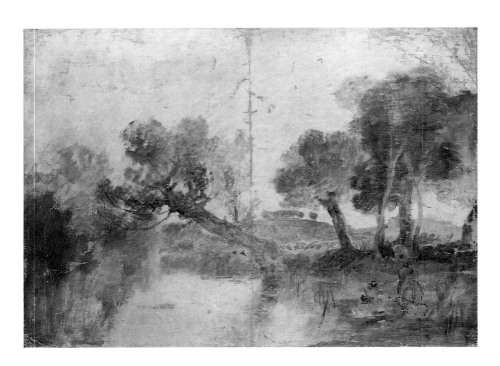

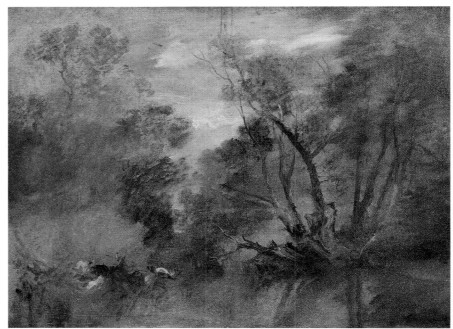

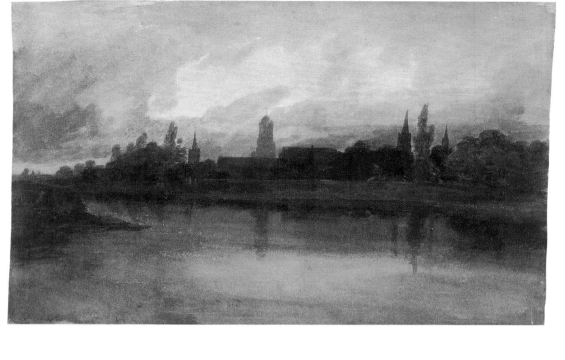

that the tour was at an end, and having reached Oxford, as indicated by a loose watercolour in the Turner Bequest (Pls 173, 174), these sketches record only a cursory inspection of the remaining sites in the upper reaches of the river before heading downstream for home.

VII London and the Estuary

The port of London and a voyage to the Nore.
Knowledge of sailing. News of the war.
The *Victory* returns from Trafalgar.

Turner stayed on at Syon Ferry House through the autumn until at least the end of the year,[106] going up to London as business required. The last expedition recorded in the Isleworth sketchbooks shows that he completed his survey of the Thames by sailing down to the Pool of London and the Estuary.[107] He took the *Hesperides (1)* sketchbook with him and a note inside the cover records that his kit also included 'Varnish / Razor / Blue Black / Bt Sienna / Fishing Rod Flies / Pallet Knife / Shoes'. He seems to have made much more use of the fishing-rod and flies than the burnt sienna or palette-knife on the way downstream, for his first sketch (Pl. 175, below) was taken from the end of Billingsgate, showing the north end of London Bridge, with St Magnus and the Monument to the right. He might even have slept on the boat, for the sun had just risen and was catching the tops of the church spires while the river below was still in shade. Masts and sails jostled around the quay and numerous figures were busy about their work, preparing and mending, loading and unloading. He used pen and ink, blue and black, burnt sienna, red, yellow, and white, a more academic palette than of late, but this was, after all, the direct successor to Claude's historical seaports, the greatest port of the modern world, and it deserved to be described in the appropriate language. Three further sketches followed, the first[108] merely a few quick strokes of pen and ink to remind himself of the architectural background, the two others[109] developing the theme with an elaborate chiaroscuro of sails and masts (Pl. 176). As at Walton, it was the poetry of the transient features, in this case boats and sails and workers, which interested him, rather than permanent features which could be recorded at any time. In between times he set down two reference drawings of a gaff-rigged ketch and a cutter (Pl. 175, above), including measurements of the sails. He even exercised his poetic eye on the arithmetic and both columns of his addition are wrong.

The boats gathered at Billingsgate came up from fishing ports along the Thames estuary and Turner seems to have been confident enough in his seamanship to hazard an

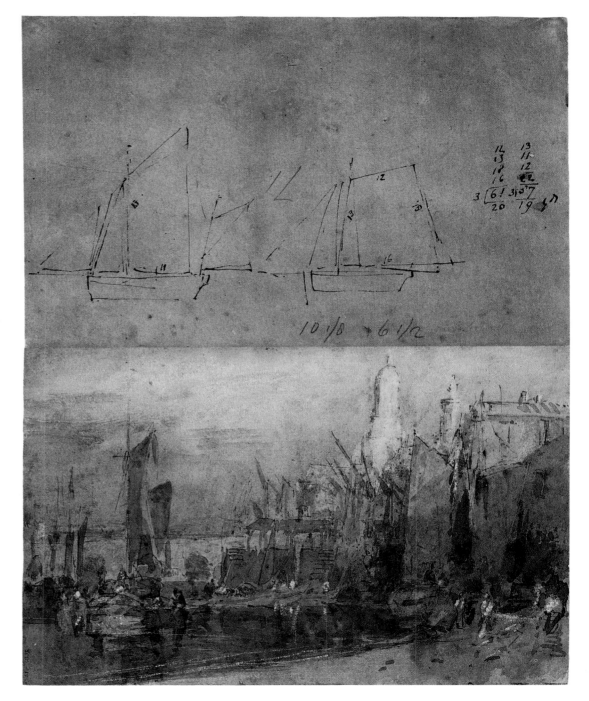

116

175 LEFT Two studies of a cutter (above) and London Bridge (below), 1805. In the arithmetic Turner is evidently trying to calculate the area of canvas required for each type of sail. His art is routinely founded on knowledge of the things he is depicting. In this case, unfortunately, his calculations are flawed by small errors in the addition.

Pen and ink and watercolour, 17.1 × 26.4 cm, 'Hesperides (1)' sketchbook, Tate Gallery, London, TB XCIII 41a-12.

176 ABOVE RIGHT St Dunstan and Custom House, 1805.

Pen and ink and wash, 17.1 × 26.4 cm, 'Hesperides (1)' sketchbook, Tate Gallery, London, TB XCIII 15.

177 BELOW RIGHT Shipping in the estuary, 1805. Turner often uses his knowledge of sailing to construct pictures of disasters about to happen. The crew of the small boat in the foreground justifiably regard the approaching cutter with some apprehension. Compare the finished picture, Pl. 201.

Pen and ink and wash, 17.1 × 26.4 cm, 'Hesperides (1)' sketchbook, Tate Gallery, London, TB XCIII 41.

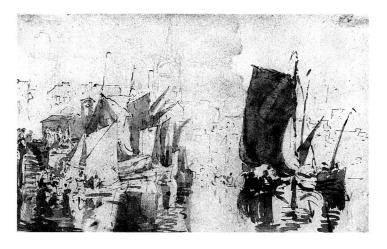

expedition out to the Nore to see them at work. Conditions seem to have been somewhat fresh and three lively sketches[110] show strong winds, dark showers, and the sea running a heavy swell. The first (Pl. 177) is the most elaborate and shows the guard ship at the Nore, the point at which the Thames meets the open sea, with Sheerness in the background and a bank of cloud spreading over the sky towards the rising sun. In the foreground a cutter is sailing broadside to a fierce breeze under full canvas and is attempting to thread its way at top speed between two small fishing boats. The one on the left is bobbing up and down with its sail down and its crew regard the approaching vessel with some alarm. The one on the right has performed an emergency stop by loosening its sail to empty it of wind. Meanwhile the cutter charges on remorselessly, and the small boats must take their chances in attempting to avoid it. The sketch is a complex construction and includes some marvellous effects of back-lighting, the sun catching the wave-tops and the translucence of the cutter's mainsail. It represents a sustained effort and a truly remarkable achievement if it was made bobbing up and down in the middle of the Thames estuary. We should bear in mind, however, that Turner could not have registered this situation all at once. His ability to draw this scene was dependent on his knowledge of these boats and their behaviour. We saw him adding to this knowledge in studies of boats in the Pool; few painters except marine specialists can have had so much knowledge of seamanship as Turner or made such dramatic use of it. He devises situations which can only be appreciated by someone with this knowledge. In this case we can see the danger only because of our knowledge and by using it we can imagine how the situation could be handled and the

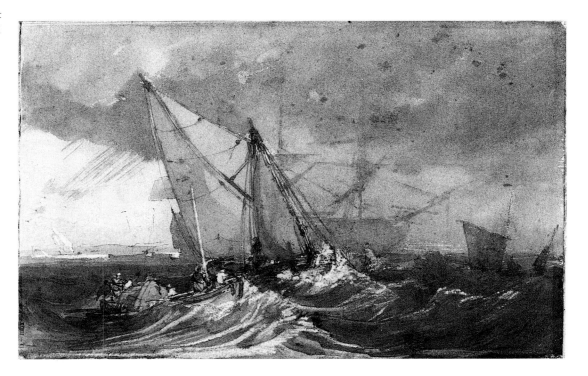

danger avoided. He was proud of having acquired it himself, and was demonstrating that his audience would be rewarded for acquiring it too. Acquisition in this case seems at the very least to have cost him a thorough soaking, to judge from the stains in the sketchbook. His spare shoes would have been welcome, if he managed to keep them dry.

It is almost as if Turner was waking up after his summer slumbers. London returned him to the present, and the estuary to matters of urgent consequence. While he was hiding away upstream, major events were unfolding on the world stage. In July, when Turner moved to Isleworth, he left Napoleon with an estimated 150,000 troops poised at Boulogne. The French Navy was engaged in diversionary action in the Caribbean, hoping to draw the English fleet away from the Channel to allow the invading armada free passage. The threat of invasion receded a little during the summer, when Britain secured an alliance with Austria and Russia, and the French Army was called away to fight in the east. On 20 October it devastated the Austrians at Ulm; when news of the disaster broke in London on the 29th it seemed as if nothing now remained to prevent Napoleon from conquering all Europe. *The Times* published an extra-ordinary edition on Sunday 3 November to emphasize the gravity of the news. Within a day of Ulm, however, Lord

Nelson defeated the French fleet at Trafalgar and by securing command of the seas ensured Britain's safety from invasion. When the news reached home at the end of the first week in November there was general euphoria. Special gazettes were issued. The papers devoted themselves for weeks afterwards to eyewitness accounts of the battle and Nelson's heroic death, and a feast day and thanksgiving was proclaimed for 5 December. The *Victory* limped into Portsmouth on 4 December and arrangements were made for a funeral appropriate to the nation's saviour. The ship was refitted to carry Nelson's body in state up to London and it anchored off Sheerness three days before Christmas.

Turner was there to see it and filled a sketchbook[111] with views, measurements, and details of the ship from every angle, together with studies of the uniforms, portraits of the key figures, and journalistic notes of the story as told by the crew (Pl. 178). As he pieced together his record he worked out a daring composition, visualizing the battle at its very height, from a viewpoint right in the thick of the action on the starboard mizzen shrouds of the *Victory* (Pl. 179). He must have set about his canvas immediately, for he managed to complete enough to consider it worth exhibiting at his own gallery in May. If his summer on the Thames had been a holiday, he was now back at work with a vengeance.

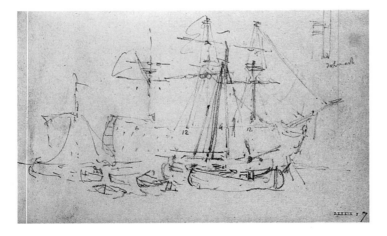

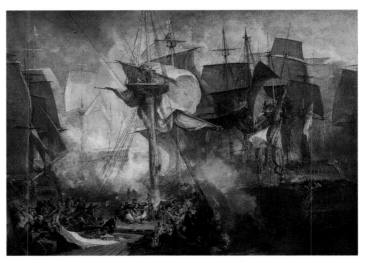

178 The *Victory*, 1805. The *Victory* returned from Trafalgar in December, and brought Nelson's body in state up to London, anchoring off Sheerness three days before Christmas. Turner went out to make sketches and to hear eyewitness accounts of Trafalgar from the sailors.

Pencil, 11.3 × 17.8 cm, 'Nelson' sketchbook, Tate Gallery, London, TB LXXXIX 7.

179 *The Battle of Trafalgar, as seen from the Mizen Starboard Shrouds of the Victory*, 1806. Turner must have worked particularly hard on this major picture through the new year, to have completed it in time for exhibition in his gallery in the spring.

Oil on canvas, 171.0 × 239.0 cm, Tate Gallery, London (480).

III RIVER OF TIME
Studio Pictures and Later Work

I Splashing to Paradise

Significance of Isleworth studies in later work. Preparations for exhibitions.
Discord in the Garden. The ideal Thames. Origins of the *Liber Studiorum*.
Richmond, Walton and Windsor. The competing claims of nature and art.

Turner's Isleworth sketchbooks and oil sketches formed the basis of finished works for years to come. Some were exhibited soon after their inception but many not for several years. Given the range and number of ideas that he laid down it is not surprising that he returned to them over a considerable period of time. This work, furthermore, cemented a relationship with the Thames which was to influence his work throughout the remainder of his career. He returned to the same sites and the same viewpoints at various times to measure their changes and development, and in the process he measured changes in himself and his attitudes.

During the autumn of 1805 he had to give some thought to which pictures he would work up for the forthcoming exhibitions. Having shown a series of epic canvases in recent years he had a reputation to consolidate and a high set of expectations to fulfil. The Thames subjects were set aside for the time being while he worked on a large canvas of the *Fall of the Rhine at Schaffhausen* for the Royal Academy[1] and on two classical subjects which he had conceived during the summer, *Dido and Aeneas* (Pl. 180) and *The Goddess of Discord in the Garden of the Hesperides* (Pl. 181). He had a pressing need for at least one major new work, for the newly established British Institution was to hold its first exhibition the following February, which promised to be one of the most important and glittering collections of modern British art for years. Lists of proposed exhibits were required in November and pictures were to be submitted in January. In deciding upon his submission we can be sure that Turner intended to make a major statement.

He had been thinking about a classical subject when he moved into Ferry House, for the very first pages of the *Studies for Pictures Isleworth* sketchbook show him drafting ideas for a composition of Claudian grandeur. He had jotted down possibilities for compositions including Pompey and Cornelia, Brutus and Portia, and Antony and Cleopatra, and conceived *Dido and Aeneas* at Richmond amid dreams of its shores crowded with classical buildings and a trireme sailing up to berth by the bridge (Pl. 68–9). Between sketching the riverside and the view from the hill he set down a colour study (Pl. 71) in which all the essentials of the finished composition were established. Having set to work in the studio, he sorted out his figure compositions in a number of studies in the *Hesperides (1)* sketchbook,[2] and set his picture (Pl. 180) at the point of the story in Virgil's *Aeneid* where Dido, stricken with love for Aeneas, has resolved to forsake her fidelity to her late husband Sychaeus. The gods agree to connive at the union of Dido and Aeneas by arranging for them to shelter in a cave during a hunt:

Meanwhile Aurora arose and left the ocean. When her rays appeared, a select company issued from the city gates. Out came the wide-meshed nets, the small stop-nets, and the hunting spears with their broad iron heads; and out dashed Massylian riders, and a pack of keen-scented hounds . . . At last she came, stepping forth with a numerous suite around her and clad in a Sidonian mantle with an embroidered hem. Golden was her quiver and the clasp which knotted her hair, and golden was the brooch which fastened the purple tunic at her neck. Up came the Trojan party too . . . As the two processions met, Aeneas,

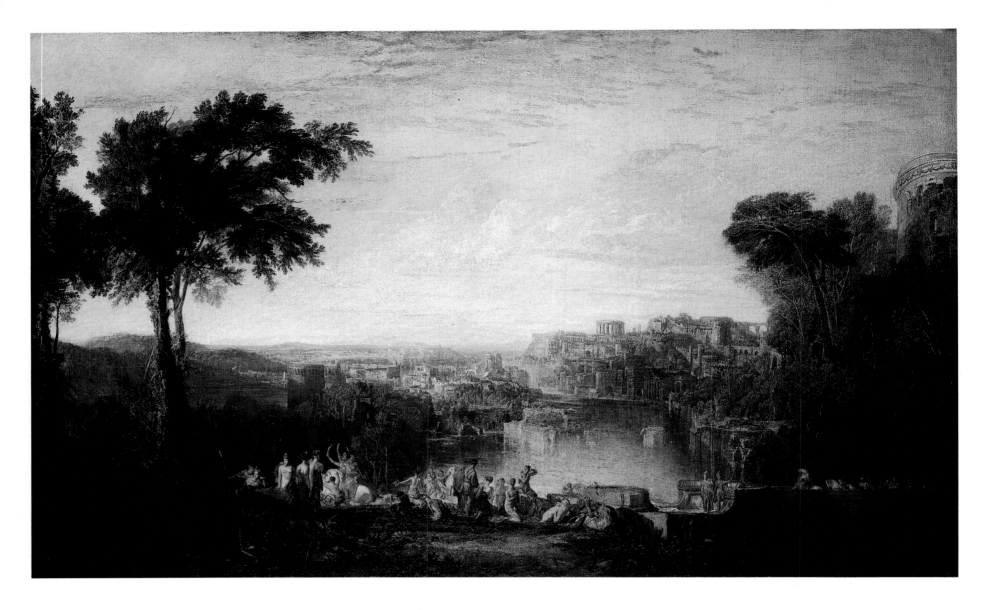

by far the most handsome of them all, passed across to Dido's side. He was like Apollo...with his clattering bow and arrows slung from his shoulder and his flowing hair pressed into neatness by a soft wreath of leaves and held by a band of gold. Aeneas walked as alertly as he; and grace like Apollo's shone from his noble face.[3]

Turner paid close attention to the text. He paid particular attention to Virgil's descriptions of his characters' dress and made a visual connection between Aeneas and Apollo by painting him as the Belvedere Apollo, a cast of which he had studied in the plaster collection of the Royal Academy (Pl. 182). Their painting marked the culmination of Turner's ideas for a grand classical scene which had occupied him throughout the Isleworth sketchbooks. It seems likely that he developed the painting near to completion during the autumn of 1805, and perhaps even considered it for submission to the British Institution. In the event a different work was chosen and *Dido and Aeneas* was exhibited elsewhere.[4]

180 *Dido and Aeneas*, exhibited 1814 (but painted 1805–6, and perhaps reworked later). The first major essay on the theme of Dido to which he returned regularly up to the end of his career.

Oil on canvas, 146.0 × 237.0 cm, Tate Gallery, London (494). (OPPOSITE PAGE, ABOVE RIGHT: detail of Aeneas.)

120

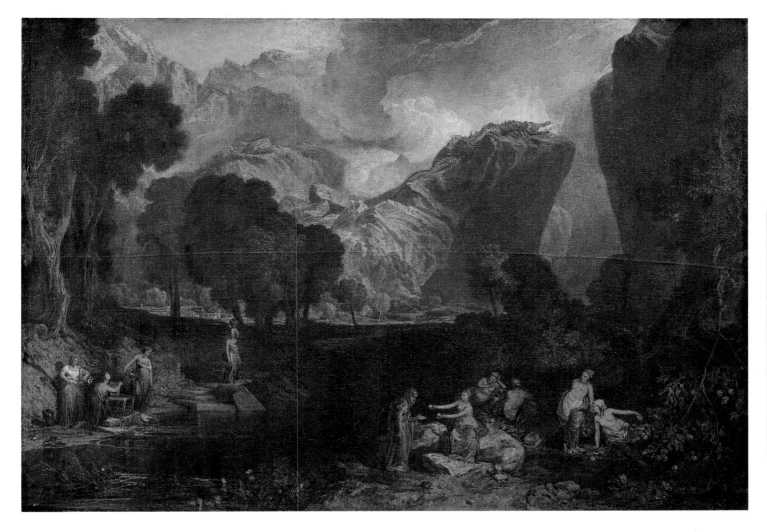

The subject sent to the British Institution was *The Goddess of Discord choosing the Apple of Contention in the Garden of the Hesperides* (Pl. 181), which he worked out in the *Hesperides (1)* sketchbook alongside *Dido and Aeneas*.[5] It is worth considering what he might have seen reflected in this subject.[6] The very exhibition for which the pictures was painted was the product of discord and contention. Turner had worked hard to win a place in the world of art, and, for someone with his background, election as a Royal Academician was a truly formidable achievement. It must have dismayed him, then, that almost as soon as he had won a place in this society it threatened to fall apart around him. During his time on the governing body the Academy was riven by internal politics and on 4 June 1805, about the

time he took up residence at Isleworth, a rival organization appeared. The British Institution for Promoting the Fine Arts in the United Kingdom was founded by Thomas Bernard to foster a new British school. Bernard claimed that the Government intended to give £3000 a year to buy works by British artists as the basis of a projected National Gallery, and that the Institution would be able to raise a further £1000.[7] On 21 July the President of the Royal Academy, Benjamin West, confided to Joseph Farington his 'disgust at the state of the Academy and said he looked to the *new Institution* for everything, and that the Royal Academy would be left a mere drawing school'.[8] By November a plot was hatched to oust West and his letter of resignation was read to the General Assembly on 2 December. James Wyatt was elected

181 ABOVE LEFT *The Goddess of Discord Choosing The Apple of Contention in The Garden of The Hesperides*, exhibited British Institution, 1806. The discord in question seems to have been that which had recently invaded the garden of art.

Oil on canvas, 155.0 × 218.5 cm, Tate Gallery, London (477).

182 ABOVE Study of the Belvedere Apollo, ?1792. An early result of Turner's studies in the plaster academy, used as the basis of the figure of Apollo in Pl. 180.

Black and white chalks, 41.9 × 26.9 cm, Tate Gallery, London, TB V D.

on the 10th. The Institution's first exhibition opened on 17 February 1806. The Directors had raised £7000 through subscription and had spent £4500 on the purchase of the Shakespeare Gallery in Pall Mall. They spent a further £800 fitting up the three main galleries like a sumptuous suite in a private mansion. There were 250 pictures and virtually the whole of the Royal Academy was represented. The exhibition was, however, the product of rivalry, factiousness, politics, jealousies, manoeuvres, plots, schemes, and deceits, and *Discord in the Garden* was a comment on the state of the world of art. In the event no one seems to have been able to see even the picture, let alone the message it contained. On 16 February Joseph Farington reported that Thomas Daniell 'had seen the pictures now arranged at the British Institution . . . the room in which the landscapes are hung is too dark, and all the pictures suffer from it . . . Turner's pictures of 'Echo' and the 'Hesperian Fruit' look like old tapestry as to general colour and effect.'[9]

One of Turner's first ideas at Isleworth was a composition based on a classical riverside temple sketched on his first expedition with the *Studies for Pictures Isleworth* sketchbook.[10] This bore fruit in a painting known as *The Thames at Weybridge* (Pl. 183). We do not know when the painting was finished or whether it was exhibited, but since it was one of his first thoughts on paper, it is possible that it was also one of the first to have been committed to canvas and might thus have been exhibited at his own gallery in 1806. In any case it seems as if he went to Ferry House in search of such a scene, and it has been contended that Isleworth was 'almost the perfect embodiment of his aesthetic requirements'.[11] There was indeed a classical pavilion just down the river from Ferry House, a waterside summerhouse in the grounds of Syon Park, which had been designed in the 1780s by Robert Mylne. This was not quite so ideal as Turner would have liked, having a rather squat form and projecting wings, and, except for its incidental appearance in more general sketches of Isleworth, he ignored it almost completely. The *Studies for Pictures Isleworth* sketches show that he found an alternative, more authentically round, which came closer to his requirements. Nevertheless reality needed manipulating to make it conform to the ideal and the initial sketches were generalized into a wash study (Pl. 33). The real Thames came close to his 'aesthetic requirements' from time to time, as at Kew (Pl. 35) or at Henley (Pl. 146), but was never so well arranged in fact as in art. *The Thames at Weybridge* pictured an ideal which the real river could only dream of. It is not an image of Weybridge or indeed of anywhere else that ever actually existed. It acquired its title

only in the 1850s[12] and the most authentic title is *Isis*, which Turner himself gave it when he published it in the *Liber Studiorum* in 1819.[13]

Turner sems to have used the word Isis to distinguish between the ideal Thames and the reality, and he was particularly interested in such matters at this time. About the time he was living at Ferry House he conceived the idea of a series of "Studies for Pictures History Mountainous Pastoral Marine and Architectural Landscape",[14] and the broad plan was to issue a series of prints in parts, each containing five plates, one illustrating each of the categories. The project was launched at his exhibition in 1807 when the first part of the *Liber Studiorum* was published. His title-page read *Liber Studiorum Illustrative of Landscape Compositions viz Historical, Mountainous, Pastoral, Marine and Architectural* and by using the word 'Studiorum' meaning 'of studies', it would seem that Turner meant us to distinguish between these works and 'finished' compositions. A study or composition was something which was incomplete, but which contained the essentials of the potential finished work, the germ, the essence, the idea, so this was to be a book of types of landscape composition, historical, mountainous, poetical, marine, or architectural, rather than depictions of real places. It was concerned with imaginative types of landscape rather than actual examples, and mezzotint, which is less capable of realizing fine detail than engraving,[15] was an appropriate choice of medium, for it is much more suited to dealing with generalities than with specifics.

In the *Liber Studiorum* Turner distinguished between pastoral subjects, such as "Bridge and Cows" or "The Straw Yard",[16] and a category referred to by the initials "E.P." He never explained his precise meaning, but a sketchbook note of about 1810 referred to "Epic" pastoral,[17] and the subjects included in the group were idealized imaginary landscapes that conformed to the type of Claude. *Isis* is a prime example of the category, as is another plate published in 1819 (Pl. 184) which featured the same temple. Although Turner did not title the plate he referred to it in sketchbook notes as "Isleworth".[18] It was recently described as showing 'Turner's own corner of Isleworth as a Claudian Idyll with the Alcove [i.e. the Pavilion summerhouse] in the foreground and the London Apprentice tavern in the left distance'.[19]

The *Liber Studiorum* developed directly out of the Isleworth sketchbooks. As we have seen, there are numerous studies in sepia wash of imaginary subjects of exactly the kind which appeared in the *Liber*. The Isleworth plate had more specific origins in a series of sketches in the *Wey Guilford* sketchbook. At first sight we see a series of what

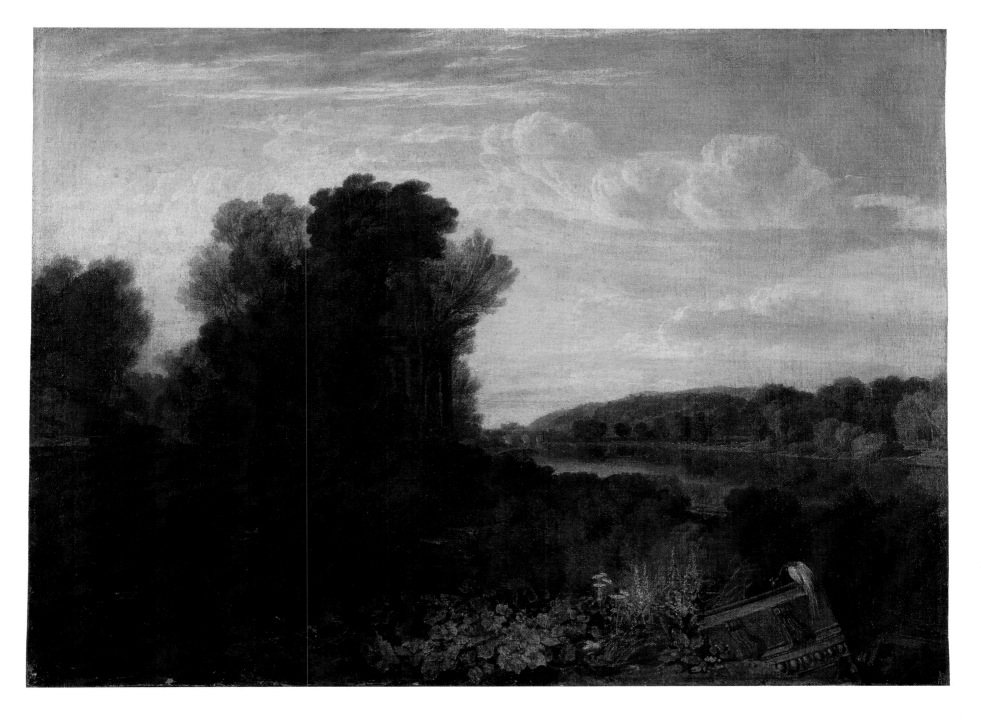

183 *Isis* (known as 'The Thames at Weybridge'), ?exhibited Turner's Gallery, 1806.

Oil on canvas, 88.9 × 119.4 cm, Petworth House, Sussex (National Trust).

seem to be imaginary, classical, riverside scenes, but a closer inspection shows that they are all composed of the same elements seen from different angles. In the first (Pl. 79), at the extreme left, can be seen the end of a classical building with engaged pilasters and an ornamentally curved end wall. To the right some steps and a slipway come down to the river, bounded at the right by a wall, just over which is a distinctive tree with a head of branches and foliage on top of a slender stem. Beyond this can be seen some houses, a smaller one in front with a larger one behind and a garden running down to the river. To the right is a riverside classical summerhouse in the shape of a circular temple with wings. To the far right is a large, plain, mediaeval-looking block with corner towers. The same elements appear in the second sketch, seen from a slightly more distant viewpoint.[20] The third sketch in the series (Pl. 80) is taken from a viewpoint closer to the bank at the left. Again there is the end of the same classical building, to the right the end of a slipway, bounded by a wall with its distinctive tree, a small house beyond with a larger one behind. To the right of these there is a classical temple and further off a large plain building with corner towers. The last of the series[21] is a more distant view from a similar angle, with trees brought into the foreground.

Imaginary scenes do not normally have such consistent geography, but real places are not normally treated in such general washes of pen and ink, lacking engagement with the local details that reality would invite the artist to describe. The details that he did include were nevertheless based on fact. The building at the left takes its baroque style with engaged pilasters and curved east end from Isleworth church (Pls 30, 55, 56), although the drawing would suggest that it was built of stone rather than brick. The building to the right follows the form of Syon House. In between was the slipway leading down to Syon ferry, and beyond it stood Ferry House, Park House, and to the right the Pavilion summerhouse. The scene was recorded as it appeared to the camera in about 1890 (Pl. 56), and although Ferry House had gone by then, there was, at the very centre of the photograph, just to the right of the slipway, a tree by a wall that could well have been the original of the one sketched by Turner.

Nevertheless these views of Isleworth should not be mistaken for the reality. By his choice of medium, line and wash, Turner was expunging the contingent detail which characterizes reality in order to create a landscape of the imagination rather than of fact. The remarkable thing about Turner's Isleworth is that it existed with equal vividness in both realms at once. At the same time as he was developing the *Liber*, he was also making detailed records of contingencies, being engaged with reality in the most direct and physical ways. At no time in Turner's career were the two extremes of art and nature, artifice and naturalism so creatively polarized.

Turner's work had its detractors, but it also had devoted admirers. One particular enthusiast was Lord Egremont of Petworth House in Sussex.[22] Between about 1806 and 1812 he bought thirteen oil paintings,[23] and five of these were based on drawings in the Isleworth sketchbooks. One of the first, *Isis* (Pl. 183), might well have been exhibited at Turner's gallery in 1806. Another, which might have appeared in the same exhibition, was the so-called *Thames near Windsor* (Pl. 185).[24] This was developed from a sketch of Richmond Bridge in the *Hesperides I* sketchbook (Pl. 66), taken from a viewpoint downstream from Richmond Bridge on the Middlesex bank. We should therefore, perhaps, retitle the picture *The Thames near Richmond*. Clearly, however, the scene was not meant to recognizable. The topographical details were followed only loosely, and many of the main features were altered. He diminished the trees on the far bank and suppressed details of the buildings, pushed the bridge far enough into the distance for us hardly to be able to see it, and altered the profile of the hill. The effect was to create a much more spacious composition than the sketch, temperate, peaceful, and timeless, whose inhabitants engage in simple work and natural pleasures. Utopia, according to this picture, consisted in the attainment of a simple peasant life when the season was always summer and the time of day warm dusk. Not all of this was fantasy. Turner's

184 LEFT *Isleworth*, 1819. An idealised version of the scenery in which he was resident 1805–6. The Pavilion is much altered, but Ferry House puts in an appearance immediately to the left, with the tree by the slipway which appears in many of Turner's Isleworth compositions (see Pl. 79) and the London Apprentice pub beyond.

Etching and mezzotint, published in the *Liber Studiorum*, part 13, 1 January 1819.

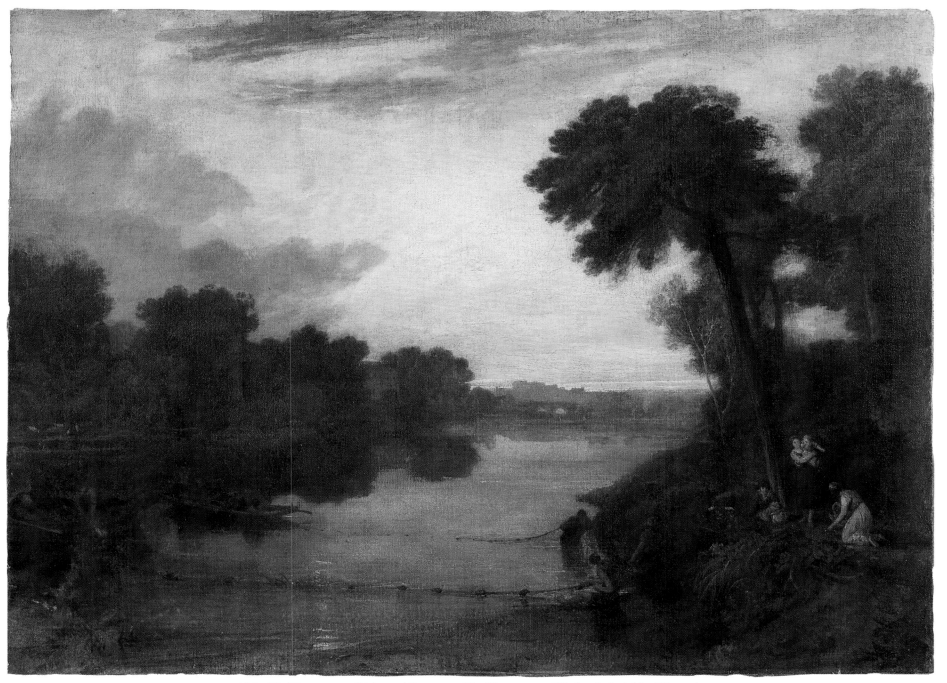

185 *The Thames near Richmond* (known as 'The Thames near Windsor'), ?exhibited Turner's
Gallery, 1806. Based on a sketch of Richmond, Pl. 66, but intended more as a type than as a
depiction of any specific place.

Oil on canvas, 89.0 × 119.4 cm, Petworth House, Sussex (National Trust).

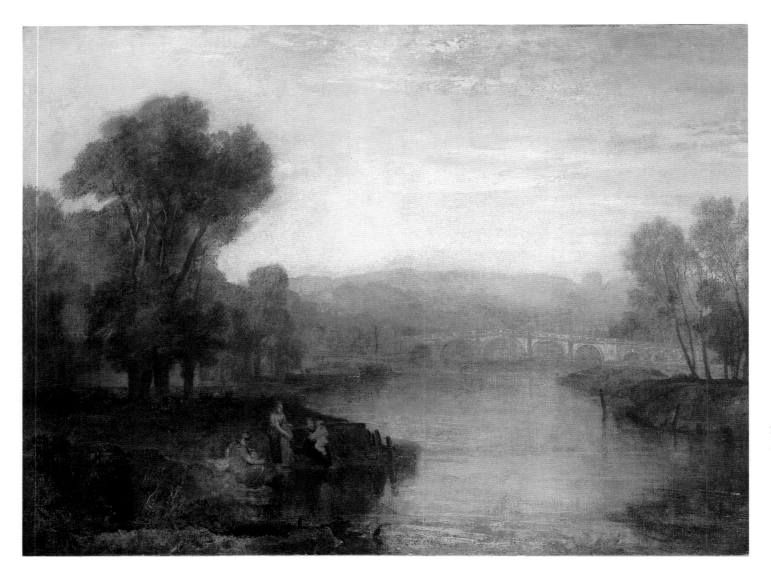

186 *View of Richmond Hill and Bridge*, exhibited 1808. Based on studies of figures bathing at Richmond (Pls. 65, 67), Turner's pastoral treatment of Richmond evidently caused problems for a number of contemporaries.

Oil on canvas, 81.5 × 122.0 cm, Tate Gallery, London (557).

sketches show that it was warm enough to swim in the river when he was there, and in 1805 the river really did teem with fish. The net which Turner's fishermen hauled ashore while he sketched them would have been full of salmon, at that time still so plentiful in the Thames as to be thought commonplace.

In 1808 he exhibited a more recognizable version of the scene, *Richmond Hill and Bridge* (Pl. 186). This was also developed from sketches in the *Hesperides (1)* sketchbook (Pls 65, 67). Turner included a variety of incident, sheep grazing, cattle drinking, barges ready to sail, women and children washing, a girl plunging into the river. In the finished picture the time of day is early morning with the sun rising to the left, just catching the right-hand side of the bridge but leaving the left still in shadow and the river overhung with cool mist. One critic, writing in the 1808

Review of Publications of Art, described it at some length:

His view of RICHMOND HILL AND BRIDGE is taken from the Surry bank, looking up the Thames, and is that beautiful river scene, ornamented with the villas of the noble and the opulent embowered in wood, which is celebrated throughout Europe, and called by the Italians the Frascati of England.

Nature has here poured forth the bounties of hill and dale, wood and water, with an unsparing hand; and cultivation under various tastes, has, in some sort, blended her wilder charms with the elegancies of art.

The most conspicuous feature in the picture is Richmond Bridge, of which, the sun being low in the horizon, the Surrey end is faintly overshadowed. By obscuring the detail of Richmond itself in the mistiness of the morning, by introducing some sheep, and the simple incident of women bathing a child near the foreground – an incident which we deem worthy of the pastoral Muse of painting, and which, had it been met with in the morning pastorals of Theocritus, would have called forth general admiration – Mr Turner has given a pastoral character to a scene of polished and princely retirement.

We are not sure that this is right, but no man will regret to throw the reins upon the neck of a generous courser who conducts him to such pleasing haunts as this picture exposes to view.

Obedient to this impulse, we feel delighted with the effects which we here behold of "incense-breathing morn." The indistinct distance of mingled groves and edifices with which Mr Turner here presents us, leaves the imagination to wander over Richmond, and finish the picture from the suggestions of the painter, where another artist would have exhausted his subject, and perhaps the patience of his observers, by the attention which he would have required to the minute accuracy of his distant detail.

We have expressed our doubts above – not of the propriety of this morning mistiness, but of giving a pastoral character to a scene, part of the beauty of which resides in its architectural elegance. The indistinctness of the morning effect we admire, and we admire also the morning incident of women bathing a child in the river.[25]

Frascati is a resort not far from Naples which has enjoyed popularity since antiquity. Theocritus was a Greek poet of the third century BC, later imitated by the Roman Virgil, who was seen as one of the originators of pastoral poetry. His work was popular in England during the eighteenth century through a translation by Francis Fawkes published in 1767, which Turner could have read in his set of Anderson's *The Works of the British Poets*. Although scenes of pastoral life could be acceptable in classical poetry, according to this reviewer they seem to have been less welcome in the resorts of the wealthy, and his enthusiasm for Richmond as a kind of Frascati seems to have surpassed his enthusiasm for Turner's version of the place. He states his reservations about Turner 'giving a pastoral character to a scene of polished and princely retirement' and was particularly worried by Turner's omission of 'villas of the noble and opulent'. He also seems to have been echoing the general view for he says, 'had it been met with in the morning pastorals of Theocritus [it] would have called forth general admiration.' We can surmise from this that the general opinion of Turner's picture was just the opposite. He excuses Turner by arguing that his indistinctness allowed greater freedom for the operation of the imagination. This was a device used often and to great effect by the artist, but the sketches justify the worry that something more subversive was afoot. The villas of the noble and opulent were a prominent feature of the Richmond riverside and appear in considerable detail in the sketch in the *Thames from Reading to Walton* sketchbook (Pl. 64). They were positively suppressed in the finished picture; even the Star and Garter to the right could easily be mistaken for a clump of trees. The polished and princely had been banished from their favourite resort.

Turner's painting was never intended to record Richmond as it was. A comparison of the bridge in the painting with that in the *Thames from Reading to Walton* sketchbook shows that he considerably enlarged the arches and made the structure altogether lighter and more elegant, so much so that the result could hardly have been built, for it left virtually no depth for the stonework of the arches or the carriageway of the road. For an artist as well trained in architectural matters as Turner this must have been deliberate, and its implausibility was intended to be noticed. Indeed, the very purpose of identifying the subject as *Richmond Hill and Bridge* in his title invites comparison of the picture with reality.

He used the relationship with reality in another striking way. From left to right the bridge runs almost directly north-east to south-west, so in order for the sun to illuminate the side shown, it must have been sunrise near the longest day, for only then would the sun be in a sufficiently northerly position. Turner sets his version of Richmond on the very

furthest boundaries of possibility, outside the realms of common experience, and thus we learn that Nature reveals herself most fully and most perfectly when most of mankind is still asleep. It takes someone with the vision of Turner to be present when the unrobing takes place.[26]

Turner started a third composition on the theme of Richmond. *Men with Horses crossing the River* (Pl. 187) was based on sketches on the flyleaves inside the front cover of the *Hesperides (1)* sketchbook which include two pencil drawings of a team of two horses being watered, with what seems to be the Star and Garter on Richmond Hill in the background.[27] The figures in this case were more important than the topographical details, however, and he worked on their grouping in further pen-and-ink studies before starting the picture. We do not know why it was not completed. Perhaps it was simply the pressure of other work, but the stage at which it was left allows us an insight into the freedom with which he developed his pictures before the gloss of finish was applied. It is also one of the best preserved canvases of this time and radiates colour and light, deep blue shadows and sun shafting through mist over the river. Once again there is no sign of the noble and opulent; the only inhabitants are simple peasants. His ideal is one in which society is banished to allow nature and man to evolve into peaceful and radiant simplicity.

One picture which was almost certainly shown at Turner's gallery in 1806 is *Walton Bridges* (Pl. 188), since it was bought by Sir John Leicester of Tabley Hall, Cheshire, and paid for in January 1807.[28] It was developed from one of a series of sketches in the *Hesperides (2)* sketchbook (Pl. 119), together with drawings of the bridge in the *Thames from Reading to Walton* sketchbook (Pl. 121).[29] The view is taken from a viewpoint upstream, where the river swings north towards Shepperton. It is sunset, long shadows reach across the foreground, and the weather has been hot and dry for some while, to judge from the water's level and clarity. The circumstances prevailing at the time of his visit were the main subject of his sketches (see Part II).

Walton Bridge was built in 1783 to the designs of James Paine, and replaced a wooden bridge of 1750. It was made of deep-coloured brick with white stone edges and must have been very distinctive. One would not know this from Turner's painting, whose golden light allows us to imagine a more classical material, such as the stone of which Paine's other bridges at Richmond and Chertsey were made. Paine would no doubt have designed his bridge with the light and spacious arches that Turner shows, with slender piers and gossamer carriageway had gravity so allowed. The founda-

tions here are difficult, however, and Paine built his structure rather more solidly than Turner would have us believe. The sketch in the *Thames from Reading to Walton* sketchbook (Pl. 121) shows it more as it was, although one might still have doubts about the stability of the centre arches. In any case they survived only until 1859 when, due to settlement of the centre pier, the two main spans collapsed. In 1864 a four-span latticed iron girder structure was opened which lasted until 1953, when the present, 'temporary' bridge was built.

As with *Richmond Hill and Bridge* (PL. 186) Turner used the bridge for its horographical potential. At Walton the bridge runs west-north-west to east-south-east from left to right and Turner shows the sun shining on the far side from the left. It must therefore be setting in the north-west and the time of year must be near midsummer. Though his picture seems to cast ordinary pastoral events in the golden glow of art, and to distinguish them with the rhetoric of pastoral poets of antiquity, he is using the time of day and year to indicate that such things, though extraordinary, might nevertheless be found in nature, and that he has been out to the boundaries of experience to report on the magnificent things that may be found there.

He based a second picture of *Walton Bridges* (Pl. 189) on the last sketch in the *Hesperides (2)* sequence (Pl. 120) showing the view from the opposite side, looking south-west through the arches towards the viewpoint of the first painting. The time of day is morning, with the sun high in the south-east back-lighting the bridge and throwing shafts of light about a fresh-looking sky. It must be calm at ground level, for the bridge is reflected sharply in the river. It is odd that these reflections are distorted as if ill-drawn. Reflections are, however, a much more complex visual phenomenon than one might at first assume and it would be absurd to think that Turner, who had probably thought longer and harder about water than any painter alive, had made some sort of blunder. Most painters could learn the conventions of reflection reasonably straightforwardly, and we have seen Turner at the age of twelve in *Folly Bridge and Bacon's Tower* (Pl. 3) at least as advanced in that respect as most professionals of the time. He seems here to have been considering afresh what form a reflection actually took when it came to the eye from different angles. Thus we look at the objects on the right-hand side of this picture from a different angle to objects elsewhere in the composition, and their forms are modified to take this into account. We can be sure that this was deliberate and considered, and we can also be sure that it was brave, for commentators with greater

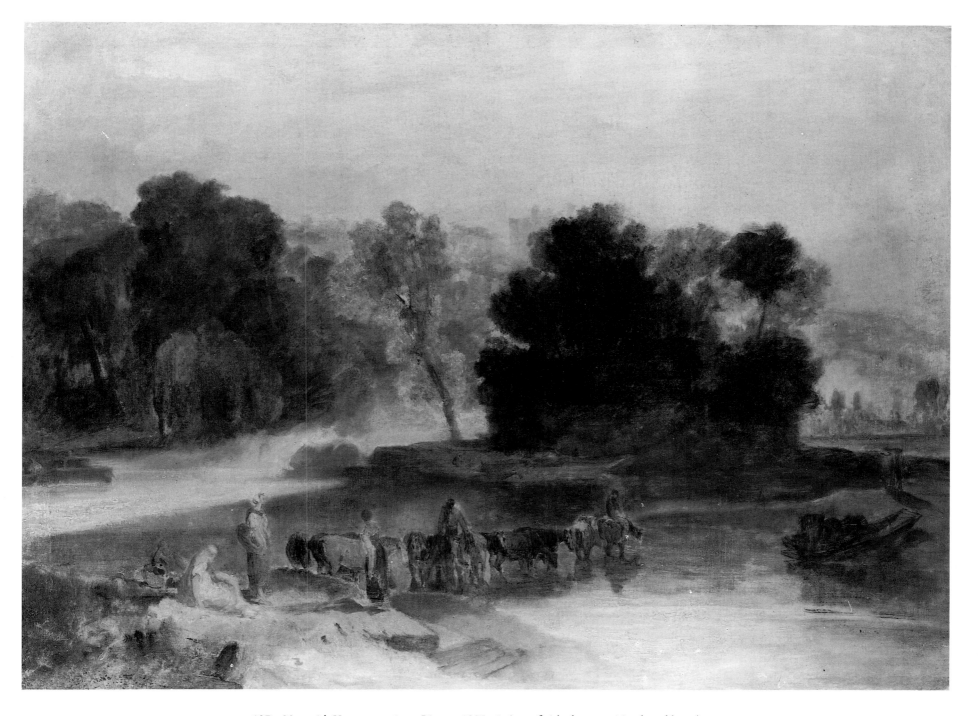

187 *Men with Horses crossing a River*, c.1805–6. An unfinished composition based loosely on
Richmond riverside scenery.

Oil on canvas, 88.0 × 118.5 cm, Tate Gallery, London (2695).

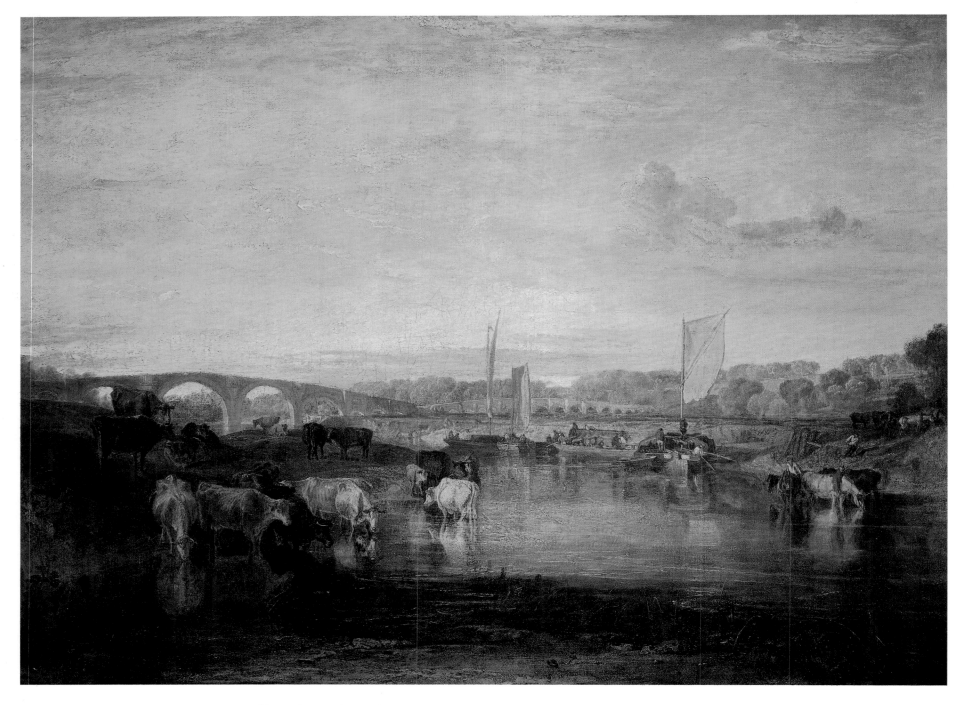

188 *Walton Bridges*, ?exhibited Turner's Gallery, 1806. Based on a series of sketches from his visit in 1805 (Pls. 119–21).

Oil on canvas, 92.7 × 123.8 cm, The Loyd collection.

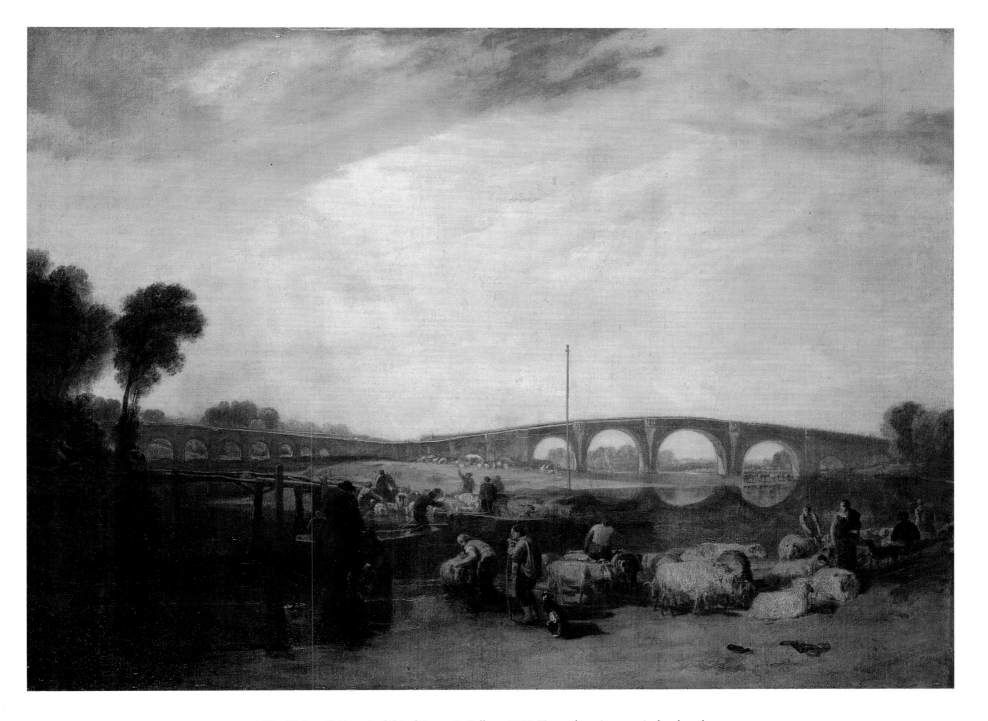

189 *Walton Bridges*, ?exhibited Turner's Gallery, 1807. Turner has given particular thought to
the reflections of the bridge.

Oil on canvas, 92.2 × 122.4 cm, National Gallery of Victoria, Melbourne, Australia.

certainty about the way things ought to be would no doubt have been glad to denounce his weakness. It had occurred to Turner, however, that the convention of simple inversion wanted examination and rethinking. His pictures of this time were very much concerned with conventions and the way in which they shape our thinking. *Walton Bridges* is an instance of his finding these conventions lacking.

In this case no one seems to have noticed. Perhaps the hubbub of activity in the foreground proved too distracting. Sheep have been brought down to the river for shearing, and a crowd of figures is setting animatedly to work. In the foreground an old shepherd and his dog gaze at the river, while to the left two sheep-shearers are overseen by a figure on horseback, possibly the owner or manager. Immediately to his right is a bemused shorn sheep, while beyond and to the right further labourers manhandle the flock. At the extreme right there is a woman whose dress suggests that she would be more at home in a painting by Poussin, and a seated figure in a black jacket, who seems to be watching, perhaps even sketching. The picture was bought by the Earl of Essex, of Cassiobury Park, Watford, in 1807,[30] and it is perhaps appropriate in view of the subject that it has now found its way to the National Gallery of Victoria at Melbourne in Australia. In contrast to the first picture this is not only busier but also takes a much more active interest in the working lives and conditions of the people who made their living in this landscape. Figures are placed prominently in the foreground and are well studied and characterized. There are also different levels of society portrayed, the employer and the employed, those that do and those that watch. The Earl of Essex's picture shows a greater level of social consciousness than Sir John Leicester's and, as we shall see, there are a number of signs that social issues came to the forefront of Turner's consciousness in the work developed from his studies on the Thames.

It was some while before social realism filtered through into the finished paintings, however, and *Windsor Castle from the Thames* (Pl. 190), which was painted at Ferry House and bought by Lord Egremont from Turner's gallery in 1806,[31] was one of the most 'epic' of Turner's pastorals. It was based on a sketch in the *Wey Guilford* sketchbook (Pl. 87), one of a series made at Windsor and Eton (see Part II). He developed his pencil sketch into a colour study in the *Studies for Pictures Isleworth* sketchbook (Pl. 191) in which he discarded the foreground detail and substituted a wide expanse of river. He introduced boats to left and right and some peasants with sheep into the foreground. The absence in the sketch of detail with regard to the castle gave him the

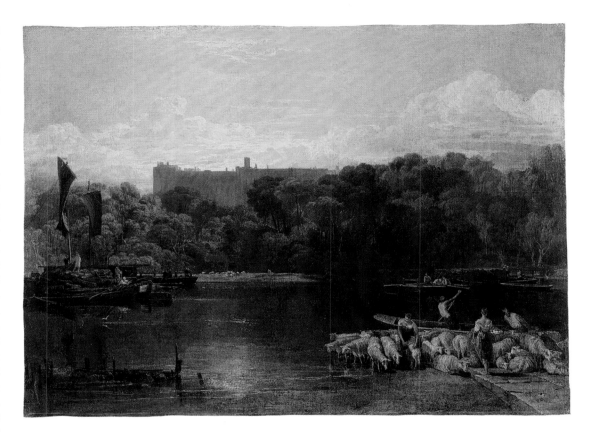

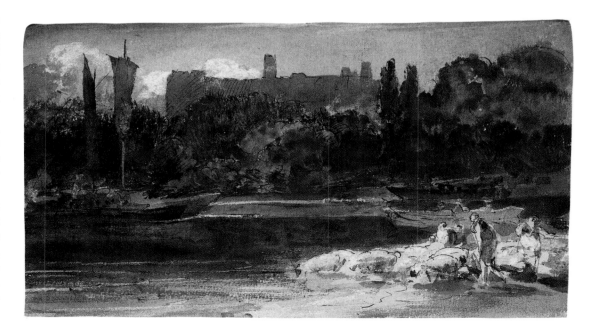

freedom to invent, shorten, simplify, and flatten the profile, turn the watch-tower into a chimney, and edit out features such as the Norman gateway or the Round Tower. He set a screen of trees between the foreground and background, and reduced the space to a series of flat planes like stage backdrops. As with Lord Egremont's other pictures, *Isis* and *The Thames at Richmond*, it is clear that Turner's intention was to remove the real specifics of place. The river triples in width, the trees in height, and the castle in size. The picture comes to depict something which more closely resembles an idea of some great legendary site, the sacred River Alph and Xanadu, Euphrates and Babylon. Of Berkshire, the Thames, real trees, or George III's castle, little remained.

The result is magnificent almost beyond possibility. The sky is clear and sharp, the light clean and white, pollution-free and moistureless. The water is so clear that it appears almost black. It is a place which has enjoyed undisturbed evolution. The trees have grown tall and magnificent down to the water's edge. It is a place of continuity and equability, a site ripe for settlement and development, and an immense palace has grown up here. We can see how big it must be from the haze obscuring its details on such an otherwise clear day. Despite its grandeur there is no sign of the owners. The only people we are shown are barge-men and shepherd girls. To the right boats are being loaded with produce. In the foreground sheep have been brought down to the river for shearing, and wait obediently for their turn. Sheep in truth are rather less compliant to their owner's convenience, and these seem so dutiful as to appear positively doting. The shepherdess looks more like a ballerina, such grace, refinement, and poise does she possess; her blouse has slipped from her shoulders and her hair is up, as if to encourage our scrutiny and admiration. Her apparent lack of self-consciousness suggests a state of innocence. This is a world without sin or fear.

Not only are the contents of this world perfect, so is their arrangement. The composition forms a neat structure of vertical and horizontal planes, while the lines of jetty, reflection, sand, and clouds form a strong diagonal cross. The elements conspire together in pattern and order, clear and stable geometry. The planal composition makes the scene almost like a stage set on which dancers play the role of peasants. It was a picture designed to hang comfortably among other productions of art, and Petworth housed works by Claude, Gaspar Poussin, Ruisdael, Rembrandt, Van Dyck, Bronzino, Holbein, Watteau, and many others.

Lord Egremont bought two more pictures based on Turner's visit to Windsor from Isleworth. The first was *The Thames at Eton* (Pl. 192) exhibited at Turner's gallery in 1808. The sketch on which it was based was the first in the *Wey Guilford* sketchbook series (Pl. 83), showing the view from near the head of the lock island looking north-north-west over the weir towards Eton College chapel. The pencil work is sensitive but the whole drawing comprises no more than a couple of minutes' work. It is hard to make out more than the general form of the weir, the trees are dashed in quickly, and the buildings are treated unusually casually. He fudged the details of the chapel's east end and forgot the roof altogether.

When it came to the finished picture he did not have a great deal to go on and was forced to invent. He had made a thorough exploration of the site, however, and knew its layout well enough to set the scene below the weir, a good place for fishermen, with the lock island on the right, beyond which a sail marks the passage of a barge through the cut. The College, however, instead of occupying the centre of the composition as it does in the sketch, is relegated to a subordinate position at the left, barely being allowed to peep into view over the trees. The details of the east end are suggested rather than made out and the roof is missing, as in the sketch. The greater part of the picture is devoted to the trees, river-banks, sky, reflections, and swans. 'Stately' was the key word used by John Landseer when he reviewed the picture at Turner's gallery in 1808; 'dignity, . . . elegant, . . . artful, . . . calm, . . . tranquil, . . . contemplated' by a 'Poet'.[32] But the stateliness and elegance is that of the trees rather than the buildings, and the poetry revolves around the contrast between the achievements of nature and those of man. In this instance he firmly sided with nature. In the foreground two anglers with their backs to the chapel fish from a punt, their minds filled with concentration on rod and line, the sight of dark water, and the still world reflected in it. The prominence accorded to the College indicates how Turner balanced the equation between the two worlds. Although *Windsor Castle from the Thames* was about nature elevated by artifice, as were most of the pictures made from this material, he gradually came to show that nature could stand on its own. Nothing could be more proud in its dignity than the swan. His inclination, even as he made the sketches in which routinely he paid more attention to the works of nature than to those of man, had been to reject human artifice and aggrandisement in favour of simple nature. The story of Jacob and Esau, which he had read with interest

190 *Windsor Castle from the Thames*, ?exhibited Turner's gallery, 1806. One of the most idealised compositions developed from the 1805 material, based on a sketch in the 'Wey Guilford' sketchbook, Pl. 87.

Oil on canvas, 91.0 × 122 cm, Petworth House, Sussex (National Trust).

191 Study for 'Windsor Castle from the Thames', 1805.

Watercolour, 14.6 × 25.4 cm, 'Studies for Pictures Isleworth' sketchbook, Tate Gallery, London, TB XC 29a.

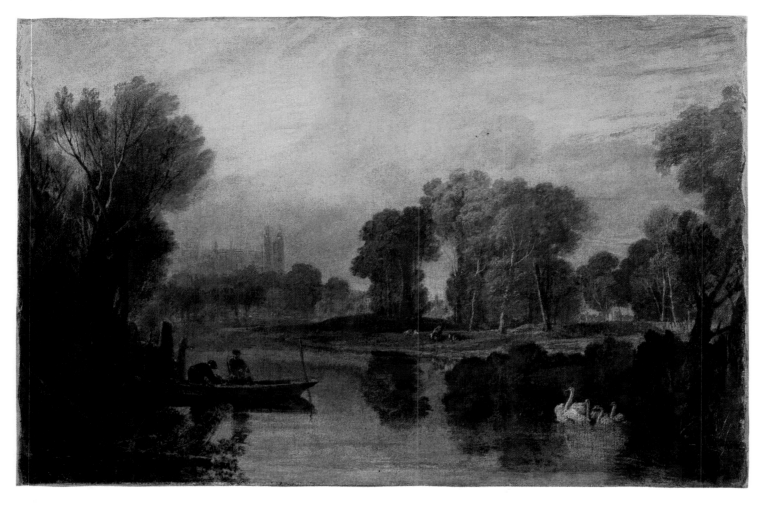

192 *The Thames at Eton*, exhibited Turner's Gallery, 1808. Based on a sketch of 1805 (Pl. 83), Turner's theme is the contrast between the simple life on the river, as represented by the fishermen in the foreground, and the life represented by the College in the background.

Oil on canvas, 59.5 × 90.0 cm, Petworth House, Sussex (National Trust).

during his Thames explorations (see Part II), encapsulated the relative merits of the worlds of man and nature, and he emphatically chose the latter. The background role of Eton College chapel in this composition is symbolic of that choice. Jacob was the sort to have gone to Eton, but Esau would have been fishing from the punt.

The third of Lord Egremont's Windsor and Eton subjects was *Near the Thames' Lock, Windsor* (Pl. 193) which appeared at Turner's gallery in 1809. Once again the sketch on which it was based (Pl. 86) is slight, showing the view from the island above Romney Lock, looking up the river towards the Winchester Tower at the end of the north terrace, and all but concealing St George's Chapel and the Round Tower behind trees. The real subject is the activity in

the foreground. He directed us to his purpose by including a quotation in his catalogue:

> Say, Father Thames, for thou hast seen
> Full many a sprightly race,
> Disporting on thy margin green,
> The paths of pleasure trace,
> Who foremost now delight to cleave
> With pliant arms thy glassy wave. – *Gray*

A few boys splashing about in the river might not seem the stuff of which great art is usually made, but Thomas Gray was one of the most admired and influential lyric poets in the later eighteenth century, and his 'Ode on a Distant Prospect of Eton College', from which the quotation was

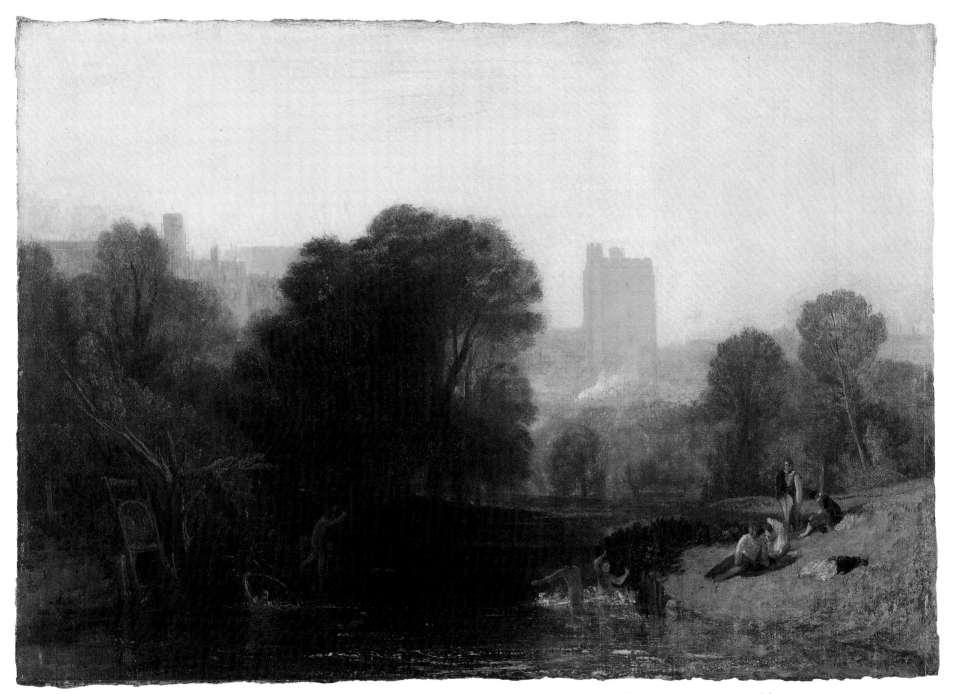

193 *Near the Thames' Lock, Windsor,* exhibited Turner's Gallery, 1809. Based on an 1805 sketch, Pl. 86, Turner quoted from
Thomas Gray to indicate his themes of nature versus art, and the fundamentally unfulfillable human condition as represented by the Eton
scholars on the banks. The boys splashing in the water have found a solution, albeit a temporary one, to the problem.

Oil on canvas, 88.9 × 118.0 cm, Petworth House, Sussex (National Trust).

taken, was one of his most famous works. John Landseer referred to it while discussing *The Thames at Eton* in 1808[33] and, since the prospect in question was that from the terrace at Windsor, it seems possible that Turner had it in mind when he sketched the same view in the *Wey Guilford* sketchbook (Pl. 93). In any case we can suppose that Turner expected the juxtaposition of poem and painting to be considered. It is, therefore, worth summarizing the poem here. Gray begins by looking out from the stately brow of Windsor's heights and surveys the distant spires and antique towers of Eton that crown the watery glade, grove, lawn, mead, turf, and shade, 'whose flowers among / Wanders the hoary Thames along / His silver-winding way'. In the second stanza the poet becomes melancholic at the loss of his youth. Gray spent nine years at Eton, 'Where once my careless childhood stray'd, / A stranger yet to pain!', and his vocabulary leaves us in no doubt as to how fondly these days were remembered: 'Happy, . . . pleasing, . . . belov'd, . . . bliss, . . . gladsome, . . . joy and youth'. The third stanza describes the sort of pleasures he and his compatriot 'idle progeny' enjoyed, enthralled by captive linnets, chasing rolling hoops, urging 'the flying ball', or swimming in the river. In the fourth stanza he considers the more 'earnest business' of study; 'Murmuring labours . . . Gainst graver hours'. Thereafter the poem darkens. In the fifth stanza we learn that for these students, 'Gay hope is theirs by fancy

fed, / Less pleasing when possest'; in the sixth that 'No sense have they of ills to come, / Nor care beyond today: / Yet see how all around 'em wait / The Ministers of human fate.' The roll-call of these ministers includes misfortune, anger, fear, jealousy, despair, falsehood, unkindness, and poverty, and continues without relief through stanzas seven, eight, and nine. In the tenth Gray concludes:

> Yet ah! why should they know their fate?
> Since sorrow never comes too late,
> And happiness too swiftly flies.
> Thought would destroy their paradise.
> No more; where ignorance is bliss,
> 'Tis folly to be wise.

Turner's Etonians defect from earnest business to the paths of pleasure. The figures on the bank are arranged in increasing states of undress and watch as their compatriots wallow in the river. The castle is no more than a backdrop of wealth, power and things coveted in 'hope . . . by fancy fed, / Less pleasing when possest'. The figures on the bank, meanwhile, watch and consider what it is for the others to launch themselves naked into cool dark water, to reach up from the pool and grasp a branch overhead, or to splash in the shallows while morning sunlight sparkles on their bodies. Turner's picture is of a moment of being exultantly and fully alive.

II Real Lives

Life in the real world. Abingdon and Dorchester Mead. Social realism.
Morland's exhibition. Vulgar nature. Low and ignorant characters.

Only painted peasants lived in paradise, and Turner's Thames subjects gradually began to reflect more of real life on its shores. His picture of *Abingdon* (Pl. 194) was one of the first to make working people his principal subject. We look south-west from upstream of the bridge, with St Helen's church spire to the right. Some cattle have come to drink but find the river much in demand by other users. To the right a water-drawer in an apron muses how to fill his barrel with clean water, since the cows will have stirred up the mud and perhaps caused still worse pollution. We can imagine what back-breaking work he does from the way he straightens up with his hands on the traces hanging from his neck. To the left another carrier apparently remonstrates

with his horse, which has decided to take a drink. In the centre a tinker waters his mount and pack-horse. To the right a group of men load a timber waggon with a consignment of tree-boles. In the distance a large-wheeled wain trundles its way across the bridge towards the town. The sails of barges hang still and heavy and as the air cools towards evening its moisture condenses into shafts of sunlight. The whole picture is suffused with a sense of settlement and calm.

Turner's water-carriers and tinkers, timber-hauliers and cows had enough appeal for the picture to find a buyer, and until 1829 it was in the collection of George Hibbert. He was probably its original purchaser, for he was active on the

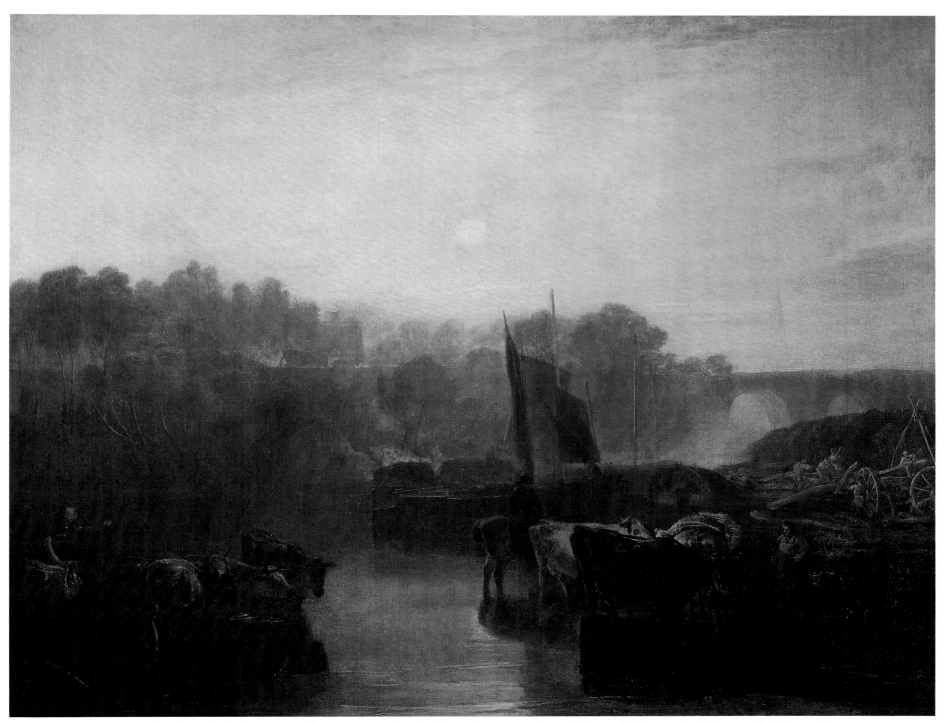

194 *Abingdon*, ?exhibited Turner's Gallery, 1806. Based on sketches made in 1805 (Pl. 172). The supplies being unloaded were probably intended
for the new gaol beyond the bridge which was built at this time. Sometimes mistakenly identified as 'Dorchester Mead', but cf Pl. 195.

Oil on canvas, 101.5 × 130.0 cm, Tate Gallery, London (485).

London scene at the beginning of the nineteenth century, being a member of the Committee of Visitors to the British Institution in 1805, a member of the Royal Institution in 1800 and 1803, and a Member of Parliament from 1806 to 1812. He was also associated with Turner's close friend W. F. Wells, and owned a number of drawings by Gainsborough which Wells published in 1819.[34] His politics were Whig and in 1807 he published *The Substance of Three Speeches on the Abolition of the Slave Trade*, a concern which he shared with Walter Fawkes of Farnley Hall, a member of the Whig Parliament of 1806, with whom Turner had been developing a friendship since about 1802. It is striking how many of Turner's friends and patrons at this time showed a marked degree of social conscience. The Earl of Egremont was a leading member of the Society for the Betterment of the Conditions of the Poor, established in 1799. Hibbert's purchase of *Abingdon* suggests that he also had an interest in working people and to have it hanging on his wall would have been a clear signal that he also had some sympathy for their plight.

We do not know when Turner sold the picture. Until now it has been assumed that this was in 1810, for scholars have identified it with *Dorchester Mead, Oxfordshire* shown at his own gallery in that year.[35] Dorchester Mead is much too far from Abingdon for this to be tenable, however, and no one could ever have referred to them as the same place. The *Union of the Thames and Isis* (Pl. 195), however, which was exhibited in 1808 and 1809, shows the confluence of the rivers Thame and Thames which is located in Dorchester Mead. According to the old poem 'The Marriage of the Thame and Isis',[36] the Thames was known as the Isis above this point and below the confluence with the Thame acquired the name Thamesis or Thames by a union of the words Thame and Isis. The two titles *Dorchester Mead* and *Union of the Thames and Isis* must therefore refer to the same picture. Turner's original title should have read "Union of the *Thame* and Isis" as in the poem, but the small misprint managed to wreck the allusion. Renaming it *Dorchester Mead* was probably an attempt to redeem the mistake and we should adopt the less confusing title henceforth.

The question still remains as to when *Abingdon* was shown, for there is no title after 1808 with which it can be identified. It could, however, have appeared at his gallery before that, for we have no lists for the early years. Given that the pictures of *Walton Bridges* (Pl. 188–89) were also developed from material in the *Hesperides (2)* sketchbook (in fact a study made at Walton faces the one of Abingdon used as the basis of the finished picture), it seems reasonable

to conclude that *Abingdon* appeared about the same time in 1806 or 1807. Whatever the case, it was a picture important enough for Turner to have bid and bought it back at Hibbert's sale in 1829, the year in which he wrote his first will and conceived the idea of creating a gallery of his work. He paid £120 15s. 0d., which would have been close to the amount he originally charged for it. Abingdon had personal significance to him as a subject. He began his career at his uncle's house at nearby Sunningwell and he made an early watercolour of the abbey granary, then in use as a bridewell (Pl. 14). A new gaol was begun in 1805 and built by French prisoners of war. The timber which Turner recorded being loaded in this painting might well have been destined for it.

During his expeditions from Isleworth Turner came increasingly to revel in the ordinary things of which experience was composed. He transcribed this experience directly into oils, at first on small boards but latterly onto canvases of the same size as many of his finished pictures. The sketches on canvas were intended more as underpainting than finished statements in their own right and it is possible that Turner intended to work them up in his studio into paintings suitable for exhibition. *Dorchester Mead* seems to be an example of one that was completed, for there are no sketches for it, and its subject – a few cows in a ditch – offers an extreme example of his embracing the commonality of the real. It must have seemed one of his strangest productions, especially in the light of the fact that he had exhibited such exciting subjects as *The Deluge*, *The Fifth Plague of Egypt*, *The Battle of Trafalgar*, *Fall of the Rhine at Schaffhausen*, and *The Garden of the Hesperides* in recent years. *Dorchester Mead* had no such interest. One cannot even see the Thames, except for a glimpse beyond the bridge. More than half the composition is empty sky. The landscape is an almost featureless flat unrelieved even by trees. In the foreground is a stream littered with old eel-pots, spanned by a ramshackle bridge, and populated by a few ducks and cows. It failed to find a buyer even though Turner exhibited it three times. It was a world with which ducks and cows could be content, but evidently not the prospective purchasers of pictures.

Turner had been fascinated by cows for years. They were a regular feature of his sketchbooks and after 1800 became the subject of a number of paintings and watercolours. He even devoted a whole sketchbook to them. When *Dorchester Mead* appeared as *The Union of the Thames and Isis* at Turner's gallery in 1809 it was accompanied by two other paintings in which cows figured prominently, *Sketch of a Bank with Gipsies* and *Sketch of Cows &c*.[37] Their repeated ocurrence suggests that they had some special significance

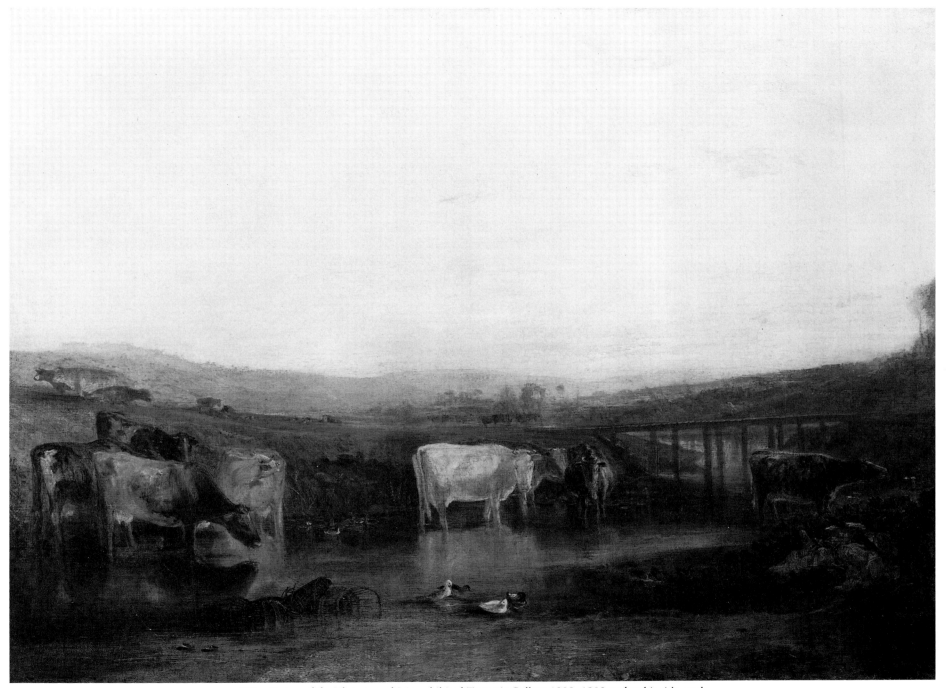

195 *Union of the Thames and Isis*, exhibited Turner's Gallery 1808, 1809 under this title, and 1810 as 'Dorchester Mead, Oxfordshire'. The confluence of the river Thame, and the Thames (or Isis) is in Dorchester Mead. The bridge here carried the Thames towpath over the Thame.

Oil on Canvas, 91.0 × 121.5 cm, Tate Gallery, London (462).

for him. In *Dorchester Mead* they seem to be included for their docility. These are the very symbols of patience and acceptance of their lot. They are stoic in a way that man is not, incapable of imagining themselves anywhere or anything else.

Many among the picture's audience would have rated bovine stoicism an ideal attribute for the poor. Enclosure and the war, rising prices of food, rents, goods, and services, and greater dependence on declining wages caused a considerable worsening of their conditions. When Thomson described the Thames valley in *The Seasons* as

> ...a vale of bliss...
> On which the power of cultivation lies,
> And joys to see the wonders of his toil
> ...where the Queen of Arts...
> Walks unconfined even to thy farthest cots,
> And scatters plenty with unsparing hand...
> Thy country teems with wealth,
> And Property assures it to the swain,
> Pleased and unwearied in his guarded toil

he was not seeking the laurel for social realism. Property assured wealth only to the propertied; the 'farthest cots' saw very little scattered in their direction, and to claim that the swain's toil was unwearying and pleasing was self-contradictory, an insult to the swain's efforts and an excuse for paying him next to nothing. The rural poor often lived in appalling conditions, lacked education and opportunity, and were ill-fed, ill-clothed, and ill-sheltered. Infant mortality was high, even among the literate classes. Serious illness was commonplace, there were regular outbreaks of cholera, smallpox, and typhoid, and complaints such as tuberculosis were endemic. The effects of injury could be devastating and often fatal. A broken leg or arm meant that a man could not work and his family might easily be reduced to begging. Lack of dental care meant that all classes suffered toothache and many took laudanum to stop pain. In truth rural life was short, hard, and mostly painful, and Thomson's *Seasons* or the pictures of Claude, Poussin, and Gainsborough merely wishful thinking. In the years following the French Revolution the British seem to have been even more determined to cling to the myth. Between 1790 and 1795 Thomson's *Seasons* went through no fewer than seventeen editions, and another eleven before 1805. Its ideals dominated Turner's formative years and his concepts of excellence in art. The arcadian myth was still being trotted out in 1811. The introduction to W. B. Cooke's *The Thames* included a banal imitation of Thomson:

> Where peace with freedom, hand in hand;
> Walks forth along the sparkling strand;
> And cheerful toil and glowing health,
> Proclaim a patriot nation's wealth.
> The blood stain'd scourge no tyrants wield
> No groaning slaves invert the field;
> But willing labour's careful train,
> Crowns all thy banks with waving grain.[38]

There was much more about sylvan shades, sweet meads, and willowy shores. Some artists were waking up to the realities of working people, however, and from the first Turner's knowledge of these realities tempered his treatment of the conventions. So the otherwise straightforward *Abingdon Abbey* (Pl. 14) is identified as Starve Castle because it was in use as the county gaol. In other Thames pictures such as *Richmond Hill and Bridge* and *Windsor Castle from the Thames* he introduced the elegant peasant girls and ruddy swains of art, but in a setting which was palpably artificial. As his audience was very well aware, the real Richmond or Windsor was very different from the pictures, and so were real people.

A series of studies in the *Hesperides (1)* sketchbook shows Turner confronting country life at its most desperate.[39] The first (Pl. 196) was made in haste as if he was working against time. To the right of centre we can make out a woman on all fours sweeping something up from the ground, possibly gleaning leftovers after the harvest. To the left an old woman leans forward to tend a child, while in the centre a younger woman, presumably the child's mother, cries out to two figures at the right. An old man kneels at their feet, wringing his hands in supplication. Whatever it was these people needed they were reduced to beggng for it. Another study (Pl. 197, above) records an indoor scene, perhaps in a tavern or workshop. A number of men are engaged in angry debate. A figure at the left is speaking, while another to the right shouts out. Others sit gloomily or glaringly around, another stands to the right with his hands thrust in his pockets as if in frustration. Another study (Pl. 197, below) is set in a blacksmith's shop with the smith straightened up by his anvil, leaving off his work as if to speak out.

The period 1805–6 was one of political crisis and upheaval. These were particularly difficult times. Prices rose, wages failed to keep pace, and resources were increasingly siphoned off into the war. The situation became a matter of widespread public concern, and in 1806 the Tory government was defeated for the first time in years and a whig government, including a number of radical reformers, was

196 Distressed Peasants, 1805.

Pen and ink, 17.1 × 26.4 cm, 'Hesperides (1)' sketchbook, Tate Gallery, London, TB XCIII 25a.

197 A Tavern disputation (above) and Interior of a blacksmith's shop (below), 1805.

Pen and ink, 17.1 × 26.4 cm, 'Hesperides (1)' sketchbook, Tate Gallery, London, TB XCIII 22a.

elected. Turner himself contributed to the socio-political debate. He developed the study of a blacksmith's shop into a finished picture: *A Country Blacksmith disputing upon the Price of Iron and the Price charged to the Butcher for shoeing his Poney* (Pl. 198), which he exhibited at the Royal Academy in 1807. The price of iron had been driven up by the war and must have been a vexatious issue in a community where iron for tools and horseshoes was a basic requirement. The blacksmith was one of the foundations of English life and the prices he charged affected everyone. If his customers could not afford to have their horses shod, tools replaced, or ploughs mended, then they could not work.

Rural genre pictures enjoyed considerable popularity during this period. The Scottish painter David Wilkie jumped to fame at the Royal Academy of 1806 with his painting of *Village Politicians*. The *Morning Post* said: 'It evinces an intimate knowledge of vulgar nature, & a facility in expressing the various passions by which she is activated that are unrivalled in the present day.'[40] It is frequently claimed that Wilkie's picture spurred Turner to his own similar efforts,[41] but there was another possible source of inspiration. Just before Turner went off to Isleworth for the summer of 1805 there was a major exhibition of the work of George Morland. *The Times* announced it on 22 May:

> MORLAND GALLERY. This valuable and extraordinary Gallery, of nearly one hundred fine paintings, by that great and justly celebrated artist, Mr G. Morland, we understand is the property of a private Gentleman, who, at the solicitations of his friends, has allowed them to be submitted, for a time, to the Public, that they might have an opportunity, at one view, of seeing some of the choicest productions of that singular genius. Macklin's Great Room, Fleet Street, formerly the Poet's Gallery, has been fitted up for their reception, with a degree of taste and elegance, worthy the owner of this unique collection which does honour to the English School. It opened last week.

Such was its importance that the paper reminded its readers to see it on 25 and 31 May, 5 and 20 June, and again on 2 July, commenting warmly on the 'distinguished approbation it daily experiences'. Morland had died an alcoholic on 29 October 1804, aged forty-one. In his short life he produced thousands of paintings and drawings and was one of the most popular painters of the day. He had specialized in rural genre subjects and cultivated a reputation for uncouth behaviour and an irreverent attitude to the rich and power-

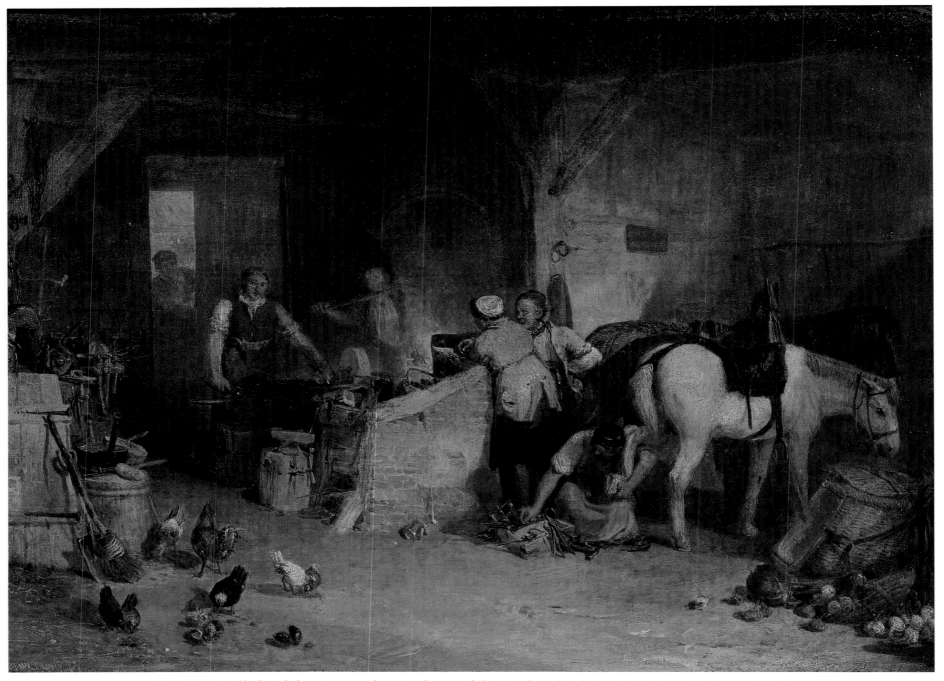

198 *A Country Blacksmith disputing upon the Price of Iron, and the Price charged to the Butcher for shoeing his Poney*, exhibited
RA 1807. Increases in the price of iron had widespread repercussions, and Turner was drawing attention to the difficulties of life
in the real landscape, as opposed to the idealised visions of landscape first developed out of his 1805 material.

Oil on panel, 57.5 × 80.5 cm, Tate Gallery, London (478).

ful. One day Lord Derby had announced himself at the door of his studio: 'Oh damn *Lords*,' vociferated Morland out of a garret window. 'I paint for no Lords. Shut the door.'[42] According to one biographer Morland 'described the manners and habits of the lower class of people in this country, in a style peculiarly his own. No painter so much as himself ever shared in the vulgarities of such society.'[43] Morland's show helped to put rural genre subjects at the forefront of public consciousness and the fact that Turner's interest in such subjects was particularly active in his Isleworth sketchbooks suggests that it might have been stimulated by the exhibition.

Turner sought out the vulgar society on his expeditions from Isleworth, and his sketches record labourers, beggars, gleaners, harvesters, fishermen, and barge-men. He recorded his days with the boatmen on the river in a painting of *Newark Abbey on the Wey* (Pl. 199).[44] The picture shows two barges tied up below a lock and an old mill. As the sun sets the barge-men prepare their supper while there is still daylight enough for them to see. In the foreground is a tender containing a few cabbages and turnips, and there is a figure leaning over the side to draw water to boil up a stew. Meanwhile another crew have got their fire going and sit in the glow, watching the steam rising from their cooking-pot. It would have been simple fare that they enjoyed: whatever vegetables they could purloin *en route*, some fish taken from the river, and perhaps some beans or grain that they brought with them. No one shows the least interest in the scenery or sunset. A pretty sunset or a ruined abbey is of no consequence to them; their work has brought them here, not the pursuit of the picturesque. They have stopped because it is too dark to go on, and because they are hungry and tired.

Turner was on the river for all the reasons they were not, to see the sights and for recreation. It seems possible that the painting was worked up from a canvas begun from nature, for he recorded a similar scene on the Thames at Cliveden in 1805 (Pl. 138). Turner was there to take pleasure in observing riverside ruins, glorious sunsets, deep shadows below lock gates, quiet mills, the people who lived in these surroundings and the ways in which they lived. In camping out on his boat he experienced something of the way of life, found out what a life bound daily to nature actually consisted of; it was by no means so straightforward as a poem by Thomson. For those who had no alternative but to live in nature, its beauty was little recompense for their circumstances. Turner, on the other hand, enjoyed a comfortable station in life in which he was free to be wherever he wished. His capacity to enjoy the scenery at Newark stemmed in large measure from the fact that he was there by choice. His picture celebrated this new station and the pleasure that might be derived from it.

Harvest Dinner, Kingston Bank (Pl. 200), exhibited at his gallery in 1809, abstained from landscape pleasure to make one of his most unflinching statements about the 'natural' peasant life. It was based on an oil sketch made in 1805 of a group of gleaners and harvesters who had broken from their labours in the field to make their midday meal (Pl. 134). In the shade of a ditch a young mother suckles her infant while another woman stands with her back to us. Above, a boy sits on the ground with a small basket on his knee, while next to him stands a man seemingly talking to the girl in the ditch. Behind them we can see other workers still reaping and loading the harvest. At the waterside an older man kneels to scoop up a drink from the river in his hands. To the right a couple of moored barges provide the only refuge in the composition. The effect merely emphasizes the picture's emptiness. There is no shade or shelter for these people. For five manual labourers and a baby there is also remarkably little food in evidence, especially when one considers ·that this would have been the main meal on one of their hardest day's work of the year. The sea of grain which they harvest is destined to fill others' purses and bellies. The man at the water's edge does not have a cup, still less a jug of beer. He is reduced on all fours to the condition of a cow. There is nowhere else for the eye to go and while swallows wheel over the water at the right, the eye must keep returning to the figures. Turner makes us look at them. He offers no sort of diversion, distraction, or entertainment; his purpose is to make us look and face up to the way these people are.

Harvsting the sea was every bit as hard as harvesting the field, and Turner's Thames explorations included observations of life as it was lived out in the open waters of the estuary. In *Sheerness and the Isle of Sheppey, with the Junction of the Thames and Medway* (Pl. 201), exhibited in 1807, he brought together his love of sailing, weather, wind, colour, raw physical sensation, and those whose lives were filled with such things. No one was more exposed to nature than a seaman, or more dependent on his knowledge of it for survival. His living relied upon understanding navigation, wind, weather, seasons, oceanography, the habits of fish, the mechanics of sailing. He had to be able to predict the development of a situation, read the signs, understand natural dynamics, foresee what would happen next, and be ready to cope with and exploit every circumstance.

In the painting the sun is low to the right and just catches the top of the waves. Since we are looking south the sun must be in the west and therefore setting. Some fishermen

199 *Newark Abbey on the Wey*, ?exhibited Turner's Gallery, 1806. Not a specific view of Newark, but a more general recollection of life on the river as Turner experienced it during his sailing expeditions of 1805 (compare Pl. 138).

Oil on canvas, 91.5 × 123.0 cm, Yale Centre for British Art, New Haven, USA.

200 *Harvest Dinner, Kingston Bank*, exhibited Turner's Gallery, 1809. Based on an oil sketch
of 1805 (Pl. 134). One of Turner's most unflinching views of the hardship of life on the land.

Oil on canvas, 90.0 × 121.0 cm, Tate Gallery, London (491).

201 *Sheerness and the Isle of Sheppey, with the Junction of the Thames and the Medway from the Nore*, exhibited Turner's Gallery, 1807. Based on studies made on a trip out to the estuary in 1805 (see Pl. 177), fully utilizing a knowledge of sailing in a sympathetic and dramatic depiction of the hardships of lives spent in direct association with nature.

Oil on canvas, 108.6 × 143.5 cm, National Gallery of Art, Washington DC (where known as 'Junction of the Thames and the Medway').

in a small boat seem to have been out for a good while, perhaps most of the day, for they have a number of fish on board. A strong wind is blowing from right to left, about 60° off our starboard bow, and the sky is overarched by storm clouds. It is high time that they made their way back to the distant shore, but their rudder is giving trouble, and one leans perilously over the stern, attending to something below the waterline. Another holds onto his legs. To the left two cutters are sailing across the wind at maximum speed. The fishing-boat is directly in its path. Another crew member shouts something to the two attending to the rudder, and from his expression we can suppose that his message has some urgency. The fourth sits up at the bow, watching two cutters passing on a port tack. These are making progress only with difficulty. They have foresails and jibsails up, and tack close into the wind. The big spritsails help, but we can see that the nearer of the two is busy trying to sheet in the mainsail, that is, to pull the boom round to the middle of the boat to try and catch some wind, and we can see that its sail is loose, compared to the more distant boat. This is mostly a product of the further boat having got windward and robbed the nearer of its wind. This is a bit unkind, particularly as the going would have been hard enough as it was.

Meanwhile, the danger to the foreground boat is acute. The cutter is bearing down at top speed, with its sail spread full to the wind. The captain would be reluctant to turn to port (that is to our right) because that would be to lose his speed and in any case he would risk a collision with the virtually stationary vessels there. He must be tempted to bear away to starboard, that is to our left, for that will maintain his speed or perhaps even increase it, but as we can see, and he cannot, there is a buoy in his way. Hitting that could prove catastrophic. The only solution would be to turn hard into the wind, tuck in behind the cutters to the right and, with the sail full (there is after all, no time to get it down),

the boat will come to a more or less dead halt. He needs to take this course immediately, but we cannot have any great confidence that he will.

Our ability to see this depends on the extent to which our experience measures up to that of the sailors in the picture. Despite the fact that many of Turner's marines contain interesting, swiftly developing, sometimes potentially disastrous situations, most of his commentators have concentrated on aesthetic aspects instead. The more noteworthy features have included such things as 'the light on the sea', 'the colouring . . . natural and masterly', the 'transparency and undulation to the sea', and the effects have been described as 'awe-inspiring', 'amazing', and 'terrific'.[45] Skills of illusion and aesthetic effect are the main things that have been required, and, while there is much of this sort to be obtained from *Sheerness*, it is hard to imagine that any of the figures in it would share our enthusiasm for the beauty or sublimity of the sky, the colour of the sea, the effects of light, or the freshness of the breeze. They have urgent reality to deal with, which is uncomfortable and unpleasant, and they would very likely consider such aesthetic ideas and their possessors fatuous and effete. And not without good reason, for the very capacity to enjoy this scene is in part a product of being insulated from the more uncomfortable aspects of reality. Turner was painting on the leading edge of a front of change in attitudes to nature. As more people came to live in cities and large towns and took jobs in the clerical, retail, or industrial sectors, so fewer came to have any direct contact with nature. It became something to read about in a poem, to dip into occasionally as a recreation activity, and to enjoy in pictures such as *Sheerness*. Turner was one of the first representatives of this new type in art. He made it his life's work to experience as much of nature as possible, and to report on what he found in his pictures.

III Relentless Flow

Home on the Thames. Hammersmith. Sandycombe Lodge. England after
Waterloo. The end of London Bridge. Retrospect and farewell. Sunrise on
Armageddon. The proper pace of things.

While still at Isleworth Turner decided to make the Thames
his home. On 10 May 1806 Joseph Farington reported that
'Turner is going to reside abt. 10 or 12 miles from London,
& proposes only to retain in London His Exhibition gallery.
This he does from an Oeconomical motive.'[46] He paid rent
on Ferry House to March 1807 (see n. 6 to Part II), but
during 1806 the opportunity arose to take a lease of a house
on the Mall at Hammersmith. He had moved in by the
autumn.[47] It was 'of a moderate but comfortable size, and
its garden, intersected by the Church Path, extended to the
water's edge. The house, a white one, with another house at
its side, was on the north of the Church Path.'[48] It stood just
beyond the Old Ship Inn near the site of the West Middlesex
Water Works, and 'stood open to the river and sunlight,
surrounded by meadows and market gardens. The Church
Path which ran in front of it was a country lane fringed with
trees.'[49] At the end of the garden was a summerhouse:
'Here, out in the open air, were painted some of Turner's
best pictures . . . he remarked that lights and a room were
absurdities, and that a picture could be painted anywhere.
His eyes were remarkably strong. He would throw down his
water-colour drawings on the floor of the summer-house,
requesting my father not to touch them, as he could see them
there and they would be drying at the same time.'[50] Some
of these pictures would have been the subjects that were
worked up for exhibition at his gallery in 1807, 1808, and
1809.

Although he did not produce any more oil sketches,
he continued to explore the river, and sketchbooks used
at Hammersmith contain observations of skies, flowers,
boats, and rural figures, continuing the themes begun at
Isleworth.[51] Up to 1808 the Thames was his principal sub-
ject. He showed "Views on the Thames, Crude Blotches"[52]
at his own gallery in 1807 and devoted almost his whole of
his 1808 show to a survey of the river from its upper reaches
to the sea. When John Landseer saw it he enthused: 'The
shew of landscape is rich and various, and appears to flow
from a mind clear and copious as that noble river on whose

banks the artist resides, and whose various beauties he has
so frequently been delighted to display.'[53]

Not only was Turner establishing a reputation as a
Thames specialist – 'so frequently' had he shown its 'various
beauties' since Isleworth, but he was also now known as a
resident of the scenery he depicted. Landseer went on to
draw attention to the truthfulness of his work:

> His effects are always well studied, and in most instances
> striking. Where they are otherwise, they are still well
> studied; and he who thinks most, and who knows and
> feels most of art, will be best satisfied that they are what,
> in those cases and under those circumstances which the
> painter has prescribed to himself, they ought to be. Where
> other artists have thought it necessary to exaggerate in
> order to obtain credit for superior truth, Turner begets a
> temperance, and steadily relies on the taste and knowl-
> edge of his observers to credit the veracity of his pencil . . .
> Perhaps no landscape-painter has ever before so success-
> fully caught the living lustre of Nature herself, under all
> her varying aspects and phenomena, of seasons, storms,
> calms, and time of day. The verdant and chearful hues of
> spring, the rich mellowness of autumn, and the gleams
> and gloom of equinoxial storms, are to him alike familiar;
> and he dips his pencil with equal certainty and with equal
> success in the grey tints of early dawn, the fervid glow of
> the sun's meridian ray, and the dun twilight of evening . . .
> The greater number of the pictures at present exhibited
> are views on the Thames, whose course Mr Turner has
> now studiously followed, with the eye and hand at one of
> a painter and a poet, almost from its source, to where it
> mingles its waters with those of the German ocean.[54]

After closing his 1808 exhibition Turner resumed his practice
of making lengthy sketching tours and made an expedition
to the north of England, including the first of subsequently
annual visits to Farnley Hall in Yorkshire. The next year he
went down to Petworth to stay with Lord Egremont, before
journeying north again to the Lake District. In the next few

years he went to Kent, Sussex, Yorkshire, and the West Country. The more he travelled, however, the deeper he planted his roots on the Thames shore, and in 1811 he designed and built a small villa for himself not far from the river at Twickenham.[55]

Sandycombe Lodge (Pl. 202) was finished by 1813. As Trimmer remembered:

> It was an unpretending little place, and the rooms were small. There were several models of ships in glass cases, to which Turner had painted a sea and background. They much resembled the large vessels in his sea pieces. Richmond scenery greatly influences his style. The Scotch firs (or stone-pines) around are in most of his classical subjects, and Richmond landscape is decidedly the basis of "The Rise of Carthage". Here he had a long strip of land, planted by him so thickly with willows, that his father, who delighted in the garden, complained that it was a mere osier-bed. Turner used to refresh his eye with the run of the boughs from his sitting-room window.[56]

The garden had a lily pond which Turner stocked with trout from his fishing expeditions;[57] he chased away bird-nesting boys who called him 'Old Blackbirdy'[58] and he entertained friends. The Trimmers of Heston were particularly close to the artist at this time, and Frederick E. Trimmer later recalled:

> I have dined with him at Sandycombe Lodge, when my father [H. S. Trimmer] happened to drop in too, in the middle of the day. Everything was of the most modest pretentions, two-pronged forks, and knives with large round ends for taking up the food; not that I ever saw him so use them, though it is said to have been Dean Swift's mode of feeding himself. The tablecloth barely covered the table, the earthenware was in strict keeping, I remember him saying one day, "Old dad," as he called his father, "have you not any wine?" whereupon Turner, senior, produced a bottle of currant, at which Turner, smelling, said: "Why, what have you been about?" The senior, it seemed, had rather overdone it with hollands [i.e. gin], and it was set aside. At this time Turner was a very abstemious person.[59]

One purpose of the house was to provide himself with a retreat, for he called it Solus Lodge in 1813.[60] As the testimony above shows, however, Turner shared it with many friends, and he subsequently referred to it as Sandycombe. Another purpose must have been to provide his father with a retirement home. He was sixty-eight years old in 1813 and for the next thirteen years Sandycombe was his home at various times, while his son got on with his travels and his work.

William Turner senior looked after the gallery in London and was initially upset at the expense of travelling up daily, but it was not long before he found a solution; 'a friend saw him "gay, happy, and jumping up on his old toes". He explained, Why, lookee here, I have found a way at last of coming up cheap from Twickenham to open my son's gallery — I found out the inn where the market-gardeners baited their horses, I made friends with one on 'em, and now for a glass of gin a day, he brings me up in his cart on top of the vegetables.'[61] Trimmer remembered that he 'had always a smile on his face. When at Sandycombe Lodge, he was to be seen daily at work in the garden, like another Laertes, except on Tuesday, which was Brentford Market day, when he was often to be seen trudging home with his weekly provisions in a blue handkerchief.'[62] Sandycombe in its modest way was the Turners' country seat, and the son often invited his friends down to visit. He enjoyed the companionship of his Twickenham neighbour, the sculptor Francis Chantrey,[63] he entertained Academicians to tea, feasted the engraver John Pye with cheese and porter,[64] and in 1821 invited the whole Pic-Nic-Academical Club to visit on their second annual excursion.[65]

Sandycombe seems to have been something of a pipedream

202 William Havell, *Sandycombe Lodge*, 1814. Turner designed and built this small house for himself in 1812–13, although he made only occasional use of it. The house still stands, a private dwelling.

Copper engraving, published in W. B. Cooke's, *Picturesque Views on the River Thames*, 1814.

for Turner, however, and the pressures of his work and travels meant that he was unable to make as much use of it as he would have liked. On 12 August 1815 he wrote to Trimmer to say:

> I suspect that I am not to see Sandycombe [this year]. Sandycombe sounds just now in my ears like an act of folly, when I reflect how little I have been able to be there this year, and less chance (perhaps) for the next in looking forward to a Continental excursion, & poor Daddy seems as much plagued with weeds as I am with disapointments, that if Miss __ would but wave bashfulness, or – in other words – make an offer instead of expecting one – the same might change occupiers.[66]

We do not know who the lady was, or what the offer could have been, but it seems clear enough that Turner was considering giving the house up, even though it was little more than two years old.

It was 1818 before he managed to spand any length of time there, and in that year he began a huge canvas of the view from Richmond Hill, which he exhibited in 1819 as *England: Richmond Hill on the Prince Regent's Birthday* (Pl. 203). Sketchbooks of 1818 show that he observed a fête on the hill[67] on or about the time of the Prince's birthday on 12 August, and it is known that the Prince rode up to the hill from Kew on the 10th.[68] The previous year Lady Cardigan had held a party in the gardens of Cardigan House on the hill, which was reported in the papers. Although Turner was on his way to Holland at the time it is possible that he had the report in mind in this picture,[69] and that something similar could have occurred in 1818.

In 1815 after twenty-two years, virtually all of Turner's professional career, Waterloo had brought the Napoleonic Wars to an end, and, although it was a little belated, Turner's painting seems to have been his way of celebrating the return of peace and the preservation of the realm. His description of the subject as *England* suggests that it represented the country as a whole. To the right some small cannon, which would have been used earlier in the day to fire a salute, remind us of the recent battles, and to the left a widow dressed in mourning black suggests the death and bereavement the war caused. Meanwhile the soldiers have been engaged in the arts of peace, a military band has been performing and their instruments are scattered around as they turn to the arts of love and carouse with the ladies in the evening sunlight. In the distance a game of cricket goes on in Petersham meadows and in the foreground some girls taken from Watteau's *L'Ile Enchantée*[70] were a reference to the concept of England as an enchanted isle that underpinned the composition. It was now a time for love and celebration, a time to turn to making real the old dream. He quoted from Thomson once again:

> Which way, Amanda, shall we bend our course?
> The choice perplexes. Wherefore should we chuse?
> All is the same with thee. Say, shall we wind
> Along the streams? or walk the smiling mead?
> Or court the forest-glades? or wander wild
> Among the waving harvests? or ascend,
> While radiant Summer opens all its pride,
> Thy Hill, delightful Shene?[71]

And no one could have mistaken the echo of Adam and Eve taking their first steps in the new world at the end of *Paradise Lost*:

> The world was all before them, where to choose
> Their place of rest, and providence their guide:
> They hand in hand with wandering steps and slow,
> Through Eden took their solitary way.[72]

There was much to see in the new world and on the river that ran through it. In 1817 the new Waterloo Bridge was opened, just upstream of the Academy's headquarters at Somerset House, and in the same year a new Custom House, designed by David Laing, was completed to replace the old one which had been destroyed by fire in 1814. Turner made a number of visits to record the new sights. On 7 July 1819 he went with a convivial party of eleven members of the Academy Club – Farington, Dance, Smirke Senior, Thomson, Westmacott, Turner, Chantrey, Mulready, Owen, Bone, and Chalon – for a day on the river in the Ordnance shallop, lent for the occasion by the Duke of Wellington. Farington recorded the excursion:

> At 10 o'clock I went to Westminster Bridge, and there found the Ordnance Shallop . . . We rowed down the river to look at the Iron Bridge [i.e. Southwark] and then proceeded up the river. Till noon the weather was rather bleak, but it then cleared up and was very pleasant. We had 10 rowers. The river was a scene of much gaity from the display of City Barges and Pleasure Boats. We stopped at Barnes, and in the Boat had a loaf and cheese while the Boatmen had fare in the Inn. We then proceed[ed] to the Eel Pye House at Twickenham, where we landed a litle after 3 o'clock, and about 4 we sat down to excellent fare brought from the Freemasons Tavern under the management of a Clever Waiter. We dined in the open air at one

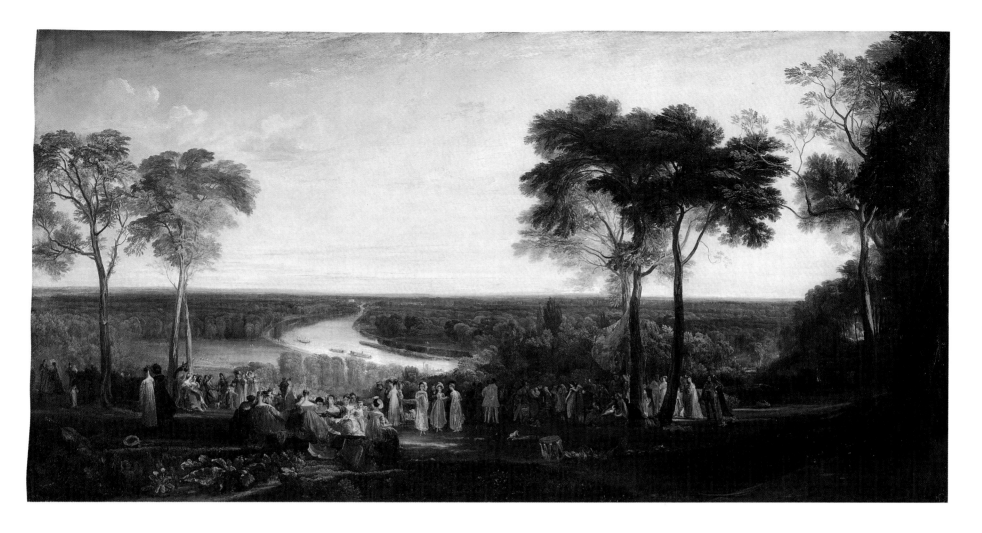

table and removed to another to drink wine and eat fruit. Everything went off most agreeably. Before 7 o'clock we again embarked and rowed down the river, – the tide in our favour, and a full moon. Turner and Westmacott were very loquacious on their way back.[73]

Turner had every reason to be happy. His *England: Richmond Hill* had attracted favourable notices at the Academy. *Bell's Weekly Messanger* for 9 May said that 'It is most gratifying to the British Nation to see her School of Arts rising so rapidly to the highest pinnacle of excellence . . . In the department of landscape Turner as usual takes the lead. He has sent in only two paintings but they are works of the highest brilliancy and merit, and fix the attention of all; a Sea Piece and Richmond Hill.'[74] In May and June Walter

Fawkes opened his collection of Turner watercolours at Grosvenor Place to the public and to rapturous reviews:

> Turner is perhaps the first artist in the world in the powerful and brilliant style peculiar to him . . . the head of all English (and in saying so we necessarily include all living) artists.[75]

> He attracted every eye in the brilliant crowd and seemed to me like a victorious Roman General, the principal figure in his own triumph. Perhaps no British Artist ever retired from an exhibition of his own works, with so much reason for unmixed satisfaction.[76]

Mixed in with the adulation, however, is another note, of Turner's individuality, perhaps making him slightly out of

203 *England: Richmond Hill, on the Prince Regent's Birthday*, exhibited RA 1819.

Oil on canvas, 180.0 × 334.5 cm, Tate Gallery, London (502).

151

step with reality. The commentator on the Grosvenor Place exhibition remarked on the style *peculiar* to him and on 16 May *Bell's Weekly Messenger* returned to the subject of *England: Richmond Hill* to say:

> The distant country is most inimitably painted with all the aerial tints of Claude; the foreground is spirited – the beautiful little peeps of the river here and there are very natural, and give a pleasing variety to the whole. The grouping of the figures is judicious to help the light and shade; but we must confess, the distance, the foreground, the trees and the figures are all Italian. On Richmond Hill, and on such a day, John Bull with his dame, with the rustic lads and lasses of the village, sporting under the sturdy oak, would have been more characteristic of England.[77]

The Claudian ideal no longer held. In the last years of the eighteenth century when Turner's imagination was formed, and even in 1805, it was possible to believe in the classical idyll, but now, in the years after Waterloo, it was dead, a casualty of the war. *Bell's* review implies that Turner was clinging to his poetry and his dreams, and that the new world was a more prosaic place altogether. It was now obvious that the world which Turner dreamed of building would never be able to come into being; it was destined to remain but an ideal. Turner seems to have decided that he wanted nothing to do with such a dull place and thereafter concentrated increasingly on the past and on travelling abroad. A few weeks after the picnic he set off for Italy in search of the classical paradise.[78] On the Thames he recorded hardly any of the new features built after 1820, but concentrated on the remains of what might have been, on the sites with which he had been associated in his youth and in 1805, and on the gradual disappearance of the world to which he belonged as the future took its place.

The process of dismantling the old world began almost immediately. In 1823 Parliament passed an Act to build a new London Bridge, condemning the structure which had stood at least since Norman times. One of the most important physical links with London's past was to be severed. The new bridge was designed by John Rennie, with some of the most magnificent arches in the world. It crossed the river just upstream of the old one, but as the new bridge took shape Turner almost completely ignored it.

As the old London Bridge was condemned so Turner began to develop a more general awareness of time passing. In 1824 he was approaching fifty years of age and taking stock of himself and his past. During the late summer or autumn he collected all his sketchbooks together and numbered and labelled them.[79] There were about 125 in all, recording his life and experience in some ten thousand pages of drawings and jottings. It had already been a long and extraordinarily full life. Mulling over the experiences recorded in these book must have been a profoundly thought-provoking experience. It certainly put him in a reflective frame of mind and he began a series of watercolours for engraving called *Picturesque Views in England and Wales*, in which he made a major retrospective survey of his exploration of his native country over a period of some thirty-five years.[80] In title and concept it took him back to the very origins of his career as a schoolboy in Brentford, colouring plates in Henry Boswell's *Picturesque Views of the Antiquities of England and Wales* and hoping that one day he too might be able to visit the sites introduced in its pages.

The death of his great friend, Walter Fawkes, in October 1825 increased his sense of mortality still further and in January 1826 he wrote to another northern friend James Holworthy: "Alas! my good Auld lang sine is gone . . . and I must follow; indeed I feel as you say, near a million times the brink of eternity, with me daddy only steps in between as it were, while you have yet *more* [Holworthy was six years younger than Turner] and long be it I say."[81] If Turner's morbidity was a little premature with regard to himself – after all he had another twenty-five years to live – his fears were real with respect to his father, now eighty. He began his letter by reporting that "Daddy being now released from farming thinks of feeding," indicating that he had come to live with his son at Queen Anne Street. His living alone out at Sandycombe had worried Turner for some time, "Dad," he is reported to have said, "was always working in the garden and catching cold, and required looking after."[82] William Turner senior spent what seems to have been a busy four years at the studio up to his death on 21 September 1829. In 1826, with his father at home with him, Turner had no further use for Sandycombe and on 19 June he sold it to one Joseph Todd of Clapham 'in consideration of the sum of five hundred pounds of lawful money'. This was less than it had cost him to build.[83]

Before he gave up the house he made a number of trips up-river, as it were to bid farewell to the landscape in which he had spent so much of his time and from which he had derived so much inspiration. His thoughts returned to the ideas which had interested him at Isleworth and in sketch-books dating from about the time he sold Sandycombe we

CCXII — 23

204 River Scene, 1825. About the time that he gave up Sandycombe, Turner revisited many of the sites studied in 1805, and revived many of the themes which had concerned him then.

Watercolour, 11.5 × 18.8 cm, 'Thames' sketchbook, Tate Gallery, London, TB CCXII 23.

find him recording the same range of Thames observations in pencil and watercolour and classical compositions in line and ink washes.[84] Unlike his earlier work, however, the pencil sketches are mostly quick notes and there are none of the detailed, time-consuming drawings of the sort found in, for instance, the *Thames from Reading to Walton* sketchbook, and the watercolours do not attempt to describe detail or the physical elements of actually being there. Many are instead composed of evanescent washes, almost Chinese in style and ethereal (Pl. 204). They are in many respects a way of *not* engaging with reality, of transcending it, of letting go, of being able to say goodbye.

Among the sites he revisited were Richmond, Windsor, Eton, Hampton Court, and Walton Bridges, which were memorialized in finished watercolours in the *England and Wales* series. In every one he reworked the scene from his

first viewpoint of the site. *Windsor Castle, Berkshire* (Pl. 205) returned to the viewpoint of a pencil drawing of the 1790s (Pl. 19) and even included the same detail of a barge with its mast and shrouds against the light and a flag flying from the castle. In *Hampton Court Palace* (Pl. 206) he returned to the scene of his earlier oil sketch (Pl. 135). Likewise in other *England and Wales* subjects of Eton, Walton, and Richmond, he returned to viewpoints visited on his expeditions from Isleworth. In every case these pictures were his final word on the subjects and he never went back to sketch at any of the sites again.

The remainder of his Thames subjects were equally valedictory. On the evening of 16 October 1834 a great fire destroyed the Houses of Parliament.[85] By seven o'clock in the evening the House of Lords was a mass of flames and by midnight the blaze had devastated more or less the whole

153

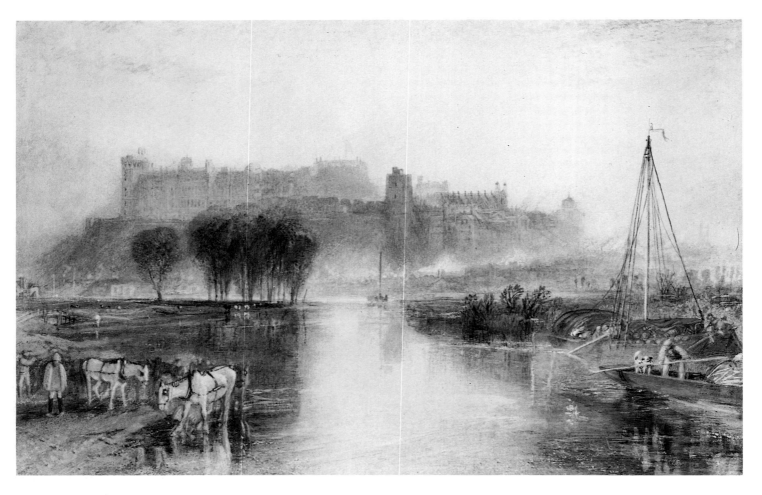

205 *Windsor Castle, Berkshire,* c.1829. Many of the subjects selected for Turner's 'Picturesque Views in England and Wales' series have a valedictory quality about them. Here he returns to the viewpoint of his first sketch at Windsor (Pl. 19).

Watercolour, 28.8 × 43.7 cm, British Museum, London (1958-7-12-432).

riverside complex, with the exception of Westminster Hall. A huge crowd gathered on the banks and in boats on the river. Turner was among them, making pencil and watercolour studies, and from these he developed some of the most powerful paintings of his career (Pl. 207). It seemed to many observers as if they were witnessing the very heart and history of England being consumed before their very eyes. As the correspondent of the *Gentleman's Magazine* put it: 'I felt as if a link would be burst asunder in my national existence, and that the history of my native land was about to become, by the loss of this silent but existing witness, a dream of dimly shadowed actors and events.'[86] Turner took no interest in the buildings that replaced them, even though the first stone was laid in 1840 and the buildings were largely completed before his death in 1851. The more optimistic looked forward to a new beginning and likened the new start

to the rebuilding of London after the Great Fire of 1666, but the new buildings were built to administer and govern a world in which Turner would take no part.

Hard on the heels of the Parliament fire came other intimations of mortality. In November 1836 W. F. Wells died. He had been one of Turner's closest and oldest friends. He was a companion in the 1790s, witnessed the inception of the *Liber Studiorum*, and in his company Turner made some of his first oil sketches from nature. Turner sobbed uncontrollably at the news and declared 'I have lost the best friend I ever had in my life.'[87] A year later, on 11 November 1837, Lord Egremont died. He had been the leading purchaser of Turner's Thames pictures after 1805 and his support was crucial during this phase of the artist's career. In the 1820s and 1830s Petworth House had been his regular resort. Egremont's death in some way brought to a

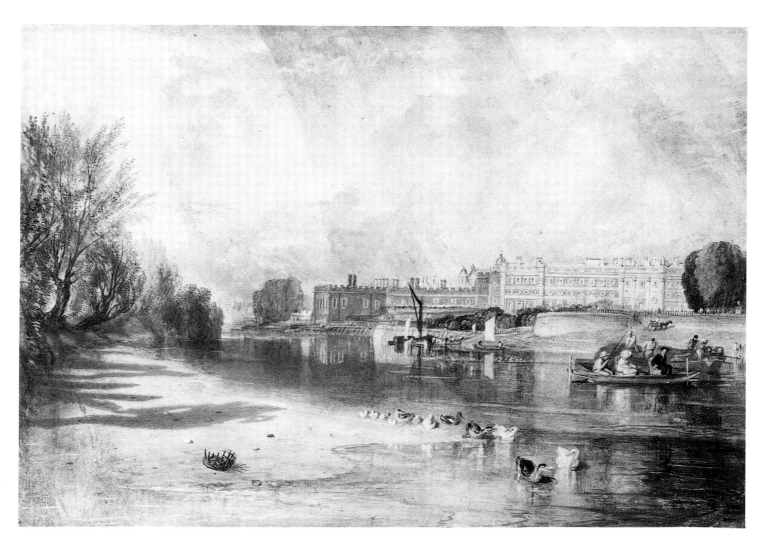

206 *Hampton Court Palace,* c.1827. Returning to the viewpoint of an 1805 sketch, Pl. 135.

Watercolour, 28.8 × 40.5 cm, Private Collection.

close the late Georgian and Regency way of life that Turner had striven for and enjoyed so much.[88] As one historian put it: 'England's greatest Romantic painter outlived his own epoch by nearly two decades and suffered the indifference and frequent hostility of an early Victorian society increasingly alien to his Romantic subjectivism.'[89] Criticism of his work concentrated on its unreality, its exaggeration, and its extravagance: 'In matters of arts, the public generally preferred a comparatively literal-minded, factual approach, but preferably a bit prettified and/or enhanced by anecdotal incident.'[90] Here was a poet who had outlived his relevance and was adrift alone on a sea of prose.

In 1839 he exhibited *The Fighting 'Temeraire', tugged to her Last Berth to be broken up, 1838* (Pl. 208).[91] The *Téméraire* had fought at Trafalgar in 1805, the year of Turner's closest involvement with the Thames, and had long outlived her utility in an age of ironclads and steam. She had been lying in ordinary since 1813, first in use as a floating prison, then as a receiving ship, and later as a victualling depot at Sheerness.[92] In 1838 the Admiralty decided to scrap her and sold her to Beatson's breaking yard at Rotherhithe. She was tugged to her doom on 6 September 1838. Although there are various stories of Turner actually seeing the ship being towed up against a glorious sunset,[93] the ship in the painting bears no resemblance to the inglorious dismasted hulk that she was in fact, and various eyewitnesses testified

155

that there was no glorious sunset on that day.[94] Turner imagined her as a great gossamer ghost, a living, creaking, breathing creature of the sea and wind, a vast co-operation between man and nature, a representative of a more natural world being tugged to death by the upstart, squat, ugly, new one. From the first it has been assumed that the sky shows a flaming sunset,[95] but Turner cannot have sailed the Thames so much for so long without having learned that if the ship was coming upstream, then he was looking *east*. Since colour printing began there has been a marked tendency to reproduce the picture as much hotter than it is in fact, thus distorting its predominantly cool background. In truth its coolness is that of dawn, and since Turner knew that he would be looking east in the painting, he clearly intended it to be read as a sunrise. As every sailor or shepherd knew: 'when the sky was red in the evening a sign of fair weather, but when red and louring in the morning a sign of foul weather.'[96] Although the reading of the picture as a memorial to the end of a glorious natural age is clearly intended, the idea that it bows out in a blaze of sunset glory presaging fair weather is more sweetly comforting than true. Turner was making a comment on the age that was succeeding. The *Téméraire* goes to its death in the livid glare of a sunrise on Armageddon.

The new age could reach into the most sequestered spots. In the late 1830s the Great Western Railway opened up the upper reaches of the Thames on its way through Reading to Bristol. The railway was the product and apotheosis of the great industrial system that had developed during Turner's lifetime. Isambard Kingdom Brunel's bridge at Maidenhead was built in 1839 and bounded imperiously across the river in the two most enormous brick arches in the world, carrying the railway across the river on a flat level so that the traveller might not even notice the obstacle he was surmounting. In 1844 Turner made this bridge the subject of a painting called *Rain, Steam, and Speed – the Great Western Railway* (Pl. 209).[97] Its composition contrasts the new bridge and its traffic at the right with the old bridge at the left, built just over sixty years earlier and needing thirteen arches to carry its narrow roadway over a steep hump to reach the other side. Things had clearly developed a long way in the years that separated them.

The road bridge was in fact almost exactly the same age as Turner, having been started in 1772 and all but completed by 1775. Its classical form and comparatively simplistic structure were precisely the stuff of which Turner himself, or at least his imagination, had been composed. Like him, it had been overtaken by a world the physics of which it could

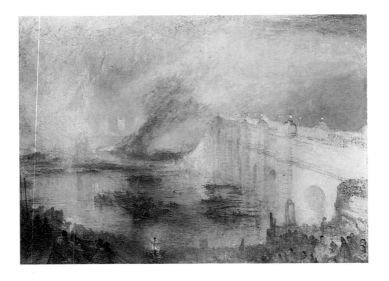

207 *The Burning of the House of Lords and Commons, 16th October, 1834*, exhibited British Institution, 1835.

Oil on canvas, 92.0 × 123.0 cm, Philadelphia Musuem of Art.

not comprehend, and which, instead of trundling along at the pace of a pedestrian or a slow cart or horse, cut across the country in a straight line at bewildering speed, without regard for contour or feature or impediment. Turner remembered his time on the river forty years earlier, when such things could never have been imagined, when he came up to Maidenhead in his small sailboat, fishing and sketching and painting as he went, waiting for locks to open or close, drain or fill, looking for a breeze or a tide, drifting with the wind or current. Then the speed of the plough, as he painted it at the right, or a hare on the tracks in front of the engine, or a small boat as at the bottom left, equipped with an umbrella to keep off the rain, or the current of the river as it meandered its way to the sea, was the measure of the true pace of things.

In 1805, when Turner was young, that pace was slow enough to savour and enjoy. Experience lasted long enough for one to consider it, reflect upon it and be fulfilled in the sensations of one's own existence. It was a world which, even if it was not quite the classical idyll of which the poets spoke, was close enough to it for there to be echoes of the old perfection within it and the possibility of still finding nymphs on its shores. In 1805 the traveller was a part of that world, in 1844 he hurtled through it at a speed of fifty miles an hour, with no regard for its existence. The river measured the natural pace of things. Man was now moving so fast as to have lost his contact with Nature. Nothing can be seen clearly, nothing can be quite grasped and known.

His paint was still a physical reality, however, and colour

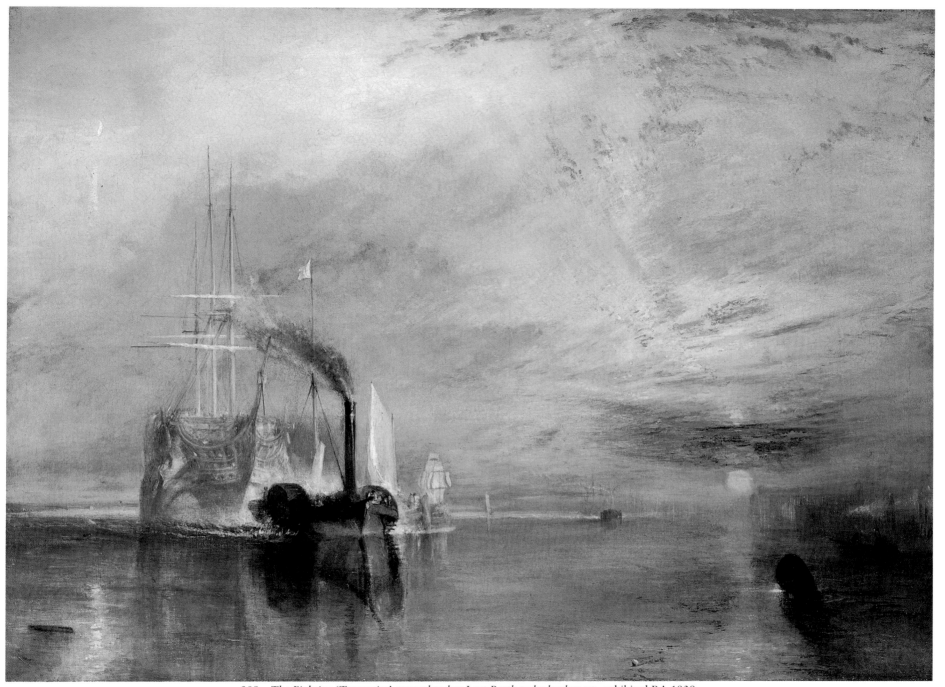

208 *The Fighting 'Temeraire', tugged to her Last Berth to be broken up*, exhibited RA 1839.
Despite the fact that we must be looking east, it is almost universally held that he has depicted a
sunset.

Oil on canvas, 91.0 × 122.0 cm, London National Gallery (524).

reels and daubs and swathes of paint testify still to his physical engagement with wherever he was. For one who had spent more or less his whole life in finding ways of structuring, detaining, and retaining his experience of the world, and of travelling through it on foot or on horseback or by boat, the spectacle of the railway must have seemed the very negation of all that he had valued and stood for. The traveller through life at this pace would have nothing whatsoever to show for his journey. Turner, on the other hand, had a memory more fully stocked with experience than perhaps anyone else alive, and a studio filled with sketches and studies as witness and testimony to having lived as fully as he could and valued that life as intensely as possible. In the last years of his life he moved to Chelsea, to a house overlooking the Thames from Cheyne Walk,[98] from which he could watch sunrises over Lambeth and sunsets over Barn Elms. He did not record it in sketches, but savoured the experiences while he could. In this house, on 19 December 1851, he died. No one has ever loved his physical and imaginative engagement with the world more passionately than Turner, and no artist has ever embodied so much of that passion in his work. Among the stock of that life in his studio were five sketchbooks, some battered boards, and some scruffy rolls of canvas that were the products and records of some of the most vivid years of that long and valued life.

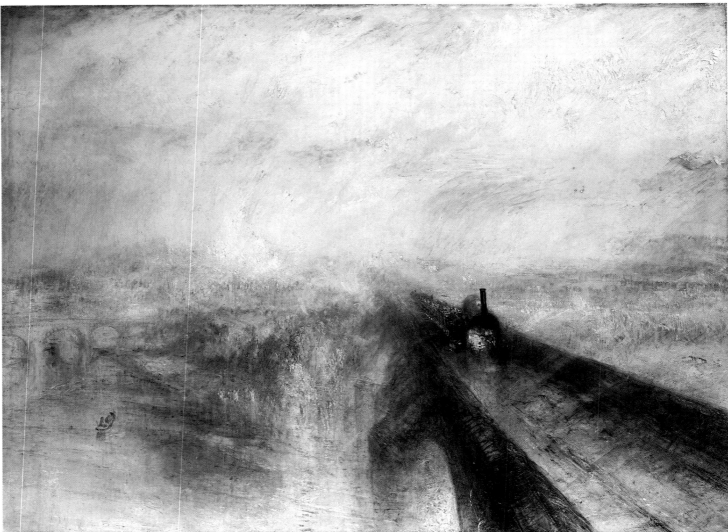

209 *Rain, Steam and Speed – the Great Western Railway*, exhibited RA, 1844. The train is passing over Brunel's new bridge at Maidenhead, with the old road bridge, opened in 1776, to the left. Turner is contrasting the pace of life of his youth, and of when he boated up and down the Thames from Isleworth in 1805, with that of the new age by which he had been overtaken.

Oil on canvas, 91.0 × 122.0 cm, The National Gallery, London (538).

IV THE ISLEWORTH SKETCHBOOKS

Contents

This book is principally concerned with Turner's residency at Syon Ferry House, Isleworth, and the sketches he made there. The following is a summary of the main arguments used in assembling, arranging, and dating the body of work discussed.

Turner paid rates on Ferry House from 17 January 1805 to 15 May 1806. From 30 October 1806 the house is described as empty (see note 6 for Part II). It is clear from this that he used the house during the summer of 1805. Turner addressed letters from Ferry House on 23 November 1805 and 14 December 1805 (Gage, 1980, nos. 11–12), showing that he continued to use the house during the early part of the winter. It is clear from the rate books that he vacated the house between late May and October 1806. We are therefore looking for a body of work produced at Isleworth in the summer of 1805, with the possibility that some Isleworth work could have been produced in 1806.

There are five sketchbooks containing Isleworth subjects: *Studies for Pictures Isleworth* (TB XC), *Hesperides (1)* (TB XCIII), *Hesperides (2)* (TB XCIV), *Wey Guilford* (TB XCVIII), and *Thames from Reading to Walton* (TB XCV). These form part of the Turner Bequest at the Tate Gallery, London. The first four contain a mixture of Thames sketches and studies for literary subjects. *Studies for Pictures Isleworth* contains Thames subjects at Isleworth, Kew, Richmond, and Hampton Court, and also has the address "Sion Ferry House Isleworth" written inside the front cover. *Hesperides (1)* contains sketches made at Isleworth, Kew, Richmond, and Windsor, and later at the Port of London and out in the estuary. *Hesperides (2)* contains sketches made at Isleworth, Walton, and on the upper Thames near Abingdon. *Wey Guilford* contains sketches made at Windsor and on the River Wey between Godalming and Newark Priory. *Thames from Reading to Walton* contains sketches covering the whole course of the Thames between Kew and Oxford. In general we can see that Turner made studies in all sketchbooks in the vicinity of Ferry House, particularly at Isleworth, Kew, and Richmond, and in the bound sketchbooks

these subjects occupy the first pages. Local exploration was followed by voyages up-river to Windsor and along the Wey as far as Godalming, and then to the upper reaches of the Thames as far as Oxford. The trip to Windsor and along the Wey to Godalming recorded in the *Wey Guilford* sketchbook is exactly mirrored by the subject range of a group of oil sketches on mahogany panels. Given the closeness of the parallels between sketchbook and panels, there seems to be little doubt that the panels and sketchbook were used on the same trip. There is a similar correspondence of subjects between the sketches in the *Thames from Reading to Walton* sketchbook and a series of oil sketches on canvas. In some cases discussed in the text, there are such specific comparisons between sketchbook and canvas as to leave little doubt that both were used on the same trip.

A number of pieces of evidence date specific sketches and studies to 1805, and by implication larger groups and sequences, to the extent that, in the absence of any evidence to suggest otherwise, it would seem reasonable to date the whole body of work to 1805. In the *Hesperides (1)* sketchbook there are studies for the painting *The Goddess of Discord in the Garden of the Hesperides*, which Turner exhibited at the British Institution in February 1806. These studies must have been made while the picture was on the easel, no later than the previous autumn. Sandwiched between these is a series of studies for *Dido and Aeneas*, which, it would seem likely, must have been on the easel at the same time as *The Goddess of Discord*. A colour study for *Dido and Aeneas* appears in the *Studies for Pictures Isleworth* sketchbook, suggesting contemporaneity with *Hesperides (1)*. Adjacent to this study is a colour study for *Windsor Castle from the Thames*. This painting is signed "IWMTurner RA Isleworth", and must therefore have been signed in 1805 or 1806, during the period of Turner's residency at Ferry House. The sketch on which this painting is based is in the *Wey Guilford* sketchbook, and since this also contains studies of Isleworth, which cannot have been made before the summer of 1805, it

would seem reasonable to conclude that the Windsor sketches were made in 1805, and the painting exhibited and signed in 1806.

The Thames from Reading to Walton sketchbook contains studies for a painting of *Walton Bridges*, which we know to have been paid for by Sir John Leicester in January 1807. This would suggest that the painting was exhibited at Turner's own gallery in the spring of 1806, and that the sketches and studies for it would have been made the previous summer. The painting is further related to studies in the *Hesperides (2)* sketchbook, which also contains Isleworth subjects, as well as subjects on the upper Thames at Abingdon, Culham, and Sutton Courtenay. These last overlap with the known upper limit of Turner's exploration of the Thames in the *Thames from Reading to Walton* sketchbook.

The sketchbooks share a common pattern in that they start with subjects around Isleworth, Kew, and Richmond, interspersed with designs for classical subjects, and then develop to include subjects ranging up the Thames and the Wey. The *Hesperides (1)* sketchbook also records a trip out to the Nore. Since we know that Turner had a boat, and there are studies of different sail types in the *Wey Guilford* sketchbook, and since many of the sketches are taken from mid-river, it would seem reasonable to assume that he practised his sailing skills first in the immediate vicinity of Ferry House, before heading further afield to Windsor, the Wey, and Oxford. The more hazardous voyage out to the open waters of the estuary could only have been tackled by someone with considerable experience. This is the order that the material is dealt with in the main part of this book.

In the sketchbook listings which follow the identifications, so far as is possible, have been established by myself in the field, and the titles are my own. Where I have been unable to improve on Finberg, 1909, I have retained his title in ⟨pointed⟩ brackets. Inscriptions by Turner are given in "double" quotation marks, others in 'single' ones. An arrow (↑) signifies that the sketch was made upside-down in relation to the main flow of sketches in that book.

'Studies for Pictures Isleworth' sketchbook, 1805 (TB XC)

Good-sized sketchbook, bound in calf, with four brass clasps. Two flyleaves of white paper at either end, the remaining 80 leaves of a heavier paper prepared with a wash of grey.

$10 \times 5\frac{3}{4}$ ins. WM: of flyleaves '1799'; of drawing paper 'J. Whatman 1794'.

Turner's label down spine: "37 Studies for Pictures Isleworth". The number is a mistake for 73, since TB XXXIX *North Wales* sketchbook is also numbered 37 and 38 is another Wales book, TB XLVI *Dolbadarn*. The consecutive numbering of TB XCIII *Hesperides (1)* (71), TB XCIV *Hesperides (2)* (72), and TB XCVIII *Wey Guilford* (74) shows that Turner considered them as a group.

Address inside front cover: "JMWTurner / Sion Ferry House / Isleworth"

Turner rented Syon Ferry House, Isleworth from January 1805 until sometime after May 1806 (see note 6 for Part II). The inclusion of the address suggests that the book was started soon after Turner took up residence. This would have been after his spring exhibition of 1805 which closed on 1 June. Page 29 has a study for the painting *Windsor Castle from the Thames* (B&J 149) which is signed "IMWTurner RA Isleworth". The painting must therefore date to 1805 or 1806.[1] The sketches on which the painting is based are in the *Wey Guilford* sketchbook (TB XCVIII), which also contains Isleworth material. Inside the front cover is a list of banknotes dated May to July 1804. Turner was presumably recording their encashment during his residence at Ferry House.

Splashes of red and white oil-paint on the front cover and oil-stains throughout the book testify to its use next to his easel. The book has a luxurious binding appropriate to a successful and ambitious young painter, and toned paper such as that used by the great masters of the past. Although many of the sketches seem to have been made first in pencil, most have been overworked in ink. The choice of literary subjects, together with the use of brown ink and washes, seems consciously old-masterish.

Contains Thames observations and studies for classical and literary subjects. Initially used in the vicinity of Isleworth, Kew, and Richmond, but later ranging at least as far afield as Hampton Court. For one study for a classical picture, f. 49a, he compiled a list of alternative titles. He was taking the opportunity to verse himself fully in the classics during this period, to take his work onto a more elevated academic and intellectual plane. In some cases we see him shaping his observations

of the Thames into grand classical theatre. In the space of a single summer he laid the foundations of finished paintings for the next decade. His Carthaginian subjects make their first appearance here, and it seems possible that a number of pictures were begun at this time, but not completed until nearer their date of exhibition. A similar range of subjects, style, and topography is found in the *Hesperides (1)* sketchbook (TB XCIII).

Inside cover: Executors' inscriptions:
'No 142 George Jones'; 'CLE'; 'WK'.
'XC [pencil]'; 'XC [ink]'

A faint pencil sketch of four boats in a line

A list of banknotes by Turner (in ink):

"2 July 1804 *164*
50 Wm Venison[?] W Diss
14 June 1804 *9534*
25 Wm Hepworth [read by Finberg as 'Kipworth']
F Kensall
5 May 1804 *7382*
20 W George Fleetwood"

The address (in ink):

"J M W Turner
Sion Ferry House
Isleworth"

Below is pasted an irregular piece of blue paper with the inscription [in ink]:

'Invent 142.
Fine studies for pictures
May be shown as it is
One leaf cut out, where a real
leaf of herb is laid. The study
cut out was of vegetation at Warwick.
The leaf probably to illustrate it.'

1 Study of a Roman embarkation scene. Pen and ink. Three alternative titles suggested at top of sheet: "Meeting of Pompey and Cornelia at Lesbos"; "Parting of Brutus and Portia"; "Cleopatra sailing down to Cyd..i..[?]", taken from Plutarch's *Lives of Illustrious Greeks and Romans*.

1a–2 Two studies of a Roman embarkation scene, with figures grouped around a stone staircase and landing with fluted columns. Pen and ink. An almost illegible pencil inscription just above the gutter. Possibly Antony and Cleopatra, cf. 84a; 11a shows a more elaborate version of the same theme of stairs, columns, and figures.

2a Blank.

3 Two studies of a figure with a bow. Pen and ink. The one on the left similar to the figure in *Apollo and Python* (B&J 115), exhibited RA 1811, but painted earlier? These studies are on top of a much fainter pencil sketch of a classical rotunda by the river,

which is developed further on 4, 5, 6, 9, 29, and 31 and in the *Thames from Reading to Walton* sketchbook, TB XCV 11, resulting in the painting called *Isis* by Turner when he published it in the *Liber Studiorum* in 1819, but erroneously known as *The Thames at Weybridge* (B&J 204).

3a Blank.

4 The same site as 3, related to *Isis* (B&J 204). Pencil.

4a Blank.

5 The same site as 3 and 4, related to *Isis* (B&J 204). Pencil.

5a Blank.

6 Study for *Isis* (B&J 204). Pencil, wash, and wiping-out.

6a ⟨Commencement of pencil sketch of trees and landscape.⟩

7 Kew Palace(?). Pencil wiping and scratching-out. Cf. 8a–11.

7a Blank.

8 ⟨Barge, with carts and horses at its side.⟩ Pen and ink.

8a Kew Palace from the river with the Dutch gables and elaborate chimneys of the old palace in the foreground and the new palace, started in 1801, towering behind it. Syon House in the centre distance. Pen and ink, over pencil. Mid-river viewpoint shows that Turner had the use of a boat. Cf. 42, 43.

9 Kew Palace and Bridge from a viewpoint further downstream than 8a. Pencil, with a little pen and ink applied to trees. Cf. *Isis* (B&J 204).

9a (In top left corner.) Pen-and-ink sketch of a similar group of trees and rustic bridge seen in 9.

10 ⟨A group of trees. Pencil.⟩

10a Blank.

11 Kew Palace and Bridge seen through trees. From a similar viewpoint to W 413, on the Middlesex bank near the entrance to the Grand Union canal. Pencil, with pen and ink applied to buildings in middle and far distance. Cf. TB XCIII 38a. Kew Palace was designed by James Wyatt and abandoned in 1811 while still a half-finished carcass. The building to the left was a basket factory.

11a ↑ Study for a Roman embarkation scene. Pen and ink. Cf. 1a–2. One of the earliest prototypes of the Dido compositions exhibited in 1815 and 1817 (B&J 131, 135).

12 Syon House seen through trees, punts in the foreground. From the same viewpoint as 11, but looking in the opposite direction (cf. trees). Pen and ink.

12a Blank.

13 Kew Bridge and Palace. A similar view to 11, but

with less detail, and not continued so far to the right. Pen and ink.

13a Blank.

14 Trees by the river. Pen and ink.

14a Façade of Roman building. Pen and ink.

15 Classical river scene with trireme. Pen and ink.

15a Blank.

16 Another version of 15. Pen and ink.

16a Blank.

17 Classical scene, prototype of *Dido and Aeneas* (B&J 129, exhibited 1814). Further developed on 21. Pen and ink.

17a Blank.

18 Richmond Hill from the river with The Wick and Wick House (built for Sir Joshua Reynolds) in the centre, Richmond Terrace to the left, and the Star and Garter to the right. Continued to the left to include Richmond Bridge on 19, following. Pen and ink. Note clouds in sky and figures in boats in foreground.

18a ⟨Classical buildings &c. Pen and ink.⟩

19 Richmond Bridge and Hill from upstream. Continuing 18 to left. Note clouds and ray of sun, and fisherman on boat at left. Pen and ink.

19a ⟨Some classical buildings. Pen and ink.⟩

20 Lord Mayor's barge and shallop. Pen and ink.

20a ⟨Some classical buildings with ships. Pen and ink.⟩

21 Study for *Dido and Aeneas* (B&J 129, exhibited RA 1814, but painted soon after the date of this sketch and reworked later?). Pen and ink, watercolour, and scratching-out. Cf. 17 above, and *Hesperides (1)* sketchbook (TB XCIII) 4a, 5, 5a–7.

21a Claudian embarkation scene. Pen and ink.

22 Thames from Richmond Hill, looking west. Pen and ink. The first of a series of four sketches of views from Richmond Hill in which he seems to have had some difficulty seeing the views for the trees. Cf. 11, 12 above.

22a A few pencil lines, continuing the drawing on 23 opposite?

23 Thames from Richmond Hill looking west. Pen and ink.

23a Blank.

24 Thames from Richmond Hill, looking east, with Richmond Bridge glimpsed through trees. Pen and ink.

24a ↑ ⟨Towers among foliage. Pen and ink.⟩

25 Thames from Richmond Hill, with Richmond Bridge, and Isleworth Church in the distance. Pen and ink. A painting by Antonio Joli of about 1750, exhibited at Somerset House in 1977 (Preston, 1977,

no. 19) shows almost exactly the same view before the bridge was built. There are numerous versions, but the view could have been known to Turner through the engraving by Vivares.

25a Blank.

26 Italianate building, presumably somewhere between Richmond and Isleworth, with indications of clouds. Pen and ink.

26a Blank.

27 Isleworth church and the Pavilion from the Richmond bank, cf. TB XCIII 26a for a nearer view of the same scene from further to the left and TB CCIV 9a for exactly the same view. Pen and ink.

27a The corner of an Italianate villa ⟨possibly the one seen in 26?⟩, statue in niche to left.

28 Isleworth church and surrounding buildings seen from a distance to the south. Tree continued onto 27a. Pen and ink.

28a ↑ ⟨Figures in boat, with cattle. Pen and ink.⟩ Loosely related to details of *Windsor Castle from the Thames* (B&J 149).

29 Study for *Isis* (B&J 204). Pen and ink.

29a ↑ Study for *Windsor Castle from the Thames* (B&J 149), pen and ink and watercolour. Based on sketches in the *Wey Guilford* sketchbook (TB XCVIII, 133–132a).

30 A classical rotunda among trees. Study for the left-hand side of *Isis* (B&J 204). Pen and ink.

30a ⟨Classical buildings on river. Pen and ink.⟩ Carthage?

31 River scene, development of 29 and 30 above. Related to *Isis*. Pen and ink.

31a Claudian seaport, with sunrise or sunset. Pen and ink.

32 ⟨On the banks of the Thames. Pen and ink.⟩

32a ⟨Group of classical buildings. Pen and ink.⟩

33 Composition of classical buildings by a river. Pen and ink, pencil, and scratching-out. Loosely based on Richmond, cf. 19.

33a Study for a classical embarkation or landing scene. Pen and ink.

34 Study for an embarkation or landing scene. Pen and ink, with pencil and scratching-out. The foreground seems Carthaginian, but the distance more like the Thames at Richmond. Inscribed "C . . . returning to Cy . . ."

34a Study for an embarkation or landing scene. Pen and ink
[A prossed leaf was found here, which has now been mounted on tissue and bound in.]

35 Syon House with vegetation in foreground. Cf. TB XCVI for other leaf studies. Pen and ink and pencil.

Cf. the large watercolour of Syon, TB LXX L

35a ⟨Some classical buildings. Pen and ink.⟩

36 Hampton Court Palace from the river. Pen and ink. Almost exactly the same view as the oil sketch, B&J 164. Later sketches from the same viewpoint in the *Isle of Wight* sketchbook, *c*.1827 (TB CCXXVI, 2a, 3) formed the basis of the 'England and Wales' watercolour (W 812).

36a ↑ A Harvest Home, cf. "Lord Essex's Harvest Home", TB CXX C. Related to the oil-painting, B&J 209. Cf. studies in the *Harvest Home* sketchbook, TB LXXXVI. Black chalk.

37 Hampton Court Bridge from upstream, with Hampton Court Palace in the distance. Pen and ink.

37a ↑ Study for *Harvest Home*, B&J 209. Black chalk and pencil. Some illegible writing along the gutter.

38 Scene on the Thames with a summerhouse to the right. Pen and ink.

38a Study for a classical embarkation or landing scene. Very Claudian, as many of these studies are, and anticipating the Carthage pictures of a decade later. Pen and ink and watercolour.

39 Bridge on the Thames, probably Kew. Pen and ink. Cf. TB XCIII, 38a.

39a Blank.

40 Distant view of Walton Bridges. Pen and ink. Cf. TB XCVIII, 17a–18.

40a ⟨Classical buildings on a river. Pen and ink and wash.⟩

41 Kingston church. Pen and ink. Cf. TB XCVIII 16a–17.

41a ⟨Group of classical buildings and shipping. Pen and ink and wash.⟩

42 Kew Palace with Syon House in the distance to the right. Dutch House in the foreground. Cf. 8a. Pen and ink.

42a Blank.

43 Kew Bridge.

43a–44 ⟨Study for a [classical] picture. Pen and ink.⟩ Continued to the right on 45, below.

44a Blank.

45 ⟨Continuation of drawing on previous page.⟩

45a ⟨A small classical building on a river. Pen and ink.⟩

46 A view on the Thames. Pen and ink.

46a ⟨Classical buldings, with shipping. Pen and ink.⟩ A more elaborate version of the composition on 45a.

47 ⟨A bend of the river. Pen and ink.⟩ The same place as 46?

47a–48 ⟨Group of trees with winding river. Pen and ink.⟩ Same place as 46 and 47?

48a ⟨Group of classical buildings, with shipping. Pen and ink and wash.⟩

49 A view on the Thames. Pen and ink. Part of same series and in same locality as 46, 47, 48. Continued to right on 50.

49a A classical embarkation scene. Watercolour. Part continued onto page opposite. Alternative titles inscribed above:
"Jason: arrival at Colchis" [the home of Aeëtes and his Daughter Medea, the scene of Jason's heroic deeds to win the Golden Fleece, and the beginning of the romance between Jason and Medea]
"Ulysses: at Crusa [?]"
"Females dancing and crowning the rope [?] with flowers, in the Foreground Figures rejoicing – The left – the Priest awaiting to receive the Fleece. Jason &Argonauts on Board bearing the Fleece" [scenes from the great festival on the Argonauts' return home to Iolchis]
"Ulysses with Ureylus offering her to her Father" [i.e. Euryalus, illegitimate son of Ulysses by Erippe, who met a tragic end at the hands of his father]
Turner's most convenient source would have been R. Anderson's *Works of the British Poets*, which contained Francis Fawkes's translation of Apollonius Rhodius' *Argonautics* in volume 13, and Pope's version of the *Odyssey* in volume 12.

50 ⟨Part of a landscape. Pen and ink.⟩ The continuation of 49 to right.

50a ⟨Study for a classical subject. Pen and ink.⟩

51 ⟨The banks of a river. Pen and ink.⟩

51a Blank.

52 ⟨A river scene. Pen and ink.⟩

52a Classical subject with figures dancing, &c. Pen and ink. Inscribed above with alternative subjects:
"Dido & Aeneas" Cf. 17 and 21 above.
"Nausicaa going to with the Nuptial Garments" (Odyssey)

53 River scene with classical summerhouse not unlike the Pavilion, Isleworth, but for the pedimented summerhouse to right. Pen and ink.

53a–54 ⟨Study for picture of "Mercury and Argus" [cf. B&J 367, exhibited 1836]. Pen and ink⟩. Ovid, *Metamorphoses*, Book I. Argus, who had one hundred eyes, was the guardian of Io, who had been changed into a heifer by Jupiter. Ovid describes her melancholic wanderings by the riverside and her meeting with her father, the river god Inachus. A cow is visible at the left centre of the composition. In order to free Io, Jupiter sent Mercury to murder Argus, whom he lulled to sleep by telling another riverside tale of Pan and Syrinx, which Turner made the subject of his next composition, page 55. Argus' memory was preserved by Juno setting his eyes on the peacock's tail-feathers.

54a ⟨Three classical figures dancing. Pen and ink.⟩ The figures are dancing by the side of what appears to be a large Aeolian harp mounted on a pedestal. Blue and red oil splashes.
Inscribed: "Phaeton's Sisters . . . by his Face". Ovid, *Metamorphoses*, Book II, follows the story of Io with that of Phaethon, who attempted to drive the chariot of his father, the Sun, and let it get the better of him. His charred body fell into the river Eridanus (now called the Po) where a memorial was raised to him. His sisters wept over the tomb until they were transformed into poplars and their tears to amber by the sun.

55 Trees beside the river, with ruined Roman bridge in the middle distance. Given the cow in the left foreground, probably an incident from the life of Io, from Ovid, *Metamorphoses*, Book I, considered on page 54. Used, with 56, as the basis of the unfinished oil painting, B&J 169. Pen and ink and wash with scratching-out; white chalk. Cf. TB XCVIII, 10, which, without the bridge, has a similar composition.

55a Possible subjects for the composition opposite (page 56): "Latona and the Herdsmen", Ovid, *Metamorphoses*, Book VI. Latona was celebrated for her beauty and often consorted with Jupiter. Juno condemned her to restless wandering. Eventually, consumed with thirst, she came to a lake, but the local people would not let her drink. She turned them into frogs. Latona made a striking speech about universal rights to nature: 'Why do you keep me from the water? Water is there for the use of all. Nature has made rippling streams, as she made air and sunlight, not for individuals, but for the benefit of all alike. I come in search of something to which all men have a right.'
"Phaeton's Sisters": see notes to 54a.
"Pan and Syrinx", Ovid, *Metamorphoses*, Book I. The story told by Mercury to Argus (see 54). Pan's pursuit of Syrinx ends when he catches her by the 'still waters of shady Ladon', a river of Arcadia. The sisters of the stream transform her into marsh reeds, which Pan binds into pipes.
"Salamacis and Hermaphroditus", Ovid, *Metamorphoses*, Book IV. An even more erotic tale than the others. Salamacis lived by a woodland pool which was visited one day by the unwilling youth Hermaphroditus. She became overwhelmingly impassioned when he stripped to bathe in the cool water and leaped upon him. Their union was made permanent in a fusion of their physical characteristics and ever after the pool retained its emasculating power.

56 A riverside landscape with a ruined Roman bridge, figures and a flock of sheep in the foreground. Pen and ink, wash, and scratching-out. A slight variation of the composition on 55, and the closer of the two to

the unfinished oil painting, B&J 169. The sheep suggest that the most likely subject is Latona and the herdsmen, which heads the list of possible subjects opposite.

56a Possible subjects for the composition opposite (57): "Jacob and Esau". The story of Jacob is related in Genesis 25–33. Particularly popular in the seventeenth century, it is the source of a number of subjects by Claude, e.g. *Jacob and Laban* at Petworth, and this may be what attracted Turner to the story. The tale itself is a farrago of deceit and dishonesty. Jacob and Esau were the twin sons of Isaac. Esau was the first-born and was a simple, country type. Jacob was a scheming 'dweller among the tents'.
"Jacob and Rachel". Jacob, having tricked Esau out of his birthright and his father's blessing, fled to Harran, where he met Rachel. Laban, her father, was just as devious as Jacob, and after various subterfuges Jacob returned to Esau, with both of Laban's daughters, most of his sheep, and his teraphim, a portable altar with statues.
"Popes Windsor Forest Pastoral or Garth's a Shepherd's Boy, he seeks no better name leading his Flock beside the Silver Thames" The lines are misremembered from Pope's second pastoral, *Summer*, subtitled 'Alexis' and dedicated to Dr Samuel Garth, then a well-known early eighteenth-century gentleman amateur poet, author of *Poem of Claremont*. Turner could have read this in volume 8 of Anderson's *British Poets* (p. 15). Turner deleted 'Windsor Forest', presumably when he looked up the reference to check its source. The misquotation is significant. The text in Anderson reads: 'A shepherd's boy (he seeks no better name) / Led forth his flocks along the silver Thame.' Turner put 'leading' in the present tense to make it relate more to his own situation, and changed 'Thame' to Thames to make it more direct.
"Laban searching for his Images". See above. Laban searched through the tents for his statues, but did not find them because his daughter Rachel deceived him. Another Jacob subject, *Jacob's Ladder*, B&J 435, originates from this time.

57 Upright composition, the basis of *Mercury and Herse*, B&J 114, not exhibited until 1811. Conceived without a fixed subject, to judge from the list of possibilities opposite. The first of six variants of the composition. For more possible subjects see 58a. Pen and ink.

57a Study for an upright composition similar to *Mercury and Herse*. Crowd of figures in forground, as in the finished picture. Pen and ink.

58 Study for an upright composition similar to *Mercury and Herse*. Bridge in foreground. Pen and ink.

58a Study for an upright composition similar to *Mercury and Herse*. Pen and ink

Inscribed:
"Eneas and Evander" [Virgil, *Aeneid*, Book VIII.
Aeneas sails up the Tiber and is resting on its banks
when the river god appears to him and tells him that
this will be his future home. Further up the river he
meets the king Evander, who welcomes him and
makes an alliance.]
"Pallas & Aenas, departing from Evander". Pallas is
Evander's son, who joins with Aeneas to wage war on
Turnus, whose name would have caught the artist's
eye.
"Return of the Argo". Cf. 49a.

59 Study for an upright composition similar to *Mercury
and Herse*. Pen and ink.

59a Blank.

60 Study for an upright composition similar to *Mercury
and Herse*. Pen and ink.

60a–61 Blank.

61a ⟨Study for a landscape composition. Pen and ink.⟩

62 Blank.

62a–63 Blank.

63a ⟨Classical building among foliage.⟩ An aqueduct.

64 Blank.

64a–68a Blank.

69 Similar composition to the studies for *Chryses* (Iliad)
in the *Wey. Guilford* sketchbook (TB XCVIII, 3a ff.)
used as the basis of the watercolour exhibited in 1811
(W 492).

69a–71 Blank.

71a ↑ ⟨Commencement of pencil sketch of a group of
trees.⟩

72 Blank.

72a ↑ The Pavilion, Isleworth, with Syon Ferry House
to the left and Syon House centre distance. Cf. TB
XCVIII, 11 for a Claudian version of the same view.

73–81 Blank.

81a ↑ Brentford from the mouth of the River Brent. Cf.
13.

82–83 Blank.

83a–84 ↑ Four studies of a procession at the festival of
"Iacchus" – see Ovid, *Metamorphoses*, Book IV, with
dancing girls following ox carts bearing effigies of the
god. On 84 a study for "Anthony and Cleopatra"
similar to that on 84a. Pen and ink.

84a ↑ "Anthony & Cleopatra" on a barge on the Nile.
Pen and ink.

Inside cover: ⟨ . . . pencil sketch of a reach of the
Thames.⟩

'Hesperides (1)'
sketchbook, 1805 (TB XCIII)

Sketchbook, bound in marbled boards with brown
leather spine and corners, with two brass clasps, top one
broken. White paper prepared with a wash of grey
except for two flyleaves at each end. Cf. *Studies for
Pictures Isleworth* sketchbook, 1805 (TB XC), which is
of similar size, with grey-toned pages and a similar range
of subjects. The slightly smaller *Hesperides (2)*
sketchbook (TB XCIV) has the same binding and is a
companion volume. Badly waterstained throughout,
suggesting a thorough soaking, possibly on the Thames
estuary.

$10\frac{3}{8} \times 6\frac{3}{4}$ ins. WM: 'Haye & Wise 1799'.

Turner's label reads "71 H"[*esperides Bk* added in a
different hand], down spine. It is not certain that
'Hesperides' was actually the word that Turner intended,
but the book contains studies for *The Goddess of
Discord in the Garden of the Hesperides* exhibited at the
British Institution in 1806 (B&J 57). These can date
from no later than the autumn of 1805, when the
painting would have been on Turner's easel. There are
studies of Isleworth and the vicinity of Ferry House,
which Turner occupied early in 1805.

There are two distinct series of sketches starting from
the front and back covers, but from the way that a
right-handed person would open the clasps, the pages
must have been numbered in reverse. As with the *Studies
for Pictures Isleworth* sketchbook, Turner began with
studies around Isleworth, Kew, and Richmond,
accompanied by studies for classical pictures. This series
ends with a study for the picture of *Abingdon* (B&J
107), which suggests that Turner made a journey up-
river, as also recorded in the *Thames from Reading to
Walton* sketchbook (TB XCV). He then restarted the
book from the opposite end, continuing his studies for
pictures, including the *Garden of the Hesperides* (B&J
59) and developing the composition of *Dido and Aeneas*
(B&J 129) which also appears in the *Studies for Pictures
Isleworth* book. The studies for *Dido and Aeneas*
suggest that Turner was working on this painting at the
same time as *The Garden of the Hesperides*, and it seems
possible that he exhibited it at his own gallery in 1806.
The series ends with a sequence of sketches recording an
excursion downstream to the Pool of London and the
estuary. The painting *Sheerness* (B&J 62) exhibited in
1807, is related to f. 16, and there are waterstains
throughout the book, suggesting that Turner received a
thorough soaking on this expedition.

The listing below follows the sketches in their
apparent chronological sequence, beginning with f. 44a
and reversing Finberg's numbering down to f. 19. At this
point the listing moves to the other end of the book and
follows Finberg's numbering in order from f. 1 to f. 19.

Ff. 41 and 11 were transposed in rebinding before
Finberg's numbering was applied. They are restored to
their proper position below but retain their indelible
numbering.

Inside cover: Two drawings related to the unfinished oil
painting, *Men with Horses crossing a River* (B&J
170, dated *c.*1806–7). There is no evidence that the
river is being crossed; the horses are being watered.

(i) Pen-and-ink composition of figures and horses,
the basis of the figures in the painting.

(ii) Pencil sketch of men with horses and a waggon,
seemingly drawn on the spot.

44a Pencil sketch of men with horses, two women to the
right, figures in a punt to the left. Evidently drawn on
the spot. Provided the general composition of the
painting *Men with Horses*, though there are no
indications of the building that appears in the
painting, and other elements, such as the punt, are
placed differently.

44 Figures and horses by a river. Pen and ink. A variant
of the group shown in 44a. Related to *Men with
Horses crossing a River*.

43a Blank.

43 ⟨Slight study of figures. Pen and ink.⟩

42a ⟨River scene, with rainbow. Watercolour.⟩
Presumably a scene near Isleworth. No pencil work
evident, seems to have been worked directly in
watercolour from the motif. Rainbow scratched out.
The first of a series of five watercolours made in the
vicinity of Isleworth from viewpoints comparable
with sketches in the *Studies for Pictures Isleworth*
sketchbook, 1805 (TB XC) and *Thames from
Reading to Walton* sketchbook, 1805 (TB XCV).

42 Blank.

11 [This leaf transposed with 41.]
⟨The Thames at Isleworth⟩ with the Pavilion and
Syon Ferry, seen from the Surrey bank. Syon House
in the distance beyond the trees. Watercolour. Cf. TB
XC, 72a.

11a Blank.

40a River scene near Isleworth with a double rainbow.
Watercolour over traces of pen and ink. Cf. TB XCV,
49.

40 Blank.

39a ⟨River scene, with barges. Water colour [over pen
and ink.⟩ There is not much chance of positively
identifying the site of this, except that it is probably
in the Richmond-Isleworth-Kew area. W 415
(possibly a leaf from the *Thames from Reading to
Walton* sketchbook) shows a similar scene.

39 Blank.

38a Kew Bridge and Palace. Watercolour over pen and
ink. From exactly the same viewpoint as the

watercolour in the Whitworth Art Gallery, Manchester (W 413), although the watercolour shows more of the view to the right and compresses the left-hand side. Cf. TB XC, 11.

38 Study of women and children, related to the painting *View of Richmond Hill and Bridge* (B&J 73). Pen and ink.

37a Richmond Bridge from downstream on the Surrey bank. Pen and ink. The first of a series of three sketches related to the oil-painting *Richmond Hill and Bridge*, exhibited 1808 (B&J 73), Cf. TB LXXXVIII, 14–15; TB XCV, 24, 28; and TB CV, 87a.

37 Blank.

36a Richmond Bridge and Hill from the Middlesex bank, a slightly more distant view than 37a. Pen and ink. Boats and a punt and a group of figures net-fishing in the foreground. The basis of the painting known as *The Thames near Windsor* (B&J 64).

36 Blank.

35a Richmond Bridge and Hill from the Surrey bank. A slightly more distant view than 37a. The closest sketch to the painting, *Richmond Hill and Bridge*, in terms of the general composition and figure poses. Most of the activity recorded in the sketch is absent from the painting, which has a curiously empty appearance in comparison. Pen and ink.

35 Blank.

34a ⟨Group of figures with landscape. Pen and ink.⟩ The first of a series of subject compositions. This seems to be a preliminary version of compositions developed on 33a and 32a. Finberg suggested that the subject could be Diana and Actaeon, which is plausible, with nymphs in the foreground and a figure evidently surprising them. The sketches, however, could be preliminary thoughts for *The Garden of the Hesperides* (B&J 57), developed more fully on 3 ff. below.

34 Blank.

33a ⟨Study for a picture of Diana and Actaeon. Pen and ink.⟩

33 Blank.

32a ⟨Study for historical subject. Possibly Diana and Actaeon. Pen and ink.⟩

32 Blank.

31a ⟨Study for historical subject. Pen and ink.⟩

31 ⟨Study for historical subject. Pen and ink.⟩

30a ⟨Study for historical subject. Pen and ink.⟩

30 ⟨Study for landscape composition. Pencil and pen and ink.⟩

29a ⟨Landscape with broken trees in foreground. Pen and ink.⟩

29 Blank.

28a Study for picture, identified by Finberg as a study for *Apollo and Python*, exhibited 1811, B&J 115, but there seems to be very little connection. Pen and ink.

28 Blank.

27a A river scene near Isleworth. Pen and ink with scratching and wiping-out. Cf. TB XCV, 12, 45, and 49.

27 Blank.

26a Isleworth church and Ferry House (to the left of the foreground tree) from the Surrey bank. Pen and ink. Cf. TB XC, 27 for a more distant view of the same scene, which also includes the Pavilion.

26 Blank.

25a Distressed peasants. Pen and ink. One crawling on hands and knees gathering something up from the ground. Two old women to the left, one leaning forward to tend a baby, while the mother cries out to two figures at the right with a gesture of desperation. To the right an old man kneels and wrings his hands in supplication. A scene of desperate rural poverty. The theme is developed through two further compositions, 24a and 23a, considering a figure composition with a radical socio-political theme, perhaps suggesting the influence of the major exhibition of paintings by George Morland, held in London in 1805 (see Part III).

25 Blank.

24a Distressed peasants. Pen and ink. A development of the idea begun on 25a, with more figures. As with the first drawing there is a central stooping woman with a gesturing mother and child to the left. In this version a figure at the right centre is making angry representations to a rather miserly-looking figure with a stick by a horse. Another figure to the left calls out and gestures. We seem to be witnessing some kind of peasant revolt.

24 Blank.

23a Distressed peasants. Pen and ink and wash. The most developed of the three compositions on this theme, showing a still more complex version of the composition on 24a, and exploring the chiaroscuro of a potential painting. It appears that the subject of the disputation is a loaded harvest waggon in the background. Exhibited RA 1975 with the bland and misleading title *A Group of Figures seated by Lamplight among [?] Carts*, whereas the scene is laid outdoors, with trees and a mediaeval town gateway in the background.

23 Distressed labourers. Pen and ink. A meeting of men, probably at a tavern, at which there seems to be an angry debate taking place. A figure at the head of the table to the left is speaking, while another standing just to the right is shouting out. Others sit gloomily

or gloweringly around, another stands with his hands thrust in his pockets as if in frustration.

22a ⟨Interior of a blacksmith's shop. Pen and ink.⟩ Identified by the RA 1975 exhibition catalogue as the study used in *A Country Blacksmith*, exhibited RA 1807 (B&J 68), and repeated in B&J, but the comparison shows that the sketch and painting, while generally close in terms of composition and the placement of the blacksmith, differ in other details, even down to extremely minor matters such as the blacksmith's apron, and they are completely different at the right-hand side. A sketch in the *River* sketchbook of 1807 (TB XCVI, 51a) re-explores the same blacksmith's theme, and continues the theme of rural distress in a sketch of beggars, TB XCVI, 52a.

22 Blank.

21a ⟨Studies for picture of "Abingdon" [B&J 107] . . . Pen and ink.⟩ The sheet has been divided into four. The two top sections contain studies of a boat and cows, that at the top left looking into the sun, both of which bear general comparison with *Abingdon*, but differ in detail.

21–19 Blank.

[At this point Turner restarted the book from the back.]

Inside cover: Windsor Castle from the west. Pencil. The first of three sketches at Windsor. Dating from the same year, and perhaps from the same visit, are sketches in the *Wey, Guilford* sketchbook (TB XCVIII, 135a ff., mostly taken from viewpoints downstream. A number of oil sketches on mahogany veneer (B&J 177–80) taken from similar viewpoints also date from this time. Turner sketched this view on one of his first visits to the site (TB VIII D) and returned to it in 1807 (TB XCVII), 1818 (TB CXL) and 1827 (TB CCXXV and TB CCXXVI) when he was collecting material for his 'England and Wales' watercolour (W 829).

↑ Mostly illegible note in ink: ". . . P fall . . . Rome which ca . . . / her from . . ."

1 Windsor Castle from the Thames. Pencil. Cf. TB XCVIII, 135a.

Written in corner, in ink:
"Varnish
Razor
Blue Black
Bt Sienna
Fishing rod. Flies
Pallet Knife
Shoes"

Executors' endorsement in ink: 'No 228 / 41 In Pencil in Color / & Pen & Ink – / [signed] C Turner [and initialled] W.K. C.L.E.'

Inventory number in pencil: 'XCIII'

1a Figure studies related to *The Garden of the Hesperides* (B&J 57). Pen and ink.

2 Windsor and Eton from the west. Pencil. From a similar viewpoint to the oil sketch B&J 178 and TB XCVII, 11.

2a ⟨Some illegible writing in pencil.⟩ Black chalk rubbed off 3, opposite.

3 Study for *The Garden of the Hesperides*, exhibited BI 1806 (B&J 57). Finberg made the connection but thought that the figures suggested a different subject. The sketch seems more dramatic than the painting, but nevertheless all the main elements are present, even down to the fallen trunk in the right foreground. The mountainous landscape seems based on the gorge of the Grande Chartreuse, near Grenoble, which Turner sketched in 1802 (cf. e.g. TB LXXIV, 34 and 36). Pen and ink, and black chalk.

3a ⟨Study of dragon for *The Garden of the Hesperides*. Pen and ink.⟩

4 Study for classical composition, similar to *Mercury and Herse*, exhibited 1811 (B&J 114). Pen and ink and wash. An elaboration of the composition developed in the *Studies for Pictures Isleworth* sketchbook (TB XC 57 *et seq.*). Part torn off leaf at top. Cf. TB XCVIII, 15a–16.

4a Studies for figures in *Dido and Aeneas*, exhibited 1814 (B&J 129). Pen and ink. Some specific echoes in the finished picture, particularly the kneeling woman and her companion, top right, and the figures with hunting dogs, lower left. The first in a series of studies for the picture, in which the full composition and most of the details are established. It seems likely that Turner started the picture at this time, and possibly exhibited it at his own gallery in 1806, before exhibiting it at the Academy in 1814. He considered a different composition of the subject in the *Wey Guilford* sketchbook (TB XCVIII, 2).

5 Study for the whole composition of *Dido and Aeneas*. Pen and ink and wash. The painting follows this composition very closely, even down to the placing of the principal figures, lower right. For a colour version of the composition see TB XC, 21.

5a Studies for figures in *Dido and Aeneas*. Pen and ink. Few close comparisons except for the principal figures, lower left, followed very closely in the painting.

6 Studies for figures in *Dido and Aeneas*. Pen and ink.

6a Studies for figures in *Dido and Aeneas*. Pen and ink.

7 Studies for figures in *Dido and Aeneas*. Pen and ink.

7a Blank.

8 Study for *The Garden of the Hesperides*. Black chalk and pencil. The first in a series exploring alternative compositions to that established on 3.

8a Alternative study for *The Garden of the Hesperides*. Pencil – no evidence of the black and white chalk mentioned by Finberg. More or less the reverse of the composition established on 3, and setting the pattern developed in the next three sketches.

9 Alternative study for *The Garden of the Hesperides*. Pencil.

9a Alternative study for *The Garden of the Hesperides*. Ink and pencil.

10 Alternative study for *The Garden of the Hesperides*. Pen and ink.

10a Blank.

[The next leaf transposed with 11]

41 Shipping in the Thames estuary, probably off Sheerness. Watercolour, Finberg identified this as a study for the painting *Meeting of Thames and Medway*, i.e. B&J 75, exhibited 1808, but the comparison extends only to the same general idea of a cutter before a man of war. He was particularly fond of sweeping diagonal skies at this time; cf. B&J 52 (1804), B&J 48 (1803), and *The Victory in Three Positions* (B&J 59). This sketch relates to 16 and 17, which might suggest that the present leaf is mounted out of sequence; 17 reverses the composition.

41a Two studies of sailing-boats, a gaff-rigged ketch to the left and a spritsail cutter to the right. Pen and ink. Measurements of the sails, that on the left "13" at the mast and "11" at the boom; that on the right, "13" at the mast, "16" at the boom, "12" at the top, and "18" at the right. To the right some calculations:

"12	13
13	11
18	12
16	22
3/61	3/57 [i.e. 59 and 58]
20	19 yds"

The column on the left refers to the right sail, and the right column to the left sail. Turner is apparently attempting to calculate which sail had the greater area.

12 London Bridge from downstream near the end of Billingsgate, with St Magnus Martyr to the right, the Monument further to the right. Pen and ink and watercolour. The first of a series of sketches in which Turner seems to have been considering a composition of the Pool of London, the modern equivalent of Claude's great historical ports. He returned to the theme in the 1820s and made a number of sketches from similar viewpoints. Cf. TB CV.

12a Blank.

13 Slight sketch of St Dunstan in the East from the river near the Custom House. Pen and ink.

13a Slight sketch of shipping on the river near the Custom House. Pen and ink.

14 St Dunstan in the East and the Custom House from the river. Pen and ink and wash. A more detailed and distant version of the view recorded on 13.

14a Blank.

15 St Dunstan in the East and the Custom House from the river. Pen and ink and wash. From a viewpoint to the left of 14.

15a A cutter. Pen and ink.

16 Study for *Sheerness and the Isle of Sheppey* (B&J 62, where it is identified as having been exhibited in Turner's gallery in 1807). Pen and ink. The correspondence is very close. Perhaps the sky of the finished picture was also infuenced by that of the watercolour sketch on 41 above, but its main lines are in any case clearly established here.

16a Blank.

17 Study for a sea-piece. Pen and ink and wash. Finberg compared this to *Guardship at the Nore* (B&J 91) but there are no specific points of comparison. The subject is a reversed version of 41 above. It is worth considering under what circumstances Turner could have made these sketches; 16 gives the impression of having been made in haste and perhaps from a boat, but both subject and viewpoint would have shifted constantly, hardly facilitating patient or detailed recording.

17a ⟨Two sailing vessels. Pen and ink.⟩ A very free and hasty sketch. A good example of the sort of work one would expect to result from sketching shipping from a boat bobbing up and down in the Thames estuary.

18 Shipping off Gravesend. Pen and ink. Gravesend church to the right. Cf. TB XCIX, 43a. Cf. Combe, 1794–6, volume 2, p. 266.

18a ⟨A three-masted vessel. Pen and ink.⟩

[19 Blank.]

'Hesperides (2)' sketchbook, 1805 (TB XCIV)

Medium-sized sketchbook bound in marbled boards with brown leather spine and corners, two brass clasps. The same binding as the *Hesperides (1)* sketchbook (TB XCIII) and probably bought at the same time.

Turner's label down spine "72 H"

White paper prepared with a wash of grey except for two white flyleaves at each end. $9 \times 5\frac{3}{4}$ ins. WM: 'J Whatman 1801'.

Comparison with the *Hesperides (1)* and *Studies for Pictures Isleworth* sketchbooks (TB XCIII and TB XC) reveals close similarities in style and content, juxtaposing studies for subject pictures with Thames views. A sketch on f. 4 is the basis of the painting *Walton Bridges* (B&J

60) which Sir John Leicester paid for in January 1807 (see note 28 for Part III). This would suggest that the painting was exhibited at Turner's gallery in 1806, particularly since Sir John paid for *Fall of the Rhine at Schaffhausen*, exhibited at the RA in 1806, in February 1807 (see Correspondence, et. Gage, 1980, no. 20). The sketches here of Walton could, therefore, have been made no later than the previous summer, i.e. that of 1805.

There are two separate series of sketches. The first begins at Walton Bridges and finishes with a series of subject compositions drawn mostly from Ovid (cf. *Studies for Pictures*, TB XC). Turner then restarted the book from the back with a series of river views, beginning at Isleworth, but consisting in the main part of hasty sketches on the upper Thames near Abingdon, Culham, and Sutton Courtenay. These were probably made in conjunction with the *Thames from Reading to Walton* sketchbook, TB XCV, which also includes subjects on the upper river.

The following listing follows Finberg's 1909 numbering to f. 34, where Turner restarted the book at the back cover. The list then turns to f. 43a to follow the sequence in reverse numeration to f. 34a, thus enabling the reader to follow the sketches in the order in which they were apparently made.

Inside cover: Executors' endorsement in ink: 'No 282 Containing 24 leaves in Pencil & Pen & Ink – [signed] H. S. Trimmer C. Turner [and initialled] C.L.E. WK

1 Blank.

1a–2 Two trees. Cf. B&J 165. Pencil.

2a Blank.

3 Blank.

3a Blank.

4 Walton Bridge from upstream. Pen and ink. The basis of the painting *Walton Bridges* (B&J 60) with most of the main elements, the cows to the left, horses to the right, and a boat in the centre, but these details much developed in the finished picture. Cf. TB XCV, 23, 22, and 6 below for similar views.

4a Abingdon, Oxfordshire. Pen and ink. The basis of the painting B&J 107. Cf. 40a below.

5 Scene on the river near Walton Bridge. Pen and ink. The crane at the left may have suggested the incident in the painting of *Abingdon* (see 4a). Cf. 7 below.

5a Walton Bridge from downstream. The basis of the painting of *Walton Bridges* at Melbourne (B&J 63). Cf. TB CXL, 45 and W 824. There are suggestions of shafts of light in the sky, incorporated in the finished painting.

6 Walton Bridge from upstream. Pen and ink. Cf. 4 above.

6a A slight sketch of a figure dragging something. Pen and ink.

7 Scene on the river near Walton Bridge. Pen and ink. Cf. 5 above. Horse and figures to the right.

7a Scene on the river near Walton Bridge. Pen and ink. A development of the themes explored in 5 and 7, further explored in 8.

8 Scene on the river near Walton Bridge. Pen and ink. Continuing the theme developed in 5, 7, 7a, and providing detail for the right-hand side of *Walton Bridges* (B&J 60).

8a A battlemented house by the river. Pencil. ?Strawberry Hill, possibly continuing 9 to the right.

9 Houses by the river. Pencil. ?At Twickenham, possibly continued to right on 8a above.

9a–10 Blank.

10a Faint pencil sketch, possibly the continuation of 11 to right or left.

11 Scene on the river. Pencil. Very faint and only a few boats and trees discernible.

11a Scene on the river. Pencil A very faint sketch with boats and in the forground and perhaps a bridge [?Richmond – see below] in the middle distance.

12 Richmond and Richmond Hill from near the bridge. Pencil. Very faint.

12a Blank.

13 "Death of Achelous". Pen and ink and wash. Ovid, *Metamorphoses*, Book IX. Achelous was god of the river of the same name in Epirus, and was defeated, but not killed, in a wrestling match with Hercules, who ripped off one of his horns while Achelous was in the form of a bull – the scene depicted here. The story was chosen for its river imagery. The horn became the horn of plenty and the story is full of water, flowers, harvests, and fruits, suggesting late summer thoughts.

13a Blank.

14 "Death of Nessus". Pen and ink and smudges. Ovid, *Metamorphoses*, Book IX (follows almost immediately after Hercules and Achelous). Nessus was a centaur and offered to ferry Hercules' wife across the river Euenus. Hercules, in a show of strength and bravado, dived into the swirling river and swam across, whereupon Nessus promptly made off with the wife, leaving Hercules stranded on the other side of the river. Hercules loosed one of his poisoned arrows, killing Nessus. This is the scene imagined here, with Hercules on the near bank, Nessus and Deianira opposite. The dying Nessus gave Deianira a tunic steeped in his gore, tainted with the hideous poison of the hydra from Hercules' arrow. This was eventually the cause of Hercules' death.

14a Blank.

15 "Death of Liycas" [i.e. Lichas]. Pen and ink and smudges. Ovid, *Metamorphoses*, Book IX (following on immediately from the 'Death of Nessus', above). Lichas was Hercules' servant and the bearer of the poisoned tunic from Deianira to Hercules. Much enraged by the effects of the cloak, Hercules swung Lichas around three or four times (the scene imagined here) and threw him into the Euboean sea, where he turned into a rock.

15a Blank.

16 "Dryope". Pen and ink and smudges. Ovid, *Metamorphoses*, IX (closely following the 'Death of Lichas'). Dryope was changed into a tree for picking lotus flowers ([do]'. . . not pick flowers from trees, but believe that all fruitful shrubs are the bodies of goddesses') beside a pool. Turner imagines the moment at which Dryope stoops to pick a flower. He seems to have been attracted by the rich description of the pool, offering an opportunity to synthesize and express his observations of the Thames.

16a Blank.

17 "Birth of Adonis". Pen and ink. Ovid, *Metamorphoses*, Book X. Adonis' mother, Myrrha, wandering in Arabia, was changed into a tree (myrrh) while still pregnant. The baby was delivered through a fissure in the bark by Lucina. Turner imagines the delivery with a city in the distance. The next composition is possibly an alternative, with a riverside setting. Ovid gives few details of the setting except for the mention of green turf.

17a Blank.

18 Composition of a subject from the *Metamorphoses*. Pen and ink and smudges. A woman half-changed into a tree in the centre is attended by other figures in a riverside setting. Possibly an alternative composition for the 'Birth of Adonis', above.

18a Blank.

19 Ruins. Pen and ink.

19a Blank.

20 Ruins. Pen and ink. Cf. 19.

20a–34 Blank.

[At this point Turner restarted the book from the back. The remaining leaves are catalogued in the order in which they were used.]

Inside cover: "Wittingham". Pencil. Showing a church and cottages by the river Possibly Clifton Hampden, near Wittenham. Cf. 34a.

43a Blank.

43 Isleworth church from the Surrey bank. Cf. TB XCIII, 26a.

42a Cattle in the river. Pencil. Extremely scrappy.

166

42 Blank.

41a Scene on the river. Pencil. A slight sketch, with a curious small building in the middle distance.

41 Abingdon bridge. Pen and ink. The continuation of 40a to the right.

40a Abingdon bridge. Pen and ink. St Helen's church to the right.

40 Blank.

39a "Culham Bridge" from the river. Pen and ink.

39 Blank.

38a "Sutton Mills". Pen and ink. Sutton Courtenay. Cf. B&J 167.

38 Blank.

37a Scene on the river, possibly at Sutton Courtenay. Pen and ink. A similar composition to *Washing Sheep* (B&J 173).

37 Blank.

36a Scene on the river. Pen and ink. Inscription illegible.

36 Blank.

35a Scene on the river. Pen and ink. Scrappy enough to wonder why Turner made it.

35 Blank.

34a Church and cottages by the river. Pencil. Possibly Clifton Hampden. Cf. inside back cover, which seems to show a different view of the same site.

'Wey Guilford' sketchbook, 1805 (TB XCVIII)

Thick, medium-sized pocketbook, bound in red comb-striped boards with brown leather spine and corners, containing 138 leaves of white paper.

Size of page 7 3/16 × 4 9/16 ins. Speckled fore-edge decoration.

Turner's label: "74 Wey Guilford", down spine.

This sketchbook can be dated to 1805 since it contains studies of Isleworth where Turner was resident from and during the summer of 1805 (see note 6 for Part II), and since ff. 133–132a is the basis of *Windsor Castle from the Thames* (B&J 149) which is signed "I W M TURNER ISLEWORTH". Turner normally signed pictures when they were sold (see note 89 for Part III), so the painting must have been sold no later than 1806 while Turner was still living at Ferry House (see note 6 for Part II). The sketch of Windsor can therefore have been made no later than the summer of 1805. The sketchbook also contains Isleworth and Richmond subjects similar to those in the *Studies for Pictures Isleworth* (TB XC) sketchbook and the *Hesperides (1)*

sketchbook (TB XCIII), also used at Ferry House. The concurrent use of these books is further suggested by the presence of a colour study for *Windsor Castle from the Thames* in the *Studies for Pictures Isleworth* sketchbook (TB XC, 29a). The delicate use of wash here indicates that Turner was developing his thoughts towards the *Liber Studiorum*.

The book contains two separate series of sketches. The first begins with classical compositions in pen and wash, developing themes from Virgil and Homer. These are followed by some diagrams of boats and by three double-page river sketches in pencil. Some of the studies are variations of Isleworth and Richmond. The second series begins from the back of the book with drawings at Windsor and Eton related to three finished oil paintings, *Windsor Castle from the Thames* (B&J 149), *Near the Thames' Lock, Windsor*, exhibited in Turner's gallery 1809 (B&J 88) and *The Thames at Eton*, exhibited in Turner's gallery 1808 (B&J 71), which were all bought by the Earl of Egremont. This series continues with a sequence of views beginning at Godalming and moving down the Wey via St Catherine's Hill and Guildford to Newark Priory. A series of oil sketches on mahogany panels, mostly of Windsor and River Wey subjects (B&J 177–94) covers exactly the same ground, including Windsor, Godalming, St Catherine's Lock and Hill, Guildford, and Newark Priory.

There is something to be gained from studying the binding of these sketchbooks. One could, for example, tell how many pages are missing from each, and what problems there might be with the order of the sheets. In this case 138 leaves is a strange number. It seems much more likely that the book was originally made up of 18 signatures of 8 leaves = 144 leaves − 2 (stuck down on covers), which suggests that 4 leaves have been lost. The second signature begins with f. 8, and since a drawing crosses from 7a–8, f. 7 must have formed the last sheet of the first signature, running through the stitching to form the inside front cover. It follows that there should be only one folio between 4 and 7, and one folio is missing between the inside cover and f. 1. Folios 137 and 138 were at one time loose and have been stuck in at the back: 137 to f. 129, which seems correct, and 138 into the gutter, which seems arbitrary.

The listing below follows Finberg's 1909 numbering, ff. 1–105, at which point Turner restarted the book from the back. The remainder of the sketches are listed in reverse numbering, ff. 138a–105a.

Inside cover: Inventory stamp 'XCVIII' (over pencil inscription). Executors' endorsement in ink: 'No 165/ [signed] H. S. Trimmer C. Turner/ [and initialled] C.L.E. WK'

↑ Inscription: '10b'?

[One leaf may be missing here; see above.]

1 Claudian composition of figures in an Italianate

landscape with a distant view of the sea, classical buildings on a hill to the right. Inscription: "Ascanius" (son of Aeneas – Virgil, *Aeneid*).

1a–2 Pen and ink and wash, over pencil. A Mediterranean harbour seen through trees, with "Dido & Aeneas" in the foreground. Cf. Dido and Aeneas compositions in TB XC and TB XCIII.

2a–3 Pen and ink and wash, over pencil. A Claudian composition of figures in an Italianate landscape with a view of a distant classical town by the sea. Inscription: "Ulysses & Ne" (Homer, *Odyssey*).

3a Pencil. A robed figure on a Mediterranean shore, with the setting or rising sun seen in various positions. Repeated with variations in 4, opposite, and in the watercolour of *Chryses* (W 492) exhibited RA 1811, with lines from Pope's translation of the *Iliad*.

4 Pen and ink and wash (crossing gutter onto 3a). "Crises", a close variant of the composition opposite (3a above).

4a–5 Pen and ink and wash. Composition of "Ulysses [and] Poly[phemus]". The basis of *Ulysses deriding Polyphemus – Homer's Odyssey* exhibited RA 1829 (B&J 330). Probably also based on Pope. *Pace* Butlin and Joll, this sketch is closely related to the painting, especially in the general composition, the bold diagonal dividing the composition into dark and light areas, the positioning of the giant relative to the ship (followed almost exactly), the confusion of mountains and clouds, and the suggestion of Nereids before the ship. The sheet is covered in oil spatters, testifying to its proximity to Turner's easel. It would be worth considering whether he might not have started the painting at the time of this study.

5a Pen and ink. Rocky bay with setting or rising sun. A similar composition to 3a and 4, and closer to the 1811 watercolour of *Chryses* (W 492) in the details of the trees on the rocky headland. Some wash marks have crossed the gutter from an opposing page, not, it would seem, from 6.

[A leaf mising here? See above.]

6 Pen and ink and wash. A Mediterranean landscape, with a rocky bay and islands seen in the distance.

6a Blank.

7 Pen and ink and wash, over pencil. Figures struggling ashore after a shipwreck. Ulysses?

7a Pen and ink and pencil. Diagrams of a boat. The first of four sides of diagrams of a shallow-draughted, broad-beamed small boat with a long cross-spar on a single forward mast.

8 Pencil, pen and ink, and wash. Diagrams of a boat.

8a Pen and ink. Diagrams of a boat.

9 Pencil, pen and ink. Diagrams of a boat.

9a Blank.

10 Pen and ink and wash. Trees by a river with a distant building. A similar grouping of trees to the oil-painting B&J 169, but without the bridge to the right, which in turn is related to two sketches in the *Studies for Pictures Isleworth* sketchbook TB XC, 55, 56. The relationship with this group is only circumstantial, and it seems more likely that this is a 'Liber'-ized version of a scene in the vicinity of Isleworth, particularly in view of the group of sketches following.

10a Blank.

11 Pen and ink and wash. The Thames at Isleworth with the Pavilion and Syon House to the right. Ferry House centre left, behind the slender tree. The first of a set of four variations on this theme including 12, 13, and 14, which show the same spirit as the *Liber Studiorum* plate of Isleworth. Cf. TB XC, 72a for another sketch of this scene.

11a Blank.

12 Pen and ink and wash. The Thames at Isleworth.

12a Blank.

13 Pen and ink and wash. The Thames at Isleworth. Note tree and wall to the left of the Pavilion, also visible in 11 and 12, which appears in watercolours in the *Thames from Reading to Walton* sketchbook; TB XCV, 12, 48.

13a Blank.

14 Pen and ink and wash. Variation on the theme of the Thames at Isleworth.

14a–15 Blank.

15a–16 ⟨A river scene, with houses on left and wooden bridge in mid-distance.⟩

16a–17 River scene with church and buildings to right. Cf. TB XC, 41, possibly Kingston.

17a–18 River scene with Walton Bridge in the distance. Cf. TB XC, 40.

18a–19 Blank.

19a–20 Pen and ink, with pencil over. Richmond Bridge from the Twickenham bank. The same theme is developed in the two following sketches.

20a–21 Pen and ink. A variation of the view over Richmond Bridge from the Twickenham bank? More distant than 19a–20.

21a–22 Pen and ink. Variation of the view over Richmond Bridge from the Twickenham bank. A more distant view.

22a Blank.

23 Pen and ink, with a large ink blot. Composition on the theme of Diana and Actaeon (see next sketch).

23a Blank.

24 Pen and ink. Composition: ?Diana and Actaeon. Note general similarity of the composition to those for *The Garden of the Hesperides* in TB XCIII.

24a–105 Blank.

[At this point Turner restarted the book from inside the back cover. This listing follows the order in which the sketches were made.]

Inside cover:

'Hampton	3	
Ripley	12 – 6	
Lock	2 – 6	
W –	1 – 6	
Guilford	10 –	
	2	
Boat	5	
Godlaming [sic]	10 – 6	
Man	2	
St Cath	3 – 6	2 – 12 – 6″

This inscription is upside down in relation to the sketches of Windsor and the Wey which follow it. One would expect a note such as this to have been made inside the cover at the back relative to where he was working in the book. In view of the problems with the binding and pagination discussed above, it seems possible that at some stage the cover has been reversed.

138a [This leaf misplaced.] Three figure studies, perhaps of a river god?.

138 ↑ Pen and ink and wash. Figures by a wooded pool.

137a Classical harbour scene. Related to the studies at the front of the book and studies for Antony and Cleopatra, TB XC, 1 etc.

137 ↑ Seated figure, ?sketching. Lacks the waterstains of 136 ff., so possibly misplaced.

136a Eton College chapel from the south-east. The basis of *The Thames at Eton*, exhibited in Turner's gallery (B&J 71). Taken from a viewpoint at the head of Romney lock island with the old weir to the left.

136 Blank.

135a Windsor Castle from a similar viewpoint to 136a, looking in the opposite direction.

135 Blank.

134a Eton College from near Romney Lock. Cf. TB I C.

134a–133a Windsor Castle from the north, with the Winchester Tower in the centre, St George's chapel to the right, State Apartments to the left, with the round tower hidden by the trees at the left. The basis of the painting *Near the Thames' Lock, Windsor*, exhibited in Turner's gallery 1809 (B&J 88), although Turner has exercised considerable license in adapting the sketch.

133–132a Windsor Castle from the north, near Romney Lock, continued to the right on 132–131a. A more distant view than 134–133a, and the basis of the painting *Windsor Castle from the Thames* (B&J 149).

132–131a The continuation of 133–132a to the right. Curfew Tower to the right. A watercolour by William Evans of Eton (Sotheby's catalogue of 7 July 1977, Lot 155, where reproduced) is taken from a very similar viewpoint and shows the site more clearly, particularly the small bridge which carried the towpath over to the lock, where Turner shows a passing boat.

131–130a Windsor Castle from the north-east, from a viewpoint downstream of 133–131a, and further to the left.

130 Blank.

129a Eton College chapel from the river to the east. Taken in the late afternoon or evening, since we are looking west with the sun low in front to the right, i.e. in the north-west. Cf. TB CXL, 14a–15, W 830.

129–128a Windsor Castle from the north, the State Apartments to the left, and St George's chapel to the right. Cf. the oil sketch so-called *Windsor Castle from Salt Hill* (B&J 177) which shows exactly the same view. Full moon rising in the south-east to the left, since the sun set in the north-west in the previous sketch.

128–127a The view from the north terrace of Windsor Castle looking north to Eton College chapel at the left. Continued to the right on 126a, and to the left on 127, 126–125a.

127 Windsor Castle, north terrace, the continuation to the left of 125–124a.

126a Windsor Castle, north terrace, entrance to the State Apartments, the continuation to the right of 128–127a above.

126–125a The view from Windsor Castle, north terrace, looking west, The Brocas to the right, Clewer church in the distance, right centre. The continuation of 126a, 128–127a to the left.

125–124a Windsor Castle, the north terrace from below, looking west. Continued to the left on 127 above.

124–123a ?Windsor Castle.

123–122a ?Windsor Castle. The same site as 124–123a from a different angle.

122–121a Willows by the river, a ruined building in the distance to the left. Possibly Ankerwycke Priory?

121 Continuation of 120a to the left.

120a Godalming from the north-west. The oil sketch of *Godalming from the South* (B&J 190) taken from the distant hill.

120 Blank.

119a Godalming from the north, with Boarden Bridge in the foreground to the right.

119 Blank.

118a St Catherine's Hill, near Guildford, from the south. A similar view to the oil sketch, *St Catherine's Hill, Guildford* (B&J 187); 110a shows the same aspect from a nearer viewpoint;

118 Blank.

117a Guildford: Quarry Street from a second-floor window in the White Lion Hotel, High Street, with St Mary to the right and the castle above to the left. An inn to the right, the sign decipherable as the Star in a watercolour by Job Bulman in the Guildford Museum, which shows the same view from ground level, c.1780. From the list of expenses above, Turner seems to have stopped overnight at Guildford.

117 Blank.

116a St Catherine's Hill, near Guildford, from the north near Guildford Mills.

116 Blank.

115a St Catherine's Hill, near Guildford, from the north, a nearer view than 116a.

115 Blank.

114a St Catherine's Hill and ferry.

114 Blank.

113a Guildford from near St Catherine's ferry. Guildford Castle and Trinity church tower to right. A similar view to the oil sketch *Guildford from the banks of the Wey* (B&J 188) taken in the evening. A water colour by W. F. Varley in the Guildford Museum shows the same view in 1819.

113 Blank.

112a Guildford from near St Catherine's ferry. A nearer view than 113a.

112 Blank.

111a Guildford from near St Catherine's ferry. A similar view to 112a. Shadows indicate that the sun is in the east, about 9 or 10 a.m.

111 Blank.

110a St Catherine's Hill, near Guildford, from the south-east.

110 Blank.

109a St Martha's Hill from St Catherine's Hill.

109 Blank.

108a Newark Priory from the north-west.

108 Blank.

107a Newark Priory from the north-east.

107 Blank.

106a Newark Priory from the north, further to the right than 107a.

106 Blank.

105a Newark Priory from the north, from a little further to the right than 106a. Taken from a viewpoint further to the left and nearer than the oil sketch *Newark Abbey on the Wey* (B&J 192), which is taken from the south-west. Another oil sketch, *Newark Abbey* (B&J 191), shows a much nearer view from the south-south-west and must likewise have been made on the same visit as the sketches.

'Thames from Reading to Walton' sketchbook, 1805 (TB XCV)

Large roll sketchbook, originally bound in marbled paper covers, only one of which has been preserved, bearing Turner's inscription in ink 'Thames from Reading to Walton', and on verso executors' inscription in ink: 'No- 160 [signed] H. S. Trimmer C. Turner [and initialled] WK. C.L.E.' Inventory number stamped in ink and written in pencil: 'XCV'.

White paper, approx. $10\frac{1}{8} \times 14\frac{3}{16}$ ins. Individual pages vary when cut at left or right edges. WM: 'J. Whatman 1797'.

This sketchbook records subjects around Isleworth and Richmond, together with upper Thames subjects, most above Cliveden, made on a boating expedition towards Oxford. Ff. 22 and 23 are related to the painting *Walton Bridges* (B&J 60) exhibited in Turner's gallery 1806 (see note 28 for Part III), which would date them to no later than 1805, when Turner was living at Ferry House, Isleworth. Other sketchbooks in use at Ferry House, *Studies for Pictures Isleworth* (TB XC), *Hesperides (1)* (TB XCIII), *Hesperides (2)* (TB XCIV), and *Wey Guilford* (TB XCVIII), contain related subject-matter, including sketches at Kew, Isleworth, Richmond, Hampton Court, and on the upper reaches of the Thames towards Oxford. Turner used a boat at Isleworth, and many of his subjects were taken from the water. A voyage up-river to Oxford could easily have taken a month or more, given that sailing the river was subject to the vagaries of wind and weather, and was probably made in September or October 1805 when the weather was fine (see Part II, section vi). A series of oil sketches on canvas in the Turner Bequest (B&J 160–76), includes upper Thames subjects across the same range as this sketchbook. Specific relationships in some cases (compare e.g. f. 17 with *Goring Mill and Church* (B&J 161)), or ff. 34 and 35 with *Willows beside a Stream* (B&J 172), and the general similarities in subject, feeling, and treatment argue strongly that they were

made on the same tour. Sketches at Clifton Hampden, Sutton Courtenay, and Abingdon in the *Hesperides (2)* sketchbook (TB XCIV) suggest that it also accompanied him on the same journey.

In making these sketches, it seems possible that Turner had some kind of Thames work in mind, such as Ireland, 1792 or Combe 1794–6, but there are so many omissions of subjects in his coverage of the Thames that one could hardly say that he was systematic, and it seems that he pleased himself where he stopped and what he chose to record. From the size of the pages, however, it seems that he attached some importance to the work he was to put on them, and that he was intending to spend some time about it. We do not know for sure that the watercolour was applied on the spot, but the freshness of handling is usually adduced as evidence that it was (cf. e.g. Spender, 1980, p. 61).

The pages were loose when Finberg came to make his *Inventory* (Finberg, 1909), and since there was no record of their original sequence his numbering was arbitrary. Of the 48 leaves, 37 are in pencil, 9 are in watercolour, and two others are coloured drawings of deer, which may not belong to this book. Of the watercolours, most seem to record subjects around Isleworth. Many subjects are newly identified here and it is also possible to see the original relationship between some pages, and whether they were left- or right-hand ones. The following list arranges the drawings in topographical order, Kew, Isleworth, and Richmond in the first section, above Richmond in the second, and unidentified subjects in the third. Individual sheets may be located by using the following concordance:

1 (xxv); 2 (xv); 3 (xvi); 4 (xl); 5 (xviii); 6 (xvii); 7 (xxii); 8 (xxi); 9 (xvii); 10 (xxiv); 11 (iii); 12 (v); 13 (xxxviii); 14 (xxxiv); 15 (xlii); 16 (xxix); 17 (xxx); 18 (xxxii); 19 (xxxi); 20 (xliii); 21 (xliv); 22 (xi); 23 (xiii); 24 (ix); 25 (xiii); 26 (xxiii); 27 (xl); 28 (viii); 29 (xxxvii); 30 (xxxvi); 31 (xx); 32 (xiv); 33 (ii); 34 (xlv); 35 (xlvi); 36 (xlvii); 37 (xix); 38 (xxvi); 39 (xxxiii); 40 (xxxv); 41 (xxviii); 42 (i); 43 (xlviii); 44 (l); 45 (vi); 46 (x); 47 (xxxix); 48 (iv); 49 (vii).

Kew, Isleworth, and Richmond

i ⟨42. Kew Bridge with Brentford Eyot in foreground; Strand-on-Green seen through arches of Bridge.⟩ Pencil and watercolour. Right-hand page. Accidental splashes of green at right. Light from left, i.e. north-west, therefore sunset near midsummer. Wind from north-east. Low tide, with sandy riverbanks exposed. The bridge was designed by James Paine (like Richmond and Walton bridges) and opened in 1789. The present bridge was opened in 1903.

ii ⟨33⟩ ?Syon Reach, looking upstream towards Isleworth church in the distance on the right. Pencil and watercolour. Left-hand page. Cf. W 412.

iii ⟨11⟩ Classical Rotunda near Isleworth. The same view as TB XC, 4, one of a series of studies for the painting *Isis* (B&J 204). The same summerhouse appears in the *Liber* plate of *Isleworth* in place of the Pavilion. A right-hand page with watercolour across the gutter at left and with splashes of grey and brown on verso. Similar grubby marks on 2 (Marlow) and 8 (Temple Island and Henley).

iv ⟨48⟩ Syon Ferry House, Isleworth. Pencil and watercolour. Right-hand page. Cf. engraving after Schnebbelie published 1806, Leigh's *Panorama*, 1828, TB XC, 27, 72a, TB XCIII, 11, TB XCVIII 10–14. Wind from left shown by smoke from chimney. One of the most intimate and personal of the watercolours in this book. Cool, unsettled, showery conditions seem to be the rule.

v ⟨12⟩ Thames near Isleworth. Pencil and watercolour. Right-hand page. Shows the same stretch of river as 45 below from a slightly different angle, possibly looking upstream from the summerhouse at the end of the garden at Ferry House, with the same tree as in 48 above, from the other side. The boat at the bottom left appears to be a ferry. The effect of shower clouds sweeping over from the right is similar to that seen in 49 below. Looking due south with the light to the right behind clouds, therefore early afternoon. Wind from left, therefore the shower is clearing.

vi ⟨45⟩ Thames near Isleworth. Pencil and watercolour. Right-hand page. A similar view to 12 above and TB XCIII, 27a. Low tide compared with these. Looking south, so the time of day is morning, the sun being in the east to the left and low down, to judge from the length of the shadows. A distant plume of smoke at the right gives the wind direction towards us.

vii ⟨49⟩ Thames near Isleworth. Watercolour, with traces of pencil and some pen and ink. Right-hand page. The punt in the foreground argues that the river is quite shallow. Cf. sky with *Sheerness and Isle of Sheppey*, exhibited 1807 (B&J 62). The same boats seem to reappear in TB XCIII, 40a, although the far boat has had its sail removed.

viii ⟨28⟩ The Surrey bank at Richmond. Left-hand page. Cf. TB XCIII, 37a and TB CV, 87a. A detail of 24 below to the left. Watercolour down gutter edge to right.

ix ⟨24⟩ Richmond Bridge and Hill. Left-hand page. Bad foxing caused by splashing with oil while in the studio. Splashes of yellow, blue, and carmine watercolour on back. Green watercolour down gutter edge to right, suggesting that the leaf opposite was painted while still in the book. From a similar viewpoint to TB XCIII, 37a, 36a, 35a, and TB LXXXVIII, 14, 15, and related to the oil painting, *View of Richmond Hill and Bridge*, exhibited 1808 (B&J 73). Continued to the right above.

x ⟨46⟩ Richmond Bridge from the Middlesex bank. Pencil and watercolour. Right-hand page. Light from right. Cf. oil sketch (B&J 165) where the bridge is more visible and more recognizable. Turner considered the idea of a view through a screen of trees on a number of occasions at this time, cf. e.g. TB XC, 1, 12, 22, TB XCIII, 38a, TB LXX L, B&J 42, and TB XCVIII, 10.

Above Richmond

xi ⟨22⟩ Three sketches:
(a) (top left) Composition study for *Walton Bridges* (B&J 60).
(b) (top right) Composition on the theme of Walton Bridge, adopting elements from iii below.
(c) ?Maidenhead Bridge; cf. watercolour by John Warwick Smith, 1787, exhibited at Agnew 1980 No. 9 where reproduced in black and white, and TB CCIV, 11. A left-hand page, continued to the right on 23a below. The stain top right matches that on 23.

xii ⟨23a⟩ A few lines, ignored by Finberg, continuing 22 to the right.

xiii ⟨23–25⟩ Walton Bridge. The basis of the painting, *Walton Bridges* (B&J 60). The composition of the painting, and of the studies on 22, is based on sketches in the *Hesperides (2)* sketchbook (TB XCIV, 4 ff.). The oil-stains speckled across these pages testify to their having been to hand while the painting was on the easel. Walton church is visible to the left of the bridge.

xiv ⟨32⟩ The Thames from Cliveden, looking towards Maidenhead. The ruins of Cliveden House, destroyed by fire in 1795. The present house built 1851. Right-hand page. Very dirty, would benefit from cleaning, as would many of these drawings.

xv ⟨2⟩ Marlow Bridge, church, weir and mill from near the lock. Inscription: "12" arches of the bridge. The scene changed dramatically during the nineteenth century. The bridge was replaced by a suspension bridge further upstream in 1831–6, and Holy Trinity church was replaced at the same time. A right-hand page. Cf. 'Payne sketchbooks' by Joseph Powell, Sotheby's, 17 November 1983, Lot 50 (reproduced), and the plate in Combe, 1794–6, vol. 1, facing page 270. Indications of cumulus billowing up from the north-west.

xvi ⟨3⟩ Marlow from Winter Hill, Bisham Church in the distance to the left. The same view in Combe 1794–6, vol. 1, p. 272. A right-hand page, with a stain at the right-hand side which matches that on 5 (Bisham) and 6, although this may be the result of damage sustained while in the Turner Bequest.

xvii ⟨6⟩ A view near Marlow? The stain at the right edge suggests that this leaf was originally situated between 3 and 5. The view resembles that from the eastern end of Winter Hill, looking east over Cock Marsh to Bourne End.

xviii ⟨5⟩ Bisham Church and Abbey. Inscribed "Calm" to left. Stain at right matches that on 3 and 6. A right-hand page. Taken from mid-river, looking almost due south. The Abbey, built mainly in the fourteenth and sixteenth centuries, was a private house from 1540 and is now a Sports Council recreation and training centre.

xix ⟨37⟩ On the river above Marlow? The position of this leaf is suggested by the oil-stain to the right, which suggests that it originally followed 5 above.

xx ⟨31⟩ On the river above Marlow? Marks to the right suggest that this leaf originally followed 37.

xxi ⟨8⟩ Temple Island, Henley, with Henley Bridge and church in the distance. Similar grubby fold-marks to 2 (Marlow). Irregularly cut at the right-hand side. The temple was built in 1771 by James Wyatt as an eye-catcher for Fawley Court. St Nicholas church, Remenham, beyond it to the right. The viewpoint of 7 (below) on the hill beyond. A right-hand page.

xxii ⟨7⟩ Henley from the east. From the Maidenhead road, looking over the bridge, with the fourteenth-century Angel on the Bridge pub to the left. Henley Bridge was built in 1786 of Headington stone, featuring masks of Thamesis and Isis. A right-hand page with a stain top right.

xxiii ⟨26⟩ Park Place, Henley, with Marsh Mill to the right. Cf. plate in Westall and Owen, 1828. Note stain top right of 7 above repeated here.

xxiv ⟨10⟩ 'Ship Lake'. Looking west, from below Shiplake Lock to left of mill, with a boat waiting to go up while one comes through. Horse grazing on bank to right. Figure in foreground boat, weir beyond. SS Peter and Paul, Shiplake, in the distance. Looking south-west, with evening sun breaking through clouds to the right, just to the south of west. A right-hand page. The first pound lock was opened in 1773.

xxv ⟨1⟩ Caversham Bridge and Reading from the north-west. Caversham church to the left. One of the most detailed sketches in the sketchbook. A right-hand page with a mark to the right matching that on 38. Taken from a slightly higher viewpoint than 9.

xxvi ⟨38⟩ Caversham Bridge and Reading, from the north-west. Caversham church to the right. Almost as detailed as 1, and taken from a viewpoint further to the left so that the church is seen to the right. The road to Wallingford is in the foreground. A right-hand page. Mark at right matches that on 1.

xxvii ⟨9⟩ Caversham Bridge and Reading, from the north-west. Caversham church to the left. A much slighter sketch than 1, but with indications of a

passing shower. Taken from a lower viewpoint. A left-hand page.

xxviii ⟨41⟩ Caversham Bridge, near Reading. Left-hand page showing a close-up of the bridge from upstream. The present Caversham Bridge was built in 1924; the bridge drawn by Turner was a ramshackle structure dating back in parts to the thirteenth century. Taken from midstream. Waggon crossing bridge. Cf. B&J 162.

xxix ⟨16⟩ "Pangbourne Lock". Right-hand page. Pangbourne Lock now known as Whitchurch Lock. Turner is looking upstream almost due west at the lock, and the lower gates are closed, where deep shadows suggest that we are looking into the light. The time of day would therefore be evening. Taken from virtually under Whitchurch Bridge, built 1792. The first pound lock on this site was built in 1787.

xxx ⟨17⟩ Goring Church and Mill, from the river. Right-hand page. Cf. oil sketch B&J 161, which is taken from a similar viewpoint. The first bridge here was not built until 1837. The first pound lock was built in 1787, at the same time as Cleeve; see 18 below.

xxxi ⟨19⟩ "Goring". A distant view from the north. Right-hand page.

xxxii ⟨18⟩ "Cle[e]ve Mill". Right-hand page. Cleeve Mill is a sixteenth-century-building, now holiday flats. Sketch taken from just below the lock, a view almost unchanged to this day. The first pound lock was built in 1787, at the same time as Goring.

xxxiii ⟨39⟩ Wallingford Bridge and Church from upstream. Inscription: "Warf" to right. Taken from a viewpoint in mid-river, upstream of the bridge. A balustrade was added to the bridge in 1809. A right-hand page.

xxxiv ⟨14⟩ "Benson". From the south-west near the entrance to the lock, seen to the left, with the weir stretching across the foreground. A right-hand page with a smear of sap-green watercolour to right.

xxxv ⟨40⟩ Shillingford Bridge from the east. Dorchester Abbey in the distance to the right. Right-hand page, which seems to have preceded 30 below, to judge from the corresponding marks e.g. the staining on the top left edge and the curling of the top right corner. The more detailed of the two sketches, looking into the evening sun (above the hotel to the left) which is north of west, suggesting that this was made in midsummer, since it will set in the north-west. Wittenham Clumps visible above the hotel.

xxxvi ⟨30⟩ Shillingford Bridge from the west. Benson church in the distance. Right-hand page. Wooden bridge on stone piers built in 1784 to replace a ferry. For a view from the opposite side see 40 above. Building to the right now Shillingford Bridge Hotel.

The present bridge is a handsome, three-arched, stone structure.

xxxvii ⟨29⟩ Dorchester Abbey church. A right-hand page. Composition seems cramped at left. Taken from the River Thame, near the site of the present bridge, built 1811–13. Stain towards left of top edge of 40 and 30 repeated here, suggesting continuity.

Unidentified subjects

xxxviii ⟨13⟩ A church and village seen from a riverside footpath with sluices and an eel trap. Pencil and watercolour. Left-hand page. Identified by Finberg as 'Benson or Bensington, near Wallingford (?)', but the site as not readily identifiable with Benson, although it has a similar church tower. A curious structure to the left of the church, which looks like a ruin of some kind. Strong sunshine from the left.

xxxix ⟨47⟩ A house overlooking a backwater. Pencil and watercolour. Right-hand page. The building should prove identifiable, possibly in the vicinity of Isleworth. Note the use of finger in blue reflection, lower centre. Misty effect, early morning. Oil splash at extreme right edge. Peculiar light spots in the sky. Same site may be depicted in the oil sketch on canvas *House beside the River* (B&J 166).

xl ⟨27⟩ Barges at a Lock. Identified by Finberg as Newark Priory by comparison with Yale painting, *Newark Abbey on the Wey* (B&J 65), but apart from the boat at the right the resemblance is general.

xli ⟨4⟩ View across river, with wooded hill beyond. Query Cliveden Woods.⟩ No identifiable landmarks, apart from hills, which ought to narrow the possibilities down a little. A right-hand page, which looks very much as if it continues a drawing from the left.

xlii ⟨15 Punt crossing river.⟩ Right-hand page, showing a horse ferry, with what appears to be a Saxon church tower at the right, possibly Sutton Courtenay; 20 shows the same site from a nearer viewpoint. For sketches of Sutton Courtenay see the *Hesperides (2)* sketchbook TB XCIV, 38a.

xliii ⟨20 Banks of the river.⟩ Right-hand page. The same site as 15, with a Saxon church tower to the left and trees by a footbridge in front.

xliv ⟨21 Drawing of trunk and branches of a tree.⟩ Possibly made for reference in a finished picture. An upright, with the gutter at the top of the page.

xlv ⟨34 Group of willows, &c., by the river.⟩ Right-hand page.

xlvi ⟨35 Group of trees.⟩ Right-hand page.

xlvii ⟨36 Figures in punt, cutting rushes.⟩ A right-hand page, right-hand edge cut down. There is nothing,

apart from Finberg's title, to suggest that the figures in this sketch are cutting rushes. One of the most elaborate of the broken-down willow compositions, it has a poverty-stricken air about it. A boat mast is visible in the background. It is tempting to read the right-hand figures as a mother and child, but the drawing is too vague to be decipherable. Possibly setting eel-pots, a favourite theme of these years. Possibly cutting osiers.

xlviii ⟨43 Various sketches of stags.⟩ Pencil and watercolour, smaller than other leaves. Finberg has the note: 'As these two leaves have been cut down it is impossible to be certain that they belong to this book. Page 43 though stuck down tight on cartridge has another drawing on the reverse side.' The drawing has since been lifted from its mount to reveal the verso (below).

xlix ⟨43a⟩ Three drawings:
(a) Willows, probably the continuation of a drawing from an opposite leaf, inscribed: '169', not by Turner; possibly an exhibit number.
(b) Two thumbnail sketches: top, buildings seen through willows; bottom, study of willows.

l ⟨44 Various sketches of stags.⟩ Pencil and watercolour, smaller than other leaves. Cf. foreground of Cassiobury watercolour, 1807 (W 189), though the similarity is only general. Possibly leaves from another sketchbook, e.g. *Fonthill* (TB XLVII).

Related watercolours

In addition to the leaves listed here, there are a number of watercolours in various collections which might originally have formed part of this book:

Barges on a river (W 410), Private Collection

On the Thames ?Syon House (W 411), Victoria and Albert Museum, 208.1887

The Thames (W 415), British Museum, 1910-2-12-285

Kew Palace and Bridge (W 416), Private Collection, USA

Kew Palace and Bridge (W 413), Whitworth Art Gallery, Manchester (Hartley 29)

The Pavilion and Isleworth Church from Syon Park (W 412), Manchester City Art Gallery, 1920.638

Scene on a river with trees and buildings in the distance (W 420 as *Warwick Castle*), Tate Gallery, 1021

A smaller watercolour of *A View near Syon House on the Thames* (8 7/16 × 10½ ins) was with Leger Galleries, London (*English Landscape Painting*, May 1990, no. 13, where it is reproduced in colour). It is similar in style if not in size to the watercolours in the *Thames from Reading to Walton* sketchbook, and might also be datable to c.1805.

Notes and References

Abbreviations

B&J Martin Butlin and Evelyn Joll, *The Paintings of J.M.W. Turner*, second (revised) edition, London, 1984
BI British Institution
RA Royal Academy
TB Turner Bequest, Tate Gallery, London
W Andrew Wilton, *The Life and Works of J.M.W. Turner*, London, 1979

Double quotation marks indicate Turner's own words or inscriptions; single marks are used for other quotations

Preface

1 R. B. Beckett (ed.), *John Constable's Discourses*, Suffolk Records Society, XIV, 1970, p. 40.
2 Finberg, 1961, p. 192.
3 Gage, 1969¹, p. 37.
4 Wilkinson, 1974, pp. 106–7.
5 RA, 1974, no. 80, p. 52.
6 Youngblood, 1982, p. 34 n. 9.
7 Finberg, 1909, dated TB XC to 1805–1806, Finberg, 1961, to 1811–12, RA, 1975 no. 94 to c.1804–6, and Wilton, 1990, no. 12 to c.1805. TB XCIII dated by Finberg, 1909, 1805–1807, RA 1975, no. 117 c.1805–7, Wilton, 1990, c.1805. TB XCIV Finberg, 1909, 1805–1807, Wilton, 1990, c.1805. TB XCV Finberg, 1909, 1806–1807, RA, 1974, nos 114, 115 c.1806, Wilton, 1990, nos 18, 19 c.1805, TB XCVIII Finberg, 1909, 1807, reiterated Finberg, 1961, p. 137, Wilton, 1990, no. 28, c.1805–7.
8 The history of the dating of the oil sketches is recounted by Butlin and Joll, 1984, pp. 115–16 and 120, where the oil sketches on canvas are dated to c.1806–7 and the oil sketches on panel to c.1807. Wilton, 1990, dates them all to c.1805.
9 Finberg, 1961, p. 136.

I. Landscape of Youth

1 The site has been vacant awaiting redevelopment during the 1980s. See *Turner Society News* 23, winter 1981–2, p. 5 for a picture of the cider cellar.
2 The basic source for 21 Maiden Lane is Finberg, 1961, pp. 8–9. Lindsay, 1973, p. 12 has a little more to add.
3 We do not know where in St Martin's the Turners removed. See Finberg, 1961, p. 9.
4 Thornbury, 1877, pp. 1–2.
5 Ibid.
6 Ruskin, *Modern Painters*, vol. V (1860), Part IX, chapter ix.
7 Ibid.
8 Finberg, 1961, p. 9.
9 For Turner at Brentford the principal source is Fred Turner, 1922, pp. 25 ff. White's school building was demolished in 1951 to make way for road widening.
10 Thornbury, 1862, vol. II, p. 39.
11 F. Turner, 1922, p. 126.
12 Shanes, 1979, p. 16.
13 Lindsay, 1975, p. 14, paraphrasing Ruskin's *Modern Painters*.
14 According to A. Watts in L. Ritchie, *Liber Fluviorum*, 1853, p. 8. Cf. Lindsay, 1973, pp. 23–4.
15 Cf. D. M. Yarde, *The Life and Work of Sarah Trimmer*, Hounslow and District History Society, 1972, p. 40. Sarah Trimmer was a prominent figure in Brentford charity education, and the mother of Turner's friend, H. S. Trimmer.
16 Watts in Ritchie, *Liber Fluviorum*, p. ix
17 Gage, 1969,¹ p. 22.
18 Finberg, 1961, p. 14.
19 TB I B (W 7).
20 TB I D.
21 Finberg, 1961, p. 17.
22 Watts in Ritchie, *Liber Fluviorum*, p. iii, quoted in Finberg, 1961, p. 16.
23 See Finberg, 1961, p. 17, quoting a manuscript memoir by Stephen Rigaud, since published in the *Walpole Society*, I, 1984, pp. 1–164.
24 W 1–4, where it is dated ?1784. This seems to be too early. Turner would have been only nine years of age. The control of perspective and paint is in no way inferior to the copies of 1787 or *Nuneham Harcourt* of the same year, and in some ways – since the Margate subjects were original compositions, possibly from nature – they represent a more mature accomplishment. They would be considered good work even from a modern thirteen-year-old.
25 Finberg, 1961, p. 16.
26 It has not been possible to pinpoint the exact location of Marshall's cottage at Sunningwell. From Turner's drawings, however, taken from near the church gate, it would seem possible that Marshall's was one of the old cottages which stand directly opposite the gate. Finberg 1961, pp. 275–6 describes a sheet of directions to Marshall's house given by Turner to W. B. Cooke c.1822. The house 'nearly faced the church' and Turner marked its position on a plan and sketched the front. I have not seen the original of this.
27 TB II, 6, 10, 15, 16.
28 TB II, 9, 14, ?26. Cf. II C, D (W. 8, 9).
29 TB II, 12, 13, TB II E(a).
30 TB II, 3, 4.
31 TB II, 18, 19.
32 Cf. Roget 1891, vol. I, pp. 43 ff.
33 Roget, 1891, vol. I, p. 43.
34 Cf. Thornbury, 1862, vol. I, pp. 49–52, quoted (and disbelieved) by Finberg, 1961, p. 18.
35 Turner also made a watercolour of Isleworth for Hardwick, cf. W 10. According to Armstrong, 1902, it measures $10\frac{3}{4} \times 15$ ins. and shows 'Barges at Anchor against wall of churchyard. Sundial on wall of church.' It was at that time in the collection of P. C. Hardwick, grandson of Thomas Hardwick, but is now untraced. It was probably based on TB II 22 (Pl. 16). A watercolour of Isleworth purporting to be by Turner was reproduced by Adrian Bury in 'Around Isleworth with Turner, Van Gogh and Others' *Connoisseur*, June, 1942.
36 Finberg, 1961, p. 18.
37 Hawes, 1982, p. 190 (VI 6).
38 Cf. e.g. Daniel Turner *Lambeth Palace with a view of Westminster Abbey*, 1802, Yale Center, New Haven (B 1976.7.1257), reproduced in Hawes, 1982, Pl. 77.
39 Youngblood, 1984, p. 5. This is the principal essay on Turner's Oxford subjects.
40 For a full discussion of this sketchbook, cf. Hamlyn, 1985. Sketches of Isleworth, f. 32, Kingston ff. 68a–69.
41 Cf. M. Cox, *Abingdon Abbey: Its History and Buildings*, Friends of Abingdon, 1970.
42 Turner's use of the name 'Starve Castle' seems to suggest some familiar usage, in spite of the fact that there is no other known recorded use of the name.
43 Dayes, 1805, p. 352.
44 Kauffmann *et al.*, 1976, pp. [2–3]. Cf. also Wilton, 1984.
45 Roget, 1891, vol. I, pp. 78–9.
46 Farington Diary, 12 November 1798. For oysters cf. Roget, vol. I, p. 82.
47 Roget, 1891, vol. I, p. 82.
48 Farington Diary, 12 November 1798. For Monro's collection cf. Kauffmann *et al.*, 1976, *passim*.
49 Wilton, 1984, p. 9.
50 Cf. Wilton, 1984, p. 8. Examples regularly appear on the London art market.
51 Dayes, 1805, p. 353.
52 W 87–118.
53 Cf. Cohen, 1985, p. 160.
54 Dayes, 1805, p. 287.
55 Dayes, 1805, pp. 301–2.
56 Dayes, 1805, pp. 287–8.
57 L. Stainton, *J. M. W. Turner Watercolours from the British Museum*, catalogue of the exhibition at Georgia Museum of Art and the Museum of Fine Art, Houston, 1982, p. 7.
58 Cf. G. Home, *Old London Bridge*, 1931.
59 Wilton, 1979, p. 49.

172

60 J. Ruskin, *Modern Painters*, vol. I (1843), part II, v, ch. iii.

61 For Turner's work on the *Oxford Almanack* cf. Herrmann, 1968, pp. 55 ff., H. M. Petter, *The Oxford Almanacks*, Oxford, 1974, and Bell, 1904.

62 TB VIII A.

63 See Wilton, 1990, p. 11.

64 B&J 10.

65 B&J 13, 15.

66 B&J 34, 43.

67 Farington Diary, 24 October 1798.

68 Farington Diary, 30 October 1799.

69 Farington Diary, 16 November 1799.

70 Cf. Lindsay, 1973, p. 56.

71 Thornbury, 1862, vol. I, pp. 5–6, quoting Trimmer.

72 Thornbury, 1862, vol. II, p. 55.

73 Finberg, 1961, p. 112, and C. Powell, 'Turner's Women: Family and Friends', *Turner Society News*, No. 62, Dec. 1992, p. 10 ff.

74 For a survey of the fact and fiction relating to Sarah Danby see Golt, 1989. The worst (and possibly the most influential) case of over-dramatizing Turner's relationship with Sarah Danby was Michael Darlow's television film, *The Sun is God*, 1975, which showed Turner and Sarah making love immediately after John Danby's funeral. Golt gives the impression that she doubts whether Turner had much of a relationship with Sarah at all, and has recently suggested (cf. J. Golt, 'New Light on Sarah Danby', *Turner Society News*, no. 56, November 1990, p. 7) that Hannah Danby, Sarah's niece, might have been the mother of Turner's two daughters. Despite this we should not lose sight of the main piece of evidence, which is Joseph Farington's report in his diary for 11 February 1809: 'Callcott called . . . [and reported of Turner that] A Mrs Danby, widow of a musician now lives with him. She has some children . . .' This is obviously Sarah. In this light I think that Turner's selection of widow, river, and fateful parting subjects from Plutarch, as recorded in his 1805 sketchbooks, is perhaps significant (see Part II).

75 Turner acknowledged the girls in his will of 1831: 'to Evelina and Georgiana, the daughters of Sarah Danby, Widow of John Danby Musician fifty pounds a year each for their natural lives'. Evelina married Joseph Dupuis late in 1817 (Lindsay, 1973, p. 147). She must have been at least 18 years of age. Cf. Wilton, 1987, p. 127.

76 Lindsay, 1973, p. 49.

77 Wilton, 1987, p. 44.

78 Lindsay, 1973, p. 94.

79 According the rate books for Maiden Lane in Westminster City Library, which show that W. Turner paid rates on the house in 1801, but not in 1802.

80 Finberg, 1961, p. 267.

81 Ibid. The work on the gallery must have been completed in 1803, for the rental value of the property was raised in that year from £60 to £94.

82 Cf. Finberg, 1961, pp. 107 ff.

II. *Imagination Flowing*

1 The account of the meeting is given in Farington Diary, 11 May 1804. The estimate of the Academicians' *esprit de corps* and Turner's disgust is in Finberg, 1961, p. 111. A full account of the troubles at the Academy is given by Finberg, 1961, pp. 93–7, 102–5, 110–11, 113–14, and 119–21.

2 Comments on 1803 exhibition collected in Finberg, 1961, pp. 99–100.

3 Finberg, 1961, p. 109.

4 Farington Diary, 11 May 1805.

5 *The Times*, 1 August 1804.

6 Turner's occupancy of Syon Ferry House is documented in the rate books for the parish of Isleworth at Hounslow Public Library. Youngblood, 1982, made use of the poor rate book, but further information may be gathered from the hitherto unused parish rate book. Andrea Cameron, Local Studies Librarian for Hounslow, has located for me the following entries for Ferry House:

12 August 1802 (Parish)	'Mr Gould'
10 November 1803 (Parish)	'Mr Gould empty'
10 May 1804 (Poor)	'Gould empty'
15 November 1804 (Poor)	'Gould empty'
17 January 1805 (Parish)	'Mr Turner [Gould or occupier *deleted*] Rateable value £21 Rate paid 5/3'
23 May 1805 (Poor)	'Turner'
2 November 1805 (Poor)	'Turner'
5 December 1805 (Parish)	'Mr Turner 5/3'
15 May 1806 (Poor)	'Mr Turner'
30 October 1806 (Poor)	'Turner empty'
28 December 1806 (Parish)	'Turner empty'
9 March 1807 (Poor)	'Turner empty'

The parish rate was paid annually for the period Easter to Easter, falling due around mid-year, i.e. November or December. The poor rate was paid twice yearly, due at Lady Day (25 March) and Michaelmas (29 September). The first payment to mention Turner is the parish rate paid on 17 January 1805, which shows that Turner took over the house from the previous occupant, a Mr Gould, sometime before then, but after 15 November 1804 when the poor rate book shows the property as Mr Gould's and empty. A letter (*Correspondence*, ed. Gage, 1980, no. 10), dated by Gage on internal evidence to c. May 1805, asks for a half-year's rent on a property, which had been due on Lady Day (i.e. 25 March 1805). Gage tentatively read the name of the sender as 'Mr? Gilly?', but this could possibly be read as 'Mr Gould', in which case the property in question would be Ferry House. The rate books show that Turner continued to pay rates as if occupying the property until 15 May 1806, but from 30 October 1806 to 9 March 1807 the rate books record the house as empty. The fact that Turner's name goes on appearing in the entries suggests that he continued to pay rent on the house, perhaps up to September 1807, but had moved out sometime during the summer or early autumn of 1806.

7 Sketches of Isleworth by Turner which feature Ferry House include TB XC, 27 (Pl. 32) and 72, TB XCIII, 26a, TB XCIV, 43, and the later sketch TB CCIV, 9a. None of these could be said to be particularly careful or detailed. See TB XCV, 48 (Pl. 54), which is extremely detailed and beautiful, and here identified as showing Ferry House.

8 The Pavilion was designed as a small summerhouse or banqueting house for the Duke of Northumberland by Robert Mylne in the 1780s. It is sometimes refered to by Turner scholars as the Alcove (cf. e.g. Wilton, 1987, p. 69), but I have been unable to find any historical authority for this. It will here be refered to as the Pavilion, as it is identified in Leigh's *Panorama*. It is now a private dwelling.

9 Turner's Ferry House should not be confused with the present Ferry House which is called 'Park House' by Aungier, 1840, and by local directories for the period 1852–90. Directories from 1899 call it Ferry House, as today. Late eighteenth- and early nineteenth-century engravings, together with the 1818 Isleworth parish enclosure map in Chiswick Public Library, show a number of buildings in the vicinity of the present Ferry House. These include the 'View of Isleworth from Richmond Gardens' c.1794, published in the *Modern Universal British Traveller*, a 'View of Isleworth Church' c.1800 by Augustin Heckel, 'Isleworth' 1806 after Schnebbelie, published in Dr Hughson's *Description of London* (Pl. 30), and Leigh's *Panorama* (Pl. 31), all in Chiswick Public Library. The *Modern Universal British Traveller* shows a square Gothic summerhouse to the right, which can be seen again in Leigh's *Panorama*. The ferry is marked in the latter and Turner's Ferry House would be the house immediately to the right of the slipway. The same house with Gothic summerhouse is shown in Turner's watercolour TB XCV 48 and features in virtually all of Turner's Isleworth sketches. Cameron, 1982, p. 2 has a photograph of the river front at Isleworth taken c.1890, which shows that Turner's Ferry House had by then disappeared.

10 The house by the ferry slipway is shown as square in plan on the Isleworth 1818 enclosure map, and we can see the side in both the Schnebbelie 1806 print (Pl. 30) and Leigh's *Panorama* (Pl. 31).

11 General sources for Isleworth include Aungier, 1840, and Cameron, 1982.

12 Cf. Wilton, 1990, no. 1 and pp. 12–13.

13 Wilton, 1990, p. 12 says that Chaucer does not appear in Turner's set of Anderson, but he occupies pp. 1–587 of volume 1 in the set at Leeds City Reference Library. Wilton also says (p. 13) that Turner read 'a great deal' of Anderson. In fact he read only a tiny proportion of it, even if the sum total of all his subjects and references is taken into account.

14 In the following account, it is assumed that Turner started his sketchbooks on the first page and worked through them systematically from one page to the next, drawing on the right hand or lower page of double-page spreads. Occasionally he would spill across onto the opposite (left-hand or upper) page of a spread, or would use it to record a detail or memorandum. Composition and studio subjects will frequently have been worked onto opposite pages in this basic sequence, and this has been taken into account. In some cases (*Hesperides (1)*, *Hesperides (2)*, and *Wey, Guilford*) he restarted a sketchbook from the back cover. This is obvious and easy to follow. Where there is no reason to suppose otherwise, it is reasonable to assume that sketches, where still in their original order of binding, were made in the order in which we encounter them. Thus, for example, where we meet sketches at Kew early in the *Studies for Pictures Isleworth* sketchbook, then sketches at Richmond, and then later more sketches of Kew, it is reasonable to conclude that Turner went first to Kew, then to Richmond, and afterwards returned to Kew. The Richmond sketches are preceded by some studies on a classical theme, and it is equally reasonable to conclude that these were made shortly before those that follow. Turner used the five sketchbooks discussed here concurrently, and made oil sketches in addition. Where subjects relate to one another across sketchbooks, and where sketchbooks relate to oil sketches this is explained in the narrative. The inter-

relationship of the sketchbooks is discussed in the detailed listing of their contents in Part IV and cross-references between subjects are given in the individual entries.

15 Wilton, 1987, p. 69.

16 Cf. TB XC 3, 4, 5, 6 (Pl. 33), 29, 31 and TB XCV 11. TB XC 3 is the first page proper of the sketchbook, following the flyleaves, and is likely, therefore, to have been the first sketch made in the book.

17 Cf. Hartley, 1984, p. 38, and the *Victoria History of the County of Surrey*, London, 1911, vol. III, pp. 482–4.

18 Cf. J. Steven Watson, *Oxford History of England: George III, 1760–1815*, 1960, p. 416.

19 TB XC, 42.

20 TB XC, 43.

21 TB XC, 81a.

22 Hartley, 1984, p. 38.

23 *The Times* published an agricultural report summarizing the farming and weather on or shortly after the first of every month.

24 Spender, 1980, p. 61.

25 Cf. Howard and Lawrence, 1976, pp. 32 ff. The bridge was opened in 1789. Turner would have seen it being built while he was a schoolboy at Brentford.

26 Spender, 1980, p. 61.

27 Wilkinson, 1974, p. 79.

28 These buildings were identified by Finberg, 1909, as Windsor Castle. This mistake has been repeated many times since, most recently by Spender, 1980, no. 31, Paris, 1983, no. 115, and Wilton, 1990, no. 19.

29 The *Studies for Pictures Isleworth* sketchbook (TB XC) begins with subjects at Kew, Syon, and Isleworth, which continue to f. 14. There follow three pages of clasical studies, and the Richmond subjects begin on f. 18. The *Hesperides (1)* sketchbook (TB XCIII) begins with five watercolour studies of Kew, Syon, and Isleworth subjects (ff. 42a–38a), followed immediately by a series of studies of Richmond Bridge, ff. 37a–35a.

30 Defoe, 1724–6, vol. I, p. 164.

31 Ibid., vol. I, p. 165.

32 Ibid., vol. I, pp. 167–8.

33 J. Burnet, *The Progress of a Painter in the Nineteenth Century*, 1854, vol. I, p. 92, quoted in Whittingham, 1985, p. 23 n. 131.

34 C. P. Moritz, *Travels in England in 1782*, translated by A Lady, 1795, p. 115.

35 See Preston, 1977, nos. 19, 22, for examples by Joli and Zucarelli. Heckel's view was widely known through an engraving by Grignion. Heckel lived at Richmond from 1746 until his death in 1770.

36 Cf. D. Hill, *Turner in the Alps*, London, 1992, p. 27 ff.

37 Cf. Gage, 1969, pp. 152, 171, and 229 (n. 64).

38 Turner's 'Backgrounds' lecture given at the Royal Academy in 1811. Quoted from the transcript published by J. Ziff in 'Backgrounds: Introduction of Architecture and Landscape: A Lecture by J. M. W. Turner', *Journal of the Warburg and Courtauld Institutes*, XXVI, 1963, pp. 124–47 (p. 144).

39 John Cloake, *The Wick and Wick House*, in *Richmond History*, no. 5 (n.d.), the journal of the Richmond Local History Society. Typescript in Richmond Public Library, p. 7.

40 Gage, 1969,[1] p. 230 n. 73.

41 Cf. Howard and Lawrence, 1976, p. 22.

42 Sketches of Richmond Bridge in the *Shipwreck (No 2)* sketchbook (TB LXXXVIII 14, 15) may also date from this time.

43 TB XLIX, inside cover. If Turner's selection of subjects is reflective of his own situation, it is perhaps significant that in Plutarch's story of the parting of Brutus and Portia, Portia has a painting of the parting of Hecter and Andromache: 'when she looked at this piece, the resemblance it bore to her own condition made her burst into tears, and many times a day she went to see the picture and wept before it' (*Dryden's Plutarch*, Everyman edition, London, 1910 *et seq*, iii, 388). It is also possible, given the frequent occurence of incidents of Senatorial back-stubbing in Plutarch, that Turner saw something reflected there of recent machinations at the Academy.

44 Ovid *Metamorphoses*, Penguin edition, London, 1955, pp. 143–4.

45 TB XC, 56a.

46 Thornbury, 1862, vol. I, p. 169.

47 Quoted B&J p. 184. Butlin and Joll are wrong when they say that there is no connection between the sketch and the painting. All the main elements are laid down in the sketch, including the sweeping diagonal of light and shade, the general composition, and the giant reclining in the clouds.

48 Sketches of Isleworth TB XCVIII, 11–14, Richmond TB XCVIII, 20–22.

49 Defoe, 1724–6, vol. I, p. 300 ff.

50 Ibid., vol. I, p. 300.

51 Turner visited Windsor in the early 1790s to make an illustration for *The Copper-Plate Magazine* (W 107). The watercolour on which this was based is untraced. In about 1796 he incorporated the castle into a capriccio (TB XXXIII H), and about 1798 he made a small watercolour (not in Wilton but reproduced in *Turner Society News*, no. 52, June 1989). This is related in general terms to an engraving published by J Greig in *Views of London & Environs*, 1804 (W 122). Three sketches of Windsor in the *Hesperides (1)* sketchbook, TB XCIII, inside cover, 1, 2, probably date from the same visit as the *Wey Guilford* sketchbook drawings, and relate to the oil sketches discussed below (see listing, Part IV).

52 A watercolour by William Evans of Eton sold at Sotheby's on 7 July 1977 (lot 155), shows exactly the same view, and makes it clear that the rustic bridge carried the towpath onto the lock island, and that the boat at the right of Turner's sketch is actually in the lock.

53 Pepys Diary, 26 February 1666, quoted in O. Hedley, *Historic Windsor and Runnymede*, 1982, p. 2.

54 Defoe 1724–6, vol. I, pp. 302–3.

55 B&J nos. 177–94.

56 B&J p. 120 summarize the various accounts of the oil sketches and various attempts to date them.

57 But cf. Finberg, 1961, p. 137.

58 TB XCVIII, 120a ff.

59 B&J p. 120.

60 M. Goodwin, *Artist and Colourman*, 1966, p. 34.

61 Ibid., p. 15.

62 Cf. Gage, 1969,[2] a catalogue of the exhibition held at the Castle Museum, Norwich, and the Victoria and Albert Museum, London. See also Conisbee and Gowing, *Painting from Nature*, catalogue of the exhibition held at the Fitzwilliam Museum, Cambridge, and the Royal Academy, London, 1980–1, and Brown, 1991.

63 Wells had a career of his own as a watercolourist, but his work is far too weak to have had any influence on Turner. However, he was well connected with the artistic world, had a good collection of pictures, and was a founder of the Society of Painters in Watercolour. Cf. Roget, 1891, vol. I, pp. 131 ff. and Turner's *Correspondence*, ed. Gage, 1980, p. 295.

64 B&J 35a–j, discussed on pp. 25–7.

65 *John Constable's Correspondence*, ed. R. B. Beckett, vol. II, 1964, p. 32. The use of the word 'painture' may be a misspelling of 'painter', or mean something like a natural 'way of painting'.

66 There is an oil sketch by William Havell of *Caversham Bridge*, dated 1805, in the Tate Gallery, London, T 1095.

67 See Gage, 1969.[2]

68 Catalogues may be found in the National Art Library, Victoria and Albert Museum, London.

69 Farington Diary, 5 April 1805, quoted in Finberg, 1961, p. 122.

70 Farington Diary, quoted in Finberg, 1961, p. 125.

71 Farington Diary, 5 May 1807, quoted Finberg, 1961, p. 133.

72 I am assuming that the oil panels were made in the same order as the sketchbook drawings.

73 W. Cobbett, *Rural Rides* (1830), Penguin edition, 1967, p. 96.

74 TB XCVIII, 111a.

75 TB XCVIII, 108a–105a.

76 As one critic described Turner's paintwork to Joseph Farington in 1806. Quoted in Finberg, 1961, p. 126.

77 As recorded by Canaletto in paintings at Dulwich College Picture Gallery (Preston, 1977, no. 25) and the Paul Mellon Collection.

78 Cf. B&J 186.

79 Thornbury, 1862, vol. I, p. 169.

80 B&J 160–76, except 169 and 170, which are studio works (see Part II, section ii, Pl. 101, and Part II, section iii, Pl. 255. The series is discussed by Butlin and Joll, pp. 115–16.

81 B&J 160.

82 For the canvas to have been primed, it must originally have been stretched. Turner worked on a 6 × 4 ft canvas in the Isle of Wight in 1827 (see B&J, p. 159).

83 B&J 174 *Margate, Setting Sun*, Tate Gallery 2700, B&J 175 *Shipping at the Mouth of the Thames*, Tate Gallery 2702, and B&J 176 *Coast Scene with Fishermen and Boats*, Tate Gallery 2698. Although catalogued by Butlin and Joll with the series of oil sketches on canvas of upper Thames subjects, these canvases are excluded from the account given here on the grounds that they do not relate to any of the sketches here identified as constituting Turner's work at Ferry House. The first seems to be a studio work related to a sketch in the *River and Margate* sketchbook (TB XCIX, 9), which seems to me to relate to later work at Hammersmith and which I would date to 1807. The title should also be *Margate, Sunrise*, since we are looking east. The others seem also to relate in general to sketches in the same sketchbook, and must also be 1807 in date.

84 *The Times* agricultural reports published on or around the first of each month. I would propose a dating of September/October 1805 for the oil sketches on canvas on the following grounds: (1) There is no reason to believe that they were not made on a single boating expedition up the Thames from Isleworth to Oxford. (2) The same itinerary is recorded in the *Thames from Reading to Walton* sketch-

book (TB XCV), which can be dated to 1805 by reference to the sketches of Walton Bridges (ff. 22 and 23) which are in turn related to the painting of *Walton Bridges* (B&J 60), which must have been exhibited at Turner's gallery in 1806 (see note 44 for Part III below). (3) Working through the sketchbooks used at Ferry House, Isleworth, starting with *Studies for Pictures Isleworth* (TB XC), as in Part II of this book, and moving on to the *Hesperides (1)* (TB XCIII), *Hesperides (2)* (TB XCIV), and *Wey Guilford* (TB XCVIII) sketchbooks as subjects overlap, it becomes clear that Turner made sketches in the Isleworth, Kew, Richmond area, before journeying further afield to Windsor and the River Wey. The oil sketches on panel record the same range of subjects. There is no evidence of a trip above Windsor in any of the earlier sketches, but the season recorded in them appears to be midsummer from the foliage on the trees and from the sun setting in the north-west in TB XCVIII, 129a (Eton). Turner would have moved to Ferry House after the Academy exhibition closed in June 1805, and this first body of work would presumably have occupied him during the midsummer months following. (4) From the evidence reported in *The Times*, the weather was very mixed from June through to the end of August and gave way to mostly fine weather throughout September and October. The earlier sketches and oil panels show mixed conditions, as one would expect, and the *Thames from Reading to Walton* sketches and oil sketches on canvas show fine conditions and harvest subjects, also as one would expect. There seems to be enough evidence here to construct the chronology followed in the main text.

85 There are two sketches of Hampton Court in the *Studies for Pictures Isleworth* sketchbook, TB XC, 36, 37. The first is taken from a similar viewpoint to the oil sketch B&J 164, and was possibly made on the same visit.
86 Two oil sketches on panel taken from viewpoints nearby (Pls. 97, 98) are also set in the evening.
87 Ireland, 1792, vol. I, p. 195.
88 TB XCV.
89 Walpole on Henley quoted in S. R. Jones, *Thames Triumphant*, 1943, p. 109.
90 Ireland, 1792, vol. I, p. 171.
91 Torrington Diaries, vol. I, p. 58.
92 TB XCV, 38.
93 TB XCV, 9.
94 Dickens, 1893, p. 132.
95 P. Horn, *The Rural World 1780–1850*, London, 1980, p. 14.
96 Ireland, 1792, vol. I, p. 147.
97 Ibid., p. 146.
98 Ibid., p. 143.
99 Ibid., p. 144.
100 Another riverside house appears in the *Thames from Reading to Walton* sketchbook, TB XCV, 44.
101 TB XCV, 31.
102 Pencil sketches of cracked and split willows include TB XCV, 37, 34, 36.
103 TB XCIV sketches of Culham, 39a, Sutton Courtenay, 38a, Clifton, 34a.
104 TB XCIV, 37a, 42a.
105 Cf. TB XCIV, 35a.
106 Turner wrote to Sir Richard Colt Hoare from Syon Ferry House on 23 November and 14 December 1805 (*Correspondence*, ed. Gage, 1980, nos. 11, 12).

107 The sketches which record this tour, TB XCIII, 12 ff., follow studies for *The Garden of the Hesperides* (B&J 57), which was exhibited in February 1806. The studies must have been made while the painting was on the easel, which can have been no later than the autumn of 1805. This provides a *terminus a quo* for the tour.
108 TB XCIII, 13.
109 The other chiaroscuro study is TB XCIII, 14.
110 TB XCIII, 16–18.
111 TB LXXXIX *Nelson* sketchbook.

III. River of Time

1 B&J 61.
2 TB XCIII 4a–7.
3 Virgil *Aeneid*, Penguin edition, 1956, p. 101.
4 *Dido and Aeneas* was exhibited at the Royal Academy in 1814. Butlin and Joll do not doubt that it was painted shortly before its exhibition. This dating is not challenged by Wilton, 1990, no. 62, although he explores the relationship between painting and sketches in some detail. It seems to me that the picture must have been begun in 1805, since the studies in the *Hesperides (1)* sketchbook (TB XCIII) and *Studies for Pictures Isleworth* sketchbook (TB XC), especially those for small details (including figures) of the finished picture, suggest that it was on the easel at the time they were made. Furthermore, the studies in the *Hesperides (1)* sketchbook are sandwiched between studies for *The Garden of the Hesperides* (B&J 57), which must have been on the easel no later than the autumn of 1805, since it was exhibited early in 1806. It seems very likely that *Dido and Aeneas* was ready for exhibition at Turner's gallery in 1806. It is possible that it may have been reworked, especially the trees, for exhibition in 1814.
5 TB XCIII, 1a, 3, 3a, 8–10.
6 *The Garden of the Hesperides* has been the subject of a number of efforts to disentangle its complex (perhaps impenetrable) symbolism. Most prominent are Ruskin, *Modern Painters*, vol. V, ix, ch. x, 'The Nereid's Guard', Gage, 1969,[1] pp. 137–9, Wilton, 1990, pp. 23–4 and no. 30, and Nicholson, 1990, ch. III. B&J 57 gives a résumé of the main references. I am here concerned only with its significance in the immediate context of its exhibition and Turner's Isleworth studies. Wilton, 1990, pp. 23–4 draws similar conclusions.
7 Finberg, 1961, p. 119 ff.
8 Farington Diary, 21 July 1805.
9 Farington Diary, 16 February 1806.
10 TB XC, 3–6.
11 Wilton, 1987, p. 69.
12 Cf. B&J 204, where it is explained that the first references to the painting as *The Thames at Weybridge* are dated 1854 and 1856. Turner referred to it as *Egremont's Isis*, TB CLIV(a) 27.
13 See Wilton, 1990, no. 54.
14 TB LXXXVII, 10.
15 Mezzotint is a process whereby a plate is covered with small pits so that it prints a single rich, velvety, dark tone. By rubbing these pits smooth with a burnisher lighter tones can be obtained in the print, but these tend to be soft-edged transitions of tone without sharp edges. Sharp details

is usually achieved by etching into the plate before the mezzotint is applied. This has to be fairly deeply bitten into the plate in order to remain visible through the mezzotint, and is therefore normally used only for the principal outlines. The medium is therefore best suited to tonal effects, but not to sharp detail. Etching and engraving is by far the best process for the latter.
16 Cf. A. J. Finberg, *The History of Turner's Liber Studiorum*, London, 1924, and G. Wilkinson, *Turner on Landscape: The Liber Studiorum*, London, 1982.
17 TB CXXII, 25.
18 TB CLIV(a) 26a.
19 Wilton, 1987, p. 76.
20 TB XCVIII, 12.
21 TB XCVIII, 14.
22 B&J 128. For Turner's relationship with Lord Egremont see M. Luther, M. Butlin, and I. Warrell, *Turner at Petworth: Painter and Patron*, London, 1989.
23 Discussed by M. Butlin, *Turner at Petworth*, 1989, ch. 2.
24 Like *Isis* (cf. n. 12 above) the earliest use of the title seems to date from 1854 and 1856. Cf. B&J 64. Also like *Isis*, the sketch on which it is based represents an early idea among the Isleworth sketches, and the picture might well have been one of the first to be put on the easel, ready for exhibition in 1806.
25 Landseer 1808, p. 30. *The Idylliums of Theocritus* were popularized through the translation from the Greek by Francis Fawkes, published in London, 1767, and included in Anderson, 1795, volume 13.
26 Turner's use of specific times of day and year does not seem to have been much considered. I was initially drawn to it by work on the Harewood collection, for it was striking that in two watercolours of Harewood Castle (see D. Hill, 'A Taste for the Arts: Turner and the Patronage of Edward Lascelles of Harewood House (I)', in *Turner Studies*, 4, Winter 1984, pp. 29 ff.) Turner opposed morning with evening, set his time of year as near midsummer, and was consistent in his angles of illumination. The watercolour of *Old London Bridge with St Magnus the Martyr and the Monument* (Pl. 24), discussed here in Part I, sets the time of day very specifically at twenty-five minutes to eleven, and must therefore have involved some consideration of where the sun would be at that time of day, and presumably also of what its elevation would be at any particular time of the year. That Turner gave some thought to light direction in pictures in general is demonstrated by some composition studies in the Turner Bequest (TB CXX B, reproduced in Wilton, 1987, p. 66). This subject would, I suspect, prove an interesting one to investigate much further than has been possible here.
27 TB XCIII, inside cover, 44a, 44.
28 D. Hall, 'The Tabley House Papers', in *The Walpole Society's 30th Volume*, 1962, p. 93. Sir John Leicester settled accounts for another 1806 exhibit, the *Fall of the Rhine* (B&J 61) in February 1807 (*Correspondence*, ed. Gage, 1980, no. 20). For Sir John Leicester in general see J. Selby Whittingham, 'A Most Noble Patron: Sir John Fleming Leicester', in *Turner Studies*, 6 part ii, Winter 1986, pp. 24–36, where it is suggested (p. 29, following Butlin and Joll, p. 51) that the payment for *Walton Bridges* might also have included the painting of *Newark Abbey on the Wey* (see Part III, section vi). If so, *Newark Abbey* must also have been exhibited at Turner's gallery in 1806.

29 There is a sheet of composition studies, TB XCV, 22.
30 Cf. *Correspondence*, ed. Gage, 1980, no. 22.
31 The painting is inscribed 'I M W Turner RA ISLEWORTH' and must therefore have been painted while Turner was living at Ferry House. Since we know that Turner left Ferry House in 1806 (see note 6 for Part II above), the picture would most likely have been painted during autumn-spring 1805–6, and exhibited at Turner's gallery in 1806. Presumably Lord Egremont bought it then.
32 Landseer, 1808, p. 28.
33 Ibid.
34 For Wells's publication of Gainsborough cf. Roget, 1891, vol. I, p. 131.
35 Cf. B&J 107.
36 Marriage of Thame and Isis given by Combe, 1794–6, vol. I introduction. Cooke, 1811, vol. I, has a plate *Junction of the Thame and the Isis*, which shows the view from the Thames of the old four-pier wooden bridge carrying the towpath across the mouth of the Thame. Turner's view shows the same structure from the opposite direction. The accompanying commentary mentions 'the old latin poem', 'Marriage of the Thame and the Isis', and it seems very likely that Turner's painting *Union of Thames and Isis* would have called forth the same associations.
37 B&J 82, 83.
38 Cooke, 1811, introduction.
39 TB XCIII, 25a–22a.
40 *Morning Post*, 9 May 1806.
41 Cf. e.g. Arthur S Marks, 'Rivalry at the Royal Academy: Wilkie, Turner and Bird', *Studies in Romanticism*, XX, 1981, pp. 333 ff.
42 Barrell, 1980, p. 84.
43 G. Dawe, *Life and Works of the Late George Morland*, London, 1807, p. 176.
44 Cf. n. 28 above, where it is speculated that the payment of £280 for *Walton Bridges* in January 1807 might also have included this picture, in which case it would also have been exhibited in Turner's gallery in 1806. The identification of the painting with Newark Priory is problematic. B&J 65 describe the view as being taken from near Pyrford Mill, but this is not the case. Nor can TB XCV, 27, be identified with any certainty as Newark. The picture is best seen as a general recollection of his sailing experiences on the Wey.
45 These and other comments assembled by L. Herrmann, 'Turner and the Sea', *Turner Studies*, I part i, 1980, pp. 4–18.
46 Farington Diary, 10 May 1806.
47 The first documentary evidence we have for Turner living at Hammersmith is the letter of receipt to Sir John Leicester for *Walton Bridges* (see n. 44 above), whice is dated 18 January 1807 and addressed from Upper Mall, Hammersmith (cf. Finberg, 1961, p. 132). We do not know when Turner moved in, but the rate books for Syon Ferry House, Isleworth (see n. 6 for Part II above) show that Ferry House was empty on 30 October 1806. The rate books for the Hammersmith house are missing for the years 1806 and 1807, but it would appear from the entries for Ferry House that Turner probably moved during the autumn quarter of 1806.
48 W. T. Whitley, *Art in England 1800–1820*, p. 95, quoted in Finberg, 1961, p. 132.
49 Finberg, 1961, p. 133.
50 Thornbury, 1862, vol. I, pp. 162 ff., quoted Finberg, 1961, p. 133.

51 TB XCVI, XCVII, XCIX, CI, CII.
52 Farington Diary, 5 May 1807, quoting Benjamin West.
53 Landseer, 1808, p. 27.
54 Ibid.
55 The most detailed account of Turner and Sandycombe Lodge is in Youngblood, 1982.
56 Thornbury, 1862, vol. I, p. 167.
57 Ibid.
58 Thornbury, 1862, vol. I, pp. 88, 122.
59 Ibid., p. 168.
60 In the RA catalogue for 1813 Turner gave his address as 'Solus Lodge, Twickenham.'
61 Thornbury, 1862, vol. I, p. 164.
62 Ibid., p. 162, quoted in Lindsay, 1975, p. 23.
63 Ibid., p. 166. quoted in Youngblood, 1982, p. 20.
64 Ibid.
65 *Correspondence*, ed. Gage, 1980, no. 96.
66 Ibid., no. 56.
67 TB CXLI, 10a–11, 11a–12, 12a–13.
68 As reported in *The Times*. Cf. Stuckey, 1981, p. 5.
69 Cf. Golt, 1987, pp. 11 ff. Turner left for Holland on Sunday 10 August 1817 and on the 12th was in Bruges (cf. Finberg, 1961, p. 249). This seems to me to be an insuperable problem in relating the picture directly to Lady Cardigan's 1817 party. Perhaps there was another party in 1818.
70 J. Ziff in *Art Bulletin*, LIII, March 1971, p. 126. Quoted and illustrated by Whittingham, 1985, pp. 10–11.
71 James Thomson, *Summer*, lines 1401 ff.
72 John Milton, *Paradise Lost*, Book XII, lines 646–9.
73 Farington Diary, 7 July 1819, quoted in Finberg, 1961, pp. 259–60.
74 Quoted Golt, 1987, p. 9.
75 Reprinted by Walter Fawkes in his catalogue to the exhibition of watercolours at his house in Grosvenor Place, London, 1819. Cf. *Turner in Yorkshire*, catalogue of the exhibition held at York City Art Gallery, 1980, no. 81.
76 W. P. Carey, *Some Memoirs of the Patronage and Progress of the Fine Arts*, 1826, p. 147.
77 Quoted Golt, 1987, p. 9.
78 See C. Powell, *Turner in the South: Rome, Naples, Florence*, London, 1987.
79 This important event in Turner's career does not seem to have been much considered. In D. Hill, 'The Landscape of Imagination and the Sense of Place: Turner's Sketching Practice', in *Turner en France*, catalogue of the exhibition held at the Centre Culturel du Marais, Paris, 1981–2, p. 143 and n. 34 p. 146, I dated the labelling operation to 1821/2, but this can now be revised to 1824. Of the 122 or so sketchbooks that Turner numbered and labelled, the latest in date that I have been able to identify is the *Old London Bridge* sketchbook (TB CCV) which is labelled '91 London Bridge'. This can be dated to the summer of 1824, because it contains sketches used as the basis of the finished watercolour W. 514, which is dated 1824, and also contains sketches (e.g. 6a–7) which show piling operations for the new London Bridge, begun in March 1824. These piling operations are at the Southwark end of the bridge and were part of a coffer-dam for the first pier of the new bridge, where the first stone was laid at a ceremony held on 15 June 1825. Operations seem to be still at an early stage, suggesting a date during the summer of 1824. The same piling operations appear at a slightly more advanced stage of development in sketches in the *London Bridge and Portsmouth* sketchbook (TB CCVI, 21a–22), suggesting a

date slightly later in the year, perhaps in the autumn. These sketches are followed by a series recording the Lord Mayor's Parade, which took place in November. This sketchbook has no label, so we must assume that it was used after the labelling operation took place. TB CCV, however, must pre-date the operation, for it was numbered 91 in a series of labels that ran up to at least number 122 (TB CLIII), including some (e.g. '93 France Swiss', TB LXXIII, 1802) which are much earlier in date, showing that Turner collected everything he had together and numbered it in one operation, rather than adding to it chronologically as new books came to be used. We can therefore be precise about the date of the labelling, which must have been done between the summer of 1824 (TB CCV) and November 1824 (TB CCVI).
80 Cf. Shanes, 1979.
81 *Correspondence*, ed. Gage, 1980, no. 112.
82 Thornbury, 1862, vol. I, p. 164, quoted by Youngblood, 1982, p. 33.
83 Youngblood, 1982, p. 33.
84 TB CCIV, CCXII.
85 The best account of the fire and of Turner's sketches and paintings is Solender, 1984.
86 *Gentleman's Magazine* 2 (November 1834) p. 477, quoted in Solender, 1984, p. 33.
87 Clara Wells, quoted in Finberg, 1961, p. 364.
88 Cf. P. Youngblood, 'Turner and Petworth', *Turner Studies*, 2 part ii, Winter 1983, pp. 30 ff., and Luther, Butlin, and Warrell, *Turner at Petworth*, 1989, p. 22.
89 Hawes, 1972, p. 34.
90 Ibid., p. 37.
91 The major sources for *The Fighting Temeraire* are B&J 377; Hawes, 1972; Shanes, 1988; Postle, 1988; and Shanes, 1990, pp. 38–44.
92 Hawes, 1972, pp. 25 ff.
93 Ibid., p. 24.
94 Letter to *The Times*, 20 December 1877, cited in Shanes, 1988, n. 4.
95 Cf. e.g. *Morning Chronicle*, 7 May 1839, quoted B&J p. 230. I am by no means the first to have wondered about the position of the sun in *The Fighting Temeraire* (cf. e.g. Hawes, 1972; Shanes, 1990). All commentators, however, have assumed that the picture shows a sunset, and therefore the question has focused on whether Turner could have been looking west or whether he simply disregarded topographical truth for symbolic purpose. Hawes and Shanes subscribe to the latter view, while Butlin and Joll, p. 229, suggest that the ship is shown off Sheerness, being towed east out to the Nore, which cannot be the case since we see both banks of the river in the picture, no more than a few hundred yards apart, whereas the estuary is several miles wide at the Nore. It seems to me, however, that we can have both topographical truth and symbolism by accepting the picture as a sunrise. Turner could not have failed to realize that if the ship was being towed up the river, then he was looking east, since he had sailed the river himself on numerous occasions. There are even some Thames estuary sketches (TB XCIX 59a, 56a) which include compass bearings. There is reason to suppose that he thought carefully about the angle of light and the bearing of the sun in some pictures, a subject investigated here in my comments on *Richmond Hill and Bridge* (Pl. 186) and *Walton Bridges* (Pl. 188). A reading of the symbolic implications of sunrise seems to me to accord very well with the generally nostalgic

trend of his later Thames work, and his general avoidance of any of the new features to appear on the Thames during his later years. In truth Turner seems to have held a very low opinion of what the future held. The fact that commentators have customarily seen *The Fighting Temeraire* as a sunset proves nothing, except perhaps, in the case of Victorian reviewers, wishful thinking.

96 William Hutchinson, *A Treatise on Practical Seamanship*, Liverpool, 1777, reprint London 1979, p. 189.

97 The principal sources for *Rain Steam and Speed* are B&J 409; Gage, 1972; and McCoubrey, 1986.

98 The house at Cheyne Walk still stands. Cf. *Turner Society News*, 53, October 1989, pp. 12–16 and Lindsay, 1975, pp. 231, 260–4, 286, 337.

IV The Isleworth Sketchbooks

1 See D. Hill, 'A Taste for the Arts: Turner and the Patronage of Edward Lascelles of Harewood House (2)', *Turner Studies*, 5 part i, Summer 1985, p. 35 and n. 23, where I noted that Turner's watercolour of the *Refectory of Kirkstall Abbey, Yorkshire* (W 234) which was exhibited at the RA in 1798 is signed 'J. M. W. Turner', a form of signature not adopted by the artist until after his election as a full Royal Academician in 1802. This anomaly is explained by the fact that it was bought by Mrs Soane for her husband, Sir John Soane, from Turner's gallery in 1804, when it must have been signed.

Bibliography

AGNEW, Thomas, & Sons Limited, *English Watercolours and Drawings from the Manchester City Art Gallery* [exhibition catalogue], London, 1977.

—— *107th Annual Exhibition of Watercolours and Drawings*, London, 1980.

ANDERSON Robert (ed.), *The Works of the British Poets, with Prefaces, Biographical and Critical*, 13 volumes, London, 1795. (Turner's own set was exhibited at the Tate Gallery in 1990; see Wilton's catalogue, no. 1.)

ARMSTRONG Walter, *Turner*, London, 1902. (Includes a catalogue of Turner's work with descriptions.)

AUNGIER, G., *History of Isleworth*, London, 1840.

BACHRACH, A. G. H., Turner, Ruisdael and the Dutch', *Turner Studies*, 1 part i, 1981, pp. 19–30.

BANKSIDE GALLERY, LONDON *see* SPENDER, Michael, *Turner at the Bankside Gallery*, 1980.

BARRELL, John, *The Dark Side of the Landscape*, Cambridge, 1980.

BELL, C. F., 'The Oxford Almanacks', *Art Journal*, August 1904, pp. 241–7.

BOSWELL, Henry, *Picturesque Views of the Antiquities of England and Wales*, London, 1786. (A copy coloured by Turner is in Chiswick Public Library.)

BRITISH MUSEUM *see* WILTON, Andrew, *Turner in the British Museum*, 1975.

BROWN, David Blayney, *Oil Sketches from Nature: Turner and his Contemporaries* [catalogue of an exhibition at the Tate Gallery], London, 1991.

BROWNELL, Morris R., *Alexander Pope's Villa* [catalogue of an exhibition at Marble Hill House], Twickenham, 1980.

BUTLIN, Martin, GAGE, John, and WILTON, Andrew, *Turner 1775–1851* [catalogue of an exhibition at the Royal Academy], London, 1974.

BUTLIN, Martin, and JOLL, Evelyn, *The Paintings of J. M. W. Turner*, 2nd revised edition, London, 1984. (First published in 1979.)

CAMERON, Andrea, *Isleworth as it was*, Hounslow, 1982.

CASSON, Hugh, 'The Burning of the Houses of Lords and Commons, October 16, 1834' – a film produced by Kenneth Corden and Bill Morton, directed by Kenneth Corden for the BBC series, *100 Great Paintings*.

CASTLE MUSEUM, NORWICH *see* GAGE, John, *A Decade of English Naturalism*, 1969.

CLEVELAND MUSEUM OF ART *see* SOLENDER, Katherine, *Dreadful Fire!* Cleveland, 1984.

CLIFFORD, Timothy, *Turner at Manchester* [catalogue of the collection of the Manchester City Art Gallery, made to accompany a touring exhibition], Manchester, 1982.

COHEN, Ben, *The Thames 1580–1980: A General Bibliography*, London, 1985.

COMBE, William, *An History of the Principal Rivers*, with illustrations after Joseph Farington. Boydell, London, 1794–6. (Only the first two volumes, devoted to the Thames, were published.)

CONISBEE, P., 'Pre-Romantic *plein-air* painting', *Art History*, 2, 1979, pp. 413–28.

CONISBEE, P. and GOWING, L., *Painting from Nature* [catalogue of an exhibition at the Fitzwilliam Museum, Cambridge], Cambridge, 1980.

COOKE, W. B., *The Thames*, London, 1811. (Revised and expanded editions were published in 1814 and 1818–22.)

CORMACK, Malcolm, *J. M. W. Turner RA 1775–1851: A Catalogue of the Drawings and Watercolours in the Fitzwilliam Museum, Cambridge*, Cambridge, 1975.

DAYES, Edward, *The Works of the Late Edward Dayes*, London, 1805. (Reprint, London, 1971.)

DEFOE, Daniel, *A Tour through the Whole Island of Great Britain (1724–26)*, 2 volumes, Everyman edition, London, 1974.

DICKENS, Charles, Junior, *Dickens' Dictionary of the Thames*, London, 1893. (Facsimile reprint, Oxford, 1972.)

DOUWMA, Robert, Limited, *The British Isles, Part 3: London* [catalogue of an exhibition at Robert Douwma Ltd., Great Russell Street, London], London, 1980.

FARINGTON, Joseph, *The Diaries of Joseph Farington, RA*, edited by Kenneth Garlick and others, 16 volumes, London, 1978–84.

—— *Joseph Farington, Watercolours and Drawings* [catalogue of an exhibition at Bolton Art Gallery and Museum], Bolton, 1977.

FINBERG, A. J., *A Complete Inventory of the Drawings in the Turner Bequest*, 2 volumes, London, 1909.

—— *The Life of J. M. W. Turner*, 2nd edition, Oxford, 1961.

FITZWILLIAM MUSEUM *see* CONISBEE, P. and GOWING, L., *Painting from Nature*, 1980, and CORMACK, Malcolm, *J. M. W. Turner RA 1775–1851*, 1975.

GAGE, John, *Colour in Turner*, Oxford, 1969.

—— *A Decade of English Naturalism* [catalogue of an exhibition held at the Castle Museum, Norwich], Norwich, 1969.

—— *Turner: Rain, Steam and Speed*, London, 1972.

—— *Turner: A Wonderful Range of Mind*, London, 1987.

GOLDYNE, Joe, *J. M. W. Turner: Works on Paper from American Collections* [catalogue of an exhibition held at the University Art Museum, Berkeley], San Francisco, 1975.

GOLT, Jean, 'Beauty and Meaning on Richmond Hill: New Light on Turner's Masterpiece of 1819', *Turner Studies*, 7 part ii, 1987, pp. 9–20.

—— 'Sarah Danby: Out of the Shadows', *Turner Studies*, 9 part ii, 1990, pp. 3–10.

GOWING, Lawrence, *Turner: Imagination and Reality* [catalogue of an exhibition at the Museum of Modern Art, New York], New York, 1966.

HAMLYN, Robin, 'An Early Sketchbook by J. M. W. Turner', *Records of the Art Museum, Princeton University*, 44 part ii, 1985, pp. 2–24.

HARTLEY, Craig, *Turner Watercolours in the Whitworth Art Gallery, Manchester*, Manchester, 1984.

HAWES, Louis, 'Turner's Fighting Temeraire', *Art Quarterly*, XXXV, 1972, pp. 23–48.

—— *Presences of Nature: British Landscape 1780–1830* [catalogue of an exhibition at the Yale Center for British Art], New Haven, 1982.

HERRMANN, Luke, *Ruskin and Turner* [catalogue of the Turner watercolours at the Ashmolean Museum, Oxford], London, 1968.

HOLME, Thea, *Chelsea*, London, 1972.

HOME, Gordon, *Old London Bridge*, London, 1931.

HOWARD, D., and LAWRENCE, N., *Richmond Bridge and other Thames Crossings between Hampton and Barnes* [catalogue of the Richmond Bridge Bicentenary Exhibition, Orleans House Gallery, Twickenham], London, 1976.

HUTCHINSON, William, *A Treatise on Practical Seamanship*, London, 1777. (Facsimile reprint, Ilkley, 1979.)

IRELAND, Samuel, *Picturesque Views on the River Thames*, 2 volumes, London, 1792.

KAUFFMANN, C. M., MAYNE, Jonathan, and JEFFERISS, F. J. G., *Dr Thomas Monro (1759–1833) and the Monro Academy* [catalogue of an exhibition at the Victoria and Albert Museum], London, 1976.

LANDSEER, John, *Review of Publications of Art*, 1808 [containing a review of Turner's gallery], reprinted in *Turner Studies*, 7 part i, 1987, pp. 26–33.

LEIGH, Samuel, *Panorama of the Thames from London to Richmond*, c.1830 [1828].

LINDSAY, Jack, *Turner: His Life and Work*, London, 1966. (Reprint 1973.)

McCOUBREY, John, 'Time's Railway: Turner and the Great Western', *Turner Studies*, 6 part i, 1986, pp. 33–9.

MANCHESTER CITY ART GALLERY *see* CLIFFORD, Timothy, *Turner at Manchester*, 1982.

MUSEUM OF MODERN ART, NEW YORK *see* GOWING, Lawrence, *Turner: Imagination and Reality*, New York, 1966.

NICHOLSON, Kathleen, *Turner's Classical Landscapes: Myth and Meaning*, Princeton, NJ, 1990.

O'REILLY, Susan, and WILCOX, Timothy, *The River Thames*, Oxford, 1983.

PARIS, GRAND PALAIS, *J. M. W. Turner* [catalogue of an exhibition held at the Grand Palais], Paris, 1983.

PERROTT, David (ed.), *The Ordnance Survey Guide to the River Thames and River Wey*, London, 1984.

POSTLE, Martin, 'Chance Masterpiece: Turner and Téméraire', *Country Life*, 15 September 1988, pp. 248–50.

PRESTON, Harley, *London and the Thames: Paintings of Three Centuries* [catalogue of an exhibition at Somerset House], London, 1977.

RICHMOND, *Historic Richmond* [catalogue of an exhibition held at Richmond Town Hall, August–September, 1959], Richmond, 1959.

—— *see also* HOWARD, D., and LAWRENCE, N., *Richmond Bridge . . .*, 1976.

ROGET, J. L., *History of the Old Watercolour Society*, 2 volumes, London, 1891. (Reprint in one volume, Woodbridge, 1972.)

ROYAL ACADEMY *see* BUTLIN, M., GAGE, J., and WILTON, A., *Turner 1775–1851*, London, 1974.

SETFORD, David, 'A Noble Patron: The 5th Earl of Essex', *Antique Collector*, August 1985, pp. 42–7.

SETFORD, David, and others, *A Fair and Large House: Cassiobury Park 1564–1927* [booklet accompanying an exhibition at Watford Museum, 17 August–2 November 1985], Watford, 1985.

SHANES, Eric, *Turner's Picturesque Views in England and Wales*, London, 1979.

—— 'Turner's "Unknown" London Series', *Turner Studies*, 1 part ii, 1981, pp. 36–42.

—— *Turner's Rivers, Harbours and Coasts*, London, 1981.

—— 'Picture Notes: The Fighting Téméraire', *Turner Studies*, 8 part ii, 1988, p. 59.

—— *Turner's Human Landscape*, London, 1990.

SOLENDER, Katherine, *Dreadful Fire! Burning of the Houses of Parliament* [catalogue of an exhibition at the Cleveland Museum of Art], Cleveland, 1984.

SOMERSET HOUSE *see* PRESTON, Harley, *London and the Thames*, 1977.

SPENCER, Richard, 'Turner and Rural Genre', unpublished dissertation submitted for the degree of BA Hons at the University of Leeds, 1985.

SPENDER, Michael, *Turner at the Bankside Gallery* [exhibition catalogue], London, 1980.

STUCKEY, Charles F., 'Turner's Birthdays', *Turner Society News*, no. 21, April 1981, pp. 2–8.

TATE GALLERY *see* BROWN, David Blayney, *Oil Sketches from Nature*, 1991, and WILTON, Andrew, *Painting and Poetry*, 1990.

THAMES, *The Thames Book, 1985*. Croydon, 1985.

—— *Thames Bridges* [catalogue of an exhibition at the Whitechapel Gallery], London, 1930.

—— *The Thames in Art* [catalogue of an Arts Council exhibition at Henley on Thames and Cheltenham], London, 1965.

—— *Up the Thames to Richmond* [catalogue of an exhibition of Thames river craft at the Orleans House Gallery], Twickenham, 1975.

THORNBURY, Walter, *Life and Letters of J. M. W. Turner*, 2 volumes, London, 1862. (Second revised edition in one volume, 1877.)

TORRINGTON, John Byng, 5th Viscount, *The Torrington Diaries, containing the Tours through England and Wales . . . between the Years 1781 and 1794*, edited by C. Bruyn Andrews, 4 volumes, London, 1934. (Reprint 1970.)

TURNER, Fred, *The History and Antiquities of Brentford*, London, 1922.

TURNER, J. M. W., *Collected Correspondence*, edited by John Gage. Oxford, 1980.

VICTORIA AND ALBERT MUSEUM *see* KAUFFMANN, C. M. and others, *Dr Thomas Monro . . .*, 1976.

WEIL, A., 'Turner's Covent Garden', *Turner Society News*, no. 23, Winter 1981–2, pp. 4–7.

WESTALL, William, and OWEN, Samuel, *Picturesque Tour of the River Thames*, London, 1828.

WHITTINGHAM, J. Selby, 'What You Will; or some notes regarding the influence of Watteau on Turner and other British artists (1)', *Turner Studies*, 5 part i, 1985, pp. 2–24.

—— '47 Queen Anne Street West', *Turner Society News*, no. 39, February 1986, pp. 8–11.

—— 'Turner's Second Gallery', *Turner Society News*, no. 42, November 1986, pp. 8–12.

WHITWORTH ART GALLERY, MANCHESTER *see* HARTLEY, Craig, *Turner Watercolours . . . 1984*.

WILKINSON, Gerald, *Turner's Early Sketchbooks, 1789–1802*, London, 1972.

—— *The Sketches of Turner, R. A., 1802–20*, London, 1974.

—— *Turner's Colour Sketches, 1820–34*, London, 1975.

WILTON, Andrew, *Turner in the British Museum* [exhibition catalogue], London, 1975.

—— *The Life and Work of J. M. W. Turner*, London, 1979.

—— 'The Monro School Question: Some Answers', *Turner Studies*, 4 part ii, 1984, pp. 8–23.

—— 'Dreadful Fire! Burning of the Houses of Parliament' [review of the exhibition at Cleveland and Philadelphia, 1984–5], *Turner Studies*, 5 part i, 1985, pp. 53–4.

—— *Turner in his Time*, London, 1987.

—— *Painting and Poetry* [catalogue of an exhibition at the Tate Gallery], London, 1990.

YALE CENTER FOR BRITISH ART *see* HAWES, Louis, *Presences of Nature*, 1982.

YOUNGBLOOD, Patrick, 'The Painter as Architect: Turner and Sandycombe Lodge', *Turner Studies*, 2 part i, 1982, pp. 20–35.

—— 'The Stones of Oxford: Turner's Depiction of Oxonian Architecture', *Turner Studies*, 3 part ii, 1984, pp. 3–21.